150 Best Mini Interior Ideas

150 Best Mini Interior Ideas

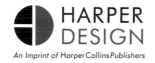

HARPER
DESIGN

An Imprint of HarperCollinsPublishers

JUL 2015

150 BEST MINI INTERIOR IDEAS
Copyright © 2014 by HARPER DESIGN and LOFT Publications

HarperCollins books may be purchased for educational, business, or sales promotional use.
For information, please e-mail the Special Markets Department, at SPsales@harpercollins.com.

First published in 2014 by:
Harper Design
An Imprint of HarperCollins*Publishers*
195 Broadway
New York, NY 10007
Tel.: (212) 207-7000
Fax: (212) 207-7654
harperdesign@harpercollins.com
www.harpercollins.com

Distributed throughout the world by:
HarperCollins*Publishers*
195 Broadway
New York, NY 10007
Fax: (212) 207-7654

Editorial coordinator: Claudia Martínez Alonso
Art director: Mireia Casanovas Soley
Editor and texts: Francesc Zamora Mola
Texts: Aleix Ortuño Velilla
Graphic editor: Manel Gutiérrez (@mgutico), Ana Herrera Moral
Layout: Cristina Simó Perales

ISBN 978-0-06-235201-9

Library of Congress Control Number: 2013954401

Printed in China
First printing, 2014

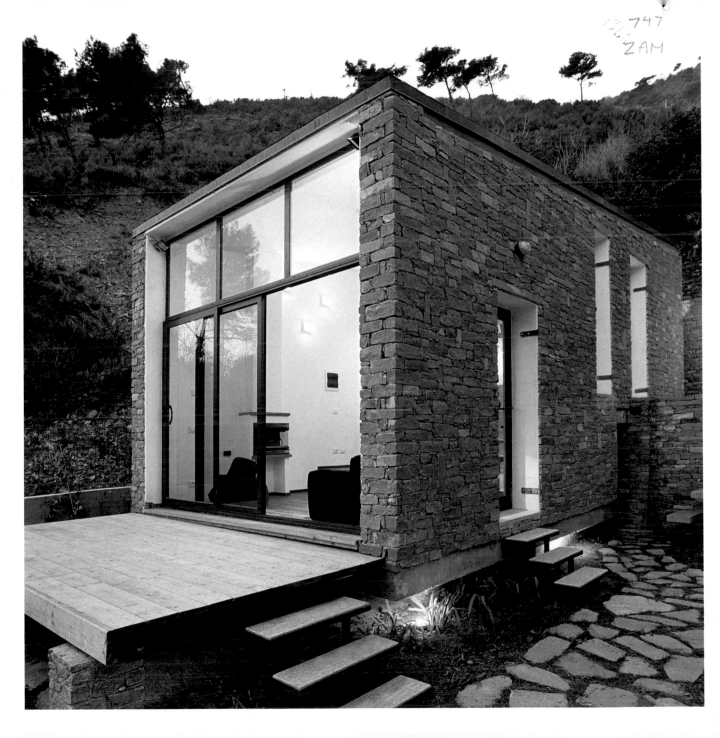

Contents

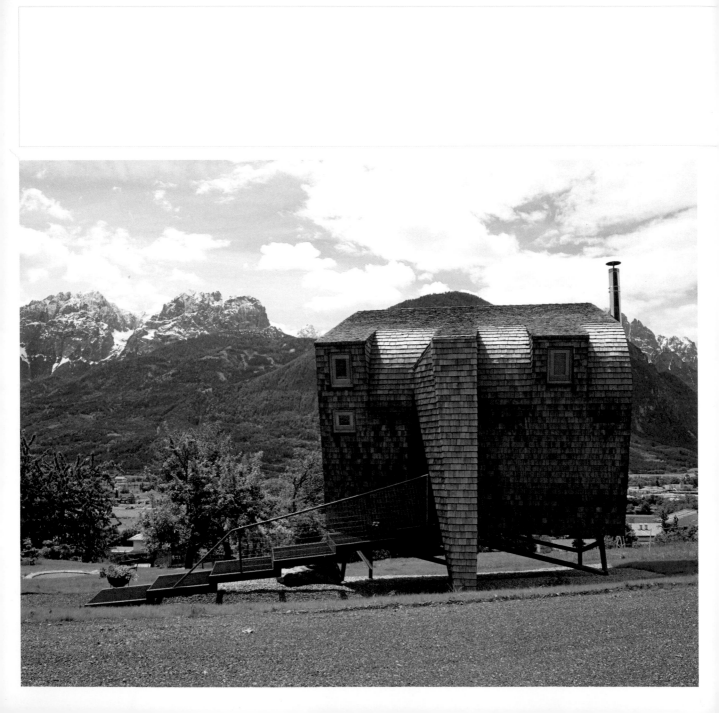

Introduction

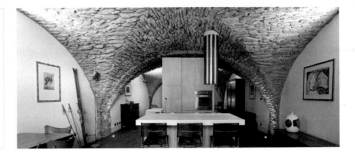

A scarcity of space can trigger talent and creativity. Nothing is sacrificed among the studios, apartments, lofts and other properties that are featured in this book. Architects do not shrink in the face of small spaces —they simply aim to achieve the same level of comfort in six hundred square feet as in two thousand.

In fact, their ambition is to achieve what may sound impossible: the same sense of space in both.

This book is a search for sensory achievement, and these words are designed to focus our attention on the tools.

The illustrations in this book are diverse: rural and urban constructions; townhouses and unusual homes; brand-new constructions and renovations of existing properties. The marks of genius are those that overcome every challenge, but the search for space where there is little is governed by a few common rules.

One important one is pulling down walls.

This creates large empty spaces, and with minimal furniture and optimal lighting, an uninterrupted space seems to expand before our eyes. The space stretches from inside to out, in touch with nature, expanding within the house by connecting it with the infinite beyond.

And many other tricks are used, of course.

Multifunctional rooms; transformable furniture; and architectural elements that are also furniture define these designs.

The items are fitted into the box so we do not feel boxed in ourselves.

What remains is an homage to the use of our living space.

Welcome to this journey through functional architecture.

It is one that you will make with very few steps indeed.

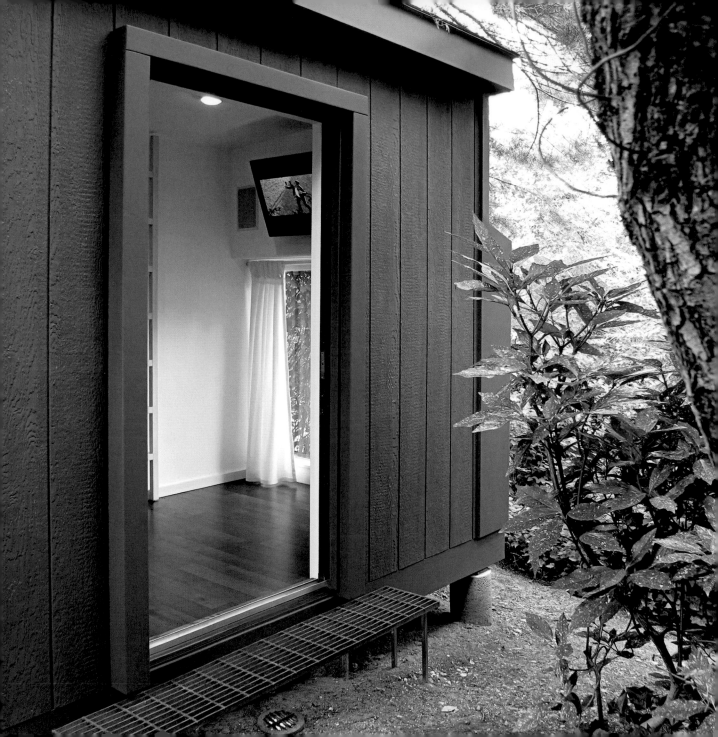

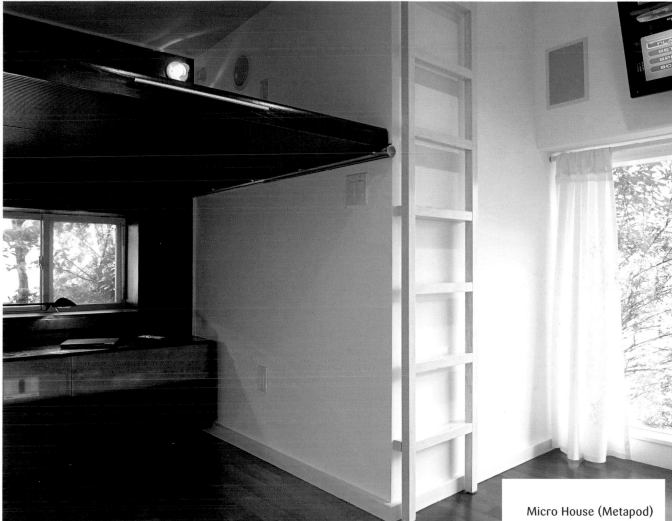

Micro House (Metapod)
125 sq ft

Designer and builder: Jerome A. Levin

Location: Roslyn Harbor, NY, USA

Photographer: © Jerome A. Levin

Micro House, also dubbed the "Metapod," was designed as a garden retreat that both adults and children can enjoy. The simple structure can also be adapted to be used as sustainable, affordable and off-the-power-grid housing. All these features contribute to the singularity and character of this project.

Side elevation

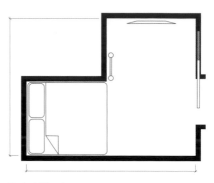

Sleeping loft floor plan

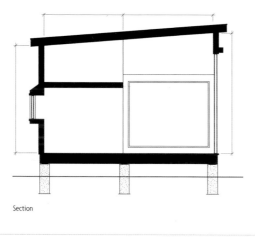

Section

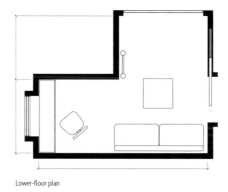

Lower-floor plan

The Metapod has a study area, an entertainment area and handcrafted furniture, including a collapsible oak loft bed. A pocket door was custom-designed to maximize the interior usable space.

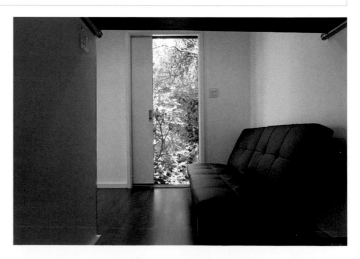

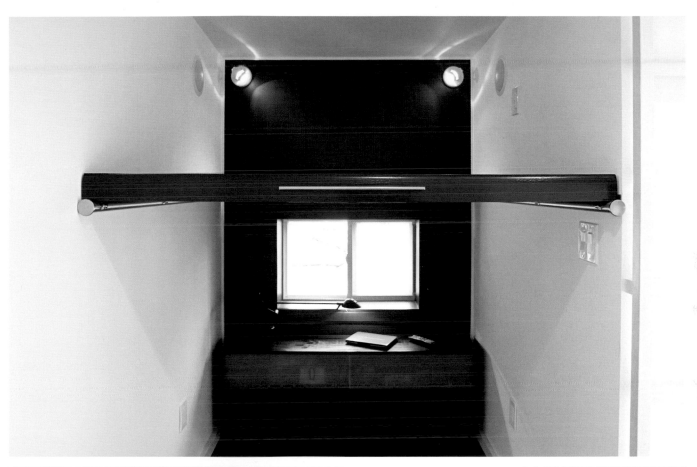

Bespoke furniture can facilitate the adaptation of a dwelling's existing space to various functions, but it is not necessarily the most cost-effective solution.

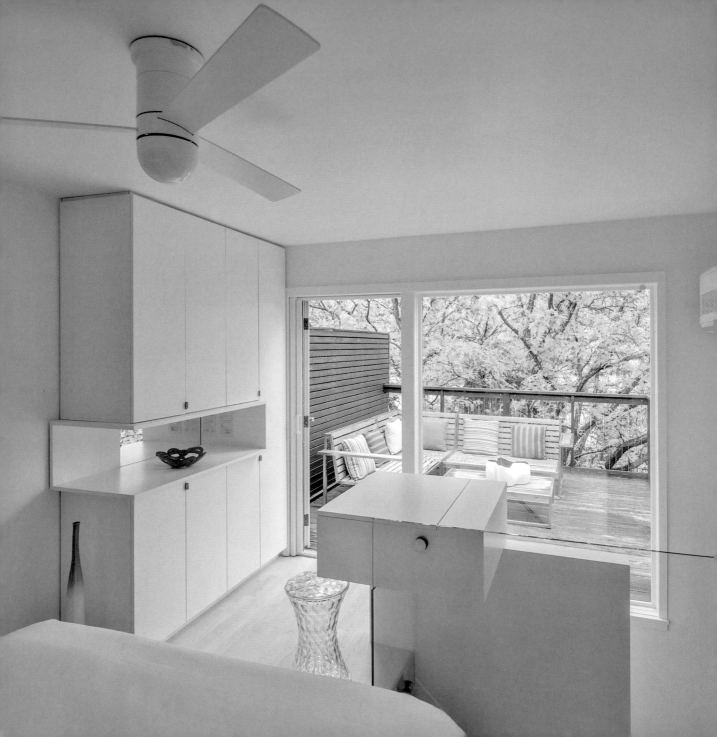

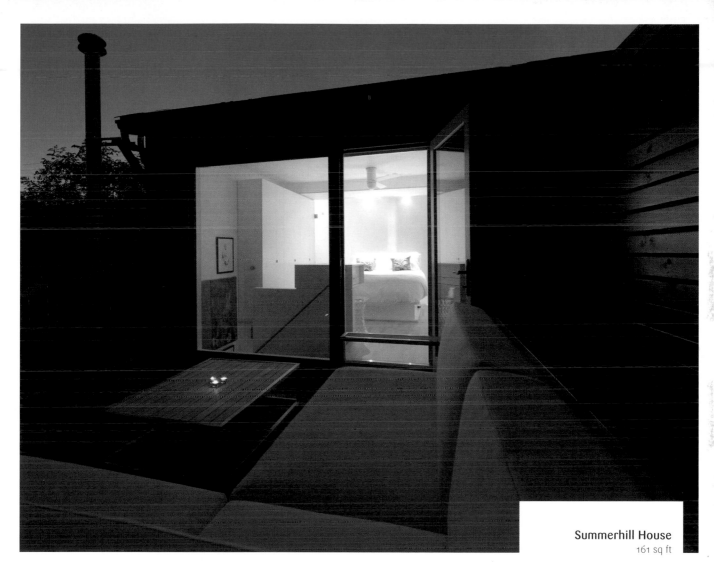

The conversion of an existing 160-square-foot attic space into a functional master suite was a challenging project for these architects, who created a room open to a shaded, south-facing terrace with views of downtown Toronto.

Summerhill House
161 sq ft

Architect: Tim Wickens
Architect
Location: Toronto, ON, Canada
Photographer: © Bob Gundu

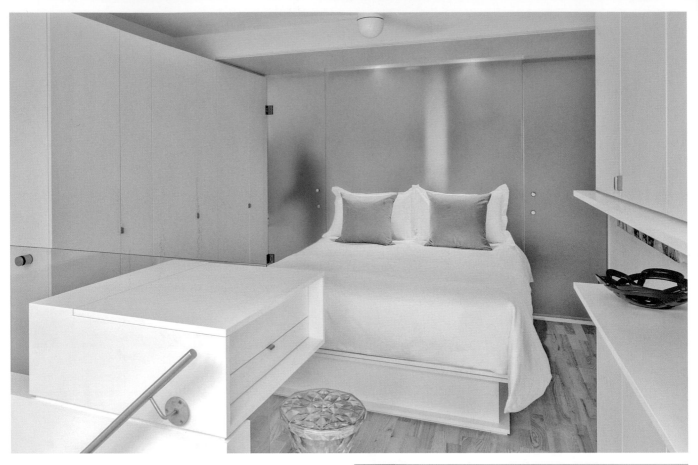

002

Put the space under the bed, which often ends up collecting random junk, to good use. Platform beds can help you take control of that area in an organized manner.

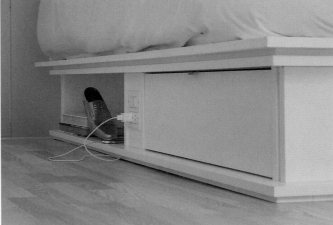

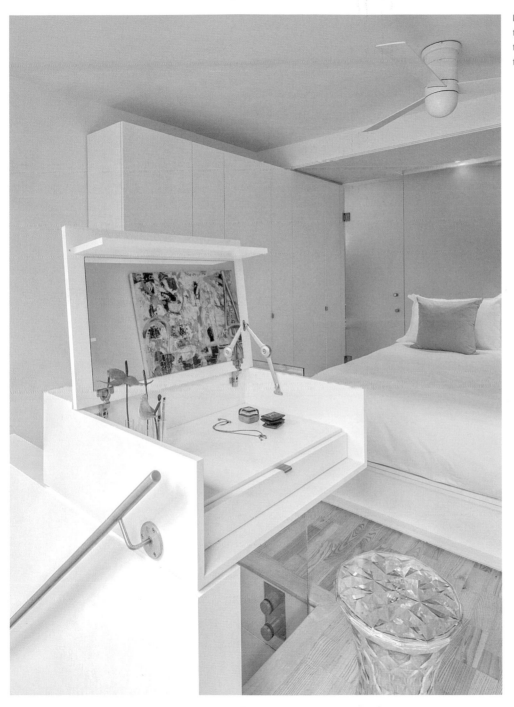

Partially supported by a glass balustrade, the makeup and jewelry table floats over the staircase to the second floor, making the most of limited space.

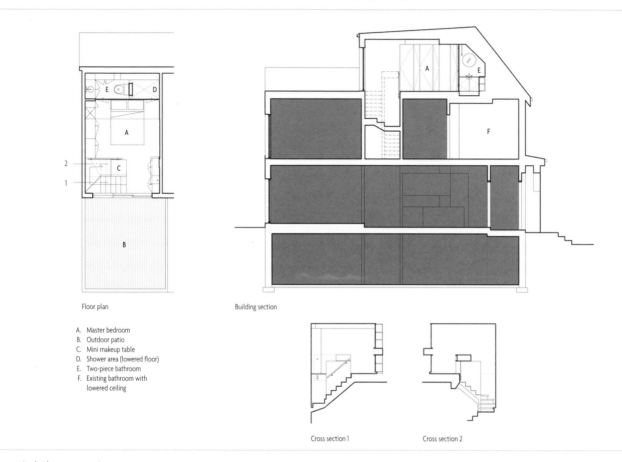

Floor plan

A. Master bedroom
B. Outdoor patio
C. Mini makeup table
D. Shower area (lowered floor)
E. Two-piece bathroom
F. Existing bathroom with
 lowered ceiling

Building section

Cross section 1

Cross section 2

The en-suite bathroom occupies a
three-foot strip of floor space under a
sloping ceiling. It is cut out and dropped
one step down into the headspace of the
second-floor bedroom below.

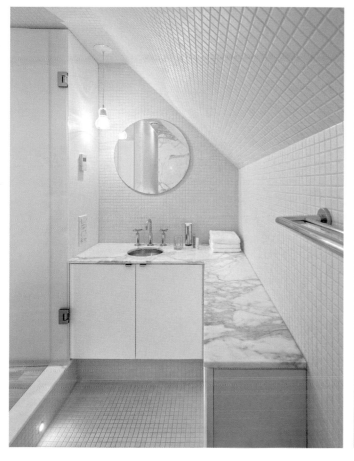

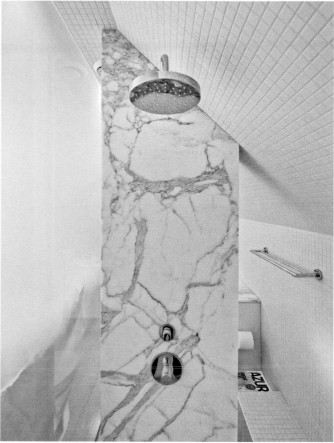

The two spaces behind the frosted glass headboard are defined by a marble pier as separate shower and powder rooms, but they are linked by a continuous tile bench that runs the full length of the wall.

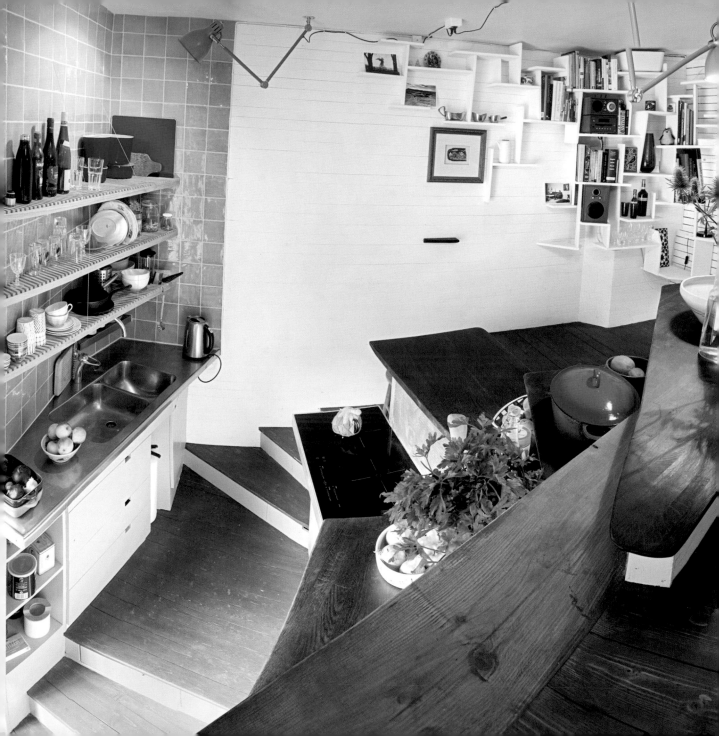

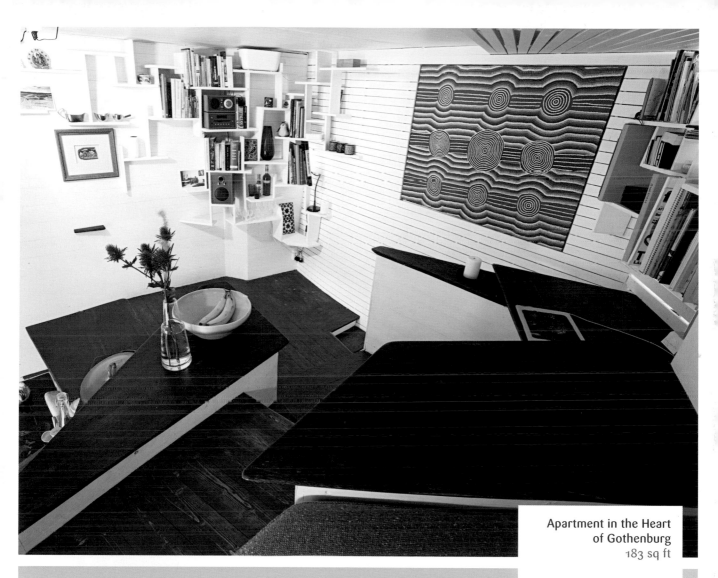

In response to the client's desire to make the most of this small space, the designers transformed it into a multilevel nest that includes two staircases, a bedroom, a bathroom with shower, a fully equipped kitchen, a home office, a closet and a living–dining room that doubles as a guest room. The different areas are placed in relation to the only window.

Architect: Torsten Ottesjö
Location: Gothenburg, Sweden
Photographer: © David Relan

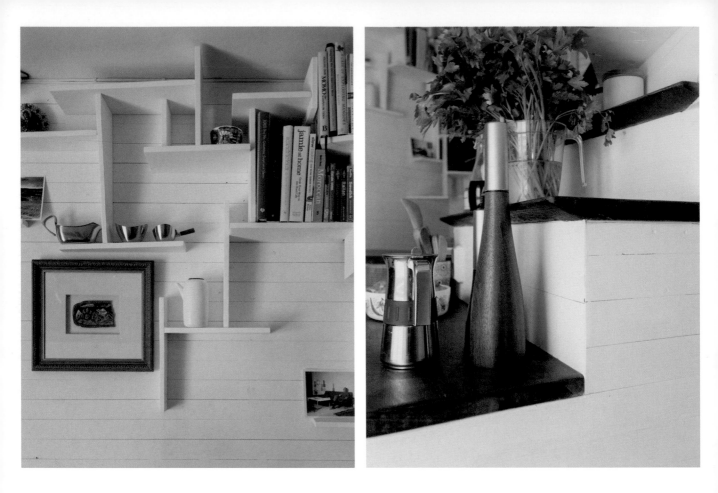

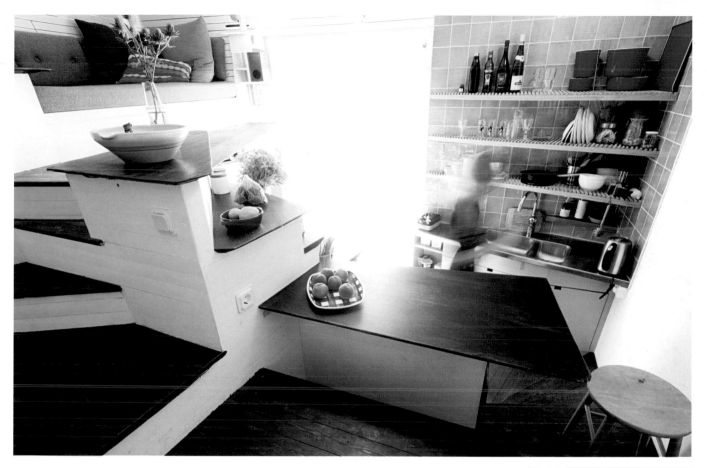

003

In small open-plan homes,
using a multilevel layout
can ensure that the space is
organized into different zones.

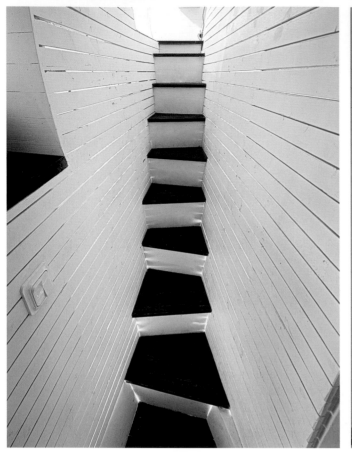
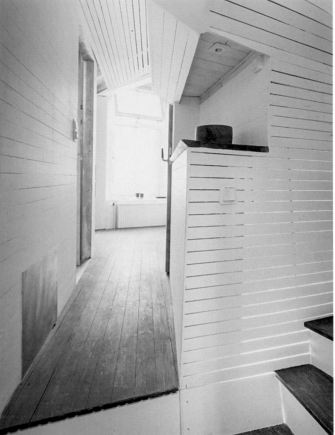

004

The creation of small livable
spaces with inexpensive local
materials generates sustainable
environments that make
a statement about living
in a resource-conscious way.

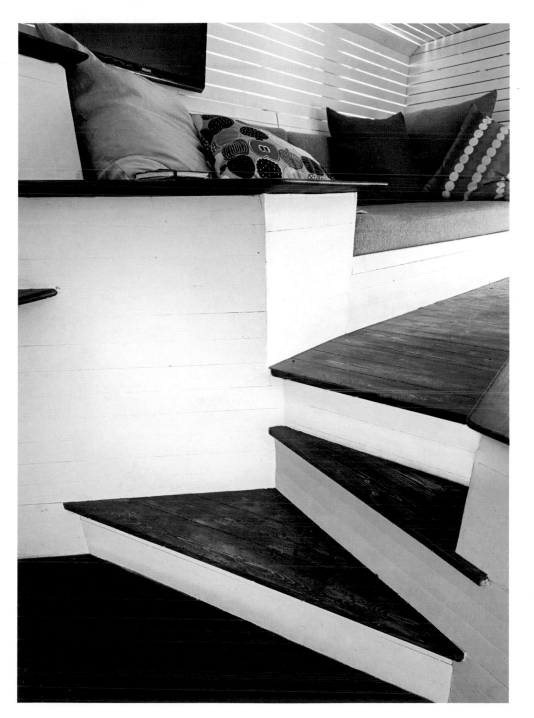

Conceptual diagram

The apartment offers a multitude of views
and perceptions of the space. The light
that filters through the separations
produces a sense of coziness and
at the same time airiness.

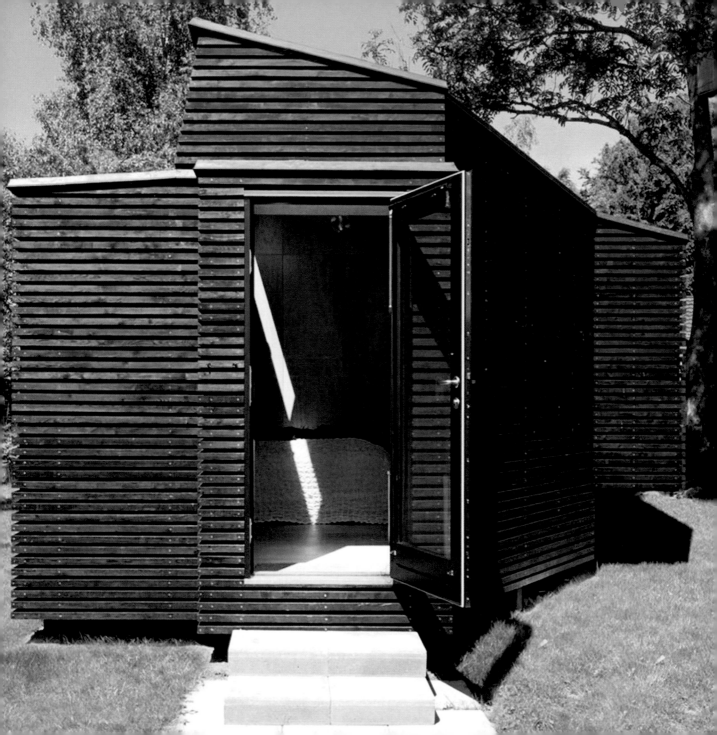

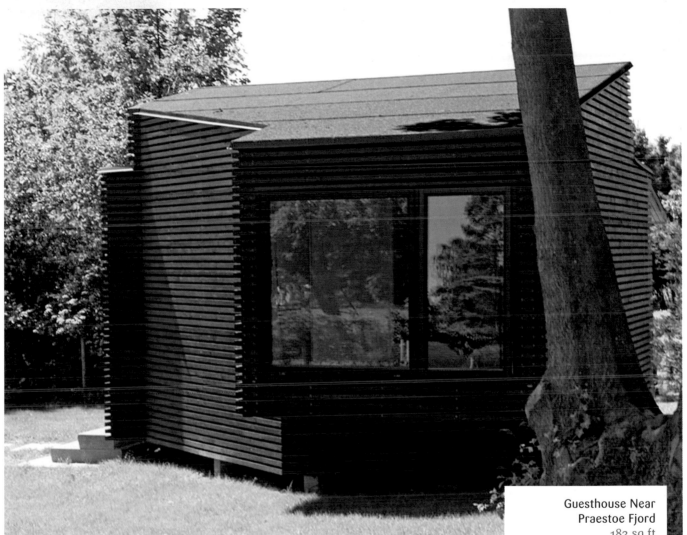

Guesthouse Near Praestoe Fjord
183 sq ft

Architect: Martin Kallesø Arkitekter
Location: Praestoe, Denmark
Photographer: © Martin Kallesø and Lars Kaslov

This guesthouse is situated in an area with a large concentration of traditional Danish summerhouses. Built as an annex to an existing house, it sits on the northwestern corner of the property, taking into account the relationship with the adjacent constructions and the client's need for privacy.

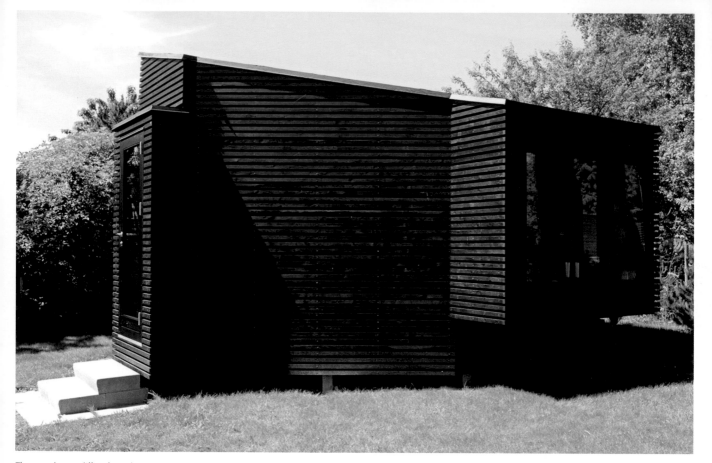

The guesthouse differs from the
surrounding constructions in its
asymmetrical shape. It was designed
based on the need to provide openings
on faces shielded from neighbors' views.

Hand-drawn sketch

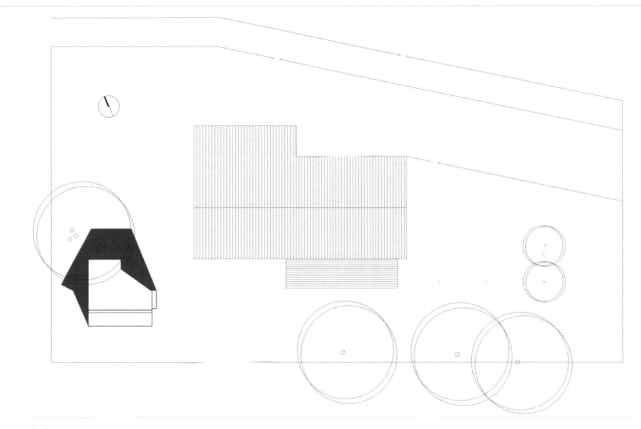

Site plan

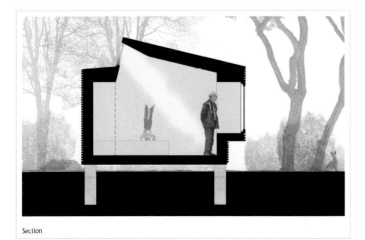

Section

005

Plan the location of exterior doors and windows in single-room constructions according to their orientation and to their proximity to adjacent buildings, as it is easy to overexpose the interior.

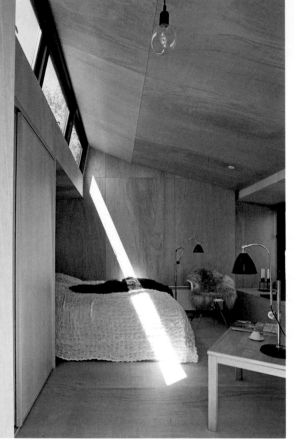
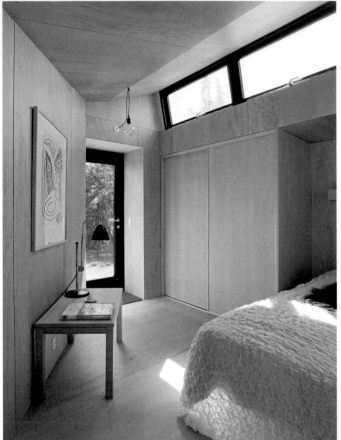

006

Use a glass-panel door instead of a solid exterior door to bring more natural light into a room. Light sources from different sides balance the light across a room.

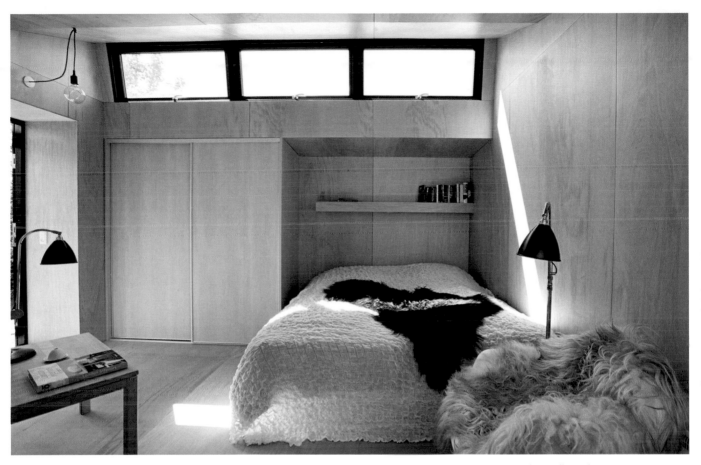

This small guesthouse contains
a double bed and a built-in closet,
enough to accommodate short-
term visitors who won't use the
space other than for sleeping.

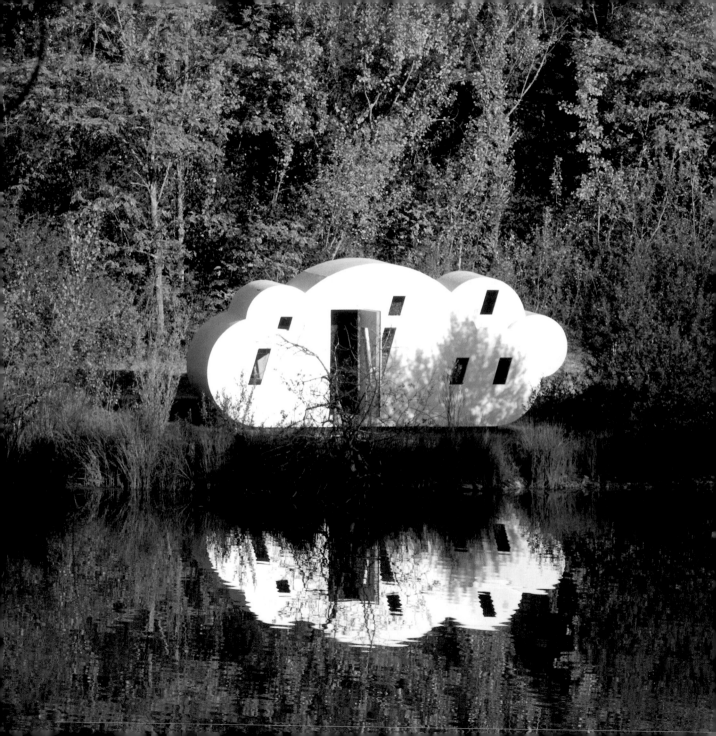

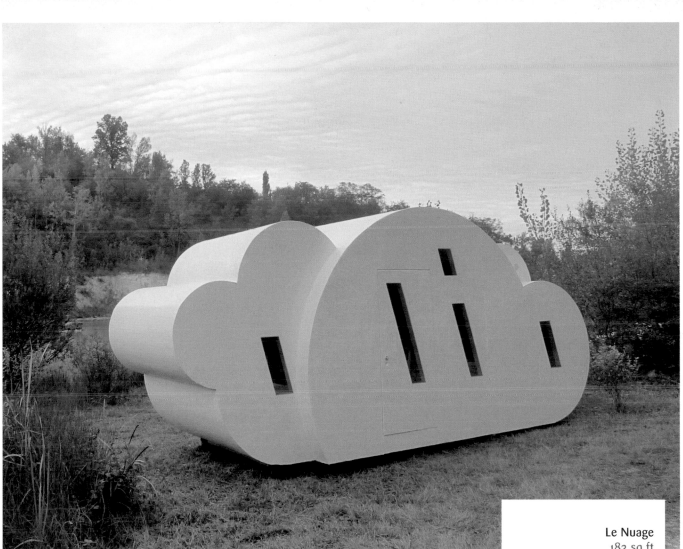

Le Nuage
183 sq ft

Designers: **Buy-Sellf / Zébra3**
Location: **Lormont, France**
Photographer: © Buy-Sellf / Zébra3

"Le Nuage"—the French word for cloud—was originally designed as a small temporary construction and art installation, commissioned by the Urban Community of Bordeaux, France. Now it is used as a new type of public equipment to promote natural areas in the proximity of urban developments. Shaped like a cumulus cloud, "Le Nuage" is a reference to utopian architecture and reminds one of a camp trailer.

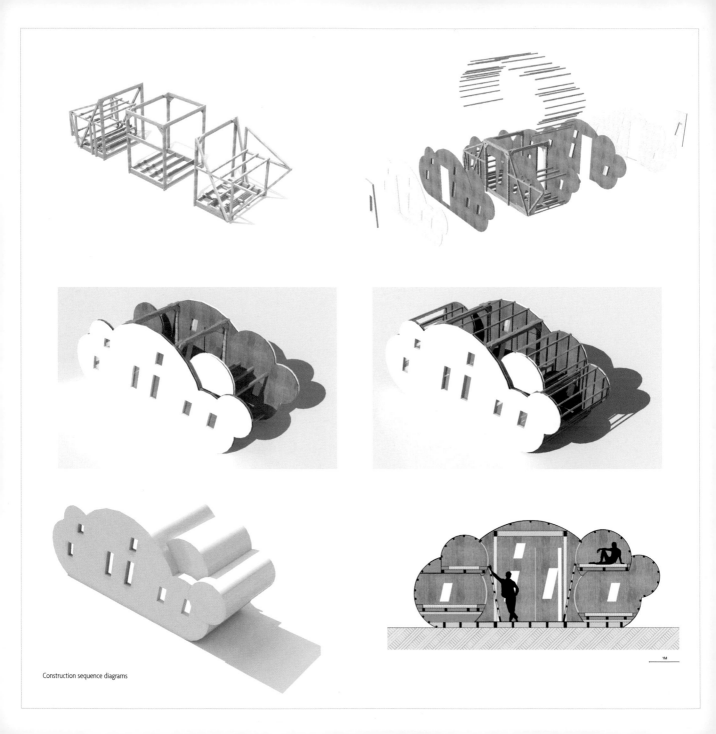

Construction sequence diagrams

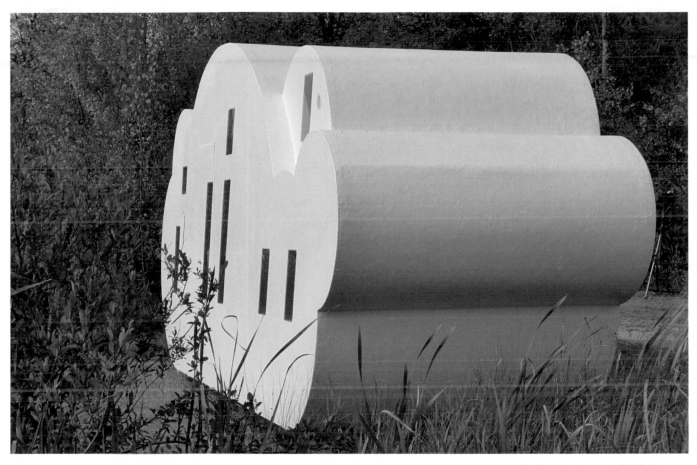

Le Nuage is a transportable shelter. Its design is in between sculpture and architecture, between artwork and construction. It is able to offer its guests an unforgettable spatial and poetic experience.

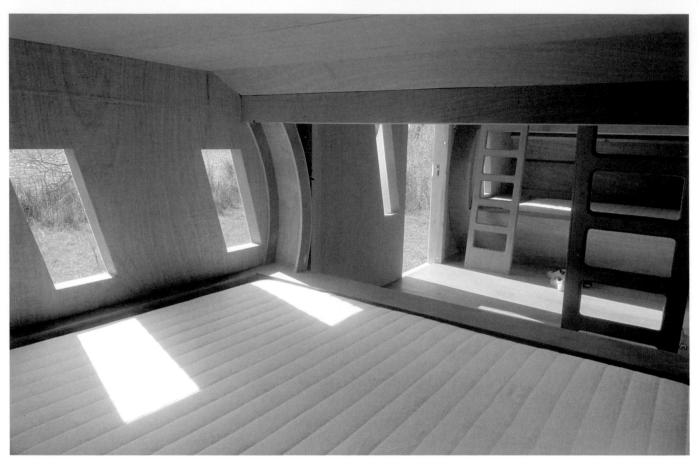

007

Modern bunk beds blend comfort and space-saving convenience. They make the bedroom more spacious and add a playful atmosphere.

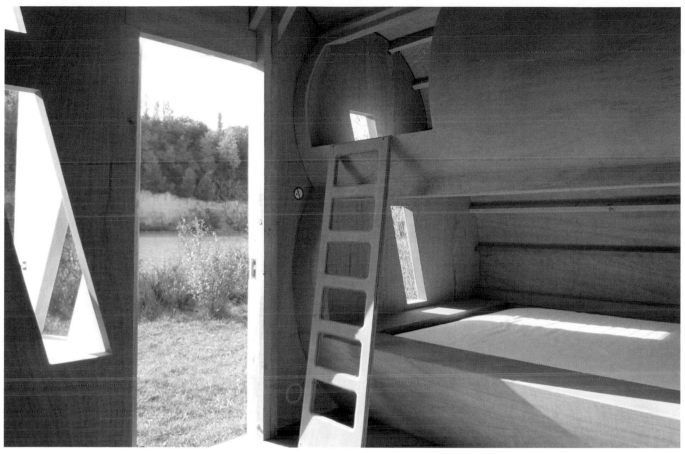

008

Built-in bunk beds can provide storage that optimizes the space they are designed to fit in. This is an advantage over freestanding bunk beds, which don't necessarily satisfy this requirement.

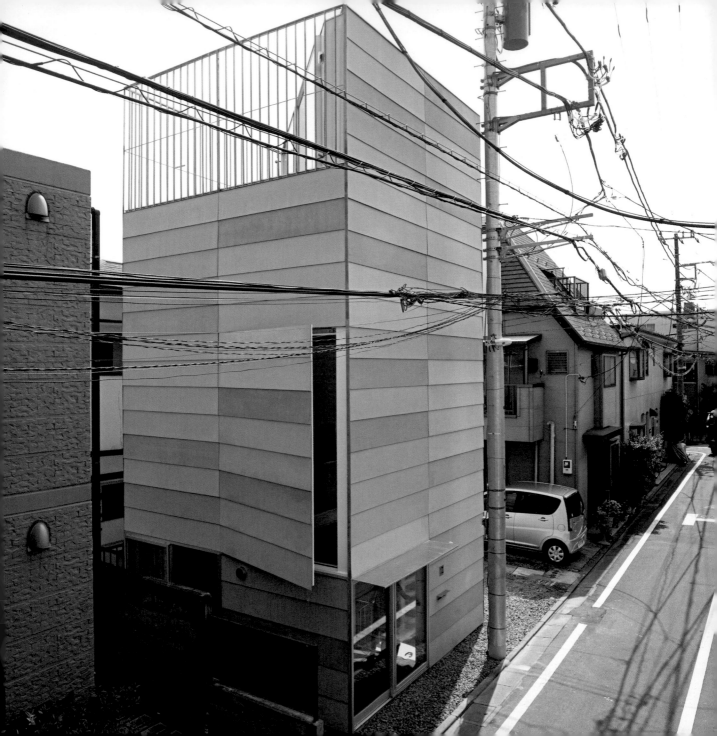

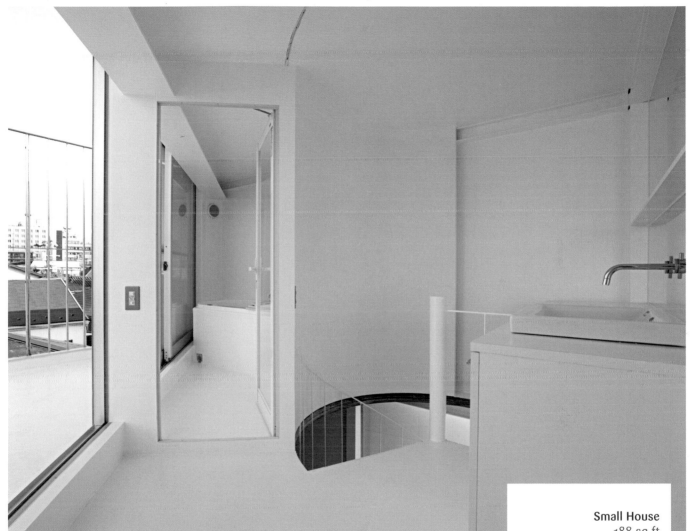

Small House
188 sq ft

Architect: Unemori Architects
Location: Meguro-ku,
Tokyo, Japan
Photographer: © Ken Sasajima

This small house stands in a densely populated neighborhood of Tokyo. The house is as small as the program allows and only occupies a reduced area within the property, leaving enough space for parking. With houses on three sides, this compressed dwelling was designed to make the most of every opportunity to capture air and light.

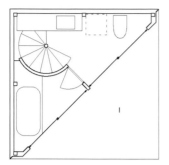

Fourth-floor plan

Roof plan

A. Bedroom
B. Closet
C. Parking area
D. Bicycle parking area
E. Dining room
F. Open to below
G. Entrance
H. Spare room
I. Terrace

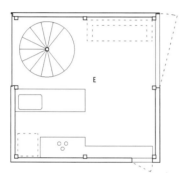

Second-floor plan

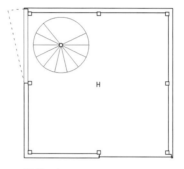

Third-floor plan

Basement-floor plan

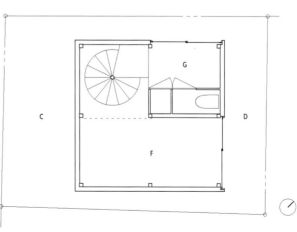

Ground-floor plan

The floor structures are reduced to a minimum: just plywood on steel joists. The floors are connected by a spiral staircase.

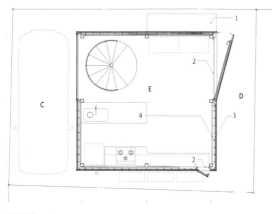
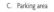
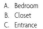

Detailed floor plan

C. Parking area
D. Bicycle parking area
E. Dining room

1. Lean-to-roof
2. Screen door
3. Exterior wall: flexible board t= 8mm siding with water-repellent coating; lengthwise furring strips cedar 15 x 45 @ 455 mm; galvanized and aluminum-coated steel sheet t= 0.3 mm; Tyvek® sheet; structural plywood t= 12 mm
4. Interior wall: whiteboard t= 3 mm; plasterboard t= 9.5 mm; lateral furring strips cedar 20 x 45 @ 455 mm; formed urethane spray finish t= 30 mm; lengthwise furring strips; steel channel 60 x 30 x 10 x 2.3 @ 455 mm

Detailed section

A. Bedroom
B. Closet
C. Entrance
D. Parking area
E. Bicycle parking area
F. Dining room
G. Spare room
H. Terrace

1. Floor: lauan plywood t= 12 mm UC; plywood sub floor t= 12 mm; mortar t=6 mm
2. Ceiling: Floor joist steel 100 x 50 x 4.5 @ 660 mm; ceiling joist cedar 26 x 45 @ 455 mm; mineral board t= 6 mm; lauan plywood t= 4 mm CL
3. Floor: lauan plywood t= 12 mm UC; structural plywood t= 24 mm
4. Interior wall: whiteboard t= 3 mm; plasterboard t= 9.5 mm; lateral furring strips cedar 20 x 45 @ 455 mm; formed urethane spray finish t= 30 mm; lengthwise furring strips steel channel 60 x 30 x 10 x 2.3 @ 455 mm
5. Exterior wall: flexible board t=8mm siding with water repellent coating; lengthwise furring strips cedar 15 x 45 @455 mm; galvanized and aluminum coated steel sheet t= 0.3 mm; Tyvek® sheet; structural plywood t= 12 mm
6. Ceiling: floor joist 100 x 50 x 4.5 @ 660 mm; ceiling joist cedar 26 x 45 @ 455 mm; mineral board t= 4 mm top coat (top of building)
7. Roof: FRP waterproof t= 3 mm top coat mineral board t= 12 mm; rigid urethane foam t= 20-70 mm; structural plywood t= 24 mm (top of building)

2000 2000
4000
X1 X2 X3

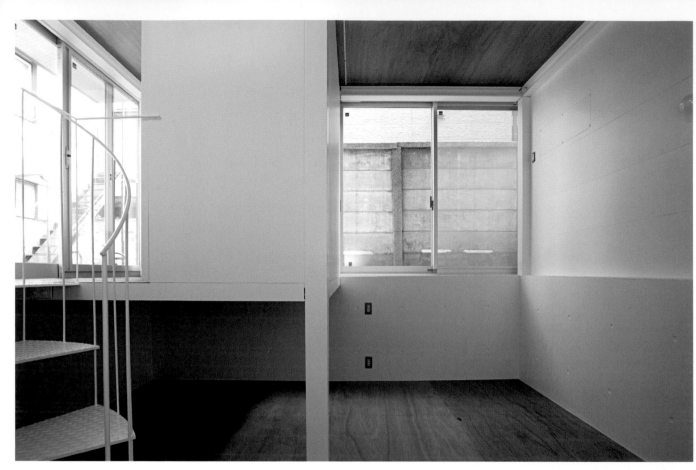

009

Spiral staircases work well in small rooms because they save floor space and fit into a space where conventional straight-flight stairs would not.

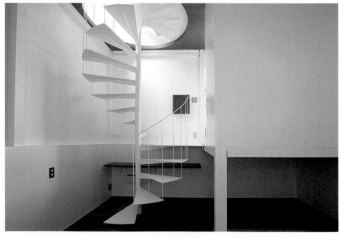

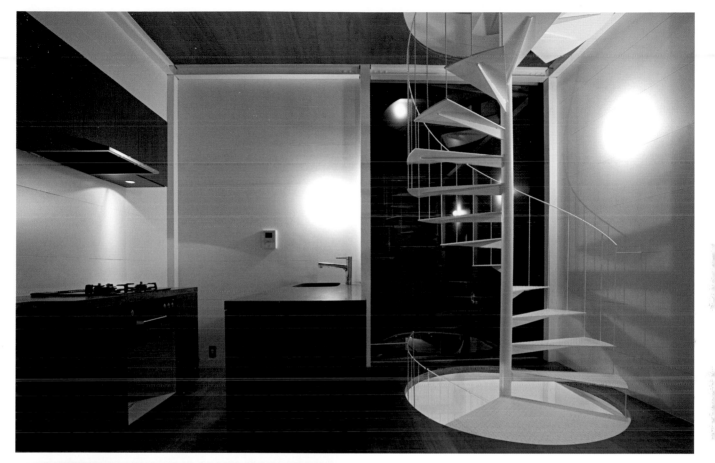

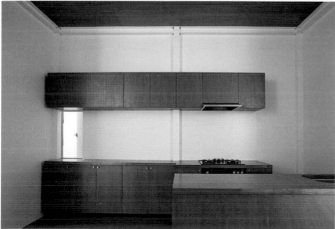

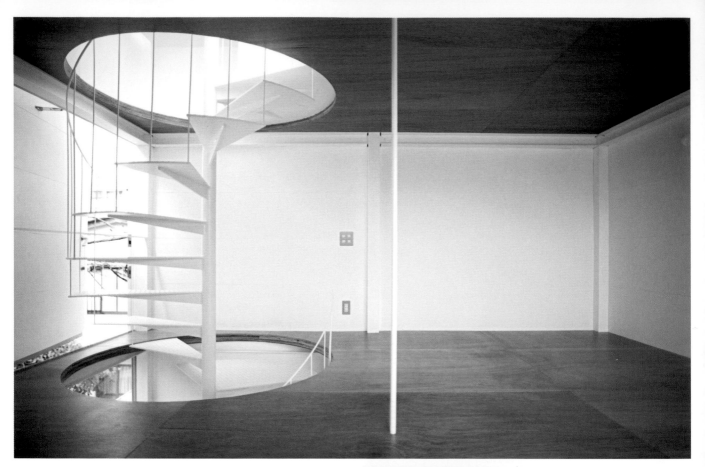

010

Will the turn of a spiral staircase allow for the landings to be in the right place? This is an important design issue that might influence the overall design of the floor plans.

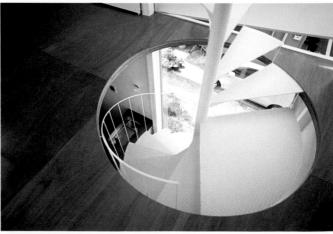

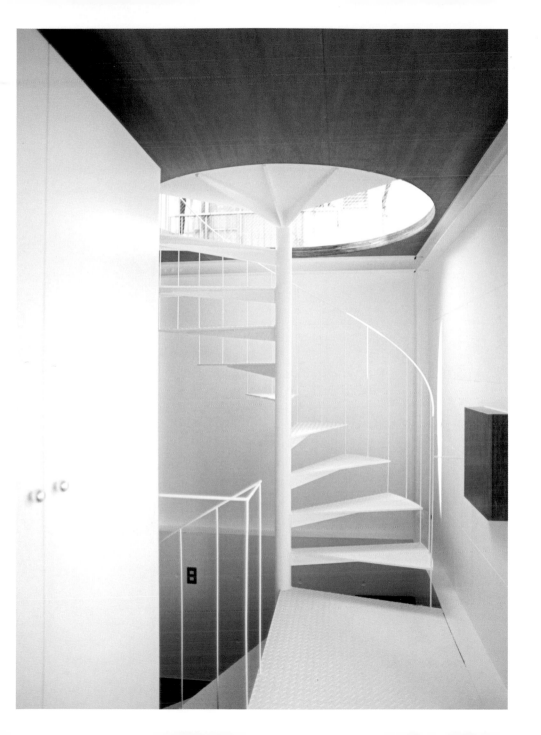

A roof terrace gives the occupants an opportunity to enjoy outdoor living, which is highly valued in such a densely populated city.

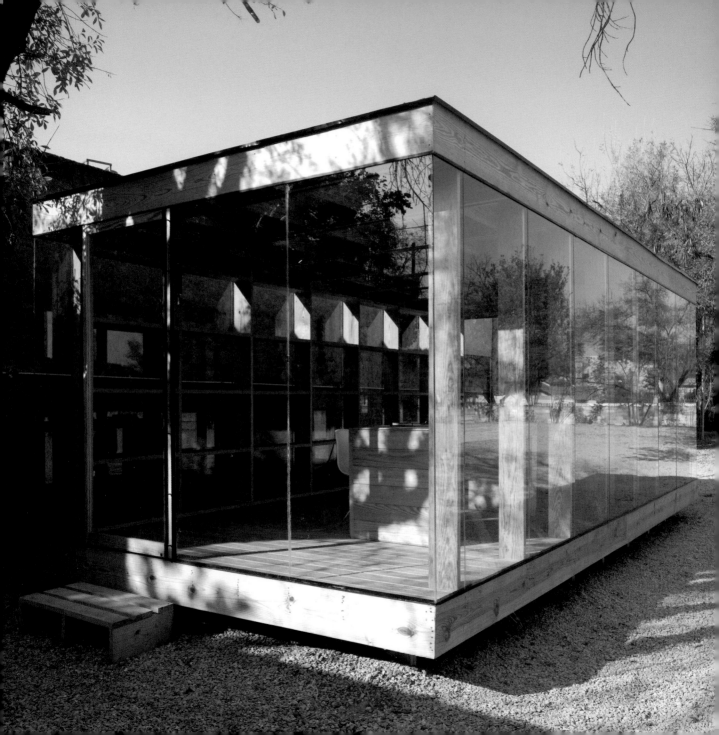

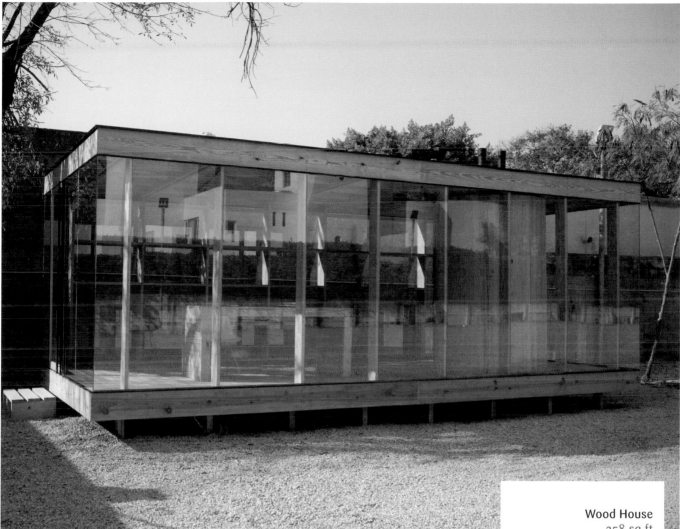

Wood House
258 sq ft

Architect: S-AR stación-ARquitectura

Location: Monterrey, Mexico

Photographer: © Ana Cecilia Villarreal

This small, experimental construction was conceived of as an isolated pavilion hosting a habitable open space that would serve as a study and bedroom for one person or a small family. The basic structure, made entirely of wood, stands off the ground to emphasize the construction method. Its glass skin reinforces the structural qualities of the building and offers views of the surroundings.

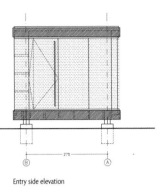

Section B-B'

Entry side elevation

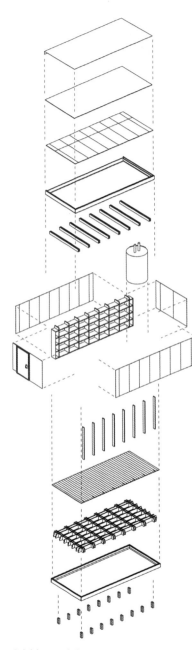

Exploded axonometric view

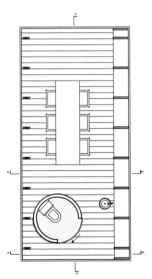

Floor plan

Roof framing plan

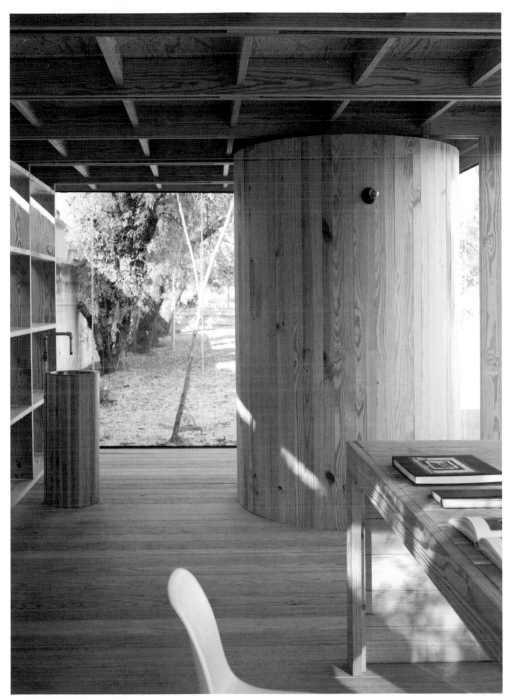

The interior is an open rectangular space dominated by a bookcase library wall and two cylinders: one is full height and contains the bathroom; the other is a pedestal sink.

011

This project, with its bookcase library wall, is a clear example of how architecture and furnishings can merge to make the most of limited space and reduce the need for freestanding furniture.

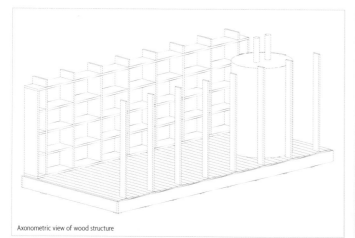

Axonometric view of wood structure

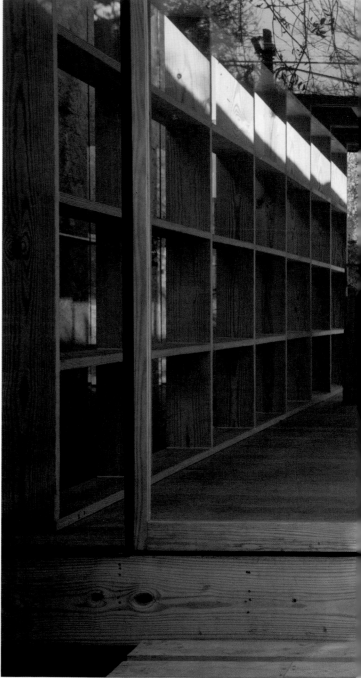

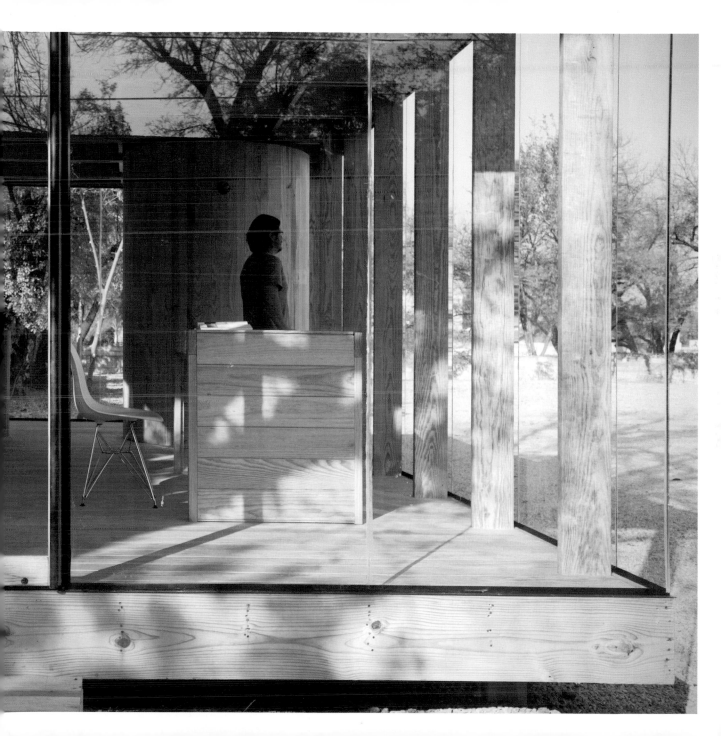

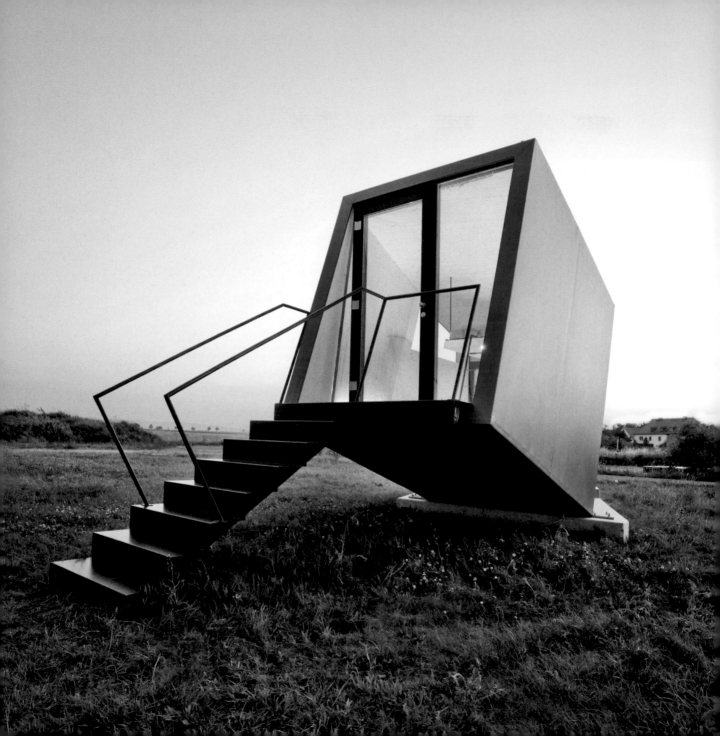

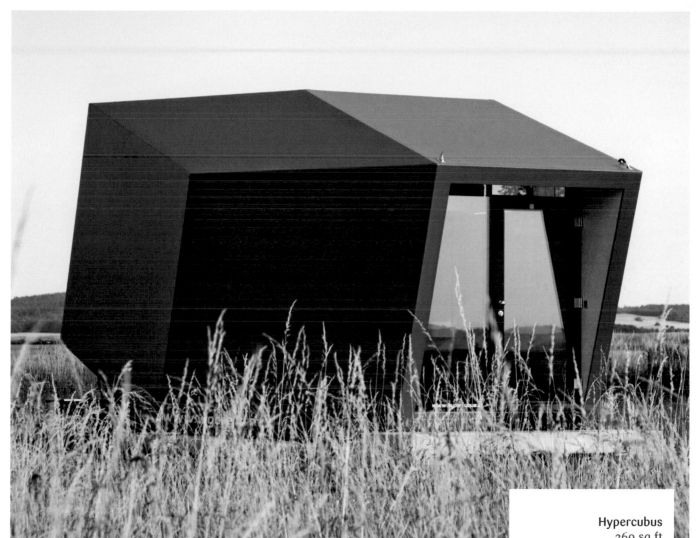

Hypercubus
269 sq ft

Architect: WG3 Architektur
und Moebel
Location: Anywhere
Photographer: © Karin Lernbeiß

Minimalism is a useful tool when it comes to building a house with minimum space. Named after the mathematical hypercube shape, this mass-produced skewed cube creates a space that has more to it than simply fitting three floors into a minuscule box: it offers an attractive lifestyle alternative.

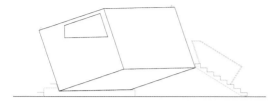

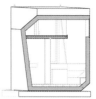

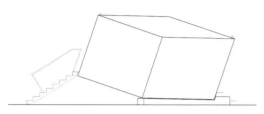

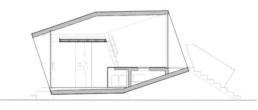

Sections

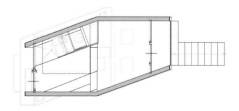

Elevations

Floor plan

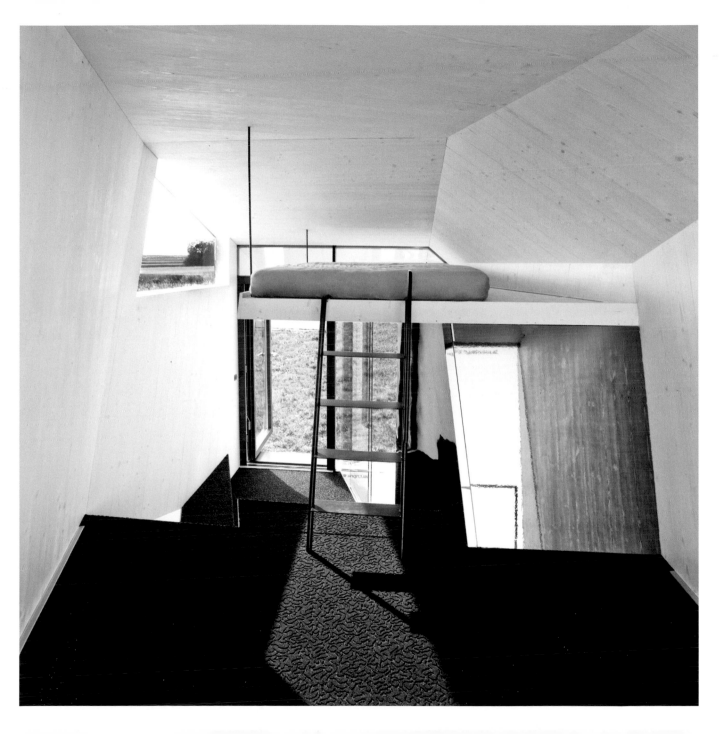

Color is a powerful tool
when it comes to changing
the atmosphere of a space,
including the perception
of its size and proportions.
Explore the creative possibilities
of paint or colored light!

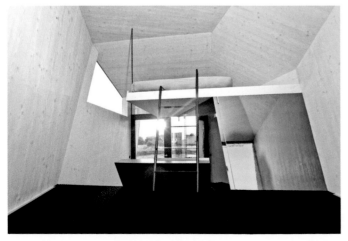

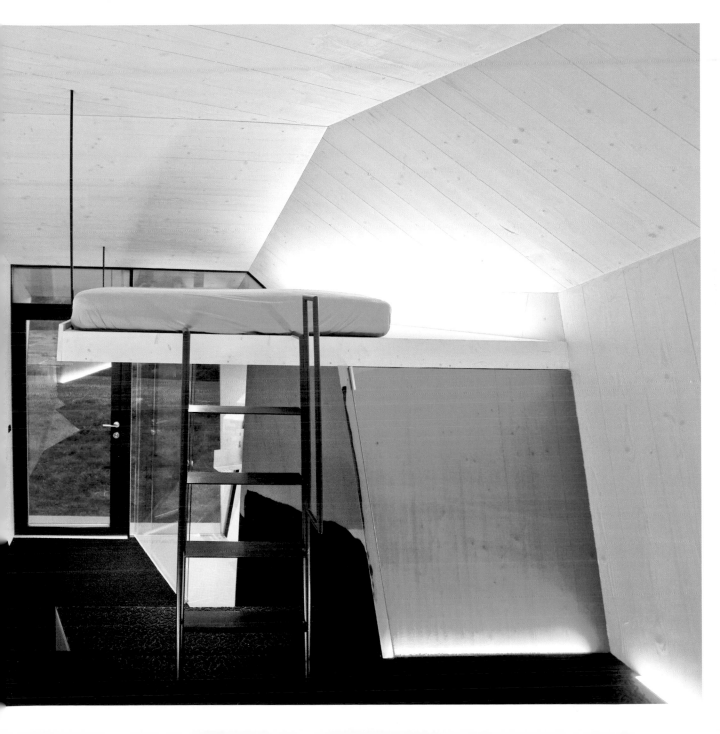

The concept of Hypercubus is based on two fundamental principles: the use of open areas with available infrastructure and the construction of small, modular, transportable living units.

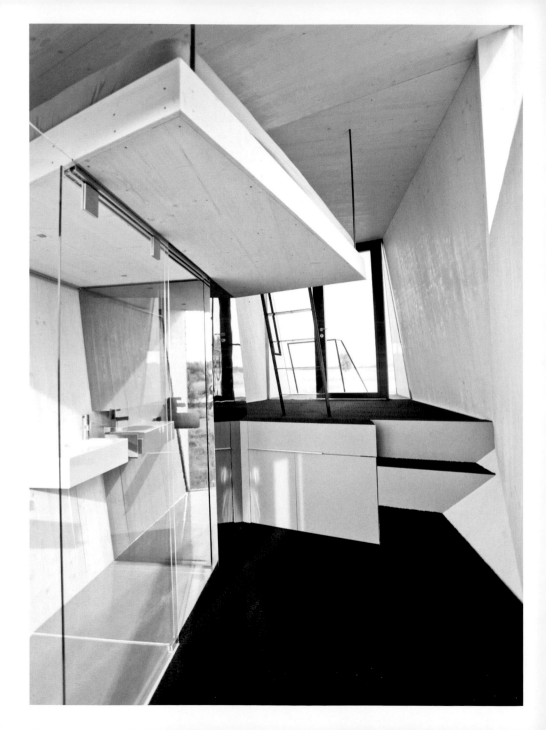

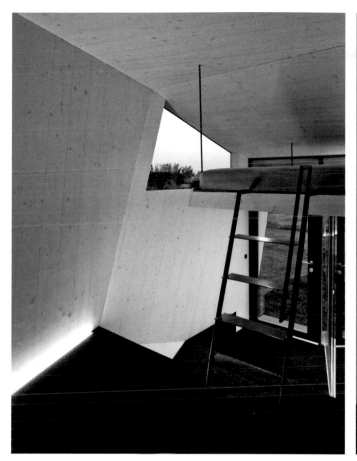

013

Beds occupy the same area regardless of the size of the room they are in. However, the smaller that room is, the more area beds displace. Recapturing that lost space is well worth the effort of installing a loft bed.

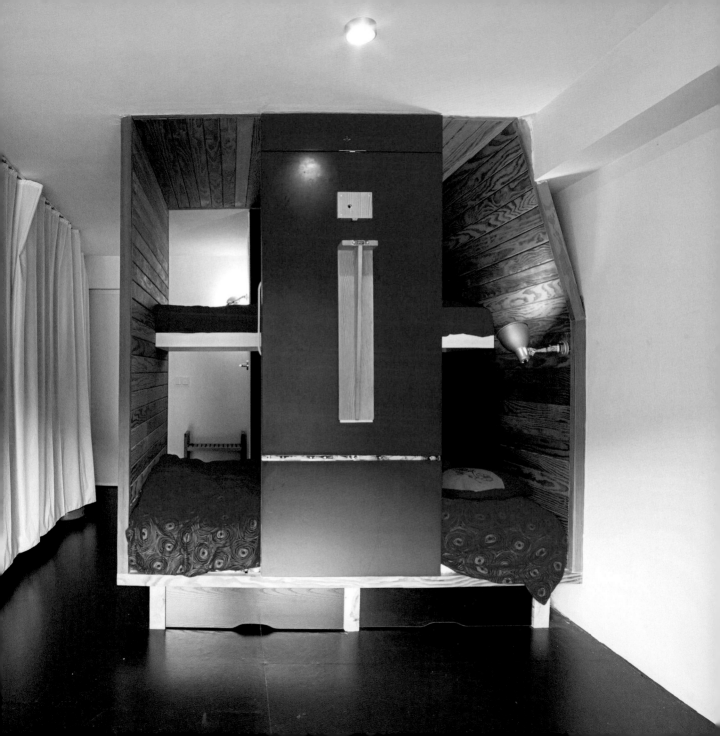

A small studio apartment was the object of an extensive remodel. It was gutted
completely, except for a small bathroom. Then two wooden boxes were inserted
into the empty space: one for living, the other for sleeping. The living box frames
the mountainous landscape through a long window. The sleeping box accommodates
a double bed below and a single bed on top.

Architect: Beriot, Bernardini
Arquitectos

Location: Navacerrada,
Madrid, Spain

Photographer: © Yen Chen

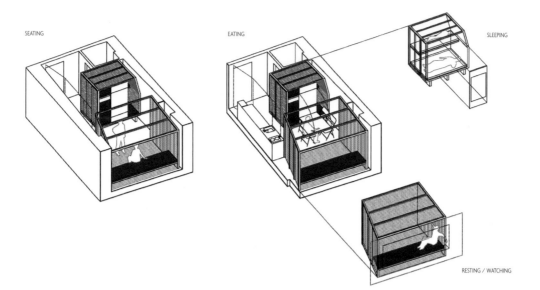

SEATING

EATING

SLEEPING

RESTING / WATCHING

Functional diagram

Cross section

Longitudinal section

Axonometric view

Floor plan

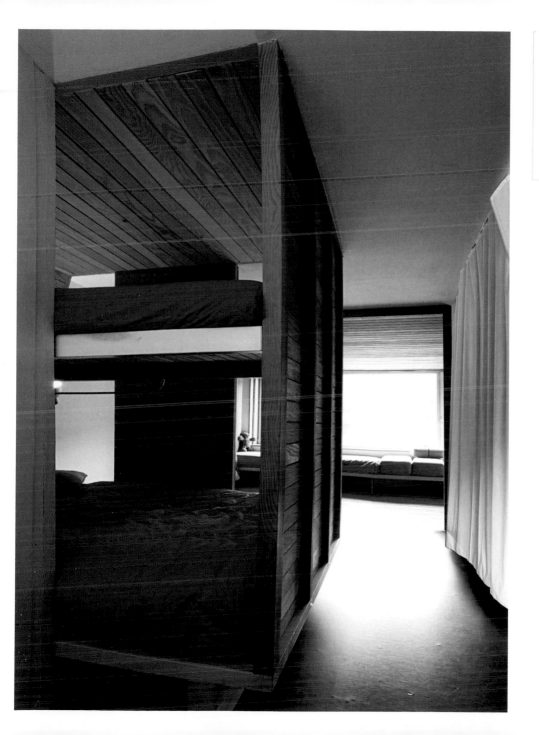

Large pieces of furniture,
such as the boxes inserted
into this small studio, can
change the geometry of
the space, separating areas
with different functions and
organizing circulation.

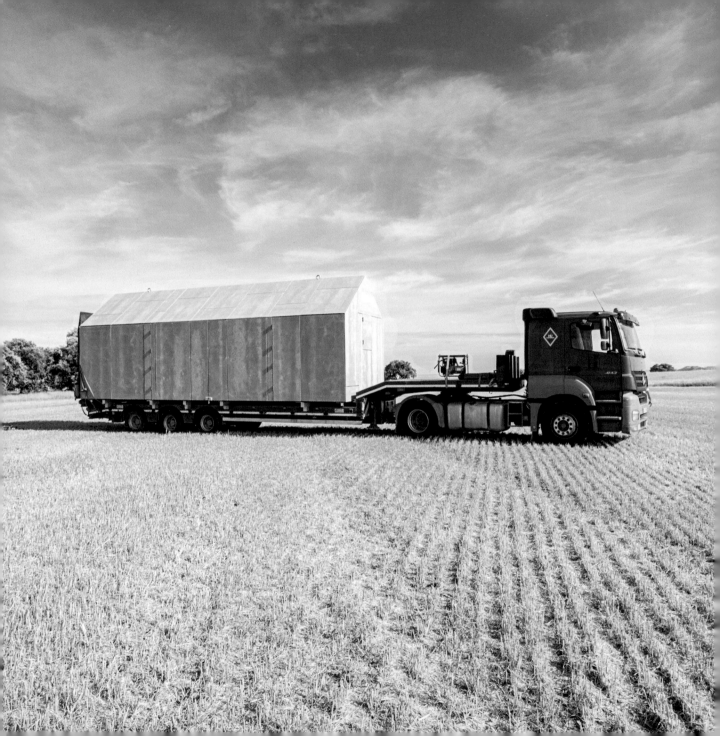

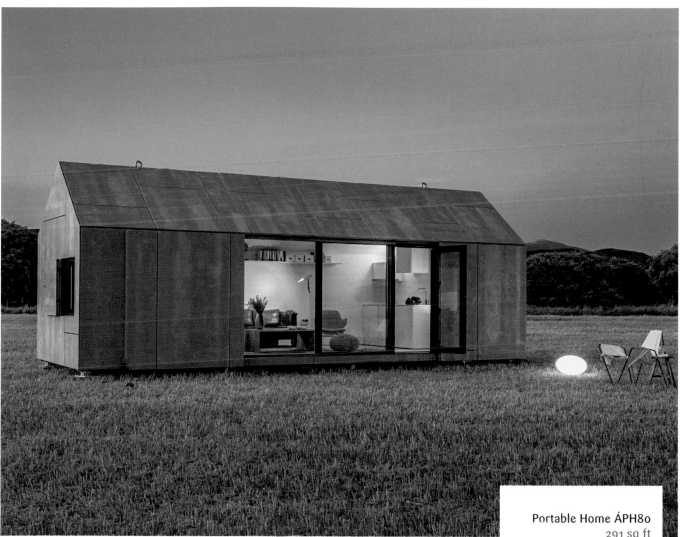

Portable Home ÁPH80
291 sq ft

ÁPH80 house was inspired by the principles of the architects who designed it: well-being, environmental awareness and simplicity. It was not commissioned for a particular client, so the design focused on making the transportable structure as comfortable and homey as possible. It is composed of three different spaces: living area and kitchen, bathroom, and bedroom. Smaller modules can be added to the main structure, increasing the usable floor area and versatility.

Architect: Ábaton Arquitectura
Location: Anywhere
Photographer: © Juan Baraja

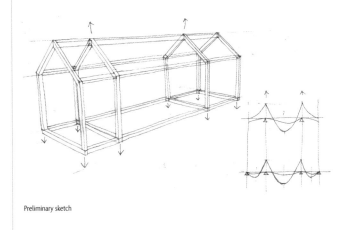

Elevation

Preliminary sketch

Floor plan

The ÁPH80 house has its origins in an earlier design, which used a shipping container. Its shape, however, is an abstraction of the archetypal rural gable-roof house, with the added quality of being transportable.

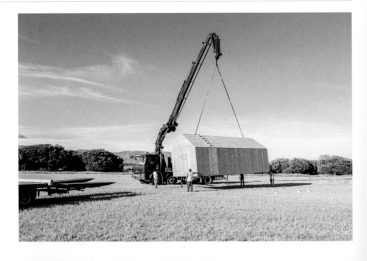

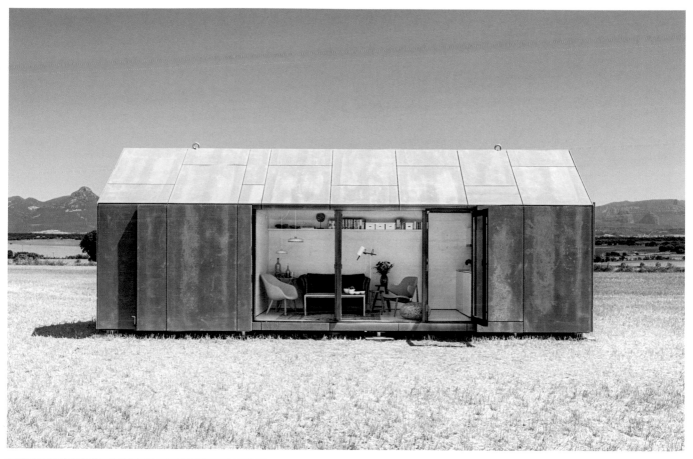

015

A pitched roof adds extra overhead space to the room directly below it. It makes the room feel larger and at the same time more cozy by making the shape reminiscent of a cottage home.

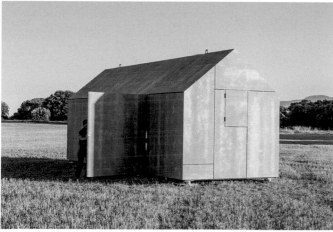

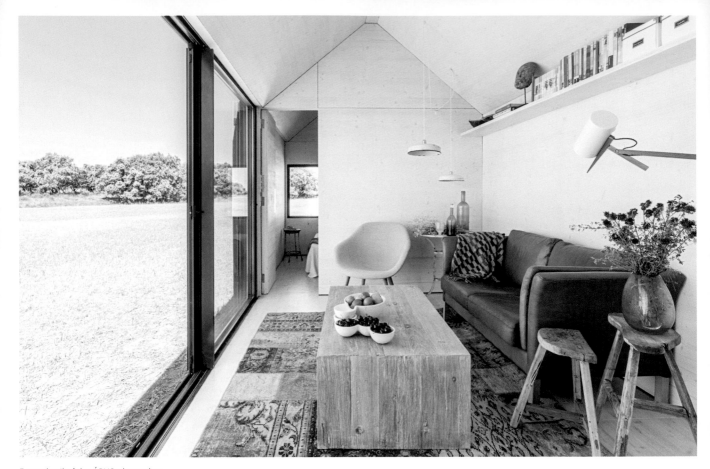

Every detail of the ÁPH80 house has been designed so that being inside is a unique experience. The proportions transmit a sense of amplitude, despite the limited dimensions.

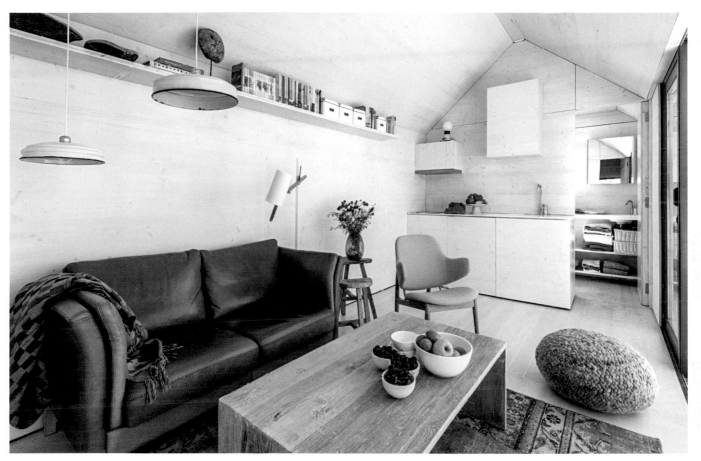

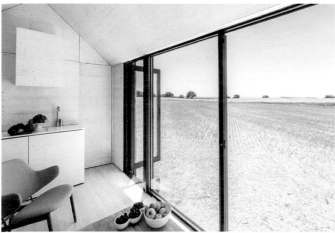

016

Create a chromatic balance between the different finishes, textures and materials in a room to achieve uniformity. Seeking simplicity will give a room a homogeneous atmosphere.

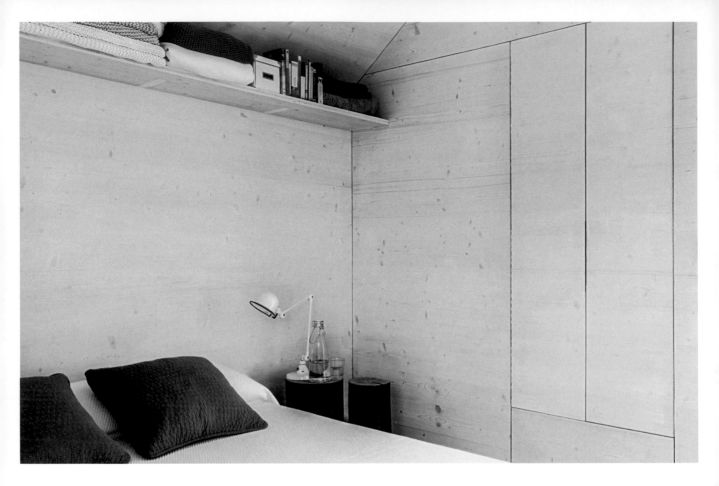

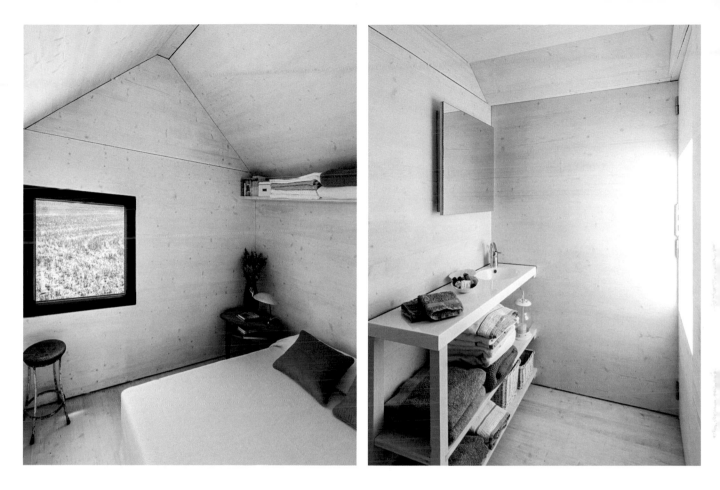

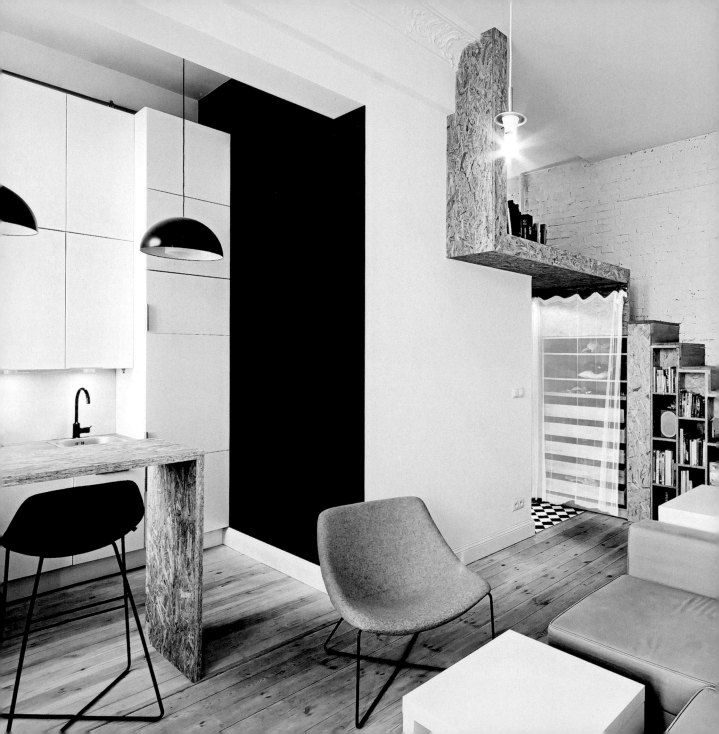

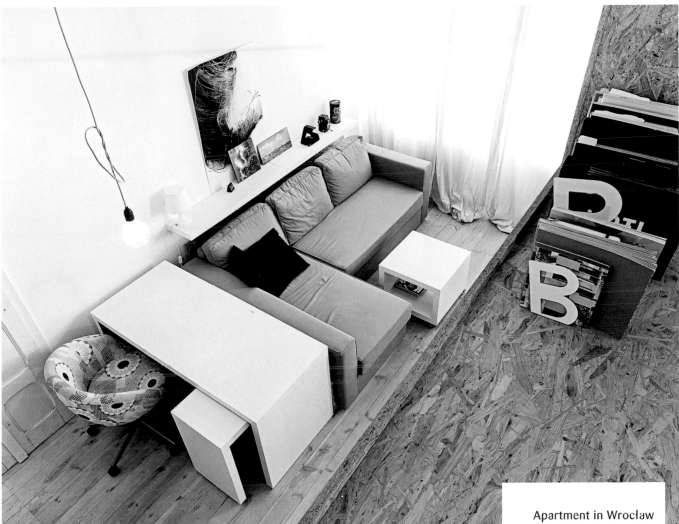

Apartment in Wrocław
312 sq ft

Architect: 3XA
Location: Wrocław, Poland
Photographer: © S. Zajaczkowski

This tiny apartment in a historic building in Wrocław, Poland, is the result of a makeover aimed at maximizing the space available. Despite its minimal dimensions, the designers made the most of the 12-foot-high ceiling to accommodate a large open space shared by the living–dining area and the kitchen, and a private sleeping area tucked up in a loft.

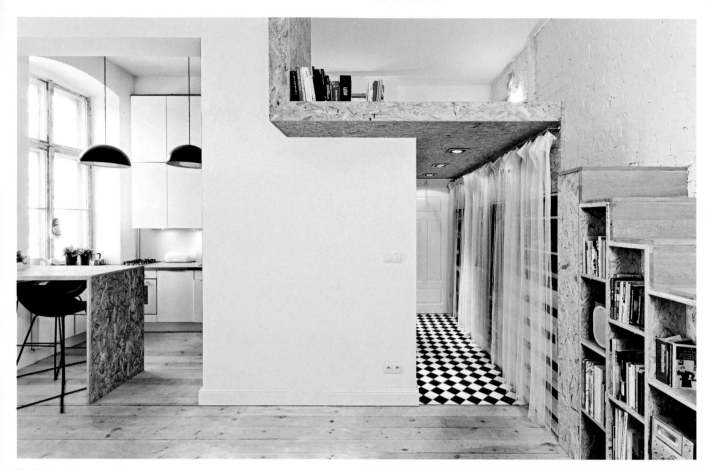

The bedroom is accessed via a narrow staircase that doubles as a bookshelf. The area below the bedroom, directly in front of the bathroom, is used as a dressing area.

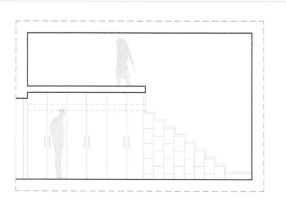

Section A

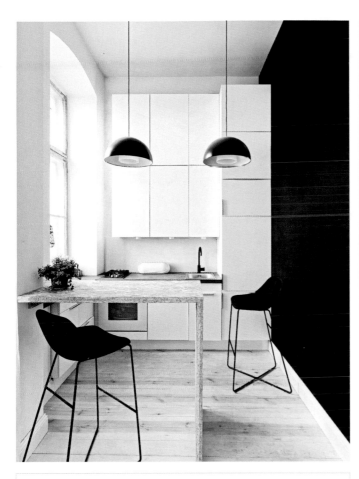

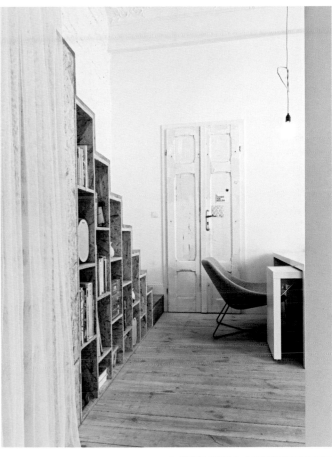

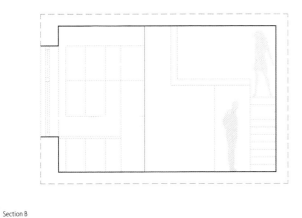

017

What's behind that door? The designers introduce a funny design gesture: placing a dummy door against one wall. No functional purpose, or a good way to hide an unsightly electric meter?

018

An open plan is perhaps the best option when dealing with small homes. Where there are no walls, furniture serves as an organizer of space, separating areas of different use.

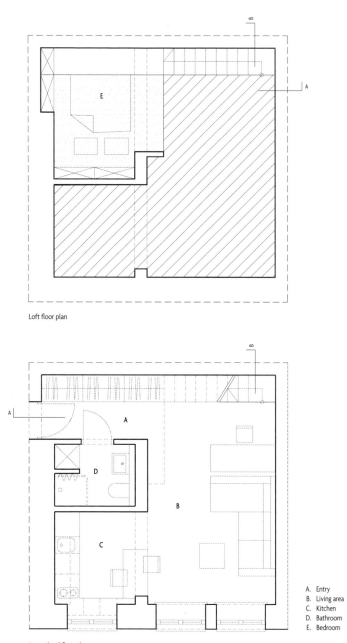

Loft floor plan

Lower-level floor plan

A. Entry
B. Living area
C. Kitchen
D. Bathroom
E. Bedroom

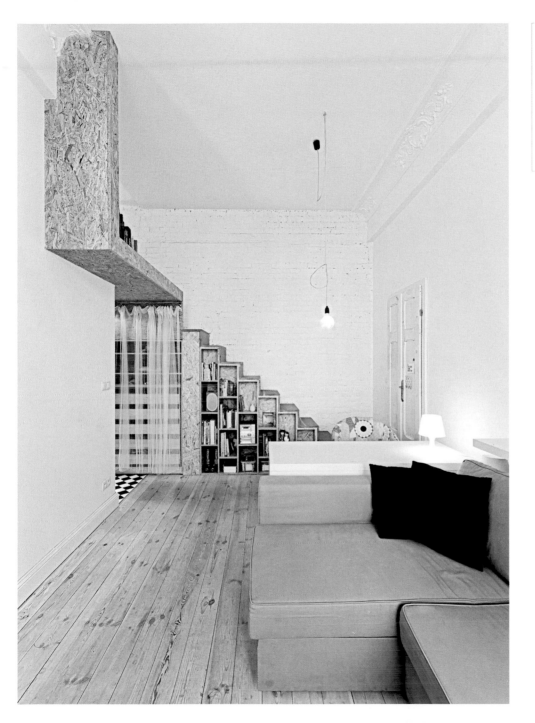

In small spaces, it is best to keep materials and colors to a minimum. But this doesn't mean you can't make a strong design statement.

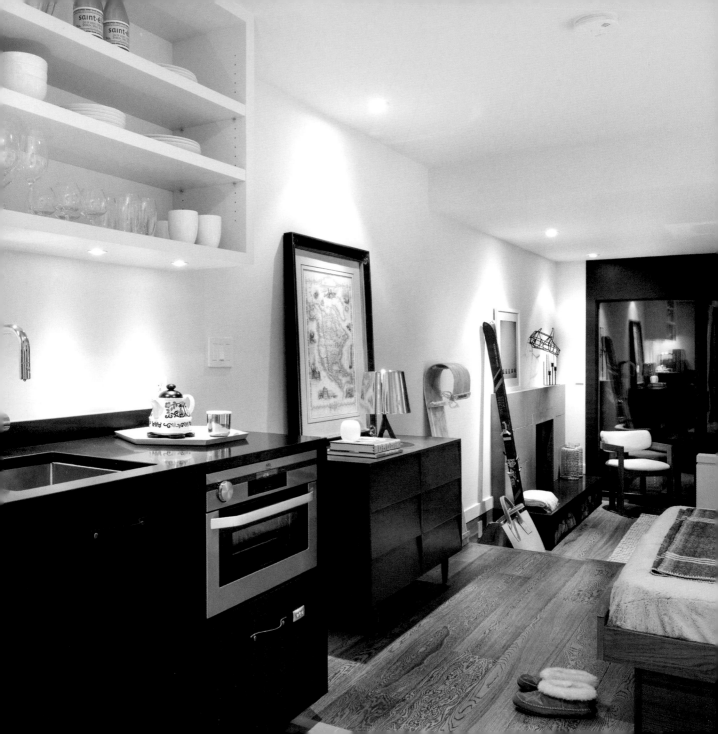

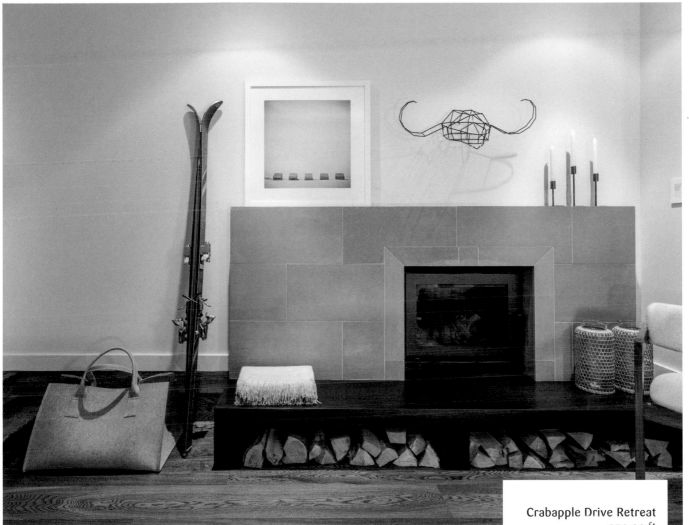

Crabapple Drive Retreat
350 sq ft

Architect: Falken Reynolds
Interiors
Location: Whistler, BC, Canada
Photographer: © Chad
Falkenberg

Cozy convenience typifies this complete renovation of an urban 350-square-foot condo close to the ski slopes of Whistler, Canada. A weekend escape from Vancouver for the clients, it combines the ease of a hotel room with the comforts of home. The biggest challenge was finding space-saving solutions that didn't sacrifice convenience.

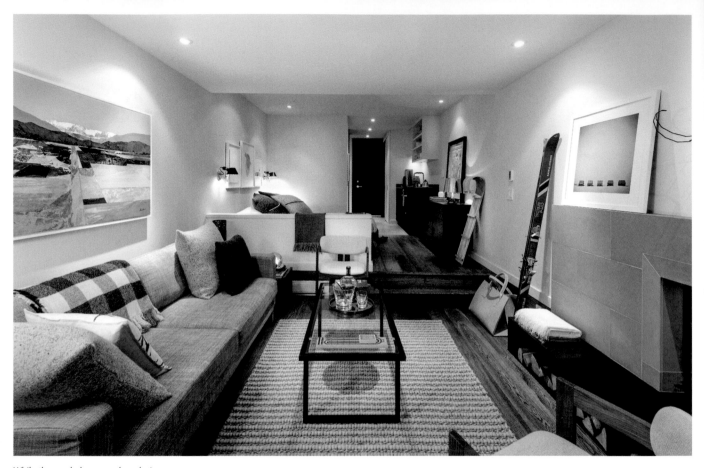

While the condo has a modern design, natural finishes with a lot of warmth and texture were chosen to give the feeling that the space had a bit of history.

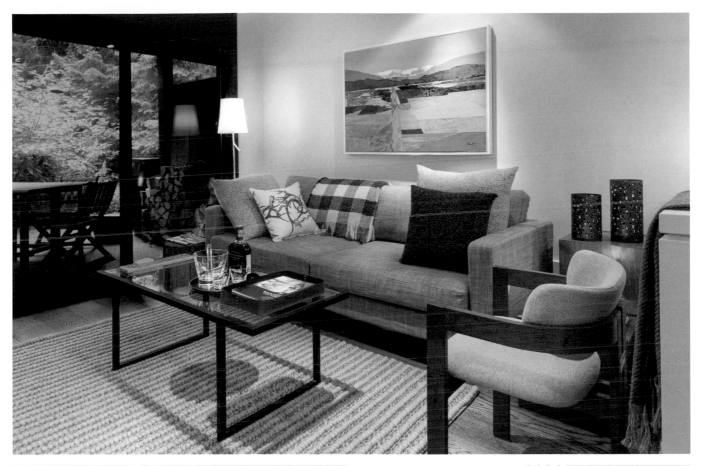

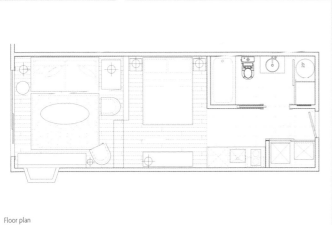

Floor plan

020

Two areas of different functions can share the same open space. This can be achieved by raising the floor of one of the two areas.

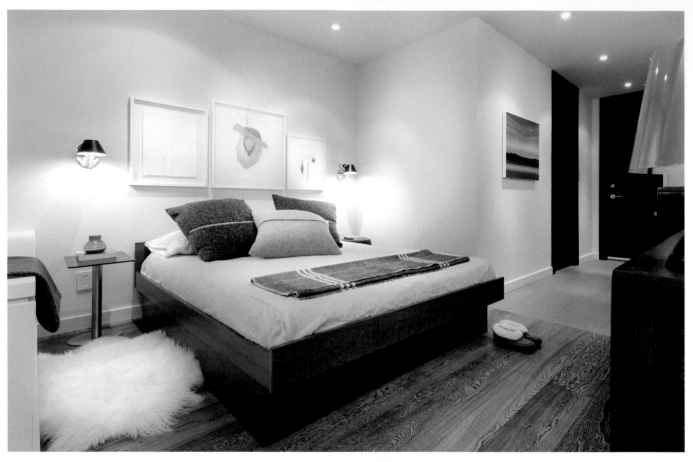

021

Using different flooring
material can create
a distinction between
areas of different functions.
This design solution is also
perfect for dividing extra-
long spaces.

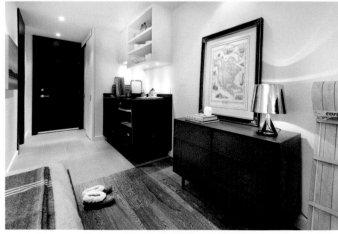

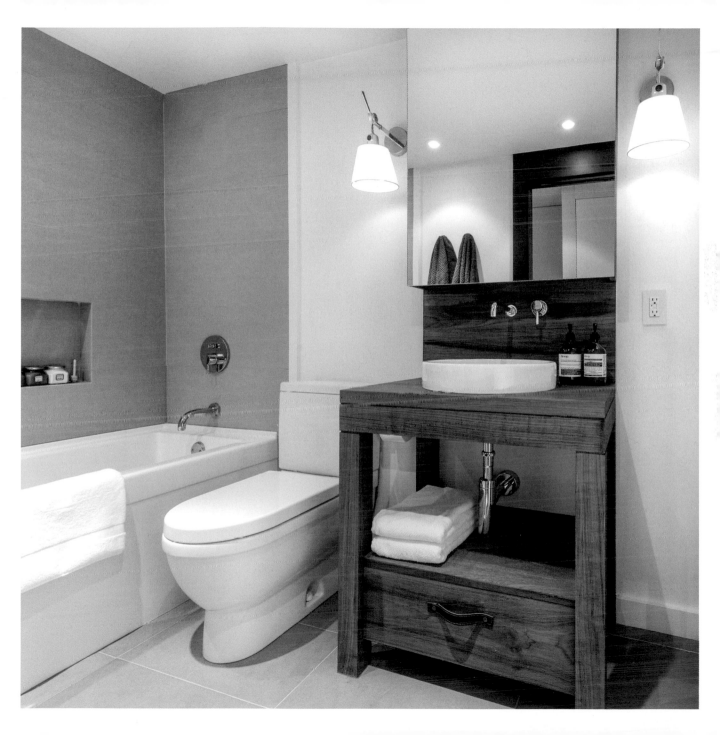

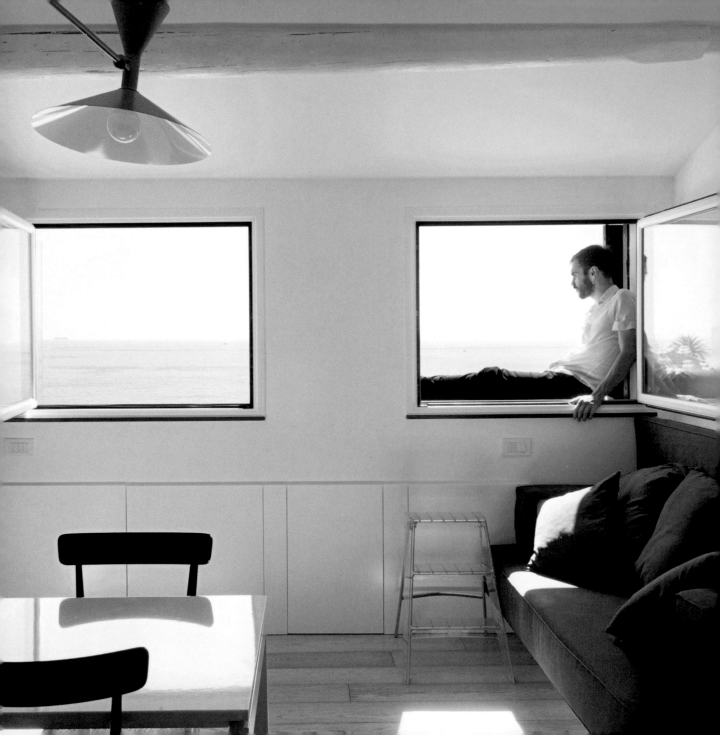

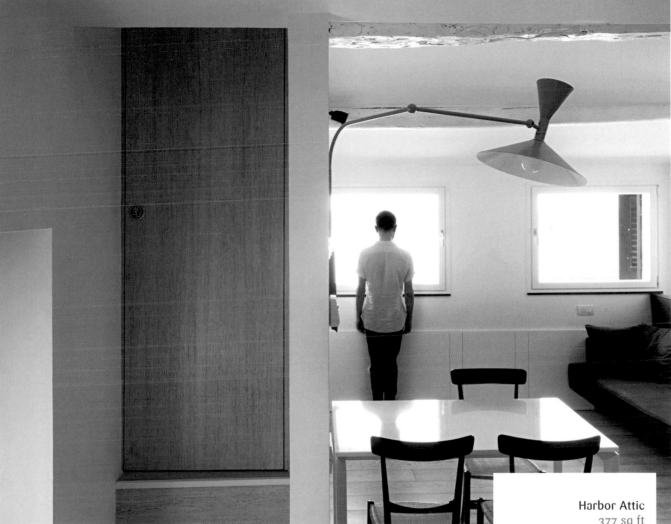

Architect: Gosplan Architects
Location: Camogli, Genoa, Italy
Photographer: © Anna Positano
(theredbird.org)

The project is the refurbishment of an attic overlooking the old harbor of Camogli, a charming fishing village near Genoa. Despite the limited area and gambrel roof, the attic includes two bedrooms, a studio, a living room, a kitchen and a bathroom. This necessitated the design of built-in furniture, which can be stored away when not in use.

022

Built-in furniture is perhaps the most efficient furnishing solution for spaces of limited dimensions: it frees up valuable floor area, makes the space less cramped and unifies the décor.

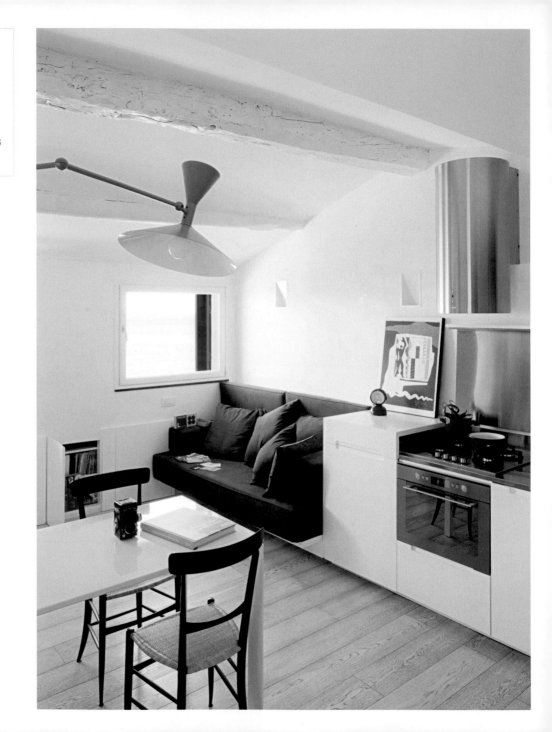

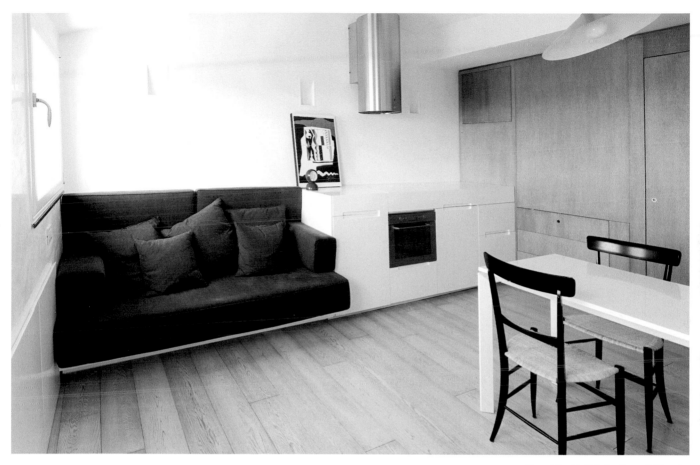

The minimal built-in furniture of this attic promotes tidy organization, which in turn highlights the architectural appeal.

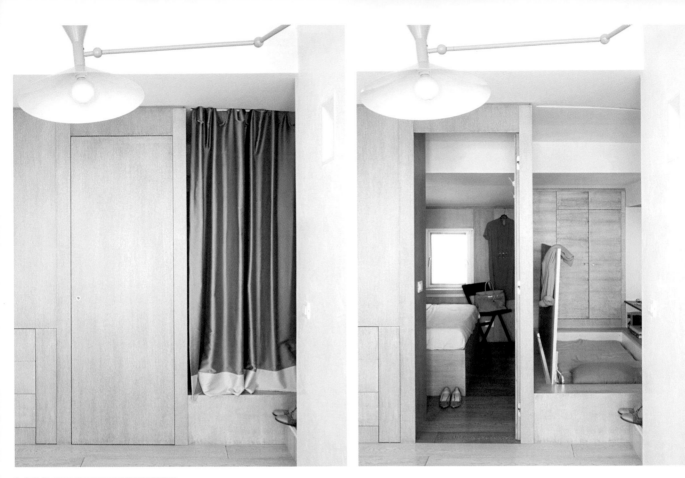

023

Live large in a small space with built-ins that provide plenty of storage. No piece of furniture puts available space to better use than a built-in.

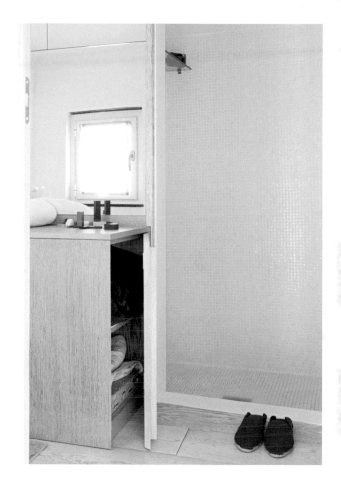

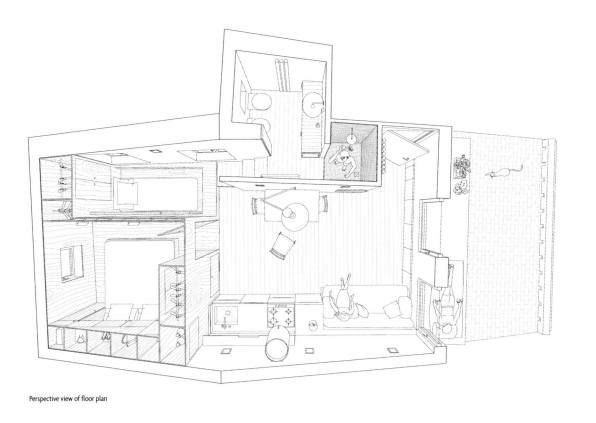

Perspective view of floor plan

024

Built-ins provide lots of storage, efficiently occupying entire walls without making a space feel smaller. And they can blend gracefully with the architecture.

Wall-to-wall and floor-to-ceiling closets maximize every square inch of this bedroom. The bed is also part of the storage system.

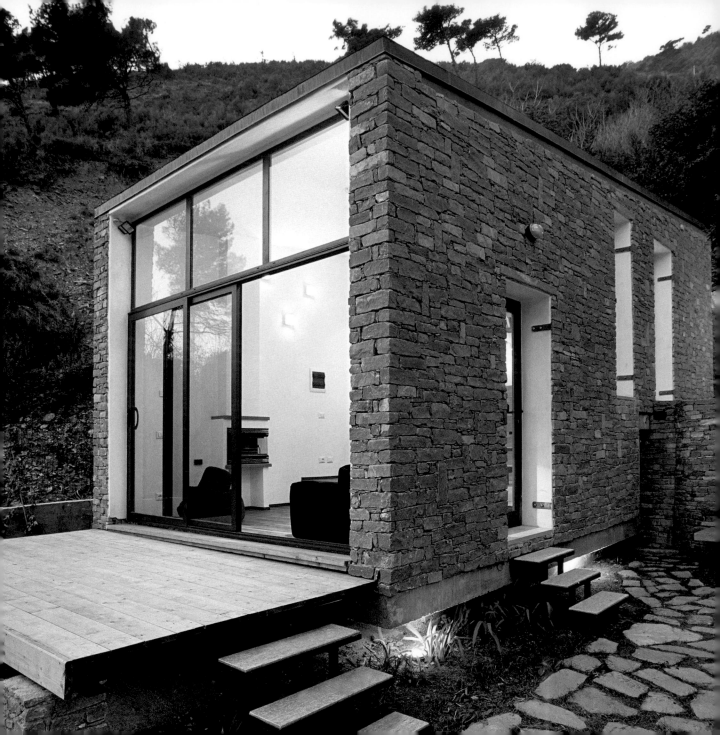

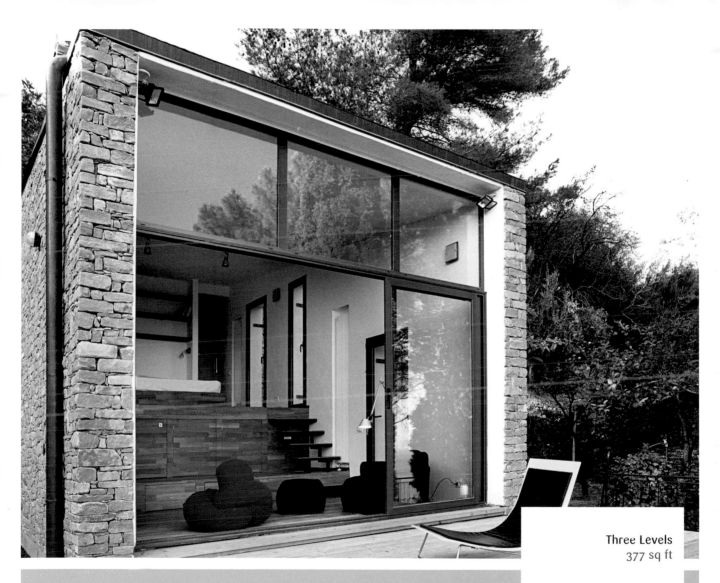

Three Levels
377 sq ft

Architect: **Studioata**
Location: **Alassio, Italy**
Photographer: © Beppe Giardino

A nineteenth-century villa included an abandoned 377-square-foot pavilion surrounded by a wide terraced park. The pavilion was demolished and a new structure was created that adapted the plan to the sloping site. This solution allowed for the separation of different areas: a kitchen, a bedroom, a bathroom and a terrace.

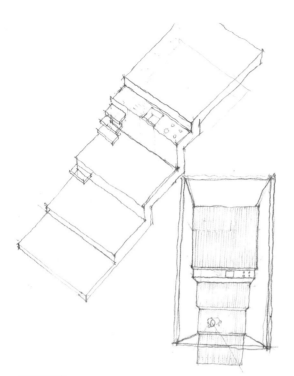

Preliminary sketch

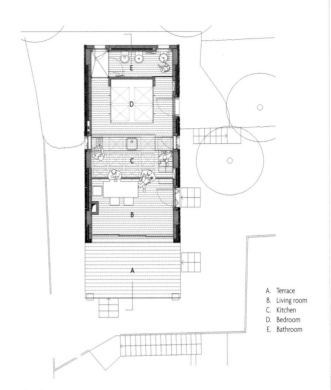

Floor plan

A. Terrace
B. Living room
C. Kitchen
D. Bedroom
E. Bathroom

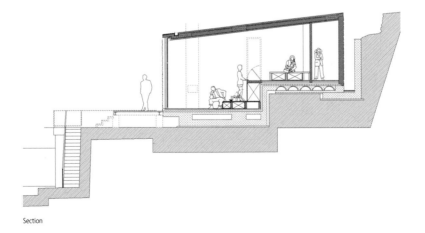

Section

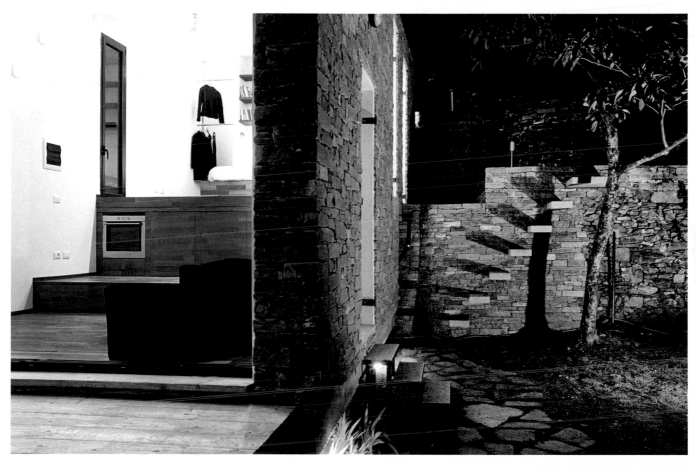

025

High ceilings allow for raised floor levels, which differentiate various functions in a space. Raised floors provide room for plumbing and electrical, as well as additional storage.

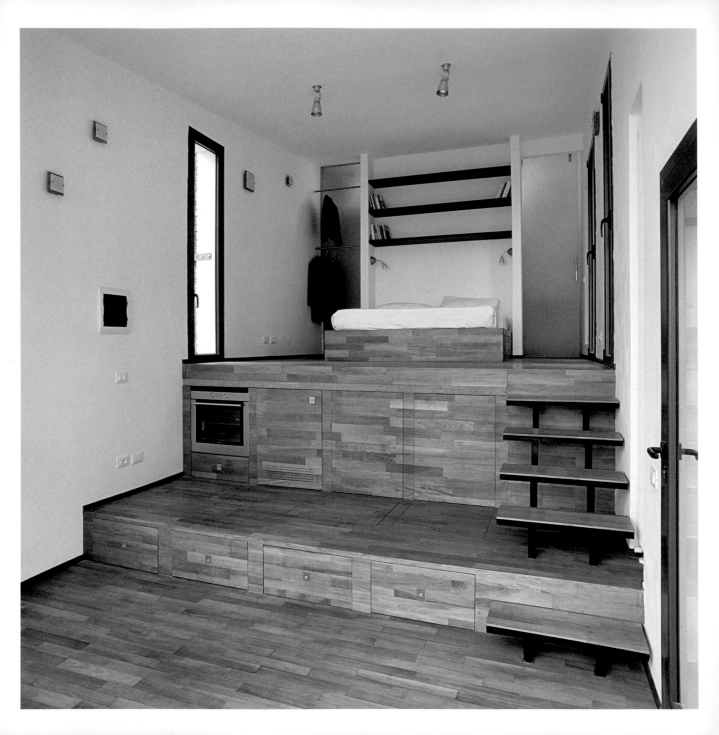

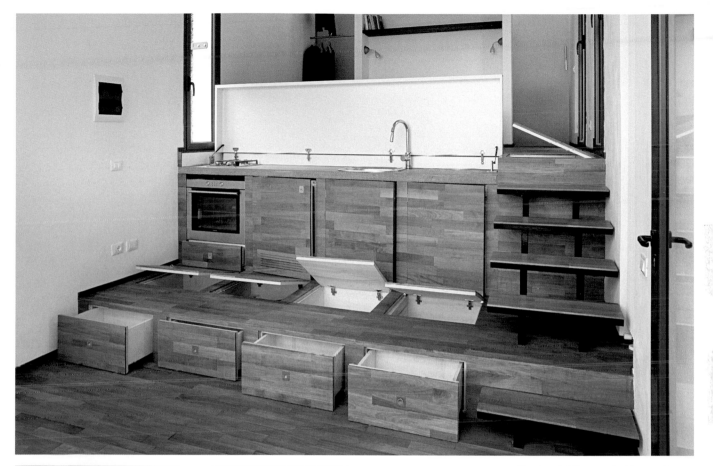

The steps in this space double as seats.
They also contain electrical appliances,
clothes and various other objects.
This solution frees the new dwelling
from clutter.

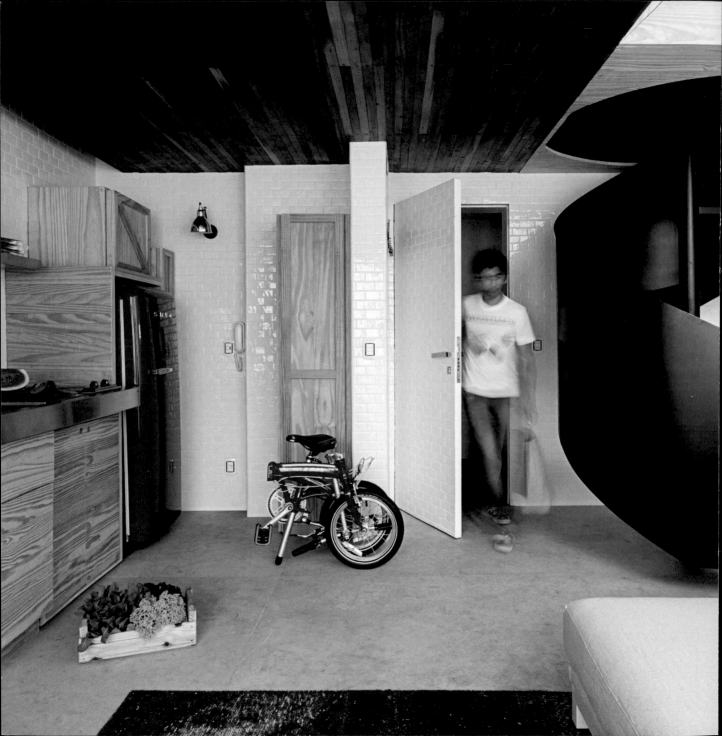

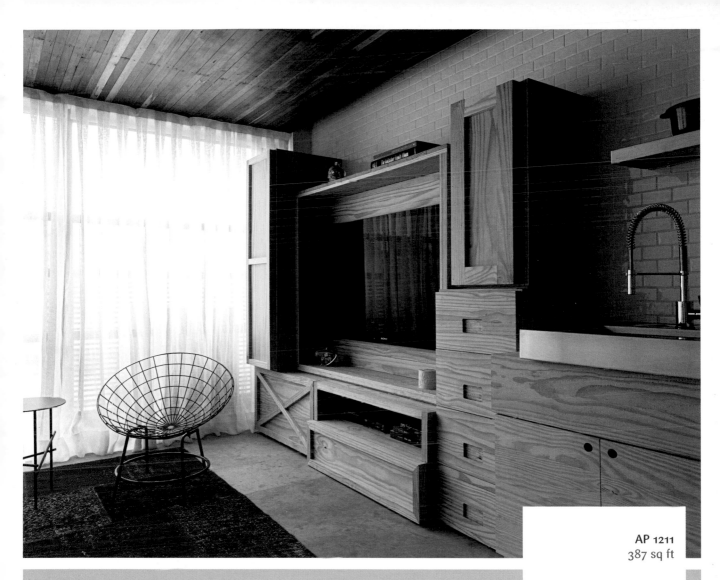

AP 1211
387 sq ft

Architect: Alan Chu
Location: São Paulo, Brazil
Photographer: © Djan Chu

This apartment is a temporary residence for a young businessman. The design plays with the transience of the moment: a time of changes, improvisation and reorganization. The space is distributed between two floors and equipped with a series of autoclaved pinewood crates of various sizes and proportions that serve different functions.

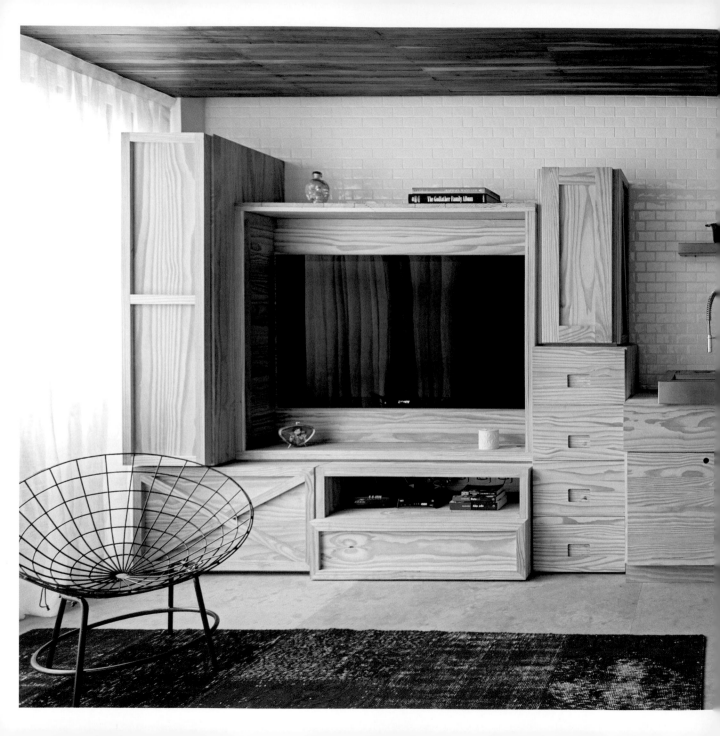

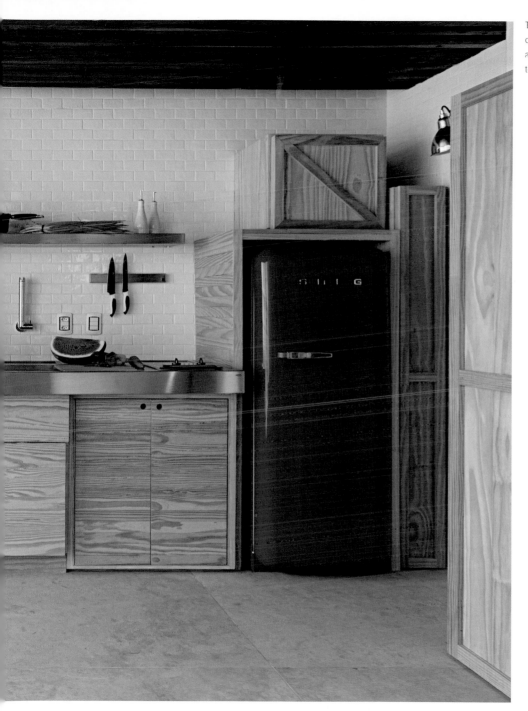

The seemingly random arrangement of the crates and the use of color bring a youthful and unpretentious atmosphere to the environment.

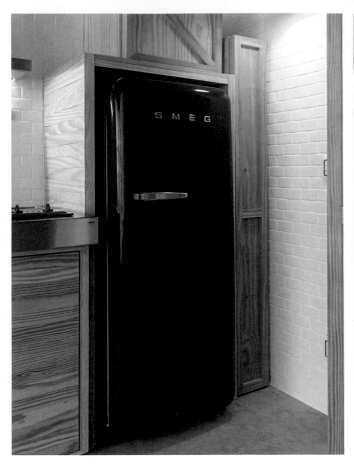
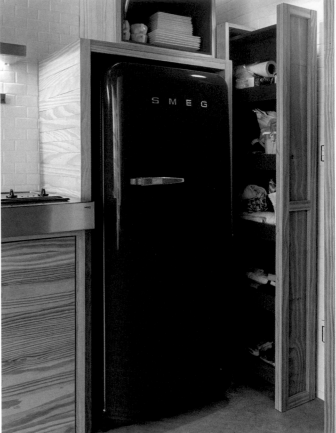

026

Think about how you are going to use your cabinets so you can choose the right type of hardware. Look into different door hinges and drawer hardware.

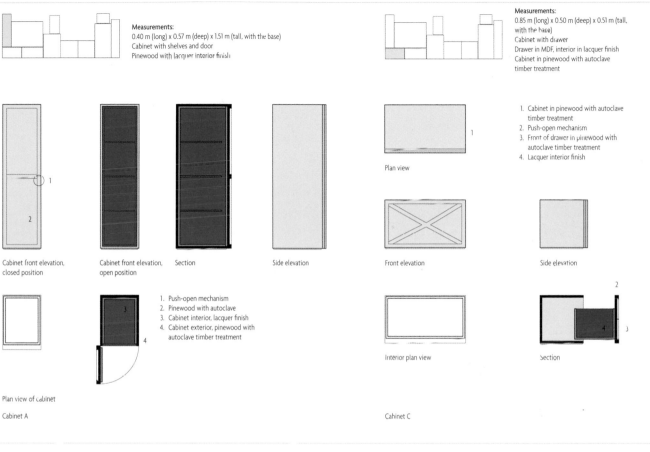

Measurements:
0.40 m (long) x 0.57 m (deep) x 1.51 m (tall, with the base)
Cabinet with shelves and door
Pinewood with lacquer interior finish

Measurements:
0.85 m (long) x 0.50 m (deep) x 0.51 m (tall, with the base)
Cabinet with drawer
Drawer in MDF, interior in lacquer finish
Cabinet in pinewood with autoclave timber treatment

Cabinet front elevation, closed position

Cabinet front elevation, open position

Section

Side elevation

1
2

1. Push-open mechanism
2. Pinewood with autoclave
3. Cabinet interior, lacquer finish
4. Cabinet exterior, pinewood with autoclave timber treatment

Plan view of cabinet

Cabinet A

Plan view

1

1. Cabinet in pinewood with autoclave timber treatment
2. Push-open mechanism
3. Front of drawer in pinewood with autoclave timber treatment
4. Lacquer interior finish

Front elevation

Side elevation

Interior plan view

Section

Cabinet C

027

Design your own modular system with crates of different sizes to bring an industrial touch to your home. It is a creative design solution, especially for short-term stays in a small space.

The crates form the kitchen, the pantry and the living room. A large one, wedged between the edge of the upper floor and the wall, tops a metal spiral staircase.

Section

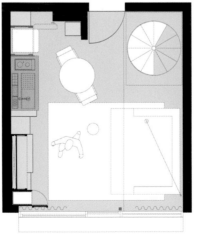

Lower-level floor plan

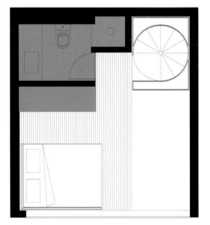

Loft floor plan

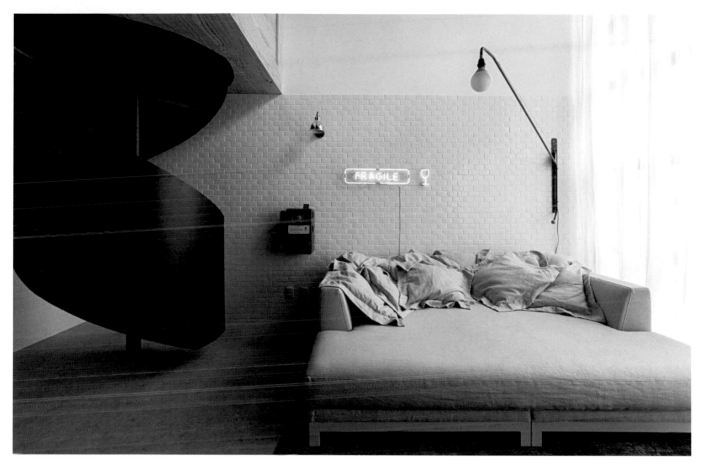

028

A spiral staircase is a compact alternative to the conventional staircase. Without a doubt, a custom spiral staircase also brings a sculptural quality to the space it inhabits.

The industrial look of the wood crates contrasts with the sleek and refined atmosphere of the bedroom, accented by the One chair designed by Konstantin Grcic for Magis.

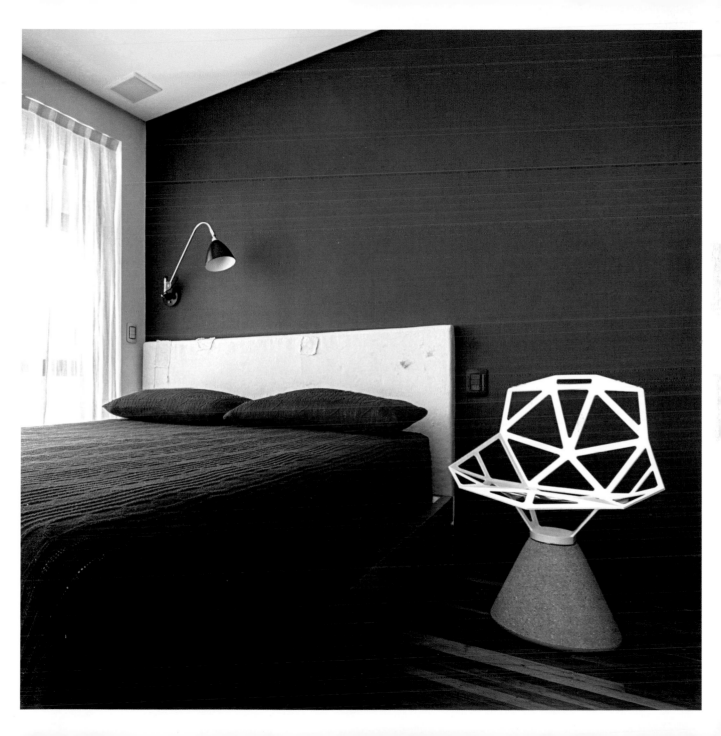

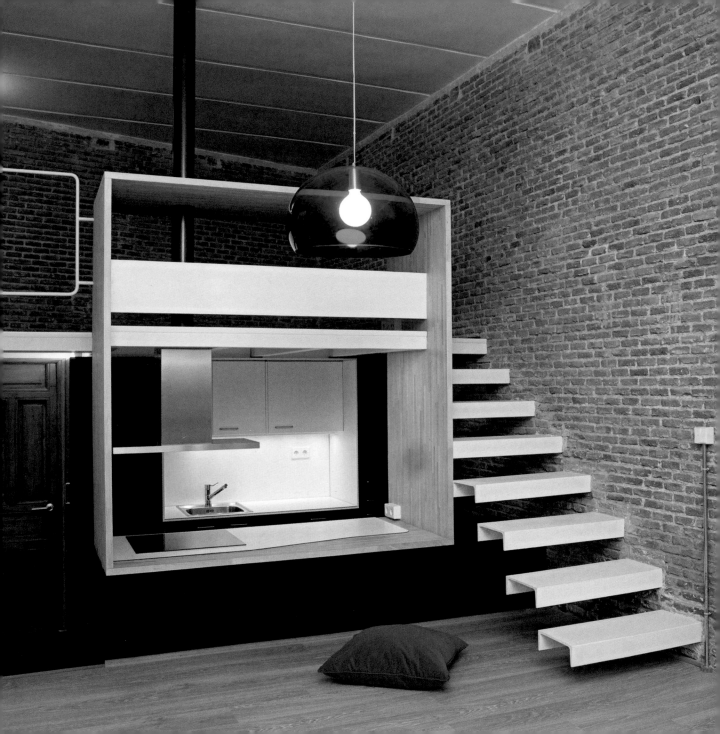

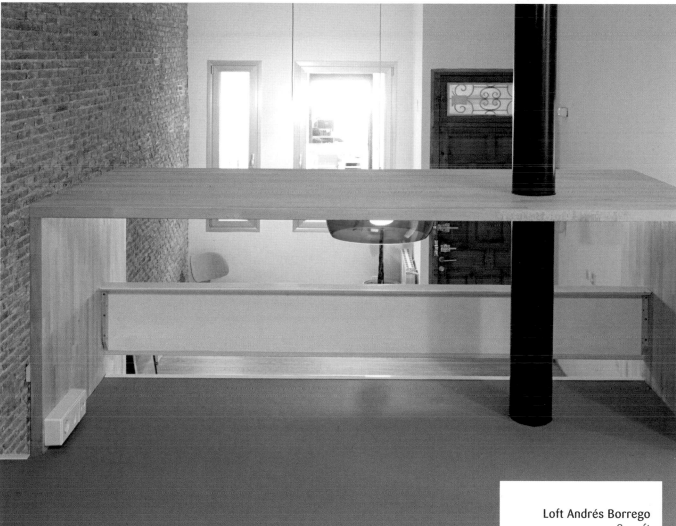

Loft Andrés Borrego
398 sq ft

Architect: Beriot, Bernardini
Arquitectos
Location: Madrid, Spain
Photographer: © Yen Chen

The ground-floor location of this apartment allowed for the excavation of about 16 inches at the back. This gained enough ceiling height for the construction of a loft, which accommodates a sleeping area. The space underneath it is used for the kitchen and bathroom.

Cross section

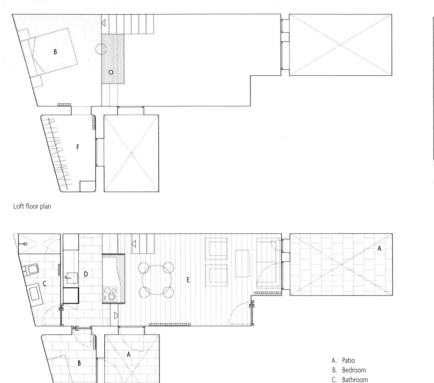

Loft floor plan

Section

A. Patio
B. Bedroom
C. Bathroom
D. Kitchen
E. Living-dining area
F. Dressing room

A laminated wooden frame hovers in front of the loft. Its lower side serves as a work surfaces for the kitchen, while its upper side doubles as a guardrail and desk on the upper level.

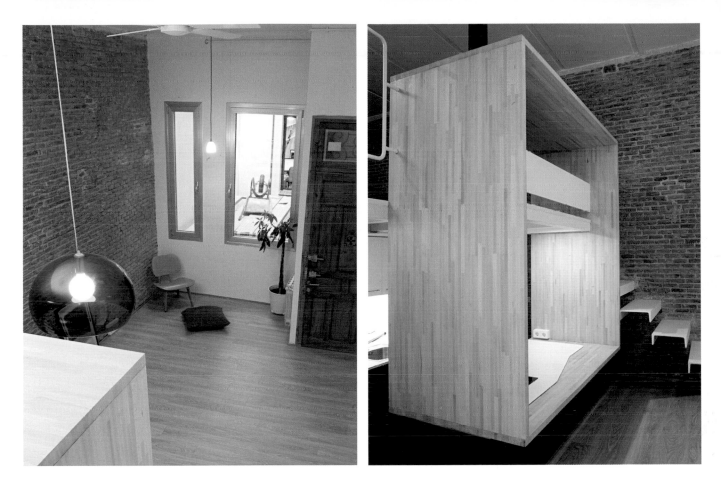

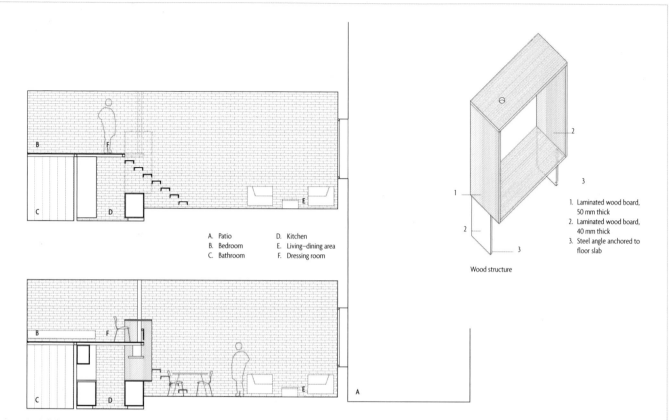

A. Patio
B. Bedroom
C. Bathroom

D. Kitchen
E. Living–dining area
F. Dressing room

Wood structure

1. Laminated wood board, 50 mm thick
2. Laminated wood board, 40 mm thick
3. Steel angle anchored to floor slab

Longitudinal sections

029

If you undertake a project that involves the construction of a loft, make sure to check the building regulations regarding headroom. In general, habitable rooms cannot have a ceiling height of less than 7 feet.

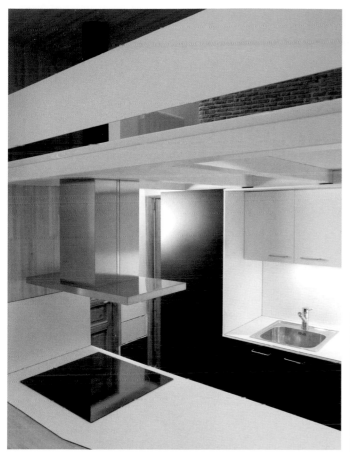

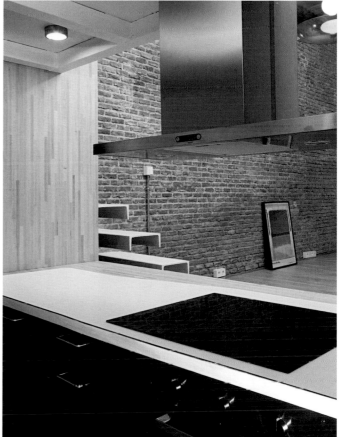

030

Furniture can be an effective room divider. It is an excellent solution for studio apartments where different functions share the same space.

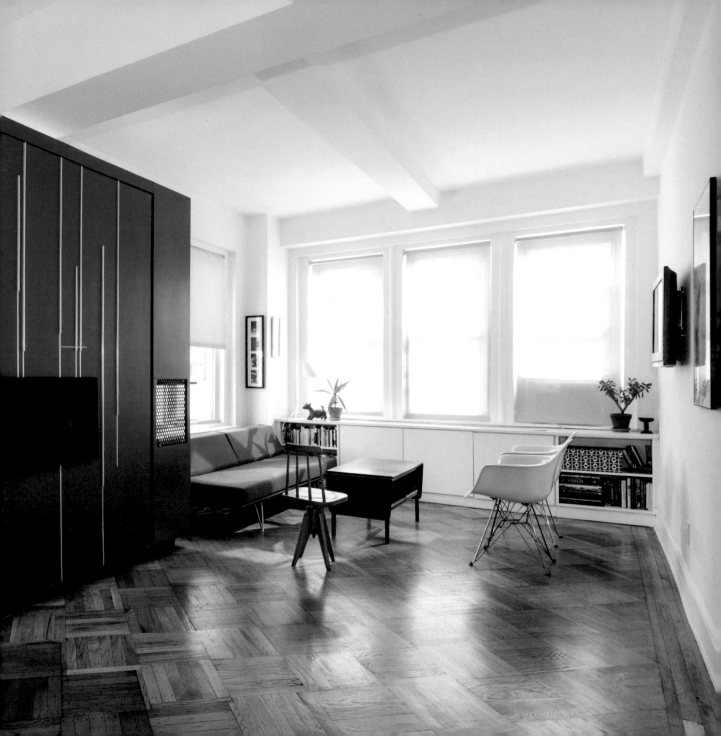

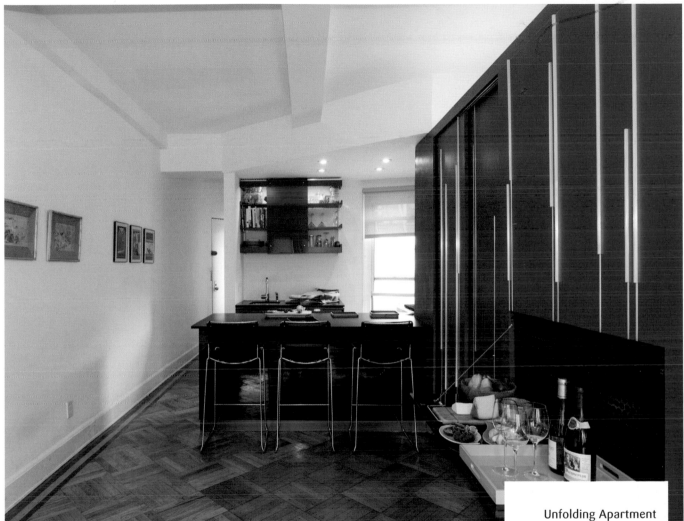

Unfolding Apartment
420 sq ft

Architect: MKCA
Location: New York, NY, USA
Photographer: © Alan Tansey

A strategy of extreme density and flexibility was employed to design an apartment for a young man who entertains frequently, often has houseguests and occasionally works from home. The challenge was to incorporate all the aspects of a larger space for working and entertaining within a compact studio apartment.

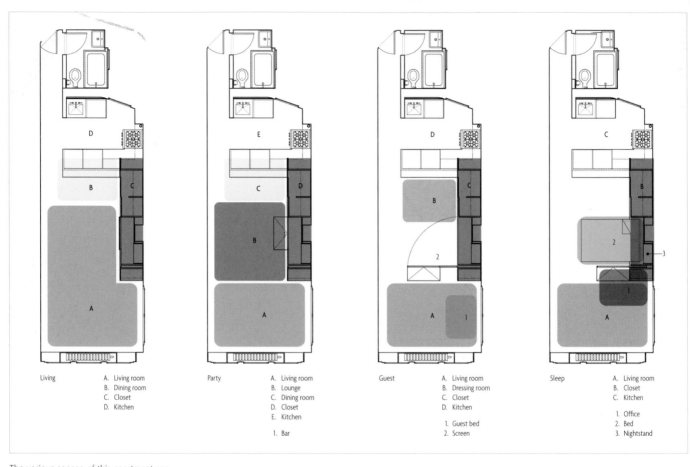

Living	A. Living room	Party	A. Living room	Guest	A. Living room	Sleep	A. Living room
	B. Dining room		B. Lounge		B. Dressing room		B. Closet
	C. Closet		C. Dining room		C. Closet		C. Kitchen
	D. Kitchen		D. Closet		D. Kitchen		
			E. Kitchen				1. Office
					1. Guest bed		2. Bed
			1. Bar		2. Screen		3. Nightstand

The various spaces of this apartment can
be expanded progressively and adjusted
via a reconfigurable series of doors
and panels that slide and pivot open
and closed.

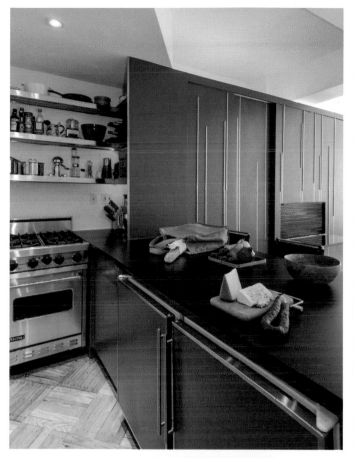

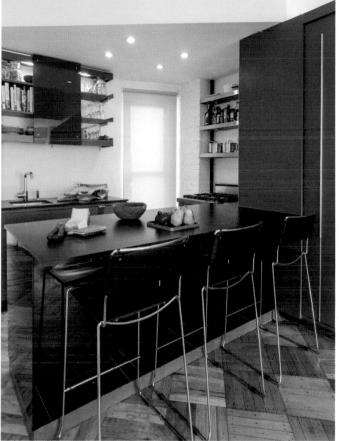

Kitchen items are collected on custom
stainless-steel shelving and concealed
behind a backlit sliding resin panel.

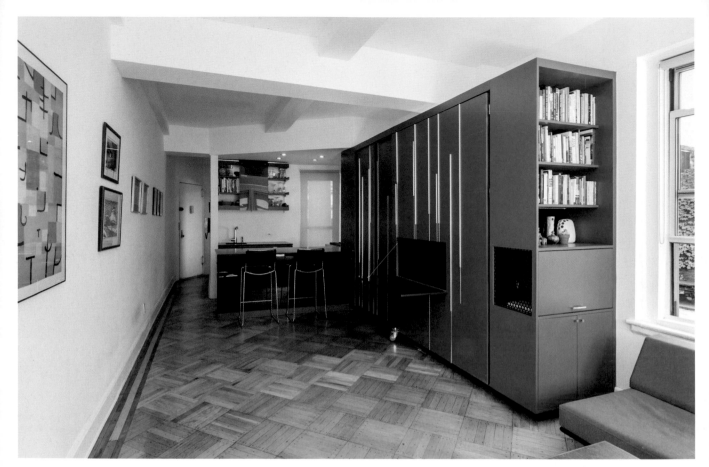

A single custom cabinetry piece was inserted along one wall. The cabinet contains functional components including a bed, a closet, a desk, a library and kitchen storage.

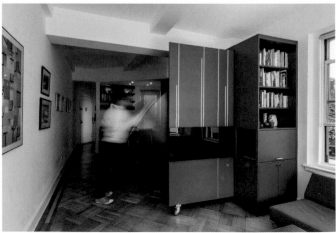

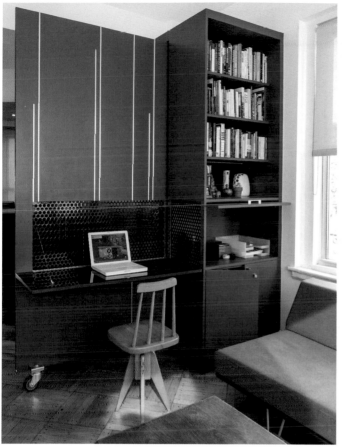

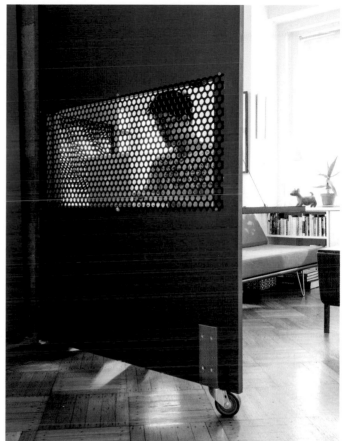

031

Integrating furniture with architecture is an efficient solution when dealing with small spaces. Flexibility and mobility are key. The best results occur when you can move items to reconfigure a space.

Mobile panels and furniture
can create an open feel when
packed away, or subdivide a
space for different uses. Spaces
can be calibrated to be private
or more porous by means of
different types of materials.

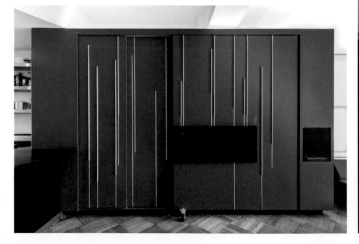

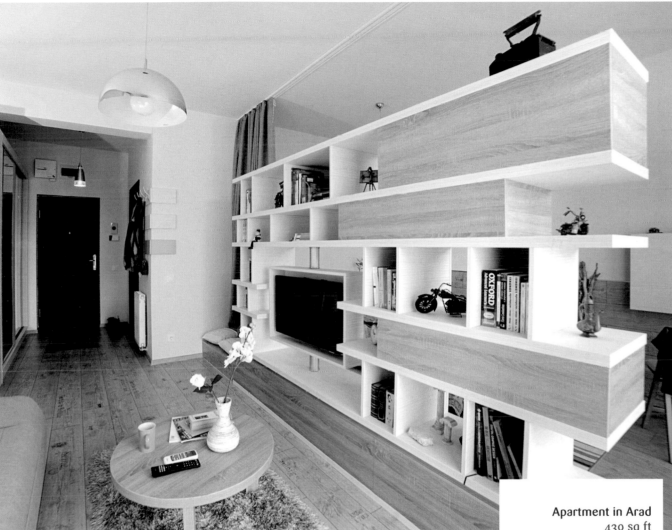

Apartment in Arad
430 sq ft

Designer: Cristina Bordoiu
Location: Arad, Romania
Photographer: © Sorin Popa

Living in a 430-square-foot studio apartment takes some creative planning and ingenious space-saving solutions. This home is an example. Three areas are clearly differentiated, thanks to a large pass-through between the kitchen and the living area and a bookcase-screen that provides the bedroom with necessary privacy.

033

It takes good organizational skills and creativity to find storage opportunities in a small space without making it look cramped. In fact, the solutions can give character to a small place.

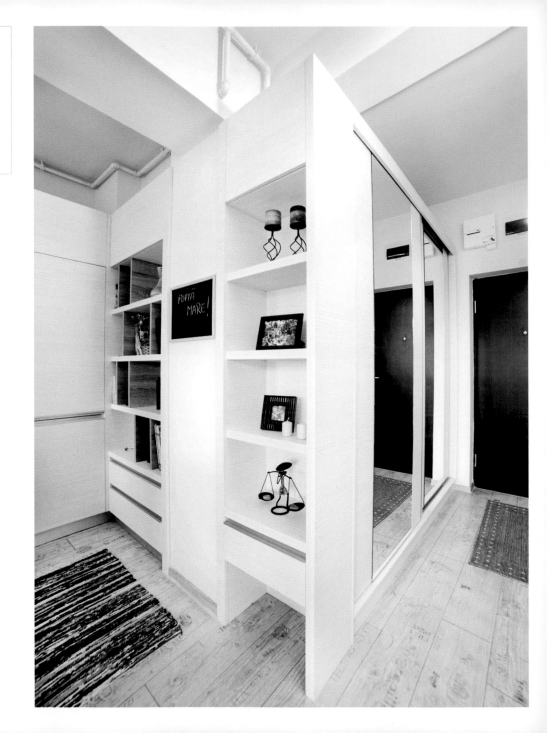

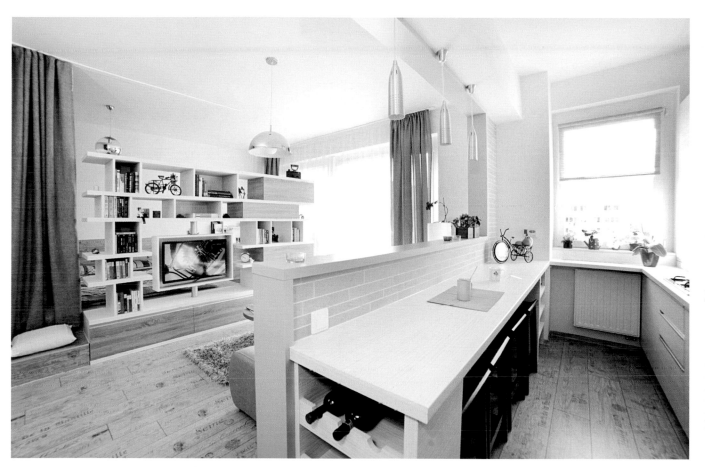

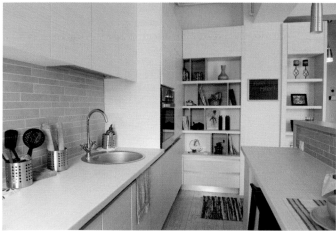

034

A large pass-through between the kitchen and the living room is a design feature that both separates and connects the two rooms. Use similar details in both areas to better integrate the overall design.

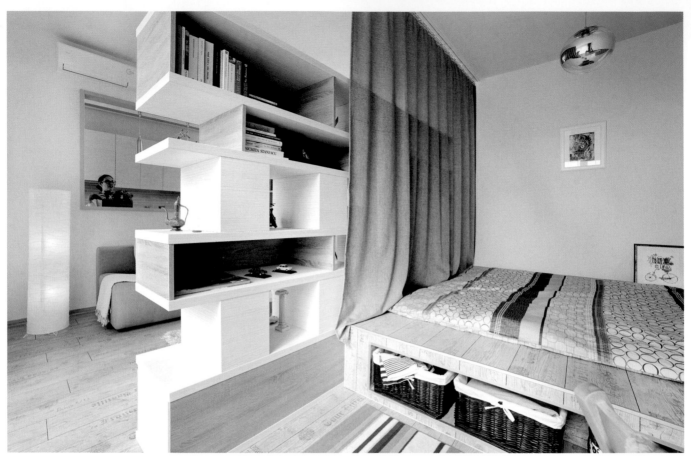

035

Putting a mattress directly on the floor eats up a lot of valuable square footage. Don't take away the opportunity for under-the-bed storage. Consider a platform bed that incorporates storage space.

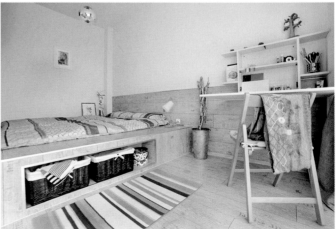

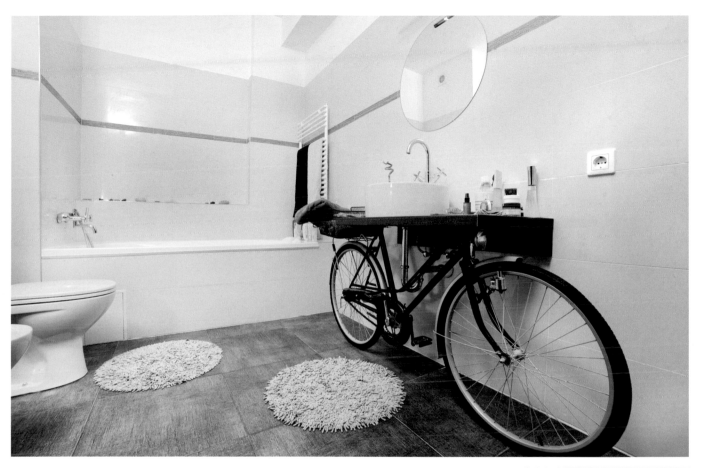

036

Give an old bike new life by using it to support a vanity. Creative customization of furniture imbues a space with personality.

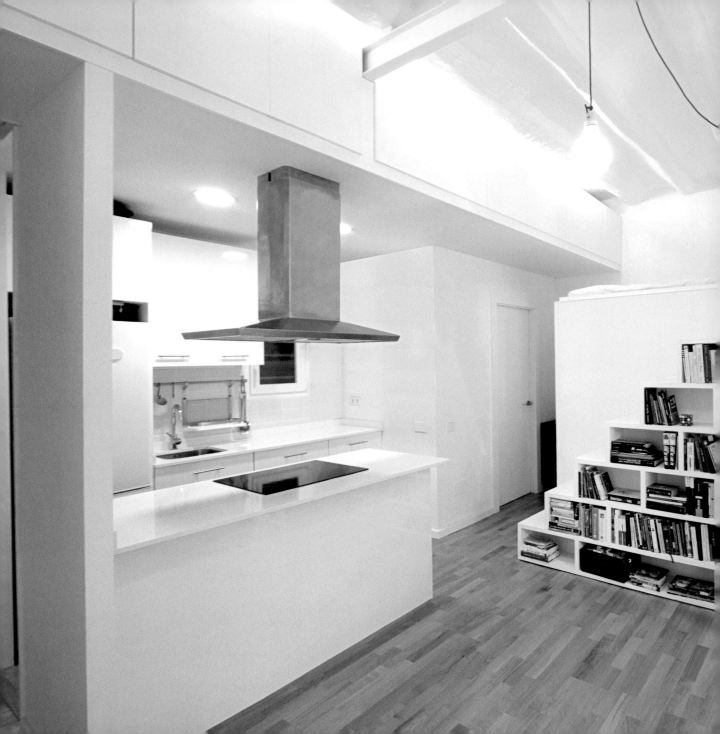

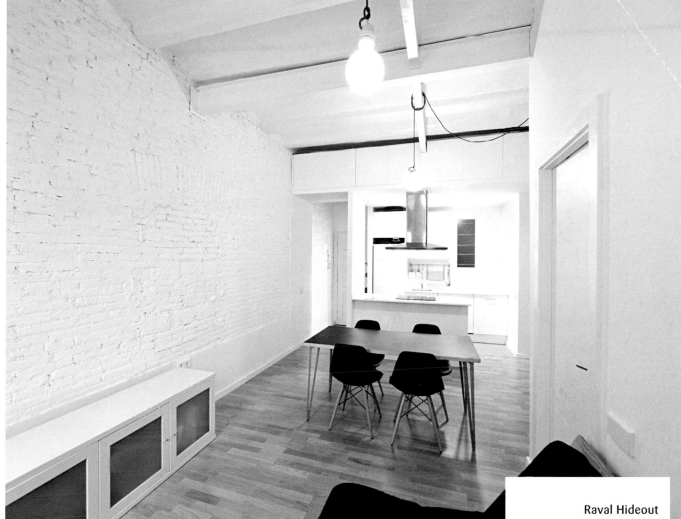

Raval Hideout
430 sq ft

Architect: Eva Cotman
Location: Barcelona, Spain
Photographer: © Eva Cotman,
Maria Ceballos

This budget-conscious project was designed to alter and improve an existing apartment for a young couple with a very active social life. The result is a compact dwelling with multifunctional elements that provide flexibility and adaptability. The apartment is organized around one piece of furniture that is simultaneously library, bookshelf, closet, bench and staircase leading up to a sleeping loft.

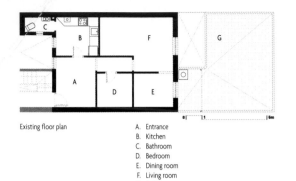

Existing floor plan

 A. Entrance
 B. Kitchen
 C. Bathroom
 D. Bedroom
 E. Dining room
 F. Living room
 G. Patio

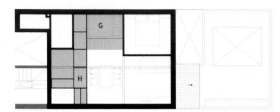

Upper-level floor plan

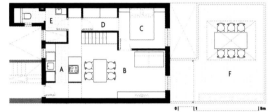

Lower-floor plan

A. Kitchen
B. Living–dining room
C. Bedroom
D. Closet
E. Bathroom
F. Patio
G. Loft with guest bed
H. Built-in storage

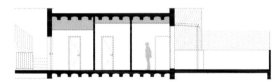

Existing section

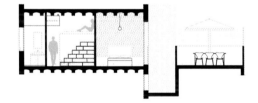

Section

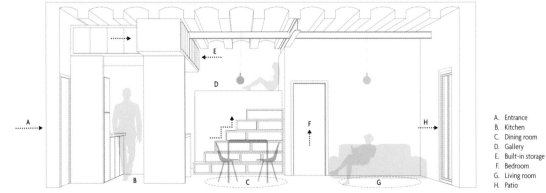

Section perspective

A. Entrance
B. Kitchen
C. Dining room
D. Gallery
E. Built-in storage
F. Bedroom
G. Living room
H. Patio

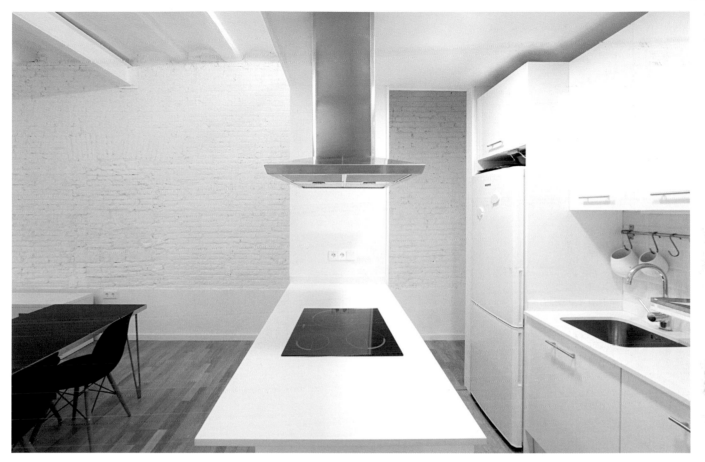

One of the most important aspects of this design is its potential for space optimization. This is achieved by means of multifunctional pieces of furniture that contrast with the original character of the space.

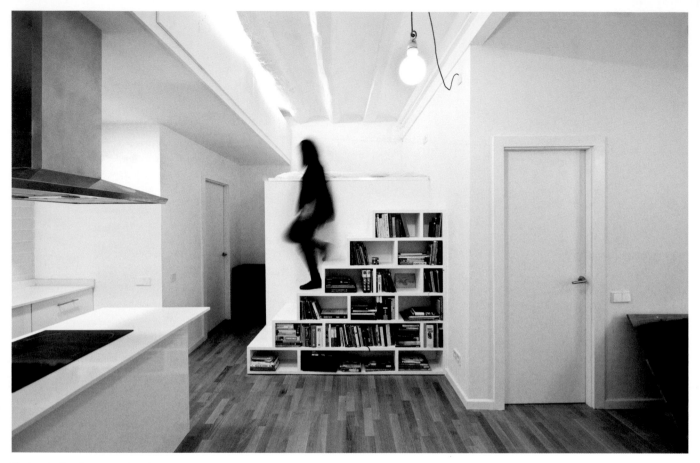

The layout offers the occupants various options to move from one space to another, enriching the spatial perception. The staircase facilitates access to the storage space above the kitchen and entry.

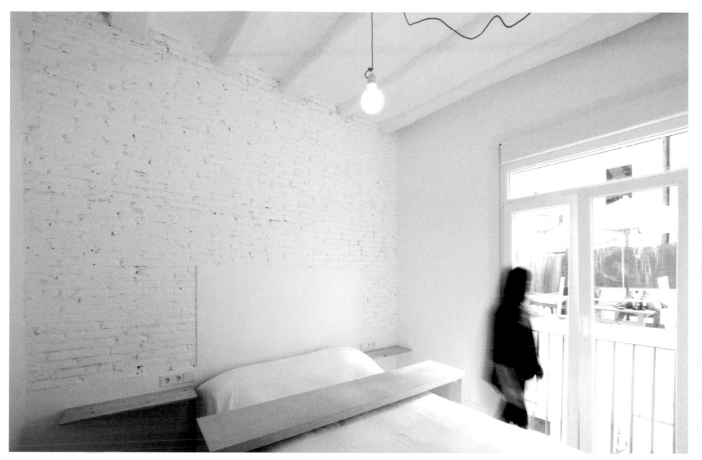

037

Make the most of natural light by establishing connections between the areas close to a natural light source and those far from one.

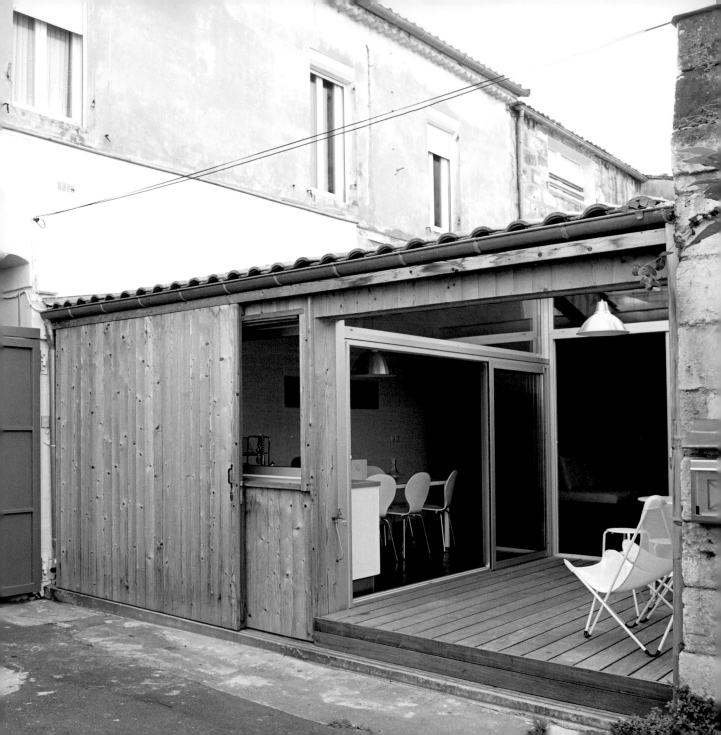

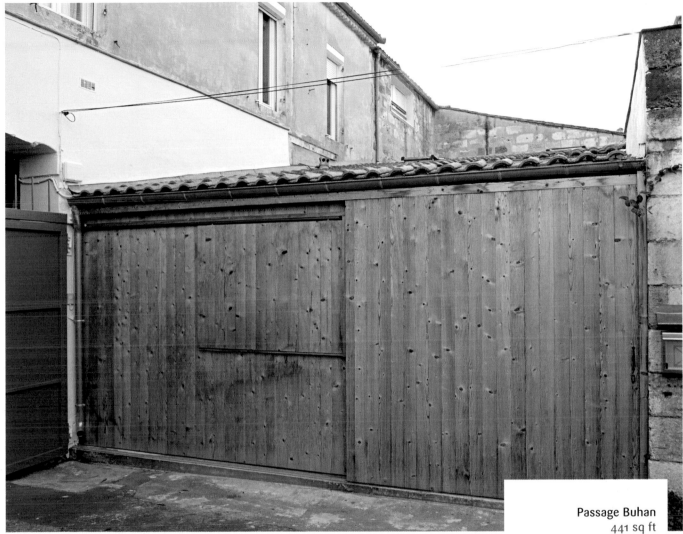

Passage Buhan
441 sq ft

Architect: FABRE/deMARIEN
Architectes
Location: Bordeaux, France
Photographer: © Stéphane
Chalmeau

This project consisted of the transformation of a garage into a single residential unit.
A 13 x 7-foot cutout into the rectangular space is used as an entry porch, facing
a quiet, narrow alley. The porch brings light and ventilation into the living area and
can be used as an extension of the interior space in good weather.

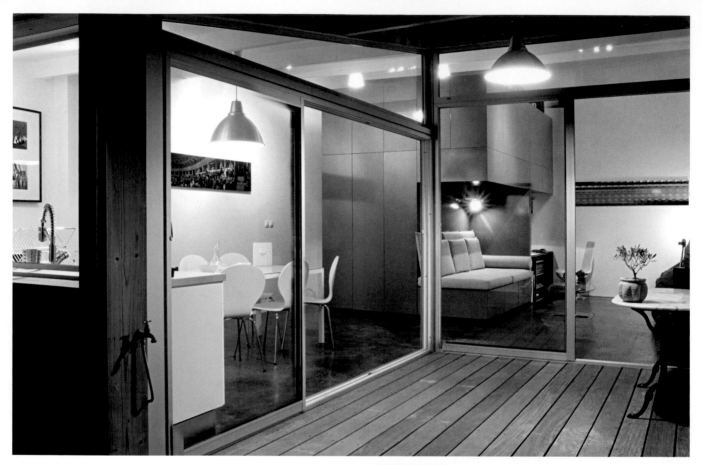

Except for the kitchen, all home functions are concentrated in a 10-foot-long by 10-foot-wide by 10-foot-tall volume containing a bathroom, a closet, a sofa bed, a desk and a sleeping loft.

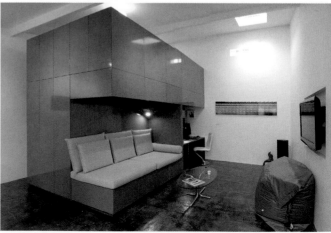

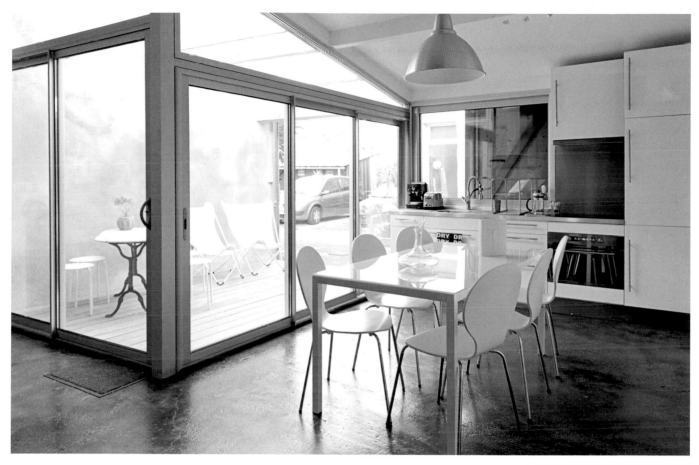

038

Place your kitchen in a well-lit section of your home if you can. A dining table can double as an island. It provides an extra work surface and makes it easier for several people to work simultaneously.

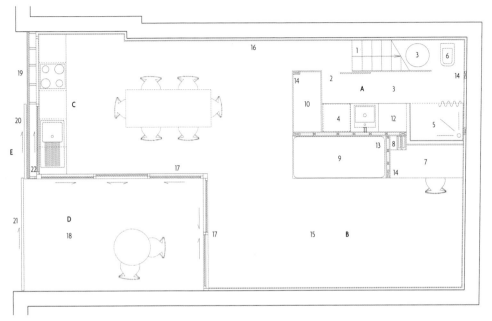

Floor plan

A. Box
1. Staircase
2. Sliding door
3. Water heater
4. Washing machine
5. Shower
6. Toilet
7. Desk
8. Shelves
9. Sofa bed
10. Closet
11. Mirror
12. Vanity
13. Wood paneling
14. Wood post

B. Living area
15. Stained concrete flooring
16. Gypboard and insulation layer
17. Sliding aluminum patio doors

C. Kitchen

D. Patio
18. Wood deck

E. Exterior wall
19. Wood cladding
20. Sliding wood shutter
21. Sliding wood gate
22. Sliding aluminum window

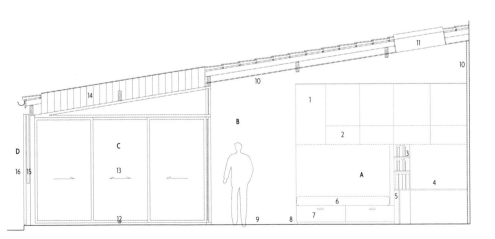

Longitudinal section

A Box
1. Fixed panel
2. Projector cabinet
3. Bookshelves
4. Desk
5. Storage
6. Sofa bed
7. Drawer
8. Base

B Living area
9. Stained concrete flooring
10. Gypboard and insulation layer
11. Skylight

C Patio
12. Wood deck
13. Sliding aluminum patio doors
14. Wood fascia

D Exterior wall
15. Sliding wood shutter
16. Sliding wood gate

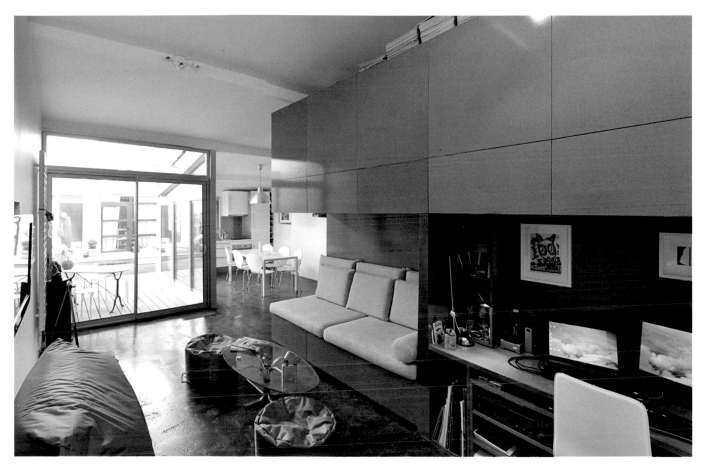

039

For small spaces, choose
furniture that is not bulky
and can easily be moved.
It is useful to be able to move
things around to accommodate
special situations.

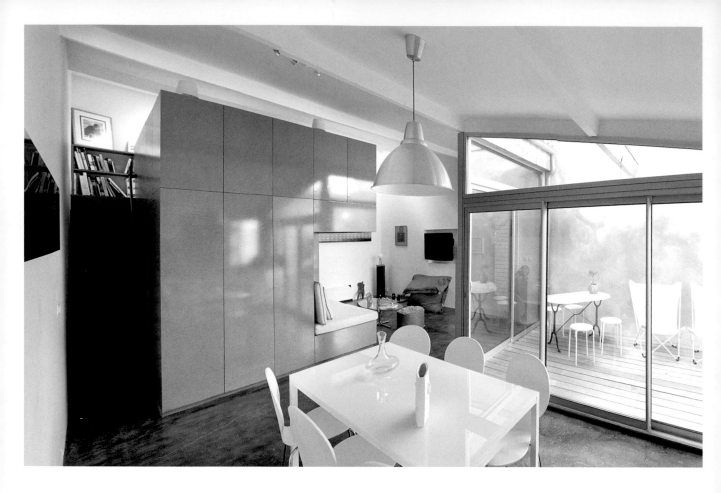

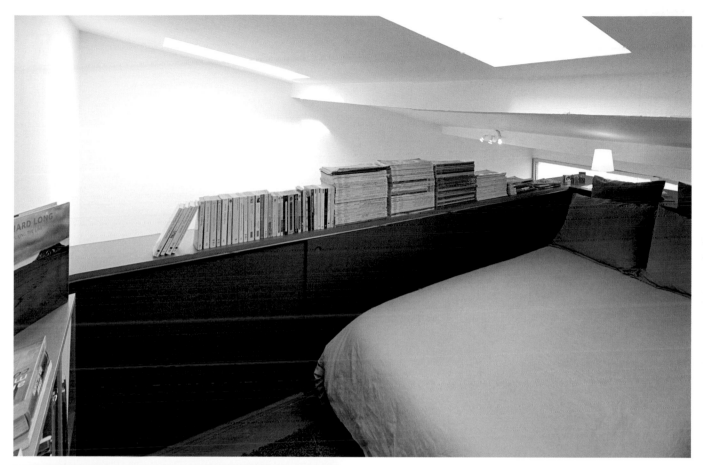

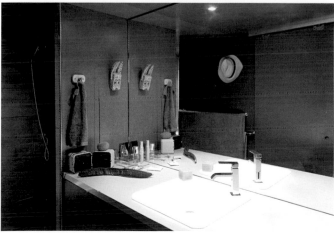

040

The swing of a hinged door takes up valuable space that limits the possibilities of a small space such as a bathroom. A sliding door is a much better option.

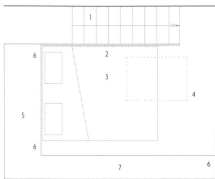

Box: plan view of loft

1. Staircase
2. Parapet
3. Bed
4. Wood floor assembly
5. Headboard
6. Electrical outlet
7. Skylight

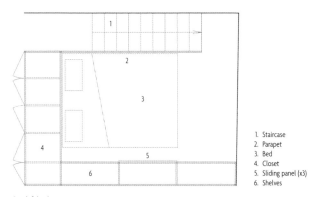

Box: loft level

1. Staircase
2. Parapet
3. Bed
4. Closet
5. Sliding panel (x3)
6. Shelves

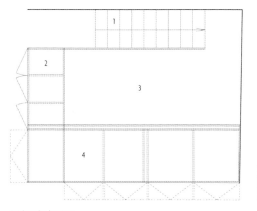

Box: lower level, interior

1. Staircase
2. Closet
3. Bathroom
4. Projector cabinet

Box: desk side, interior

1. Fixed panel
2. Closet
3. Bookshelves
4. Desk
5. Storage
6. Sofa bed
7. Drawer

Box: desk side

1. Fixed panel
2. Projector cabinet
3. Bookshelves
4. Desk
5. Storage
6. Sofa bed
7. Drawer
8. Base

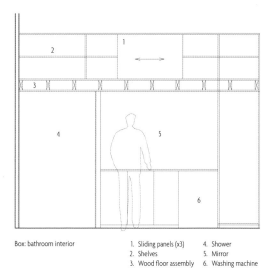

Box: bathroom interior

1. Sliding panels (x3)
2. Shelves
3. Wood floor assembly
4. Shower
5. Mirror
6. Washing machine

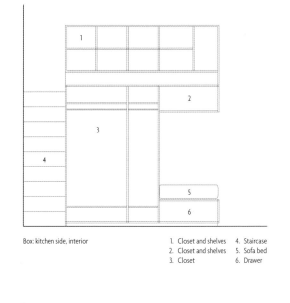

Box: kitchen side, interior

1. Closet and shelves
2. Closet and shelves
3. Closet
4. Staircase
5. Sofa bed
6. Drawer

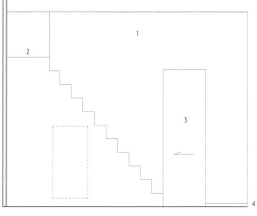

Box: bathroom exterior wall

1. Parapet
2. Wood floor assembly
3. Sliding door
4. Base

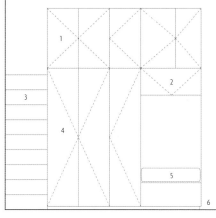

Box: kitchen side

1. Wood paneling
2. Projector cabinet
3. Staircase
4. Wood paneling
5. Sofa bed
6. Base

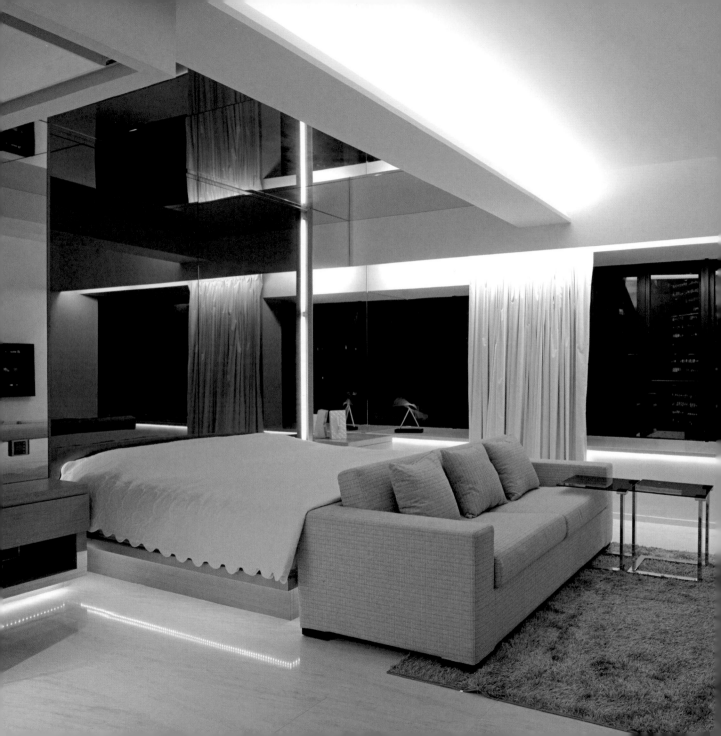

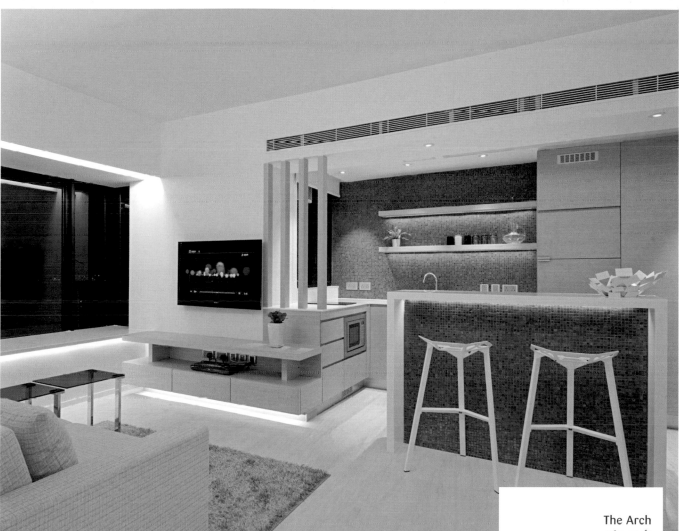

The remodel of this apartment in Hong Kong is a study in planning for small spaces. As a starting point, the interior was completely gutted in order to start with a clean slate and satisfy the client's requirements. The reconfiguration of the apartment achieved an increase in natural light and a more voluminous interior by avoiding partitions and maximizing the ceiling height.

The Arch
460 sq ft

Designer: **Clifton Leung Design Workshop**
Location: **Hong Kong (SAR), China**
Photographer: © **Red Dog**

041

In open-plan spaces, a ceiling treatment can be an effective way of demarcating the area directly below. Consider dropped ceilings above particular areas, in conjunction with appropriate lighting.

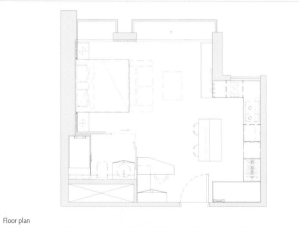

Floor plan

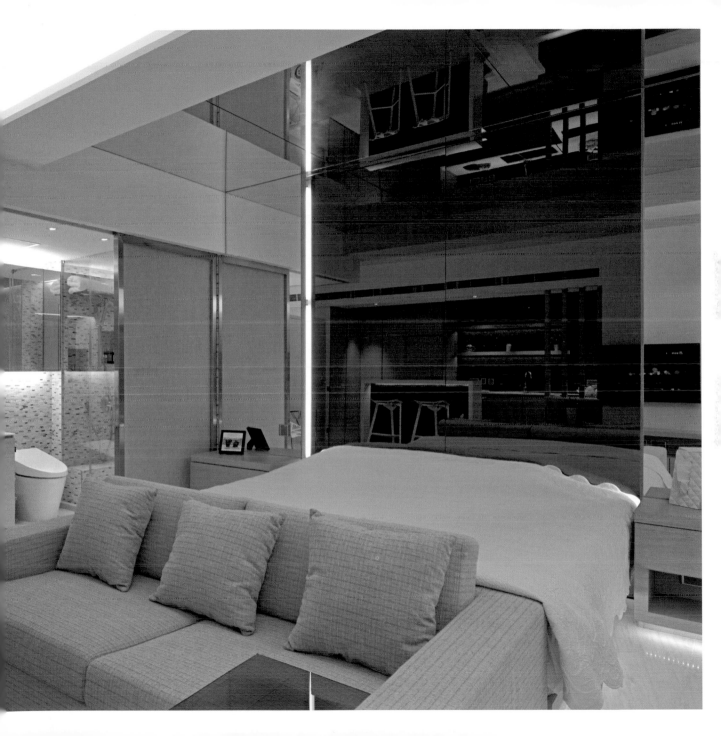

A mirrored ceiling over the bed puts a focus on this area. It amplifies the space and reflects light.

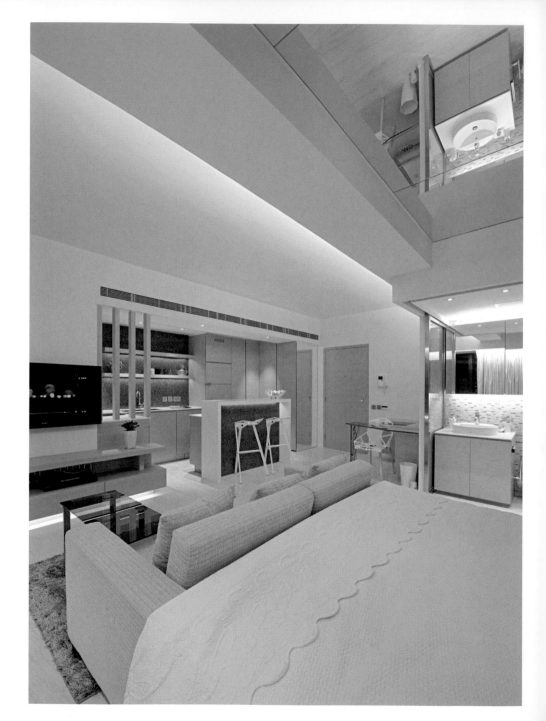

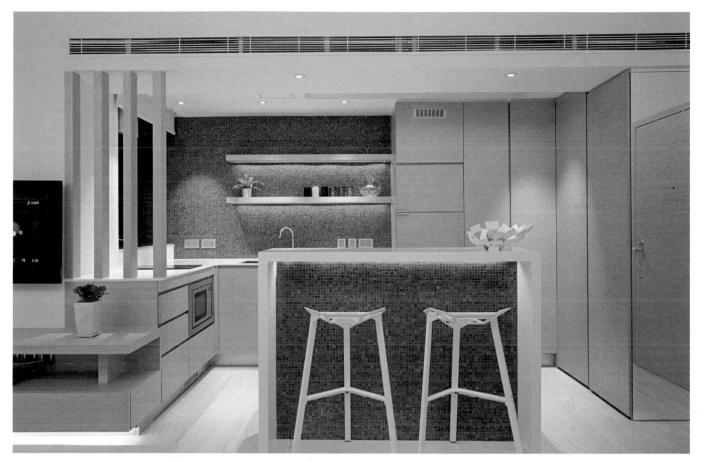

042

Understand different lighting types and the purpose each one serves to create the appropriate setting. Ambient lighting should be combined with task lighting in functional areas like kitchens.

Customize your furniture to give your home a personal touch: adapt it to your particular needs and to the available space.

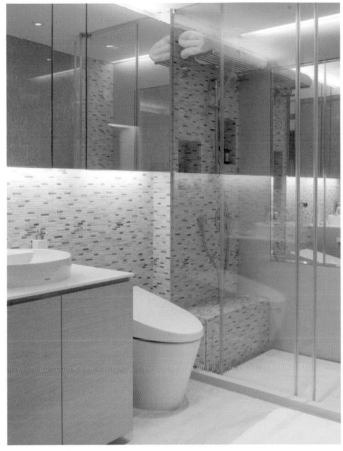

Conveniently placed against a duct chase, the bathroom is enclosed by two sliding glass panels that meet at a right angle.

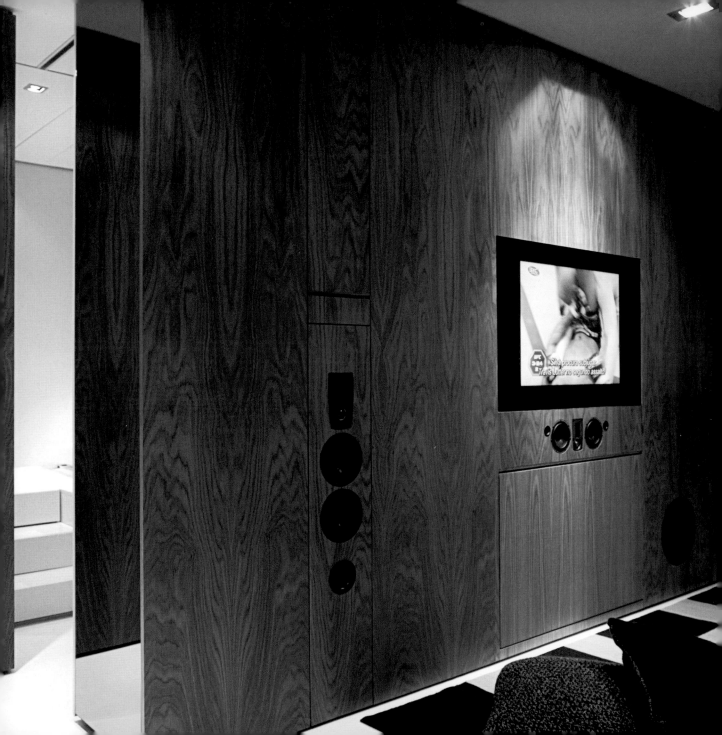

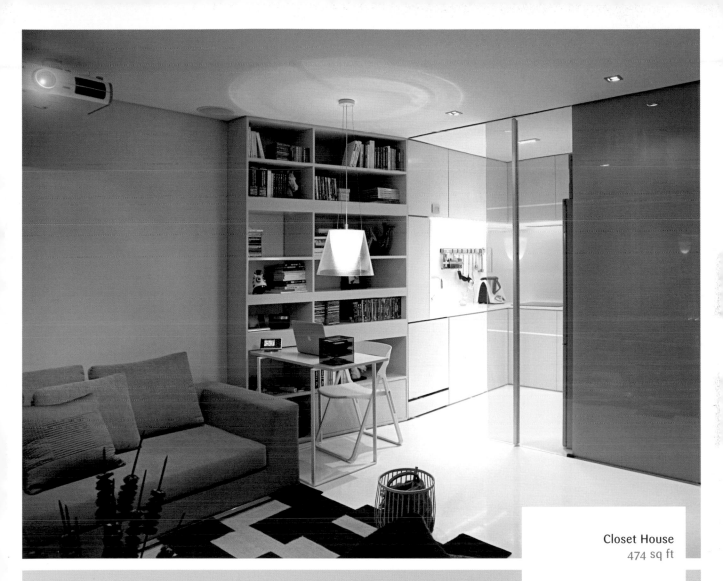

Closet House
474 sq ft

Designer: **Consexto**
Location: Matosinhos, Portugal
Photographer: © Amândio Neto

The optimal use of space coupled with automation technology transforms a tiny space into a functional home. It's composed of five spaces, two of which can be transformed by means of a movable cabinet. The side of the cabinet facing the bedroom is a closet. The side facing the living area has a fold-out table, a minibar and an entertainment center.

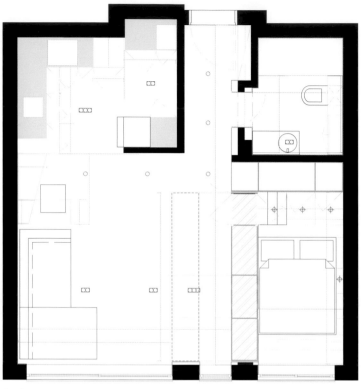

Floor plan

044

Before you order a bespoke closet, think about what you are going to store in it and how you are going to use it. The right configuration can increase the storage space.

Hand-sketched cabinet elevation and section

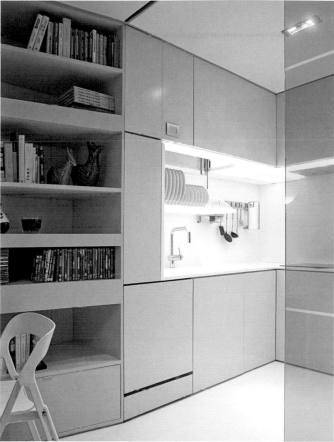
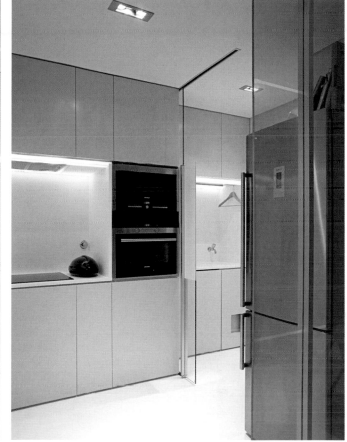

045

Freestanding furniture tends to be inconvenient in small spaces. Limit the number of these items to make circulation around the space easy. This will increase the sense of amplitude.

046

You may want to keep
appliances and other utilitarian
devices out of sight, in cabinets
fitted with electrical outlets,
to keep surfaces clear.

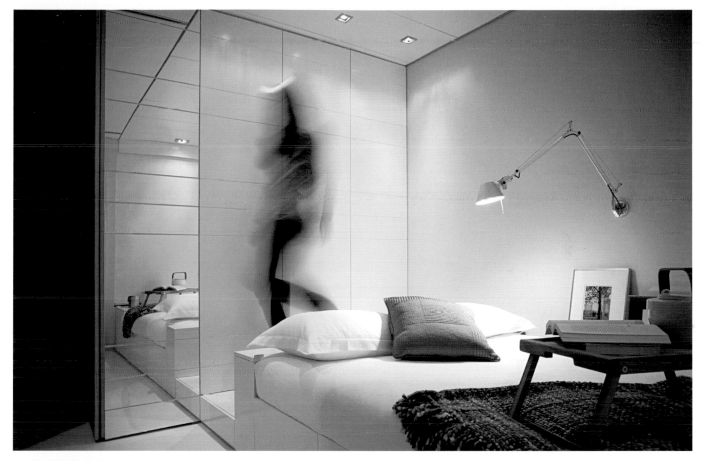

All electronic devices, network solutions and lighting in this small apartment are efficiently controlled by a sophisticated home automation system that allows remote control from computers and mobile devices.

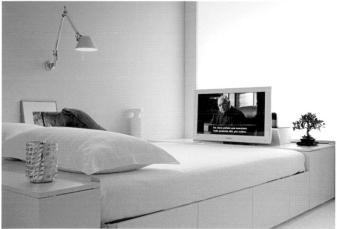

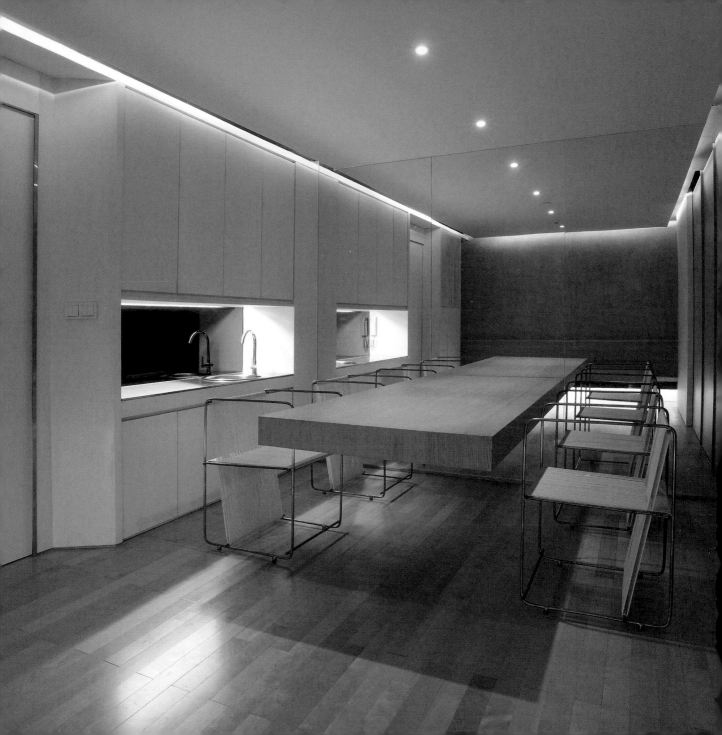

Chou's Apartment
484 sq ft

Architect: Chrystalline Architect
Location: Jakarta, Indonesia
Photographer: © William Sebastian

This remodel of a small studio apartment required a design that would optimize the space. Special attention was paid to adapting the apartment to the lifestyle of the occupant, a businessman often on the road. Solutions included the use of transparent partitions to open up the space and the construction of versatile built-in furniture.

047

Cove lighting has the effect of
expanding a space and lifting
a ceiling. As this type of lighting
is only used to create a soft
and comfortable atmosphere,
it is important to complement
it with accent and task lighting.

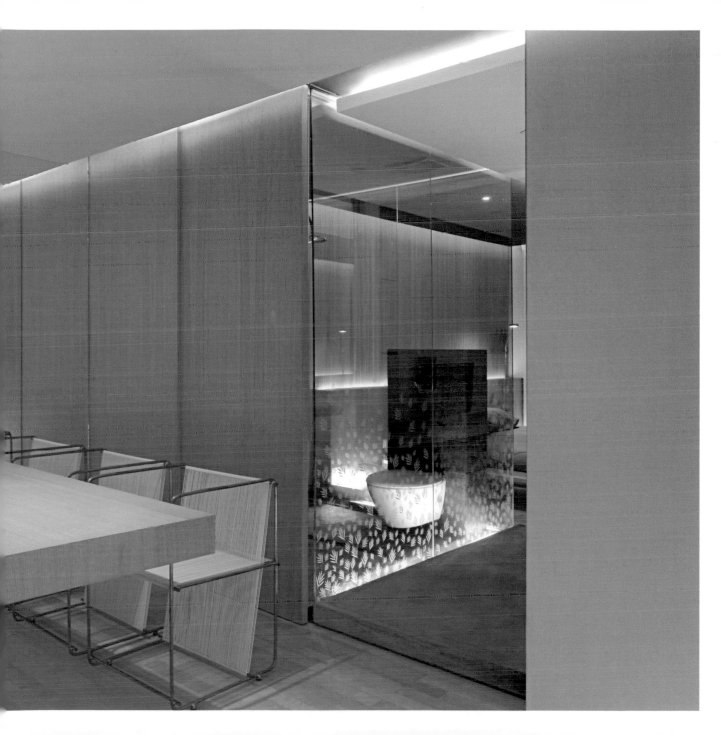

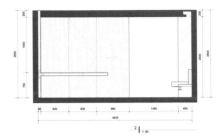

Section A-A

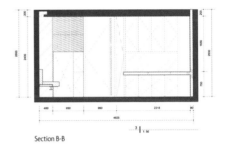

Section B-B

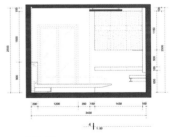

Section C-C

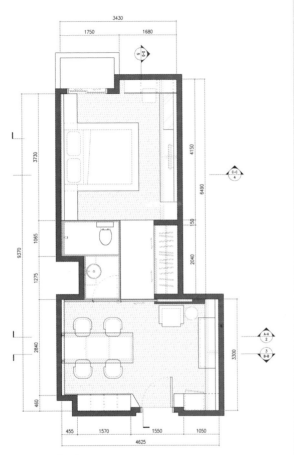

Floor plan

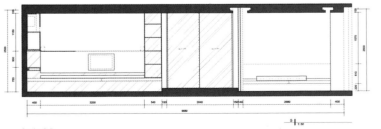

Section D-D

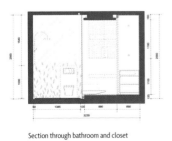

Section through bathroom and closet

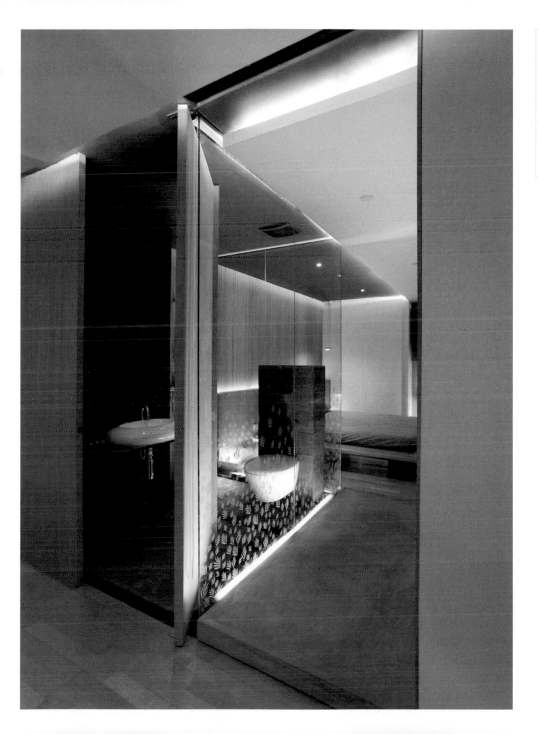

Camouflaged doors provide discreet access to an adjacent room. They maintain the continuity of a wall and create a space as simple and unified as possible.

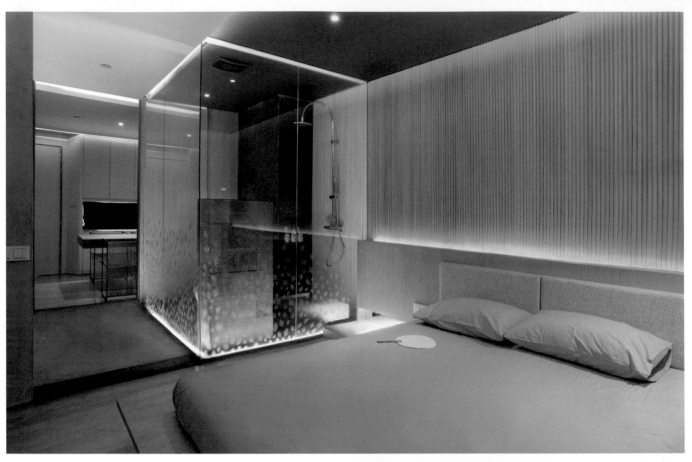

049

Cove lighting can emphasize
special interior design details,
such as unusual dropped
ceilings and printed glass
partitions that produce
a floating effect.

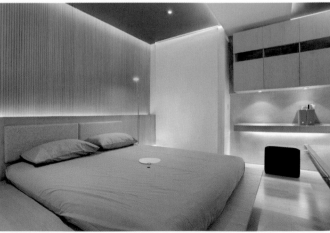

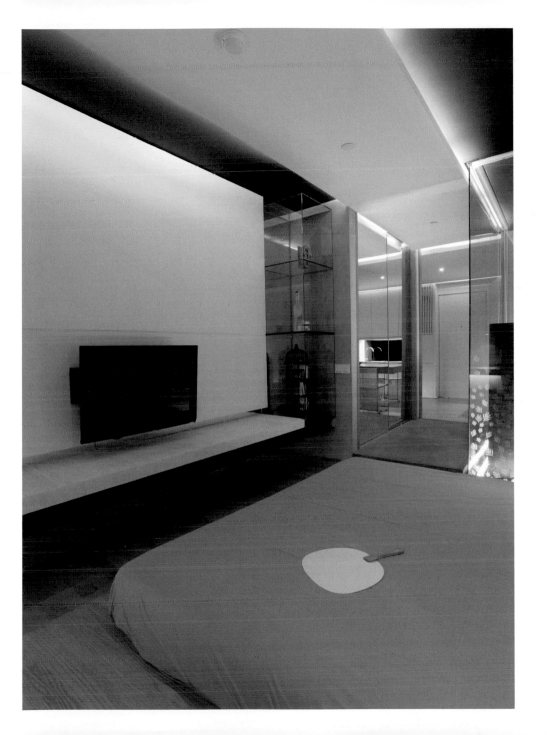

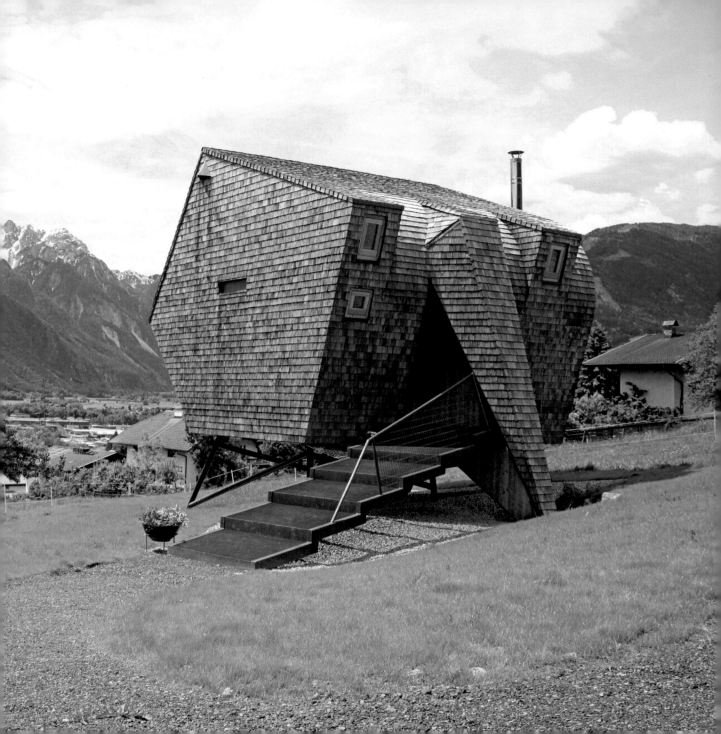

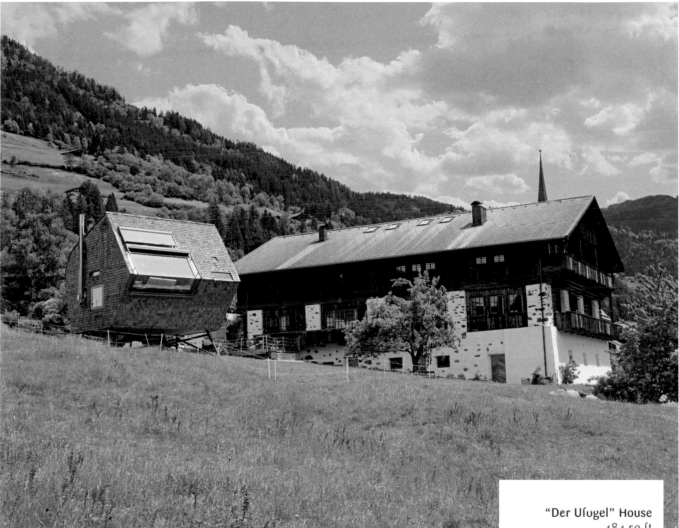

"Der Ufogel" House
484 sq ft

Architects: Architekturbüro Jungmann & Aberjung Design Agency

Location: Nußdorf-Debant, Lienz, Austria

Photographer: © DI Lukas Jungmann

Built on stilts and with a shape that reminds one of a large bird, this house doesn't go unnoticed. The interior reveals a multifunctional living space with a sleeping loft. It is efficiently equipped with a kitchen, a bathroom and a furnace. Large windows on various surfaces open the interior to the dramatic alpine landscape, enhancing the feeling of amplitude.

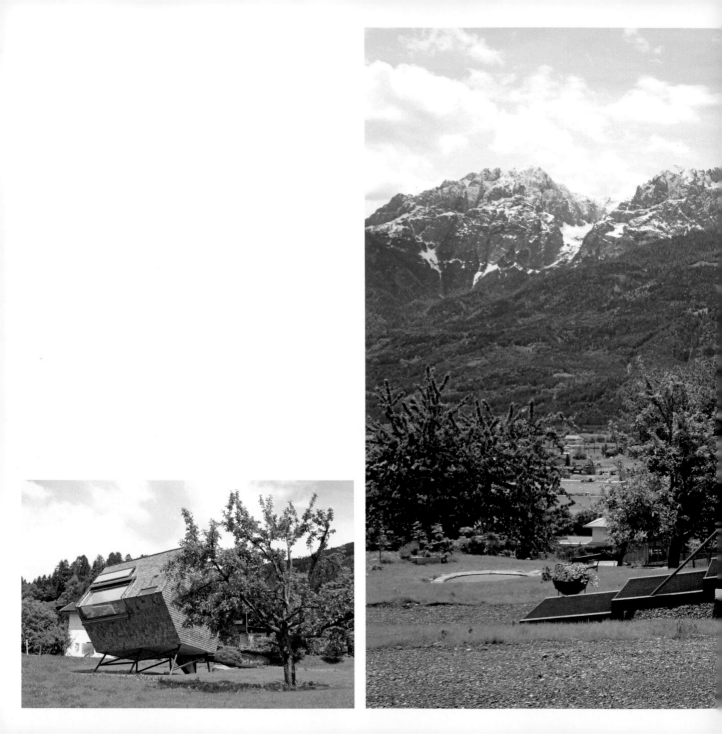

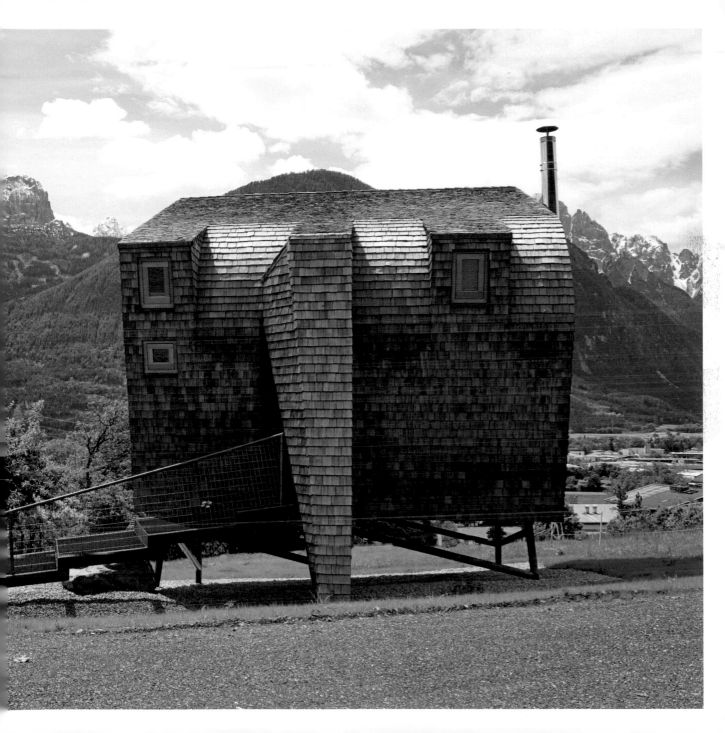

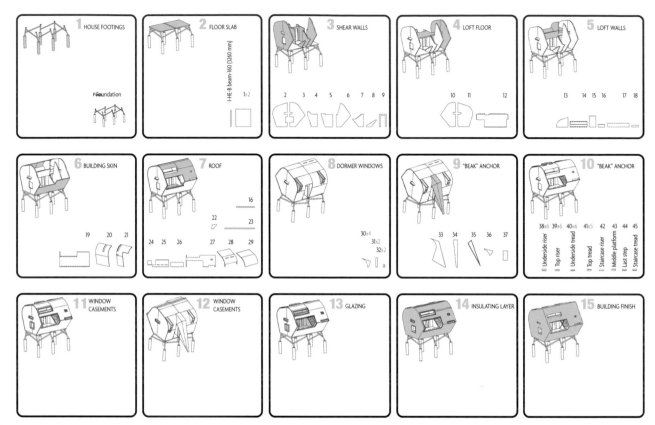

Construction sequence diagrams

1 HOUSE FOOTINGS — Foundation

2 FLOOR SLAB — I-HE-B beam-160 (3260 mm) — 1x2

3 SHEAR WALLS — 2 3 4 5 6 7 8 9

4 LOFT FLOOR — 10 11 12

5 LOFT WALLS — 13 14 15 16 17 18

6 BUILDING SKIN — 19 20 21

7 ROOF — 16 22 23 24 25 26 27 28 29

8 DORMER WINDOWS — 30x4 31x2 32x2

9 "BEAK" ANCHOR — 33 34 35 36 37

10 "BEAK" ANCHOR — 38x6 39x6 40x6 41x5 42 43 44 45 — Underside riser, Top riser, Underside tread, Top tread, Staircase riser, Middle platform, Last step, Staircase tread

11 WINDOW CASEMENTS

12 WINDOW CASEMENTS

13 GLAZING

14 INSULATING LAYER

15 BUILDING FINISH

This 484-square-foot multifunctional living space, comfortably equipped with a kitchen and a bathroom, offers both openness and security. Stripping away the superfluous, Ufogel embodies adaptability.

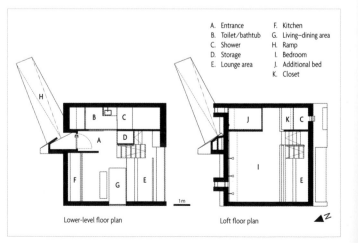

A. Entrance
B. Toilet/bathtub
C. Shower
D. Storage
E. Lounge area
F. Kitchen
G. Living–dining area
H. Ramp
I. Bedroom
J. Additional bed
K. Closet

Lower-level floor plan

Loft floor plan

1 m

N

Design development sketches

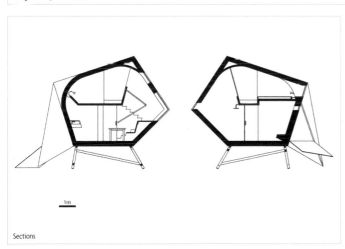

050

Adaptable interiors are key for putting every square foot of an interior space to good use. This is a common trait of small open spaces, enabling endless flexibility of spatial and functional aspects.

1m

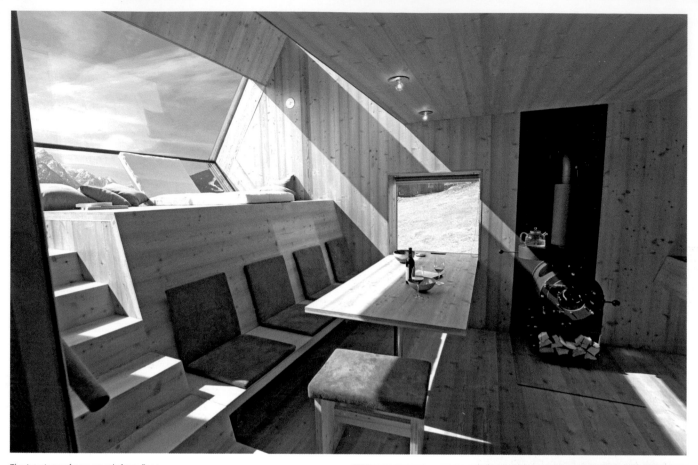

The interior surfaces morph from floor to bench or steps. The use of the same material throughout enhances the continuity from one plane to another.

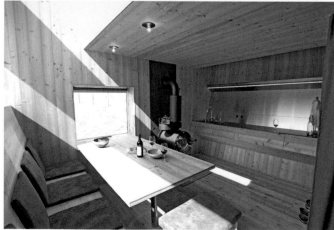

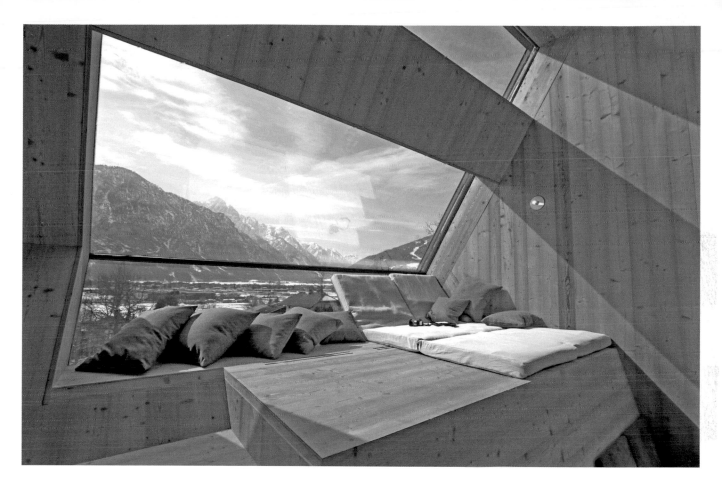

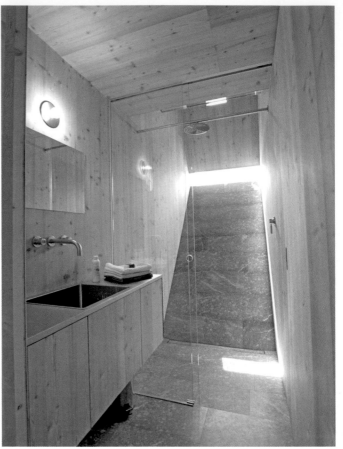

051

Light and brightly colored
surfaces are reflective,
making a space feel open
and airy. It is critical to find
the balance between color
and amount of light to avoid
uncomfortable glare.

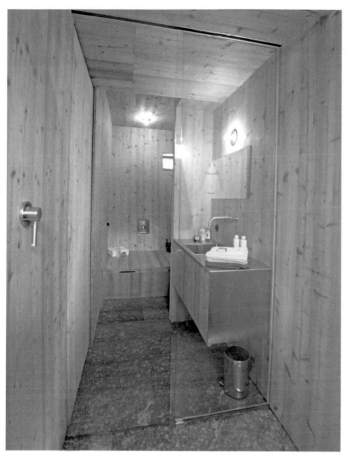
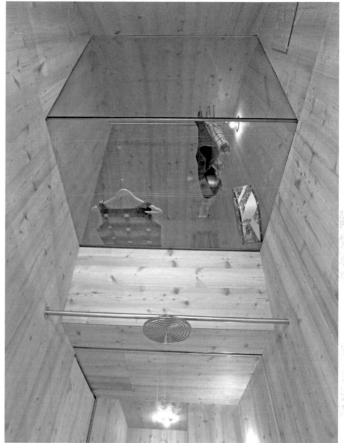

052

Where privacy isn't an issue, glass partitions are a wonderful idea to separate a bedroom from an en-suite bathroom. This allows decoration based on continuity, which makes the room look spacious.

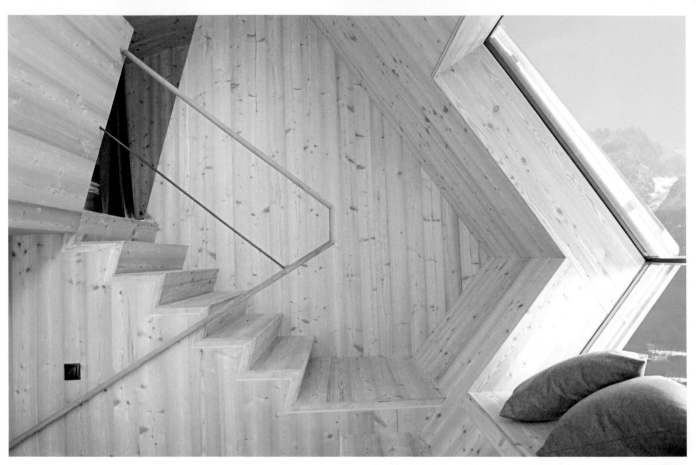

053

Go easy on the decoration
in a small space where finishes
are attractive and can shine
on their own.

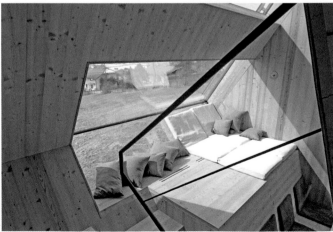

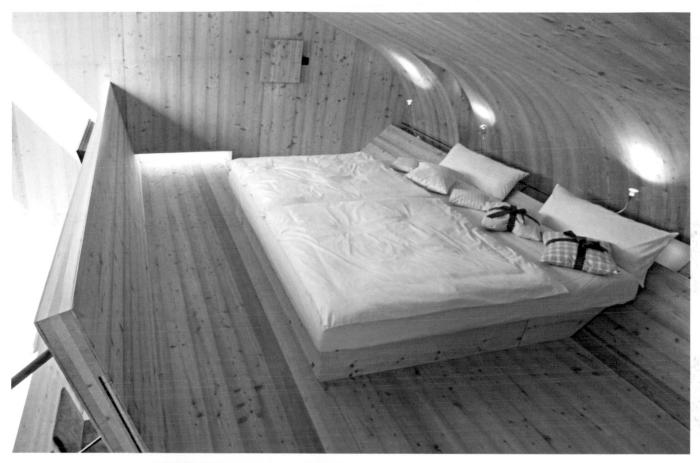

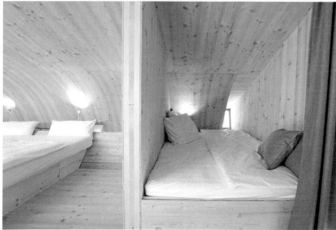

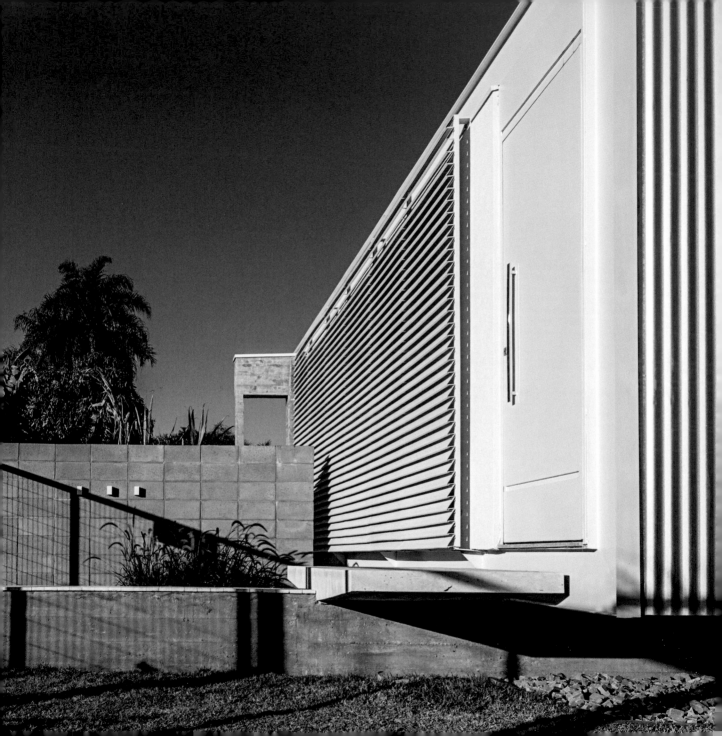

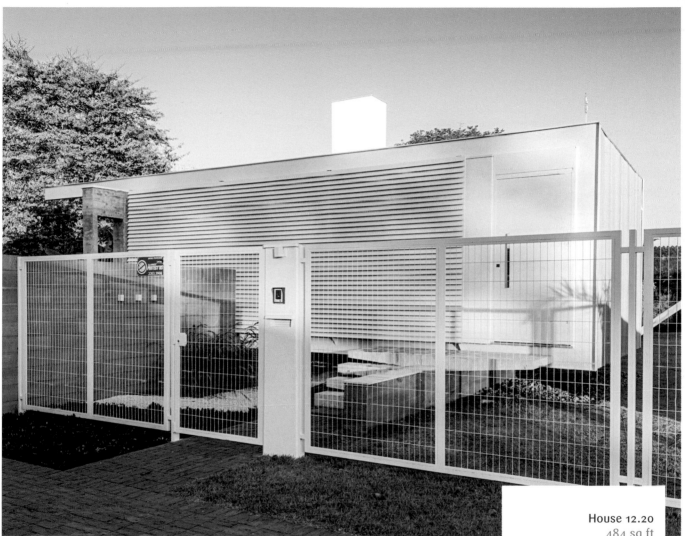

House 12.20
484 sq ft

Architect: Alex Nogueira
Arquiteto
Location: Campo Grande, Brazil
Photographer: © André Barbosa

In this 30-foot-long by 16-foot-wide space, the orthogonality and rigidity of the architectural environment contrast with the light and stripped atmosphere brought by the colors, the furniture, some of the finishes and the generous opening that faces the garden. The large sliding glass door and the deck draw the exterior into the interior, and vice versa.

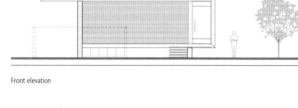

Front elevation

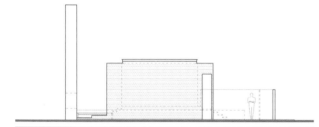

Side elevation

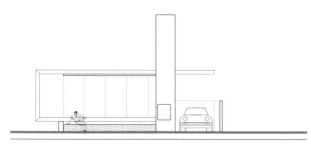

Back elevation

Section AB

Section CD

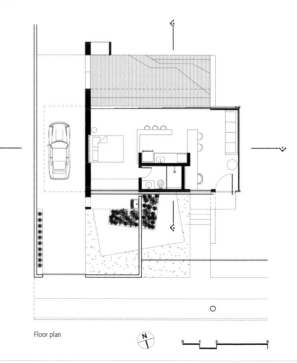

Floor plan

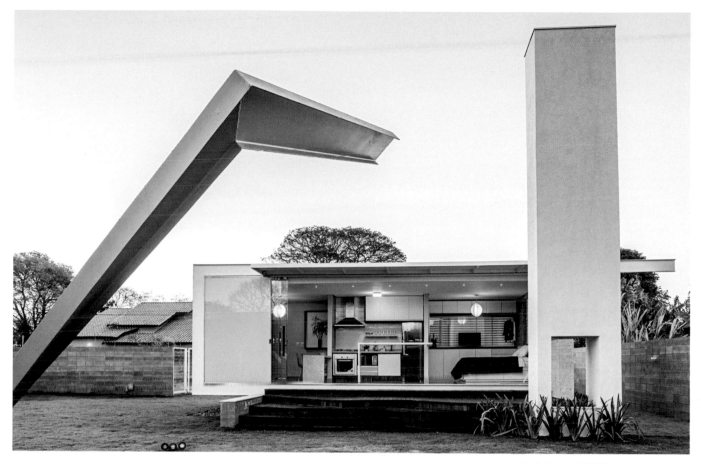

054

Sliding glass walls are the
epitome of indoor-outdoor
living. Make them all disappear
so that a small interior and
an outdoor space read as
one large area.

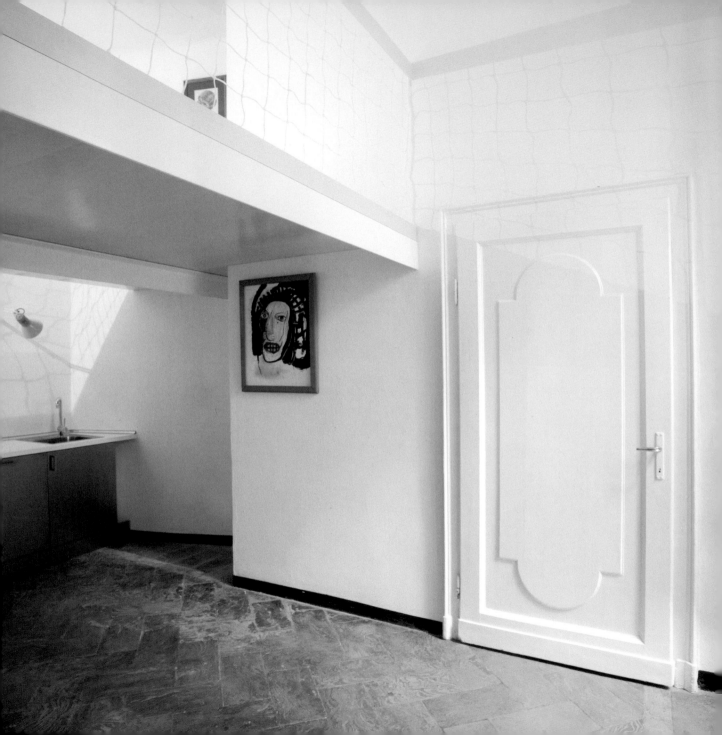

House C
484 sq ft

Architect: Francesco
Librizzi Studio
Location: Milano, Italy
Photographer: © Giovanna Silva

An existing apartment with two rooms and a bathroom is characterized by a small floor area in comparison to its high ceiling. This was the starting point of a powerful remodel. An added loft acts as a new layer in the almost untouched shell, reinforcing the original identity of the apartment.

Exploded axonometric view

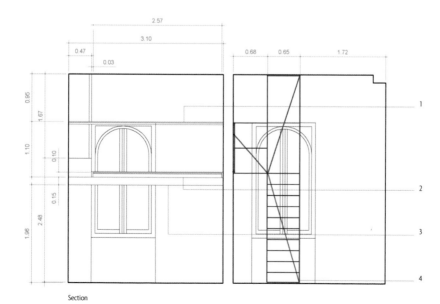

Section

1. Railing made of steel angle
 50 x 5 mm, powder coated,
 RAL 9016
2. Poplar wood flooring, clear-
 coat finish, bolted to steel
 beam
3. Steel beam 100 x 150 x 12 mm,
 powder coated, RAL 9016
4. Ladder made of steel angle
 14 x 14 mm, powder coated,
 RAL 9016

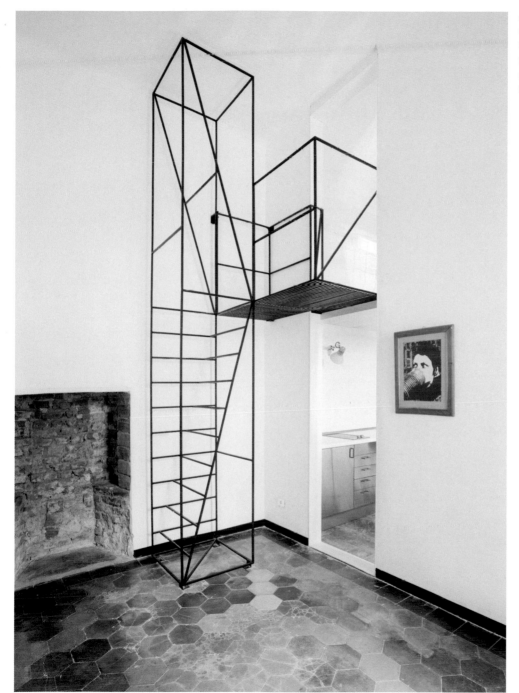

A ladder made of welded steel rods adds a minimalist touch to the apartment. The designers chose this simple, yet striking design to adapt this early 1900s apartment to a new use.

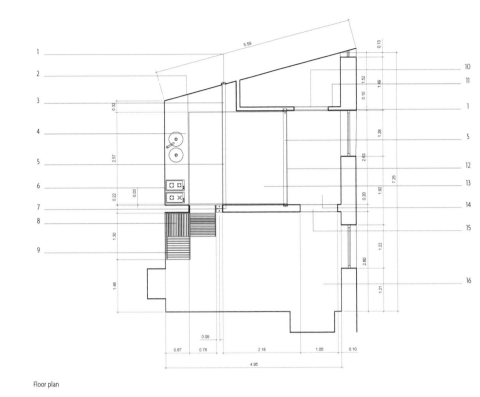

Floor plan

1. Steel column UPN 100, powder coated, white, RAL 9016
2. Steel angle 50 x 5 mm, powder coated, white, RAL 9016
3. Steel beam 100 x 150 x 12 mm, powder coated, white, RAL 9016
4. Steel railing 50 x 5 mm, powder coated, white, RAL 9016
5. Steel beam 100 x 150 x 12 mm bolted to wood floor, powder coated, white, RAL 9016
6. Steel beam 40 x 4 mm, powder coated, white, RAL 9016
7. Steel beam HEA 200, powder-coated finish, white, RAL 9016
8. Shelves in 25 mm thick plywood, laminated white, RAL 9016
9. Ladder in 14 x 14 mm steel angles, powder-coated finish, white, RAL 9016
10. Existing bathroom door, refinished with enamel paint
11. Bathroom wall finish
12. Steel railing 50 x 100 x 8 mm, powder-coated finish, white, RAL 9016
13. Poplar wood flooring, painted
14. Existing terra-cotta flooring, polished
15. Existing bathroom door, refinished with enamel paint
16. Existing flooring of hexagonal colored concrete tiles, cleaned and polished

055

Simple solutions are sometimes all you need for a powerful and effective design, especially when space restrictions are a limiting factor.

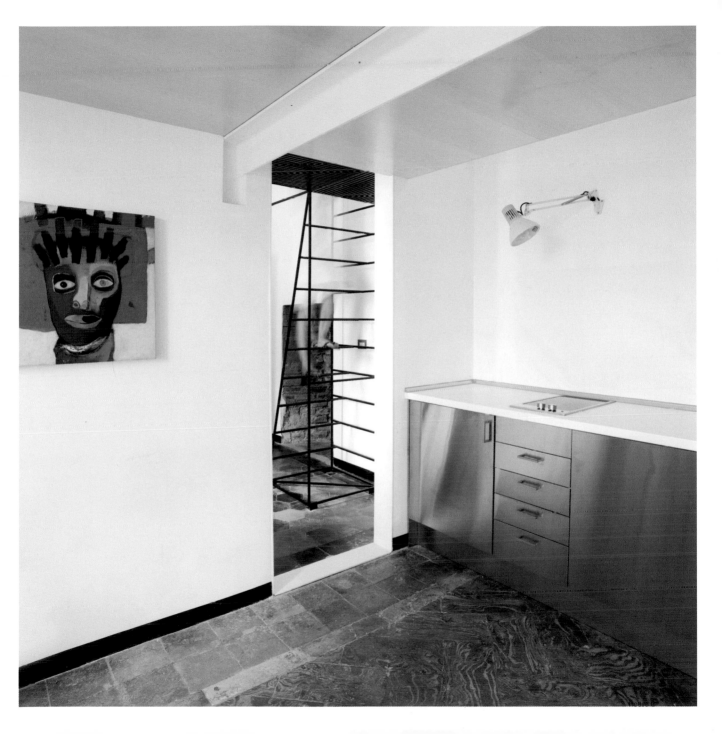

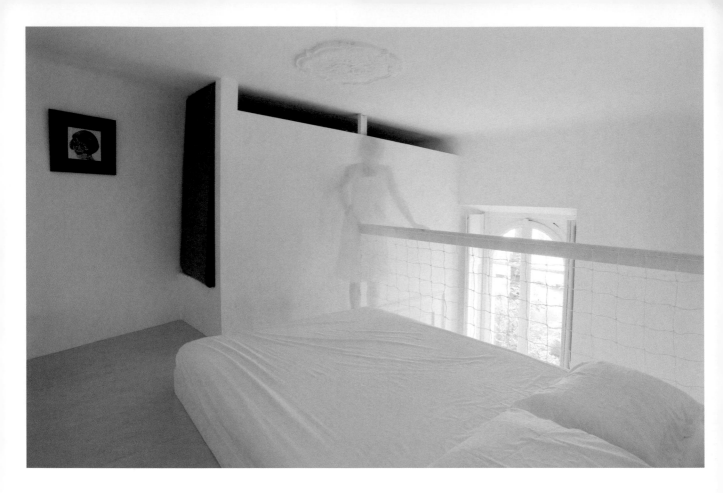

The remodel included the upgrade of the kitchen and bathroom. A minimalist design approach was chosen so as not to obscure the original identity of the apartment.

The White Retreat
484 sq ft

Architect: Colombo and Serboli
Architecture
Location: Sitges, Spain
Photographer: © Roberto Ruiz

When the owner of this apartment in a small coastal village of Spain hired architects to remodel it, he envisioned a peaceful place for introspection, flooded with light. An extremely reduced budget asked for simple, inexpensive solutions. The result is a completely secluded place, facing only an interior courtyard. The lack of views is compensated for by silence and light.

The space is composed of three blocks: the bathroom/kitchen, the living room/bedroom and the terrace. The last two are very permeable, only divided by a large window in the living area.

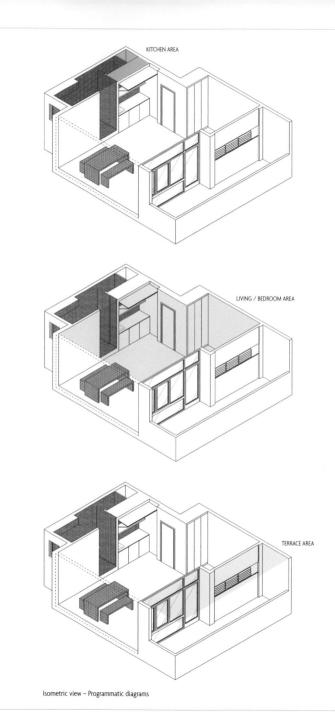

KITCHEN AREA

LIVING / BEDROOM AREA

TERRACE AREA

Isometric view – Programmatic diagrams

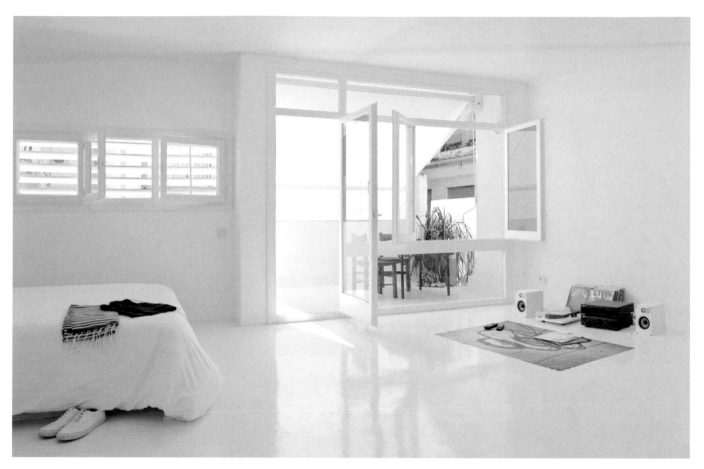

056

Continuous flooring
softens the transition between
interior and exterior spaces.
A roof can be extended out
with a canopy to create
a protected outdoor space.

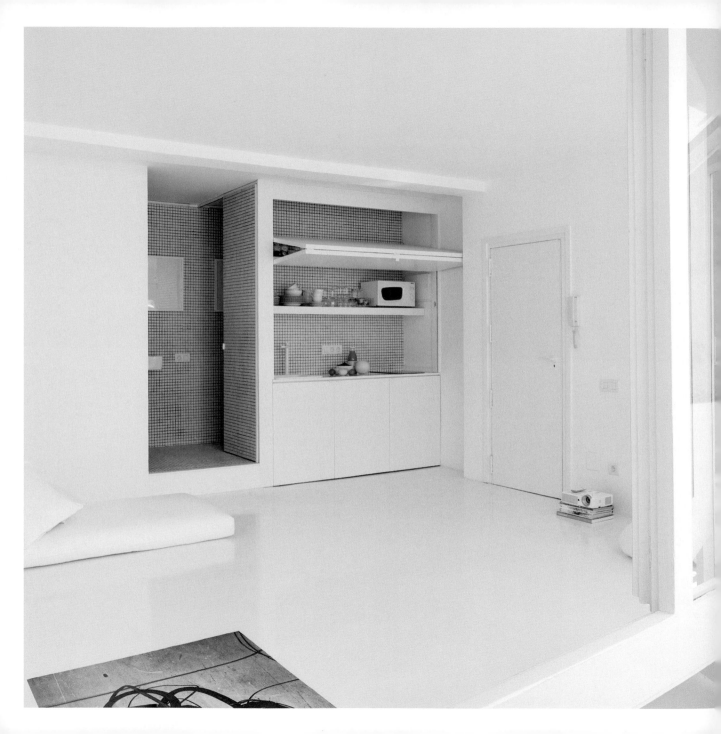

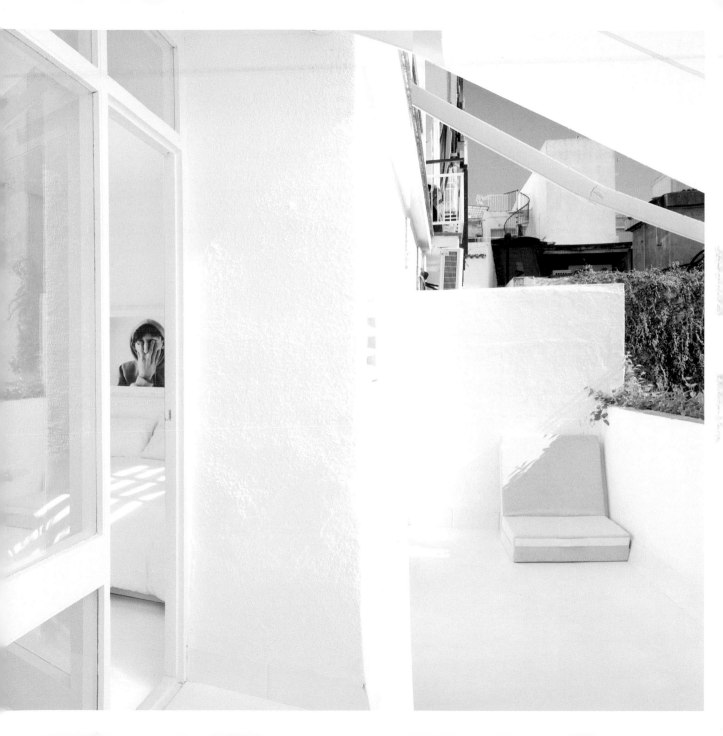

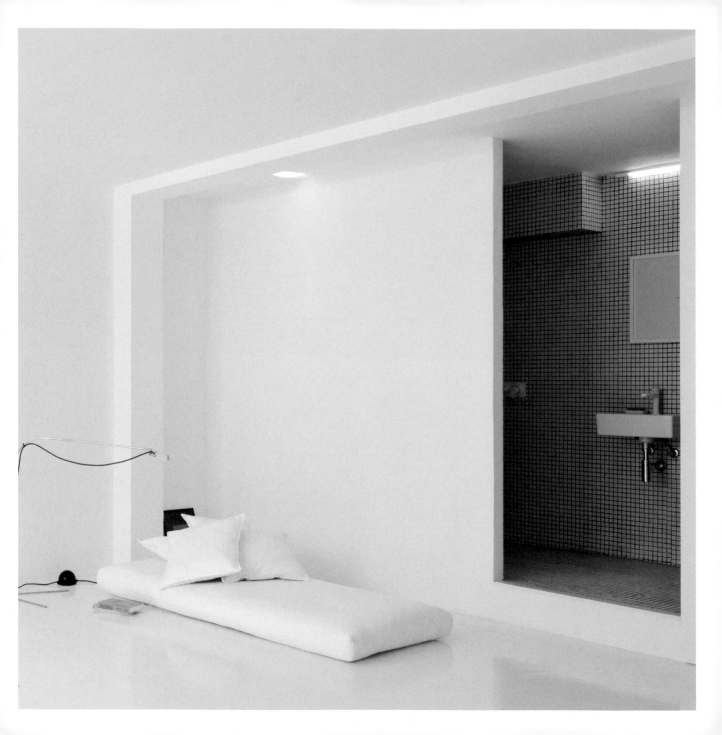

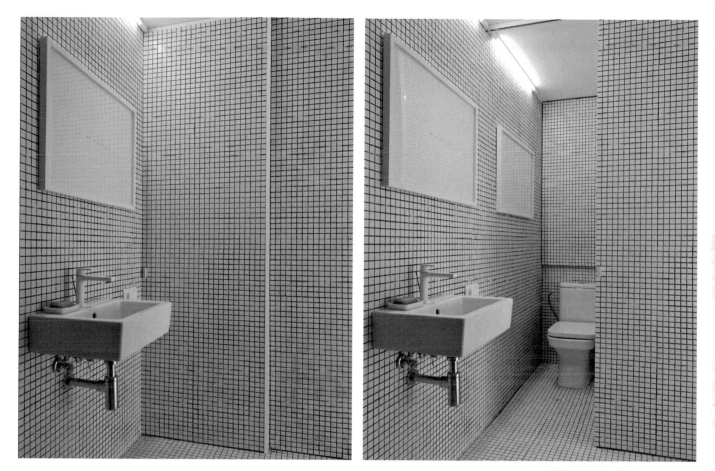

It is the color rather than
the size of the tile you use
in your bathroom that makes
it look larger or smaller.
However, floor-to-ceiling
tiling can visually expand
a small bathroom.

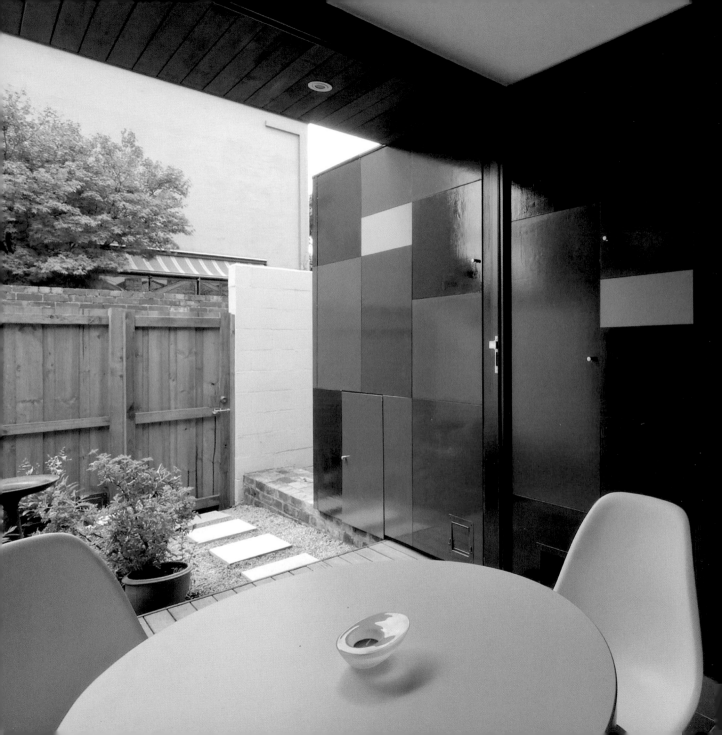

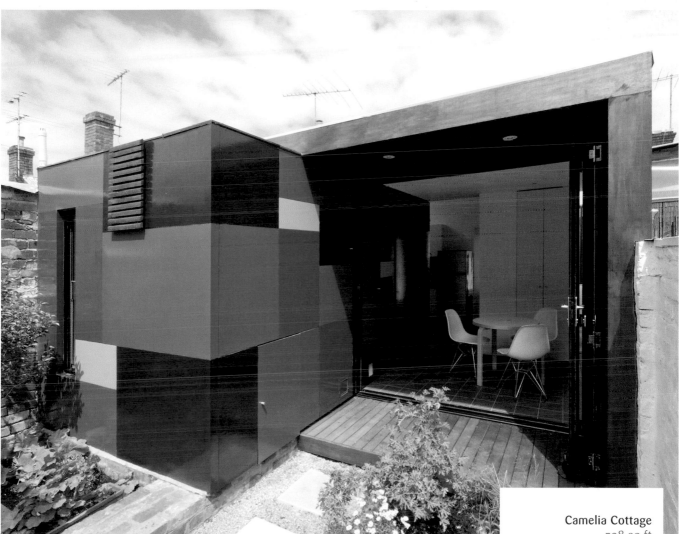

Camelia Cottage
538 sq ft

Architect: 4site Architecture

Location: Carlton North, Melbourne, Australia

Photographer: © Kevin Hui

Suburban terrace houses usually consist of a layering of various add-ons from various points in time. This very low-budget project minimized the work that needed to be done by keeping the existing bathroom addition. The design consists of the reorganization of the space to create a more usable and comfortable environment, while producing a visually striking effect.

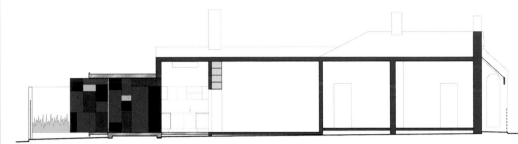

Elevation

Section

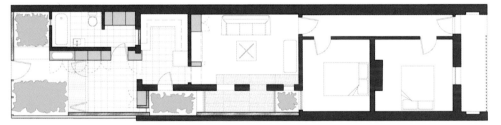

Floor plan

The colorful joinery wall is the key element that visually connects the interior with the exterior, which are only separated by bifold glass doors.

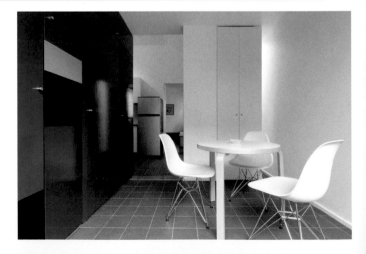

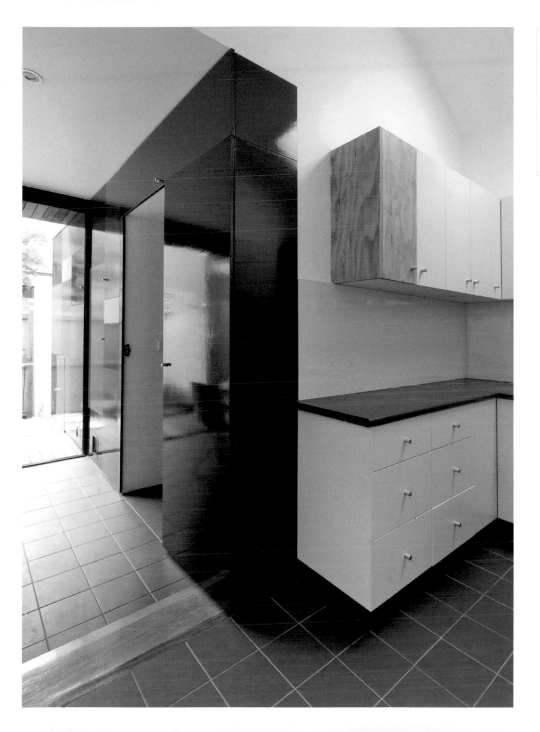

Wall-hung, under-counter cabinets are ideal for small kitchens. Lifted off the floor, they have a less bulky appearance than floor-standing cabinets.

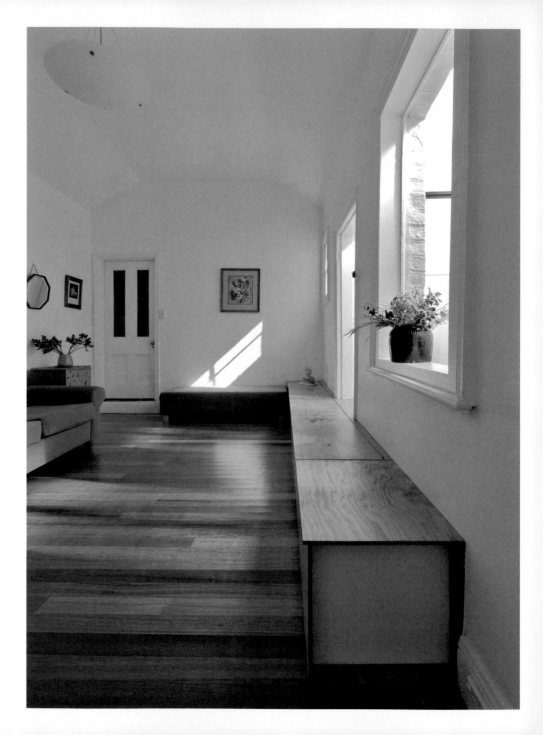

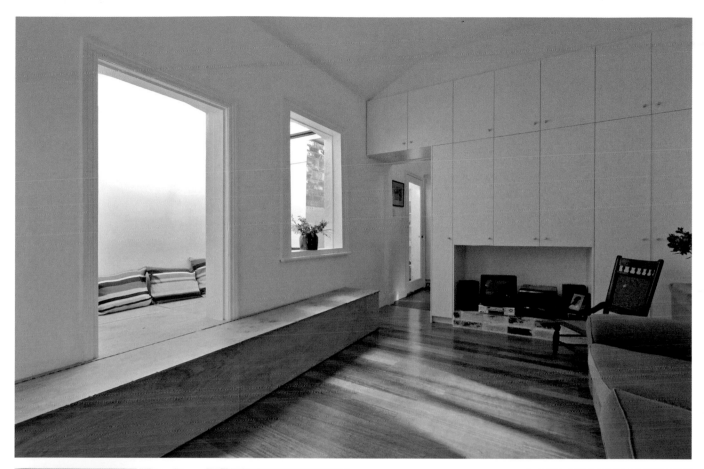

Not only do raised floors
separate different functions,
but they can also conceal
ingenious storage systems.

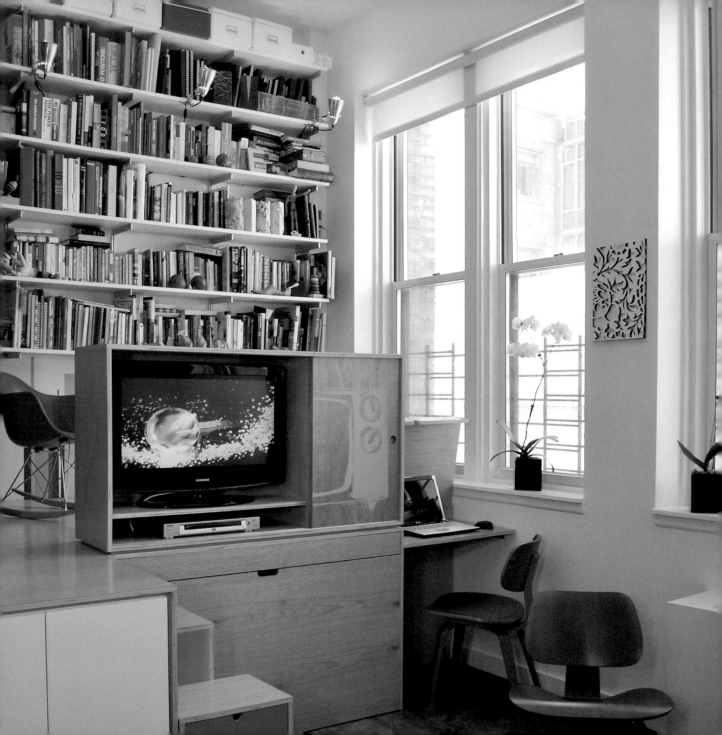

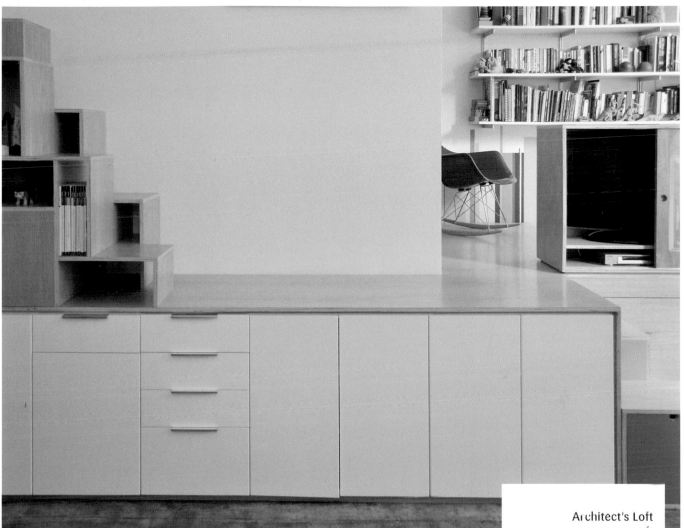

Architect's Loft
550 sq ft

Architect: PorterFanna
Architecture
Location: Brooklyn, NY, USA
Photographer: © L. J. Porter

This 550-square-foot loft is located on an upper floor of the former St. John's University Law School in downtown Brooklyn, which was converted into apartments in the 1980s. It has a full wall of windows and 12-foot-high ceilings, which flood the space with sunlight. Creative use of lighting and custom-designed cabinetry create a space that feels larger than it is.

The loftiness of the space is used to its fullest. This allowed for the creation of separate living, dining, working and sleeping areas that are nonetheless visually connected to one another.

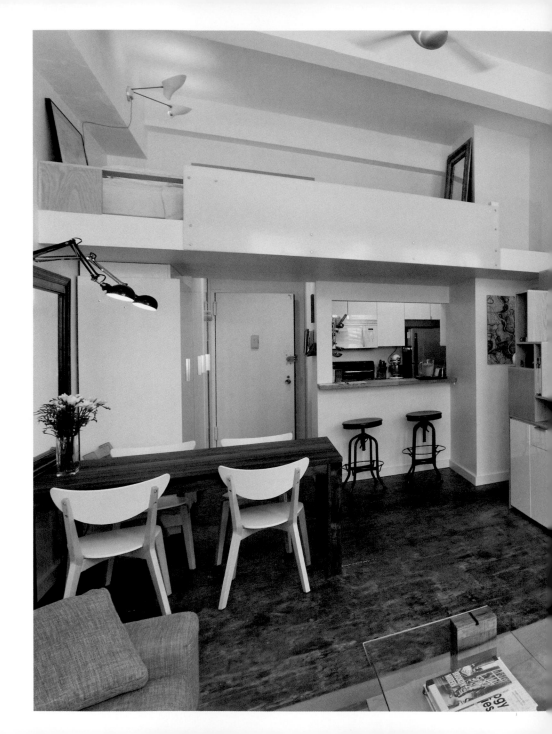

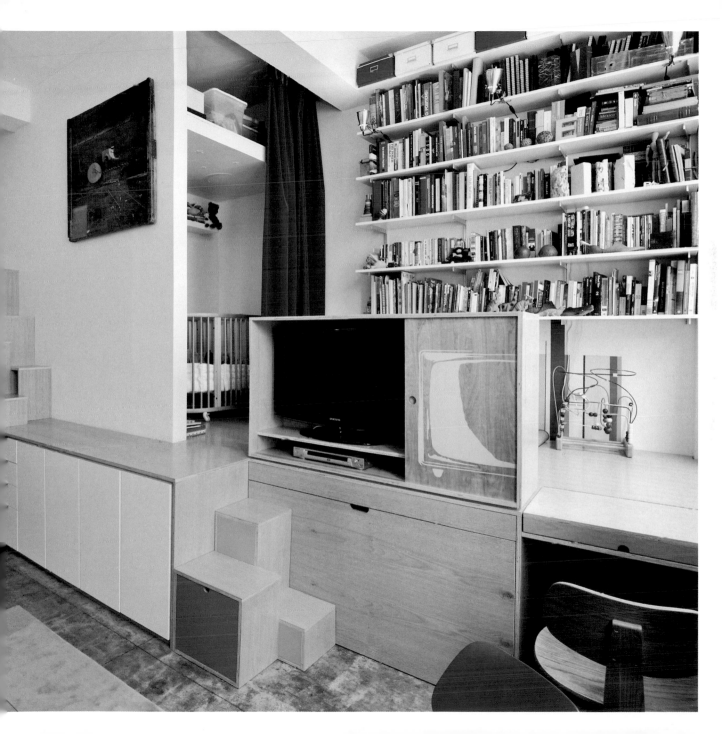

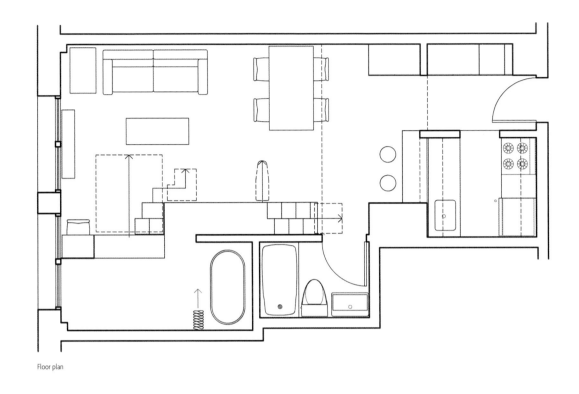

Floor plan

A storage area above the kitchen was converted to a sleeping area. An alternating-tread staircase that doubles as a bookcase provides access to this area.

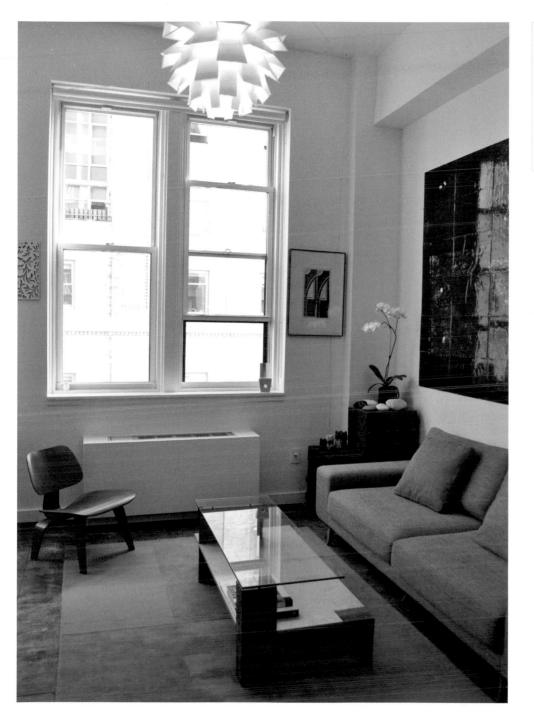

A corner with a few
simple pieces of furniture
feels spacious and airy.
It compensates for another
part of the space where
multifunctional customized
furniture is concentrated.

Toy box sketch

Staircase cabinet sketch

061

Creative design solutions can be integrated into the plans to maximize living space and reduce clutter. Everything has its place, even in a small home!

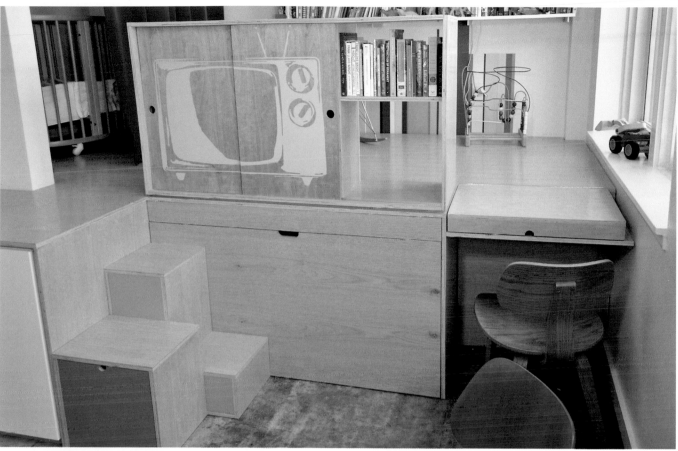

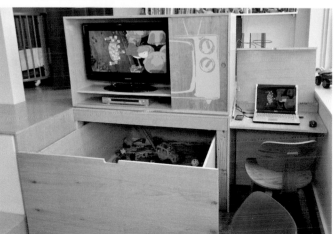

A colorful box of movable steps and drawers doubles as a toy box. When pulled out completely, it reveals a large, long-term storage area under the deck.

Architect: **Sandra Meštrović**
Location: **Mallinova Ulica,**
Zagreb, Croatia
Photographer: © Tomislav Marić

The living and working space of architect Sandra Meštrović is a completely refurbished apartment located in a 1930s building. The living area satisfies the practical needs of domestic and working life. The plan of the apartment is long and narrow, with a bay that is large enough for a bedroom and a bathroom.

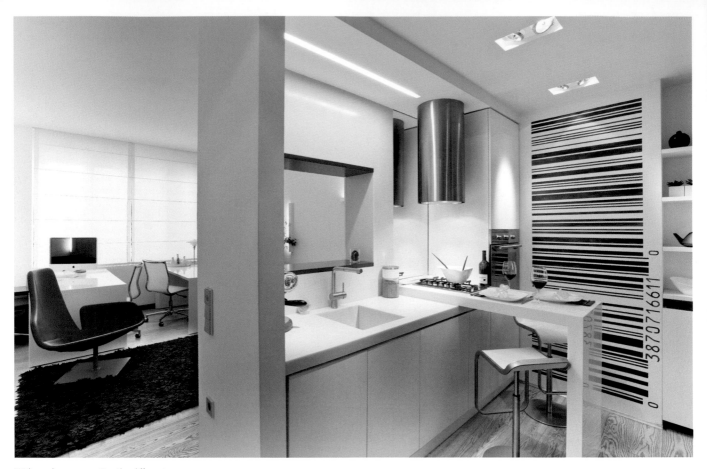

With no doors separating the different spaces and with an opening between the living area and the kitchen, a visual connection is established between the two ends of the apartment.

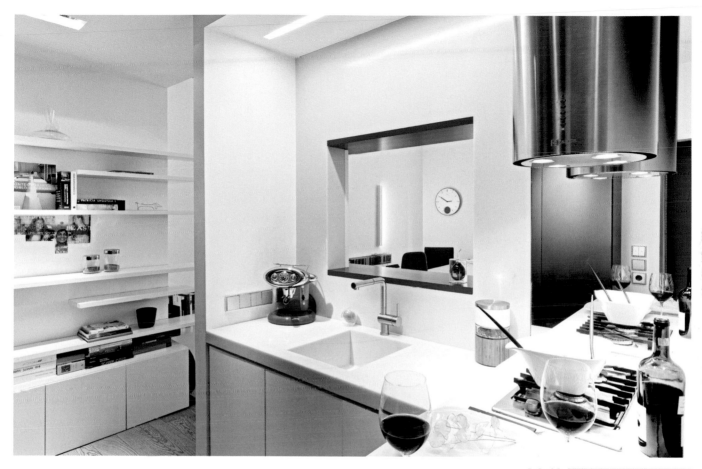

Light paint colors and good illumination are key to making a kitchen a comfortable and functional room. Don't let too many utensils and appliances take over the work surfaces.

Floor plan

063

Put a corridor to good use with open shelves along one wall. In this case, the shelves are opposite a graphite volume containing the bathroom, following the concept of "a box within a box."

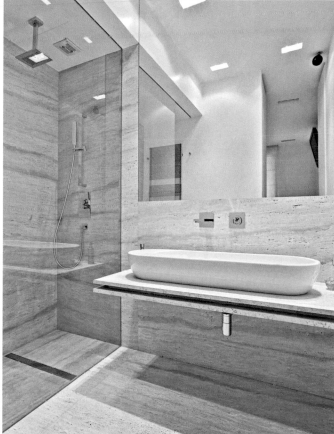

064

Consider using a palette of the same color range throughout, preferably light, to create a bright and airy feel. Keep in mind that using different floor, walls and ceiling colors can be overwhelming.

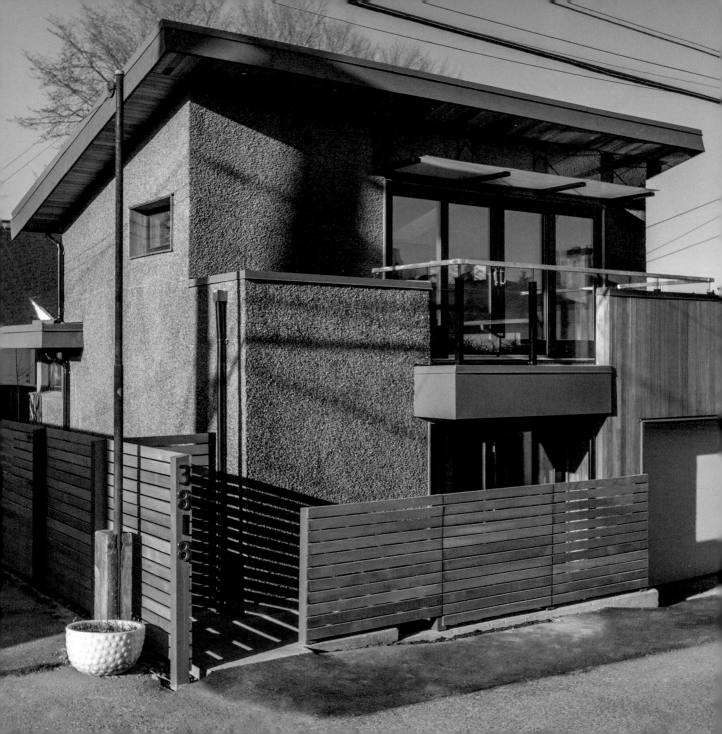

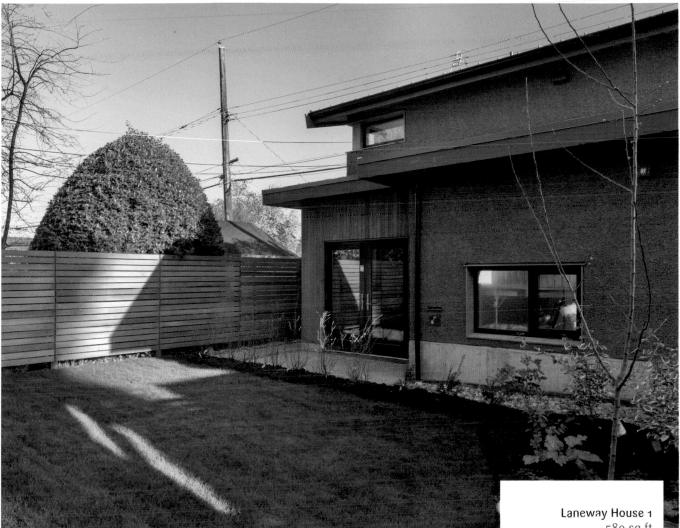

Laneway House 1
580 sq ft

Architect: Lanefab
Design/Build
Location: Vancouver,
BC, Canada
Photographer: © Colin Perry

Laneway housing is an increasingly popular type of residential construction on the west coast of Canada, especially in the Vancouver metropolitan area. It originated as part of a program aimed to increase urban density while keeping the small-neighborhood feel. Averaging 550 square feet, laneway houses are required to be built in the back of a traditional lot, where garages are usually built. This 580-square-foot house also incorporates several green features, such as a rainwater collection system, highly insulated walls and triple-glazed windows.

The main living area, located on the
upper floor, is brightened by large
sliding doors that open onto a terrace.
Two skylights above the kitchen area
balance out the light, thus avoiding
a harsh lighting contrast.

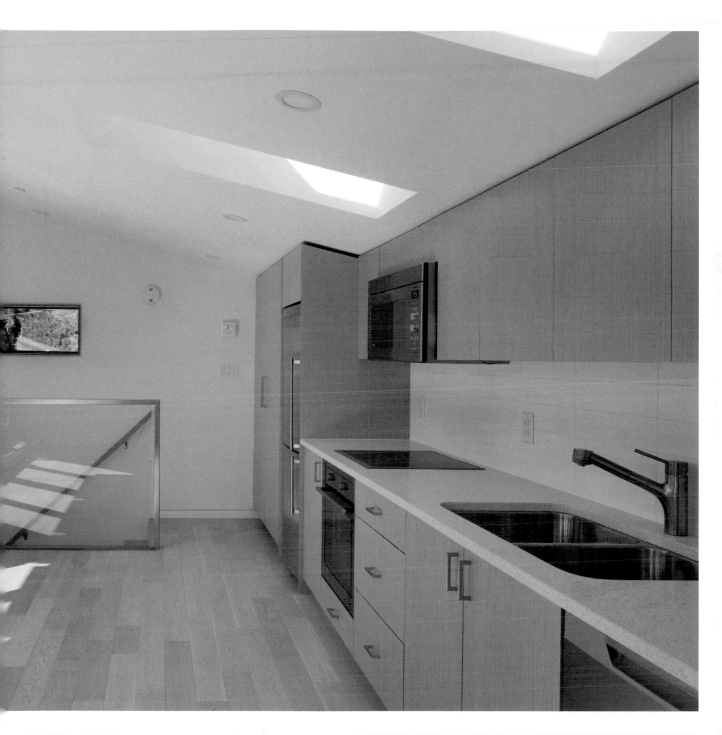

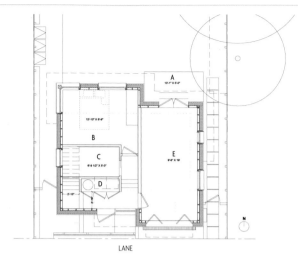

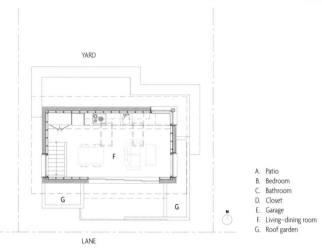

A. Patio
B. Bedroom
C. Bathroom
D. Closet
E. Garage
F. Living–dining room
G. Roof garden

Lower-floor plan

Upper-floor plan

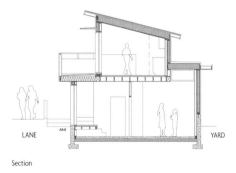

Section

065

Scale and proportion are important aspects to take into consideration when furnishing a space. Choose your furniture and accessories according to the size of the room where you want to put them.

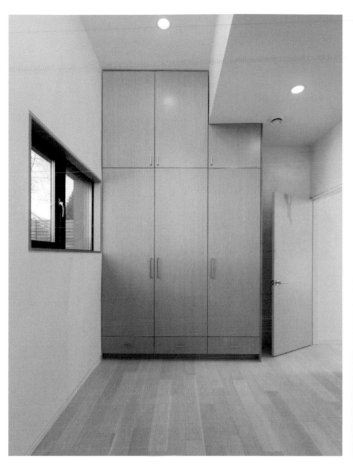
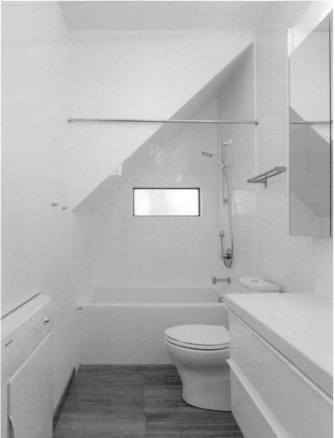

White walls, clean lines and a well-thought-out placement of openings and lighting work together to create rooms.

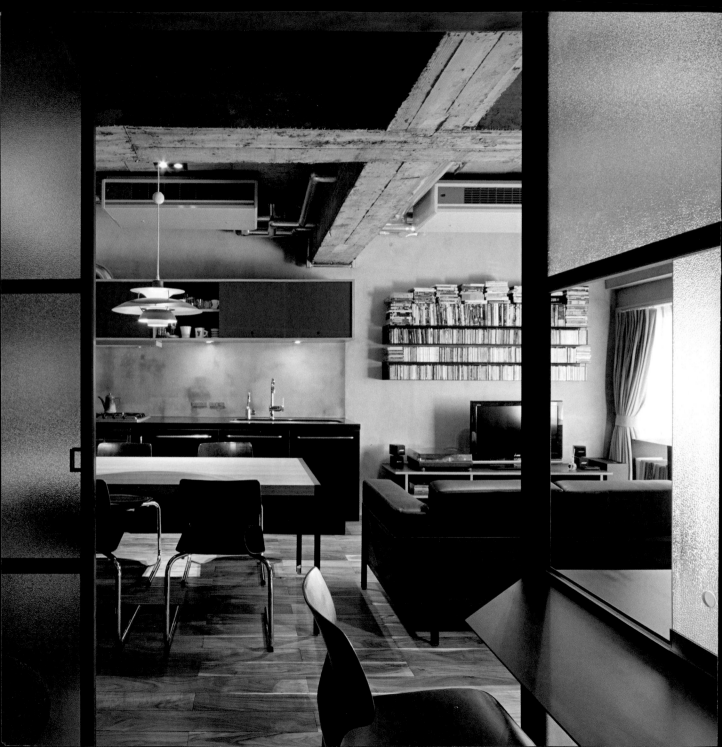

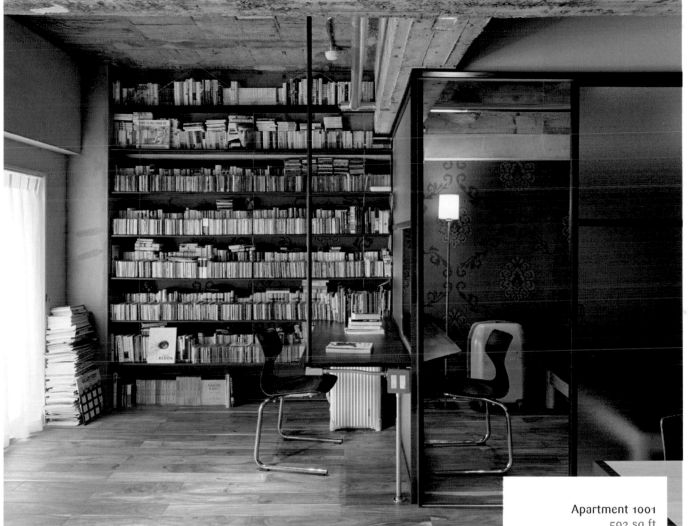

Designed for two music and wine lovers, 1001 is a newly renovated 592-square-foot apartment in Tokyo. The plan for the apartment called for a cozy "hotel room." It had to have lots of storage space for large collections of comics, CDs and books. The project also involved the design of furniture, screens, doors and kitchen cabinetry. Consistent color, material and form create a unified interior.

Apartment 1001
592 sq ft

Architect: **Keiji Ashizawa Design**
Location: **Tokyo, Japan**
Photographer: © **Takumi Ota**

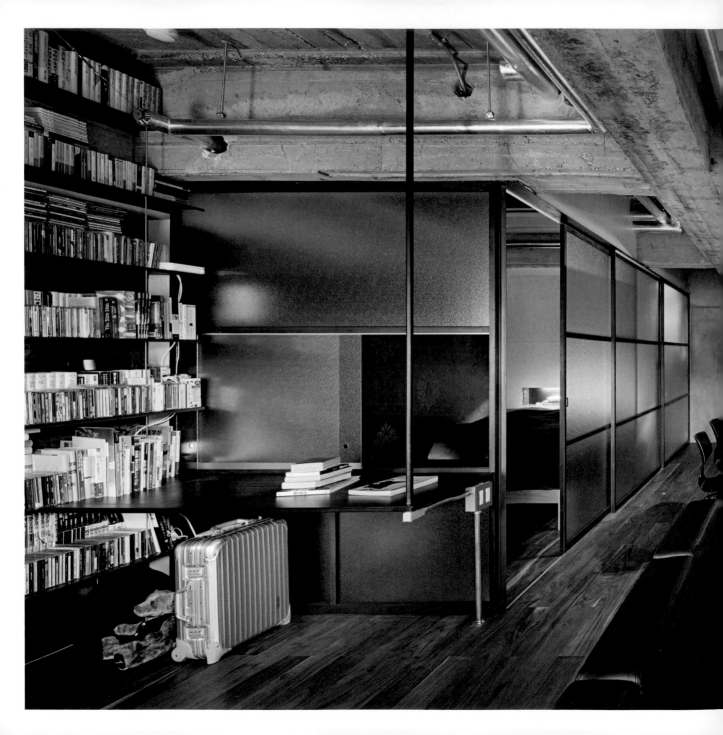

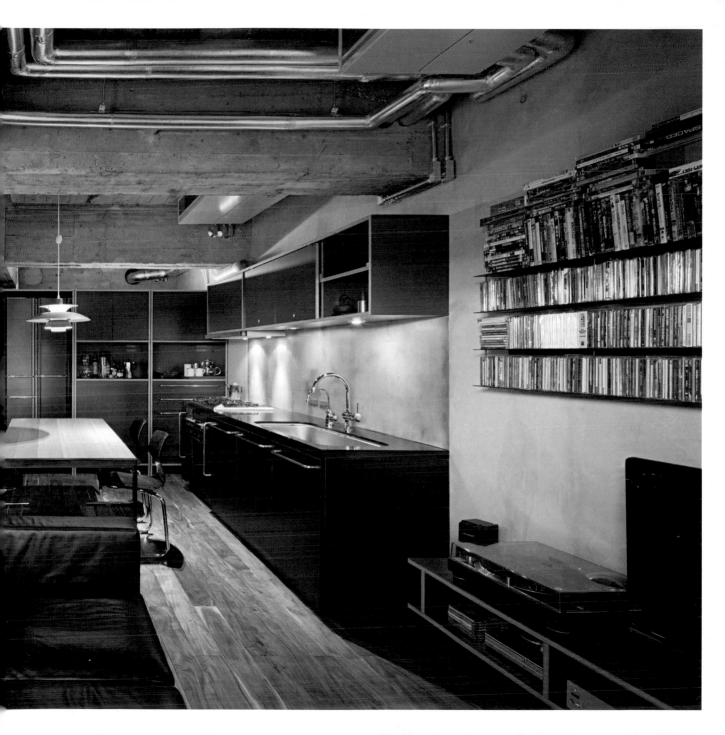

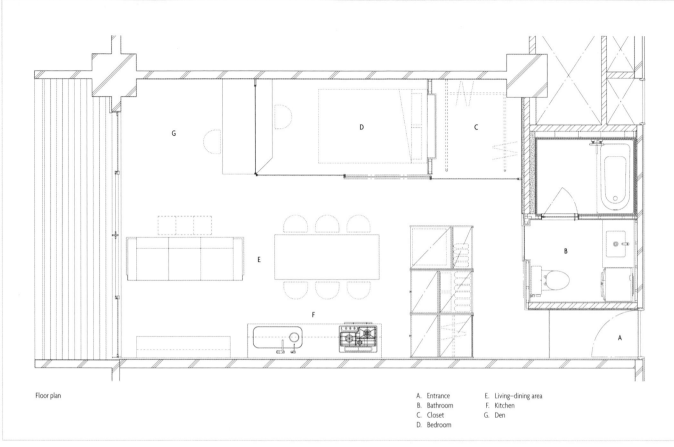

Floor plan

A. Entrance E. Living–dining area
B. Bathroom F. Kitchen
C. Closet G. Den
D. Bedroom

067

A clear distribution of space combined with a good design concept is key for the creation of a comfortable and efficient small place. Unnecessary decoration should be avoided.

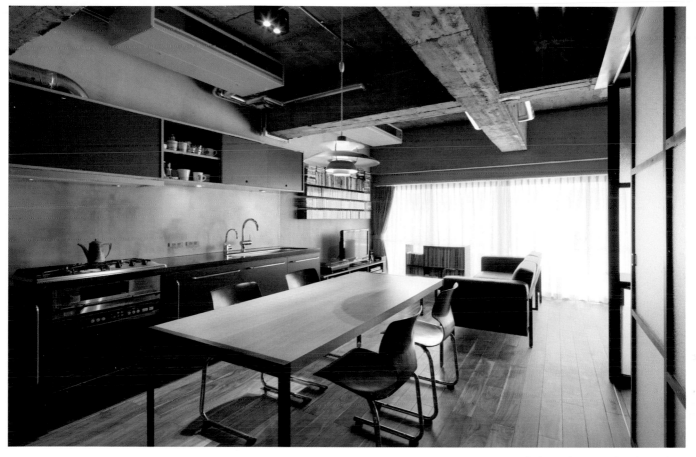

Sleek new elements such as the steel-and-glass partitions, the dark-blue satin finish of the cabinetry and the wood flooring stand out against the rough concrete finish and exposed ducts.

Translucent partitions accompanied by strategically placed lighting add depth to a small room, creating the illusion of a larger place.

069

Transforming your bathroom into a wellness sanctuary can be as easy as using calming colors and dim light. If space allows, keep appliances separate.

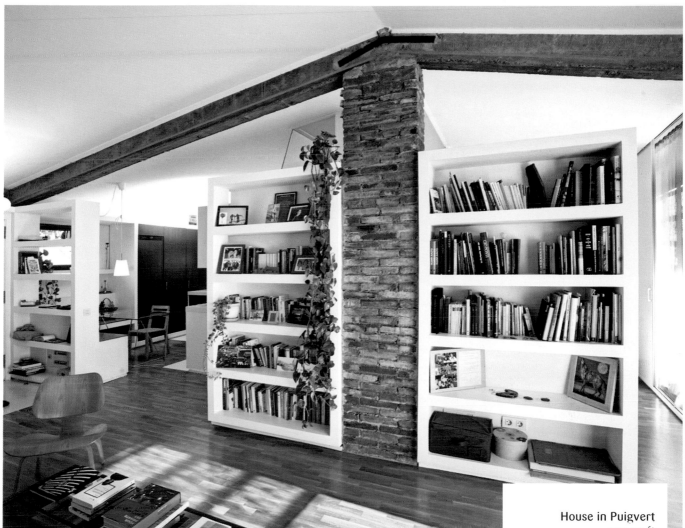

An old stable with a single central pillar was transformed into a habitable space. After a thorough restoration of the shell, the interior was subdivided to fit the spatial needs. The design uses dividing walls that end short of the ceiling, making a clear distinction between existing and new construction.

House in Puigvert
592 sq ft

Architect: Sauquet
Arquitectes i Associats

Location: Castellar del Vallès,
Catalonia, Spain

Photographer: © STARP estudi

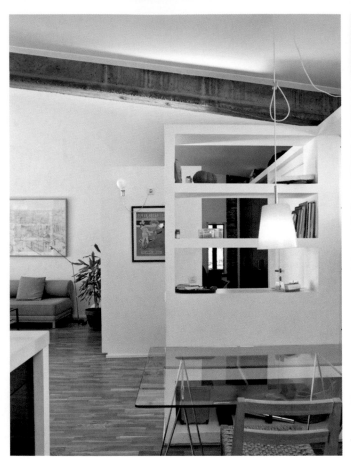

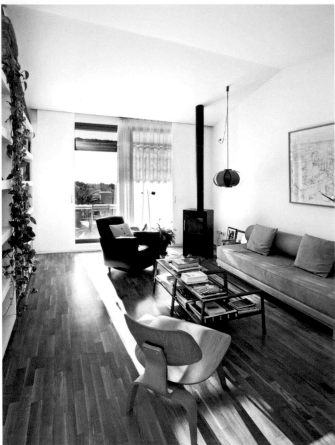

With the interior space having been completely gutted, the central pillar of the former stable is used as an articulation point for the organization of the different areas.

Hand drawn, colored interior perspective

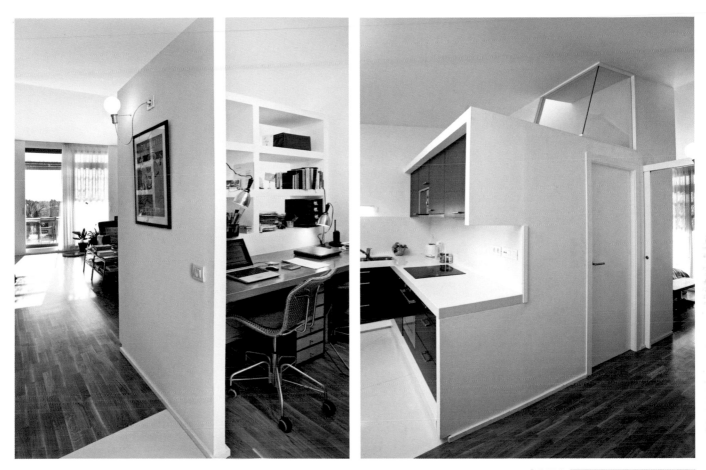

070

Open-plan homes come with
obvious benefits, such as good
natural lighting and ventilation.
Open shelves and low walls
satisfy separation needs
but don't block the flow
of light or air.

One common way to organize
an existing open–plan home
is by using furniture as room
dividers. Privacy issues can
be overcome with clever
solutions, such as sliding
panels.

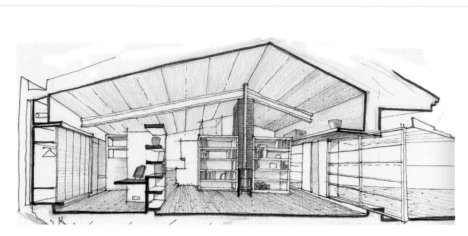

Perspective section

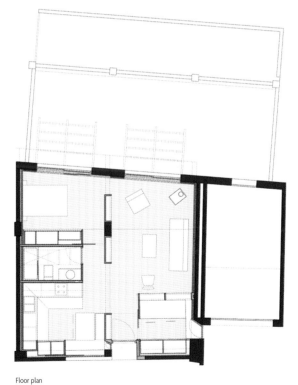

Floor plan

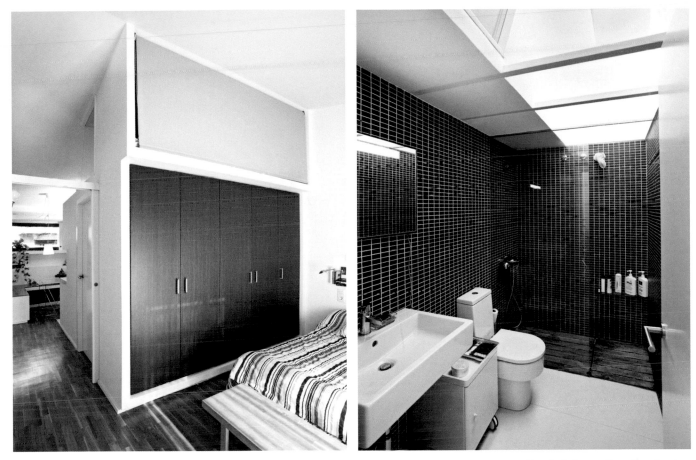

Even the bathroom, the only enclosed
room in the house, enjoys abundant
light by means of a skylight.

Hand-drawn, colored elevation and interior perspectives

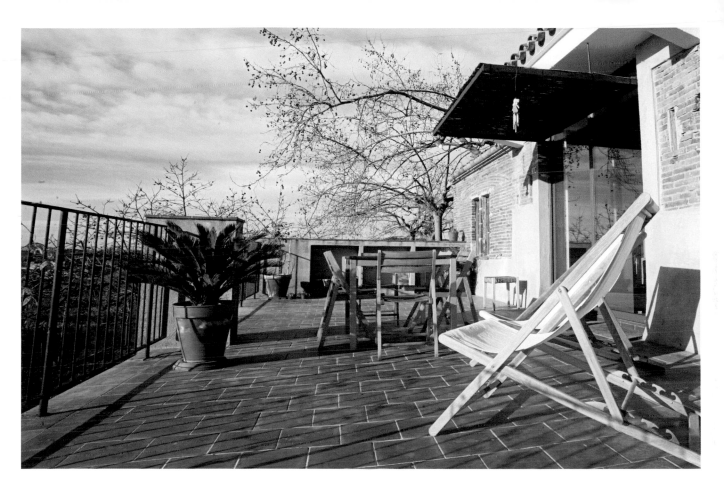

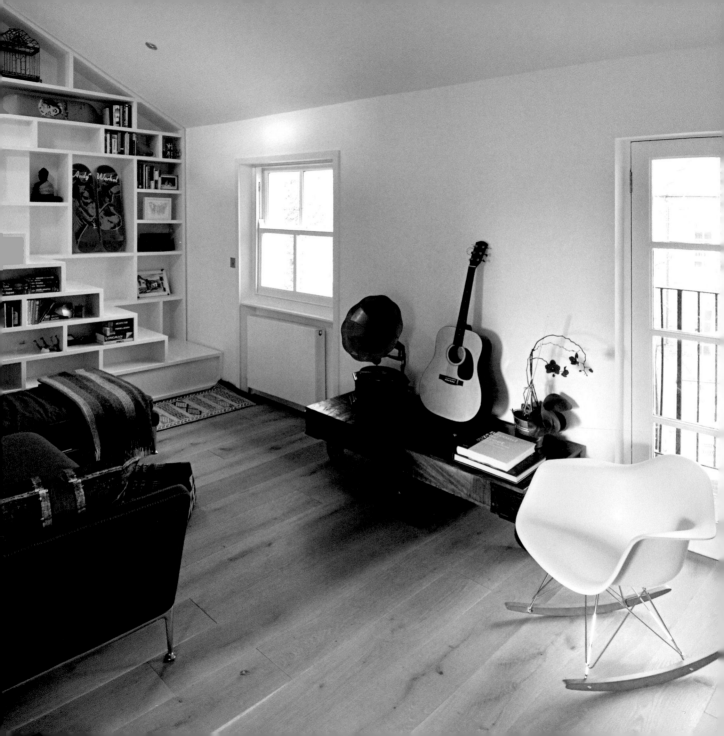

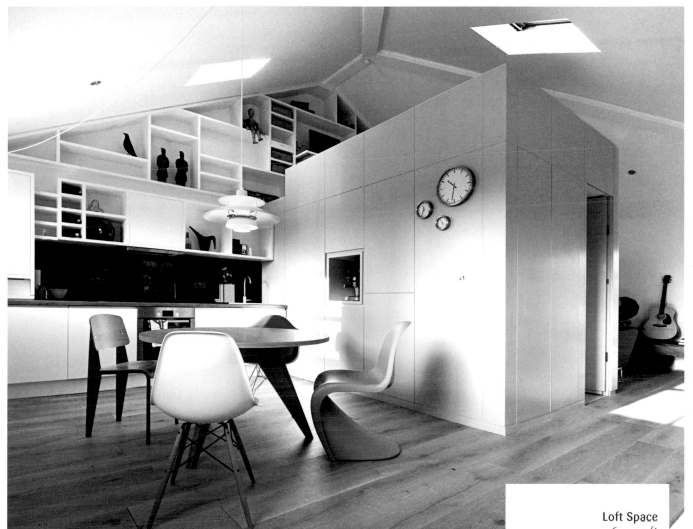

Loft Space
603 sq ft

Architect: Craft Design
Location: Camden, London, UK
Photographer: © Armando Elias

This small attic space, which used to be an open-plan office, was converted into a bespoke and innovative environment that efficiently responds to the demands of the occupant's lifestyle. This was achieved by inserting a volume that divides the space into various areas of different uses and contains the bathroom and storage space.

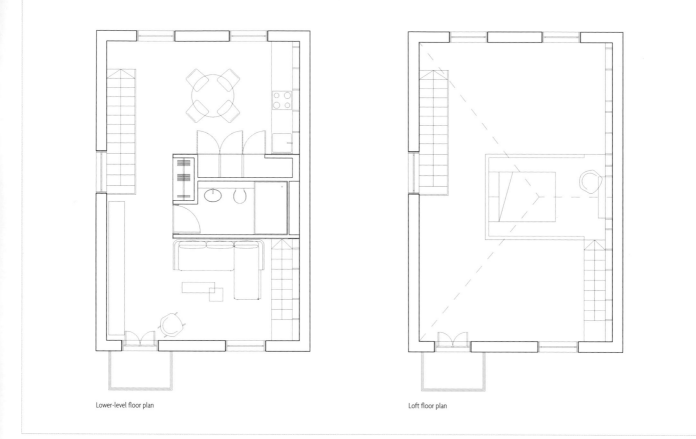

Lower-level floor plan

Loft floor plan

The plan called for the optimal use
of the space, while keeping a simple
and efficient layout.

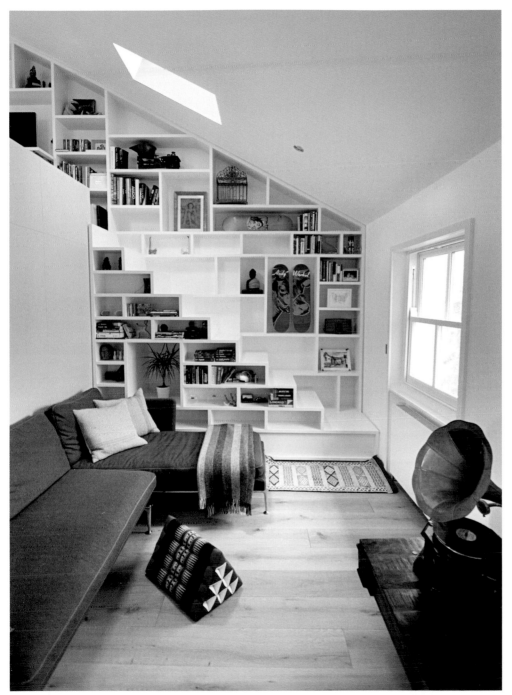

The staircaise leading to the loft is cleverly integrated into the box. Its simple design doesn't upstage the occupant's collection of objects and books.

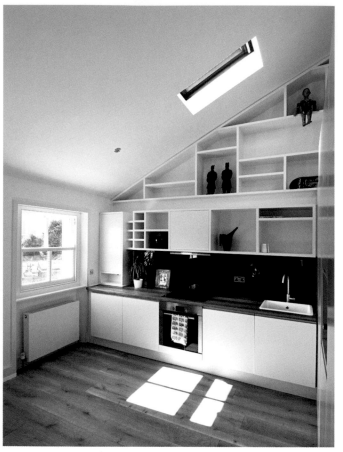

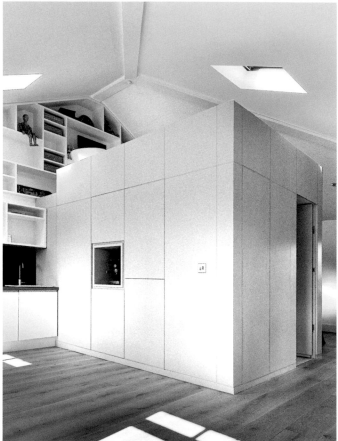

072

A kitchen along just
one wall is an excellent,
budget-friendly solution for
homes where space is at an
absolute premium.

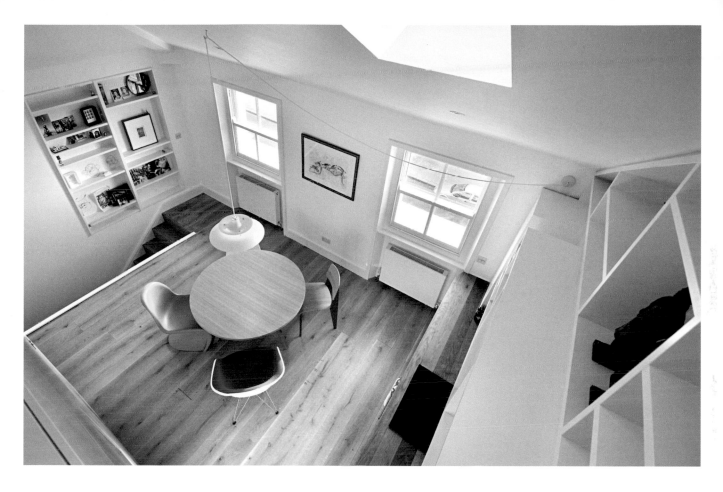

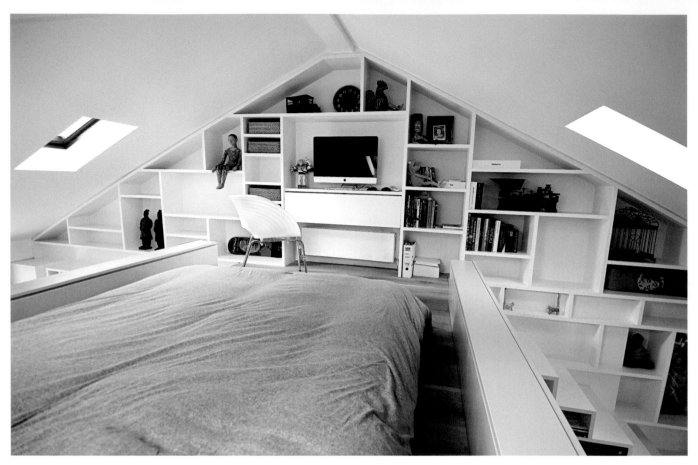

073

In spaces with high ceilings, lofts can solve space issues, but to comply with building regulations, they need to offer adequate headroom and load-bearing capacity.

Axonometric view

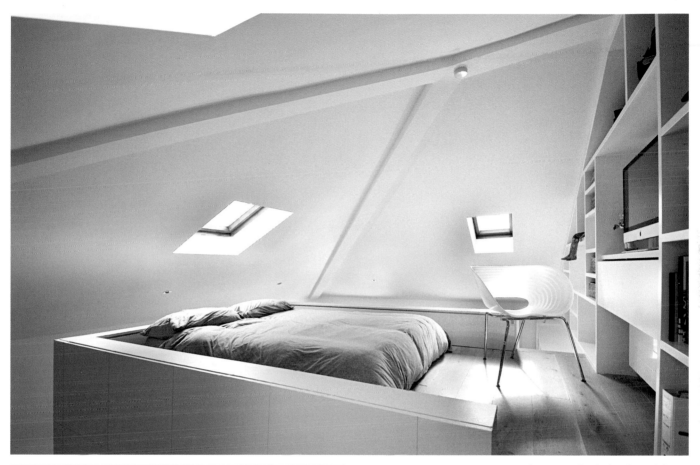

The attic's 15-foot-high walls are fully lined with shelves. The height allows for a loft accommodating a sleeping area and a home office.

Axonometric view

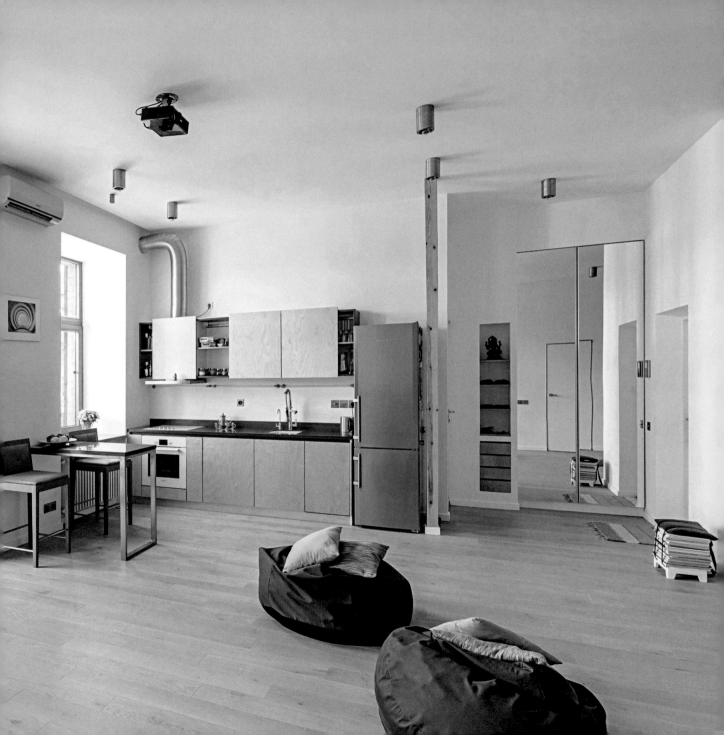

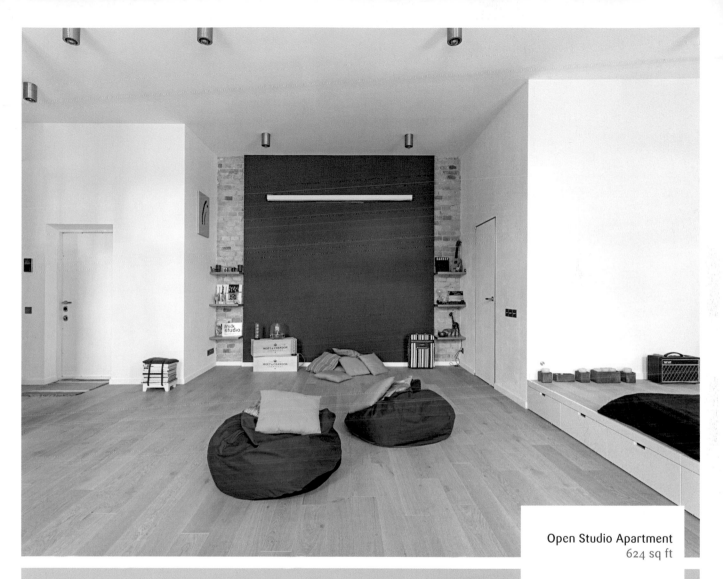

Open Studio Apartment
624 sq ft

Designer: FILD
Location: Kiev, Ukraine
Photographer: © FILD

This open-plan studio was initially a two-room apartment. The new layout includes an open kitchen and a separate dressing room and bathroom. The design integrates the simplicity of the plan with clever lighting, storage and decorating ideas to turn this studio into a comfortable, inviting home.

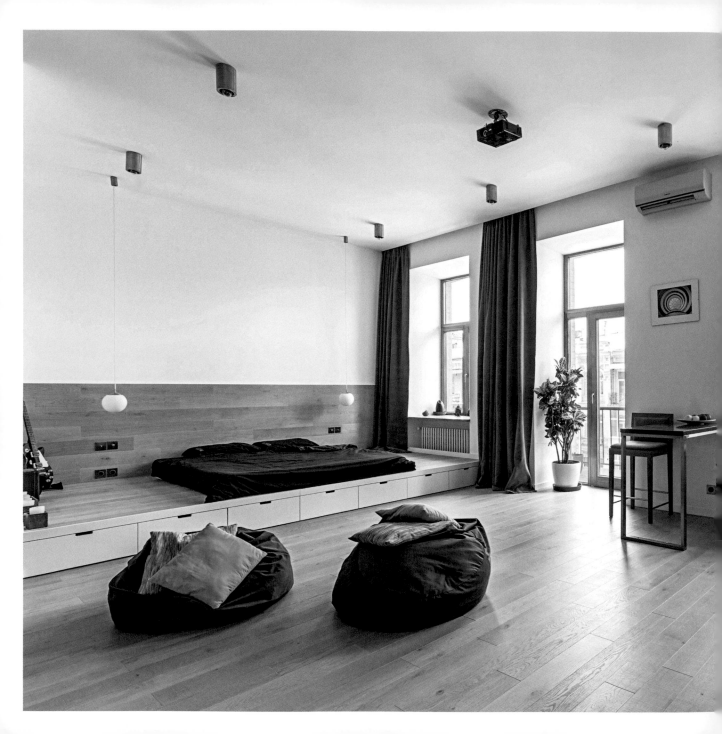

A small space challenges you to provide utility with every square foot. Raise the floor to separate different areas, and use the underside of the raised floor for additional storage.

Floor plan

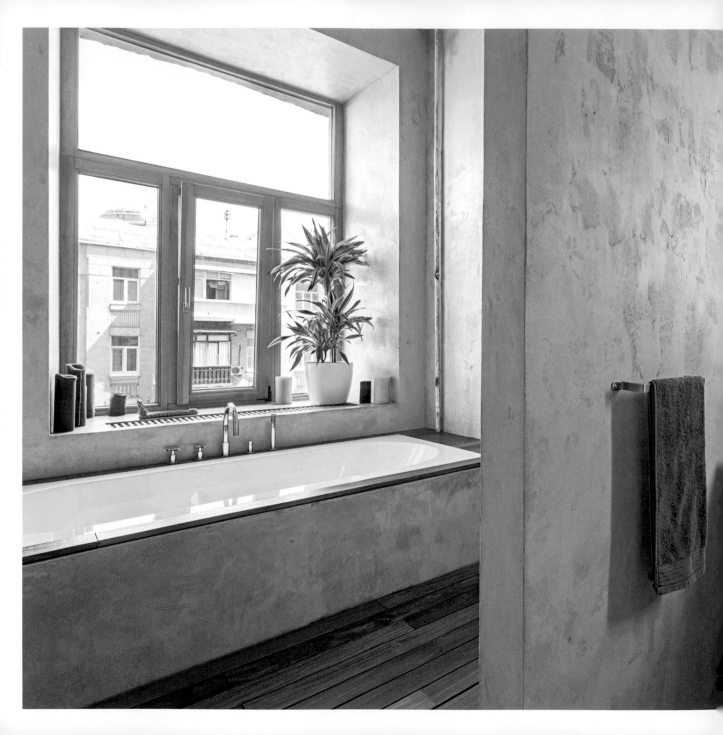

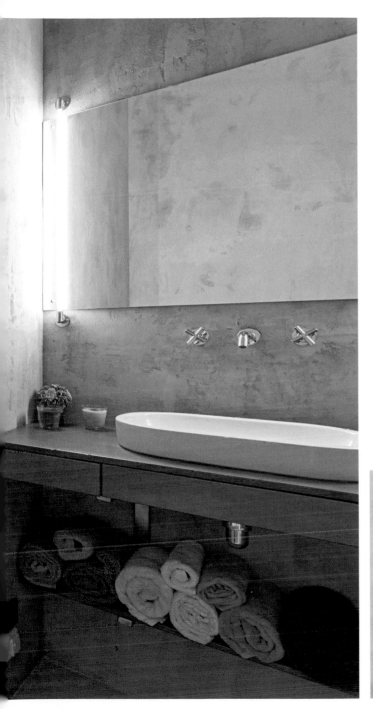

With the wet area of the bathroom separated, the dry area can benefit from greater design opportunities, especially when it comes to finishes.

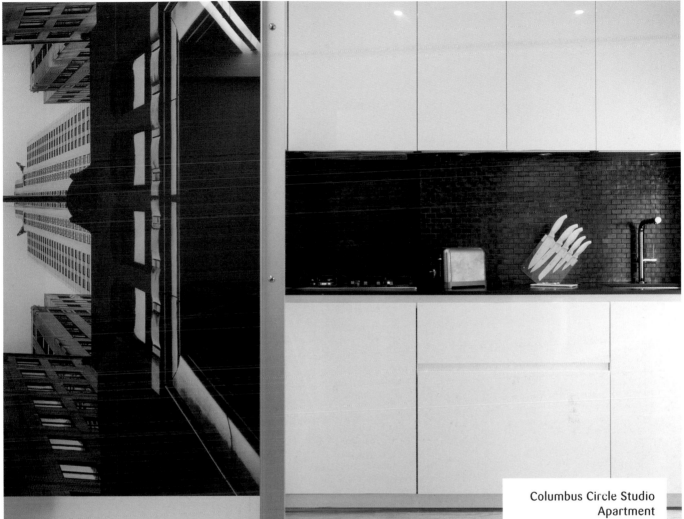

Minimal USA and Studio Bichara teamed up to develop a design for a studio in
Columbus Circle. The design of a 27-square-foot kitchen and 16-square-foot wardrobe
for this studio proves that luxury doesn't belong exclusively to big spaces.

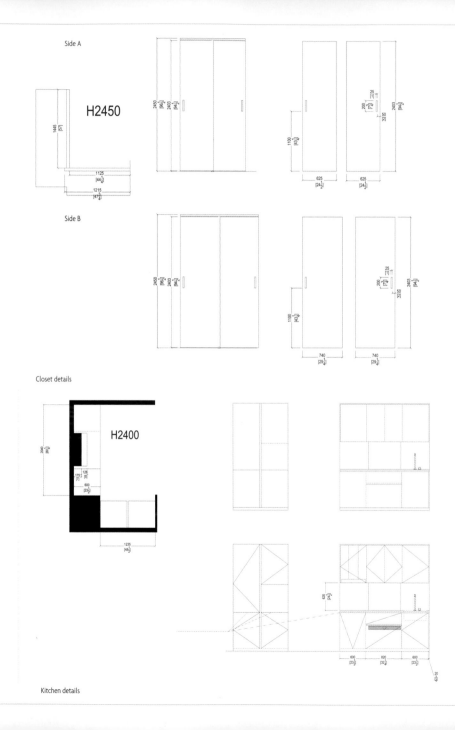

Side A

H2450

Side B

Closet details

H2400

Kitchen details

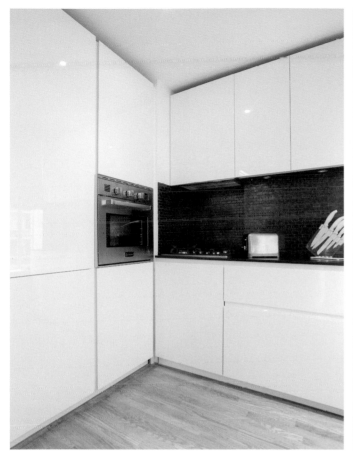
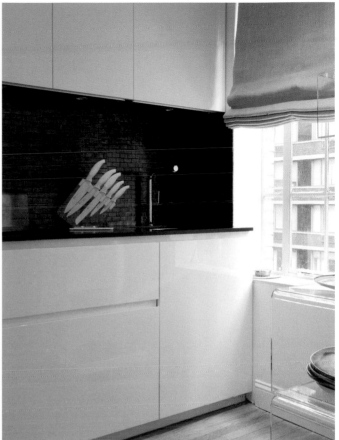

076

Reflective materials such as ceramic tile and stainless steel amplify light effects. This is especially effective in a kitchen, where good lighting is critical.

The closet doors in glossy white
lacquer create a mirror effect that
confers amplitude on the room.
They slide, creating a play of light
that gives depth to the small area
leading to the bathroom.

077

Use a low-contrast color scheme in a small space so it doesn't feel claustrophobic. To confer a feeling of airiness on a room, use reflective and transparent materials such as polished stone and glass.

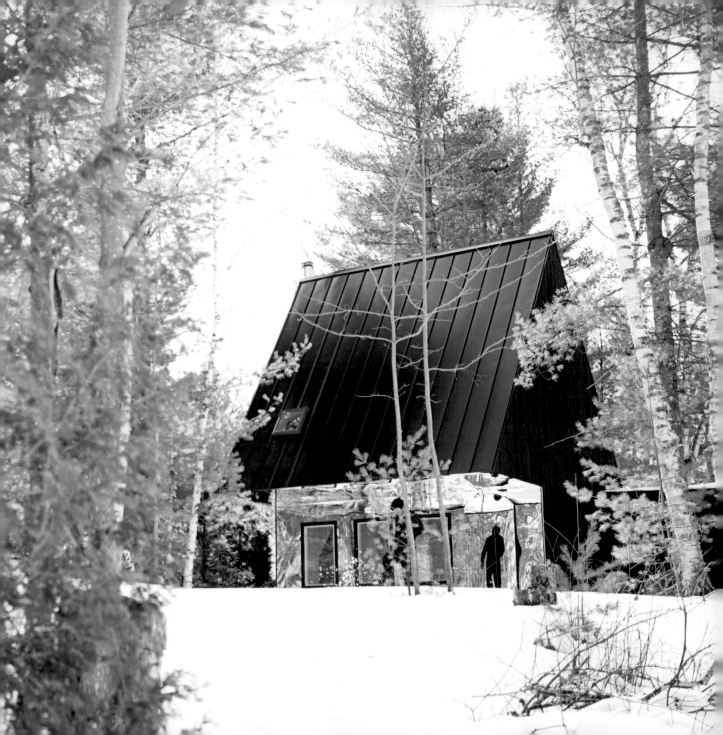

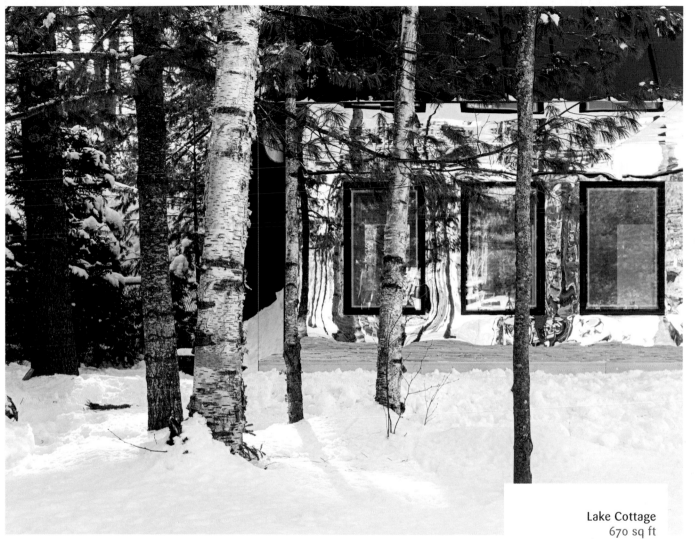

Lake Cottage
670 sq ft

This lake cottage reinterprets the tree house. It was designed as a two-story, multiuse space for a large family. A deep cut in the building creates an overhang that protects the outdoor space. Clad with mirrored glass, this sheltered space reflects the forest surroundings, blurring the distinction between construction and nature. The close connection with the natural environment continues in the interior.

Architect: **UUfie**
Location: **Bolsover, ON, Canada**
Photographer: **© Naho Kubota, Uufie**

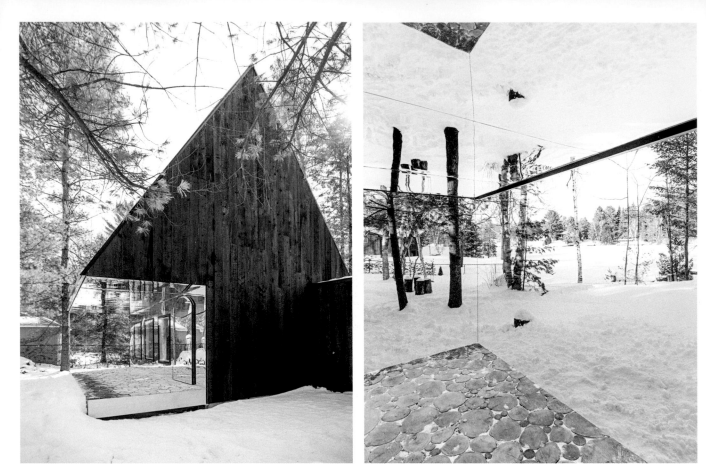

078

Mirrors expand and reflect light. You can transform a small room into a larger and brighter space by using illusion wisely.

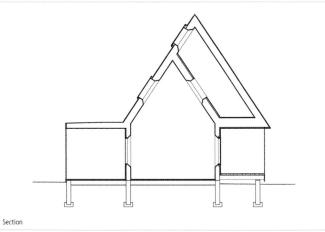

Section

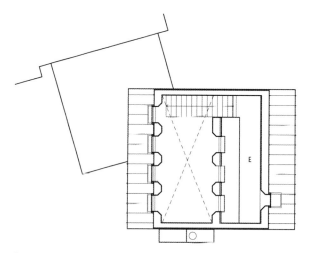

Second-floor plan

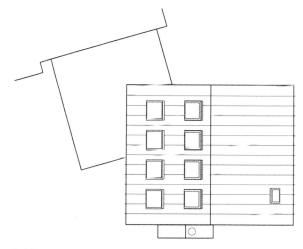

Roof plan

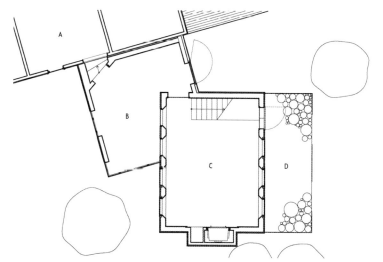

Ground-floor plan

A. Existing structure
B. Dining area
C. Living area
D. Terrace
E. Loft

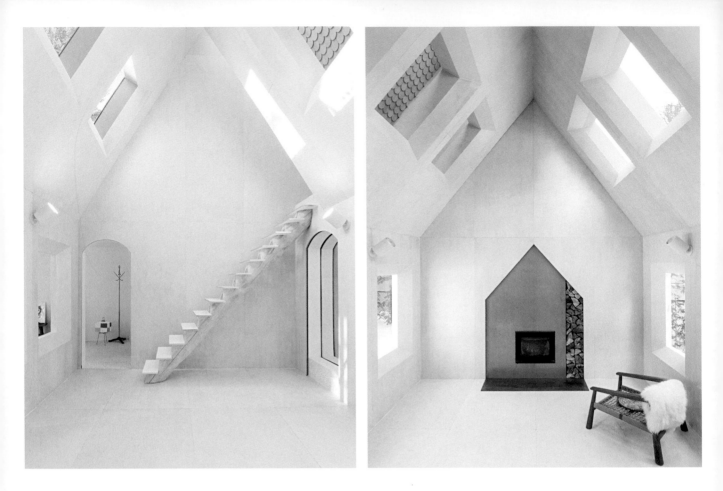

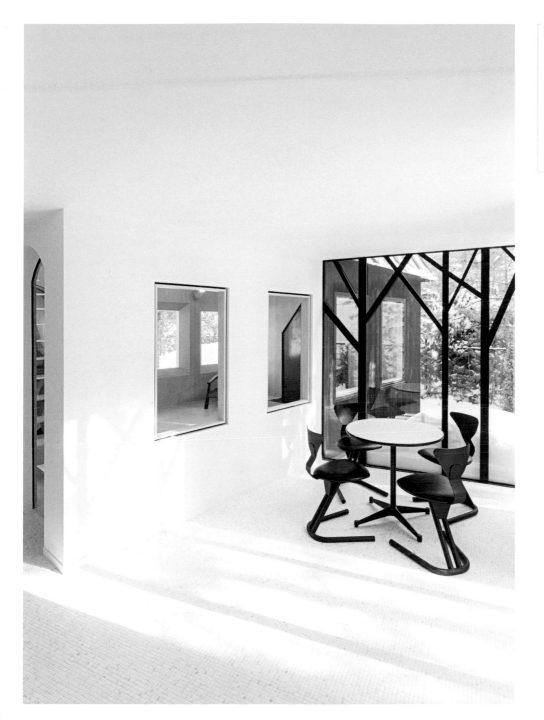

Cutting holes in walls visually connects different spaces and creates a sense of continuity. These openings can also serve to improve light distribution.

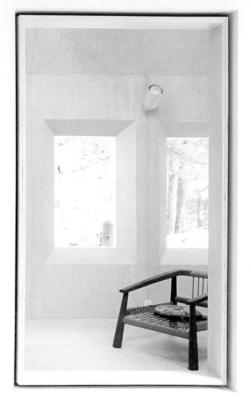

The abstract nature of the interior
allows the imagination to fly. Domestic
spaces can become playrooms
at a moment's notice.

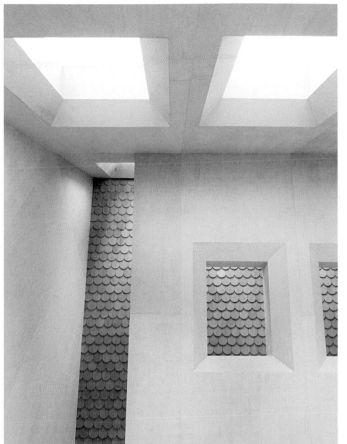

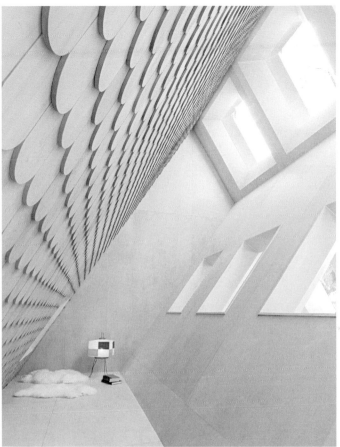

The attic was mainly conceived of as a sleeping area. With the shingle-clad wall creating the illusion of the outdoors, the attic is also a place for meditation.

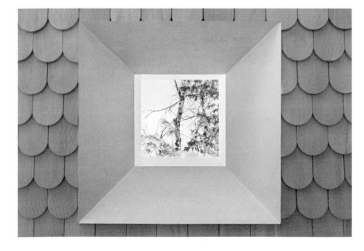

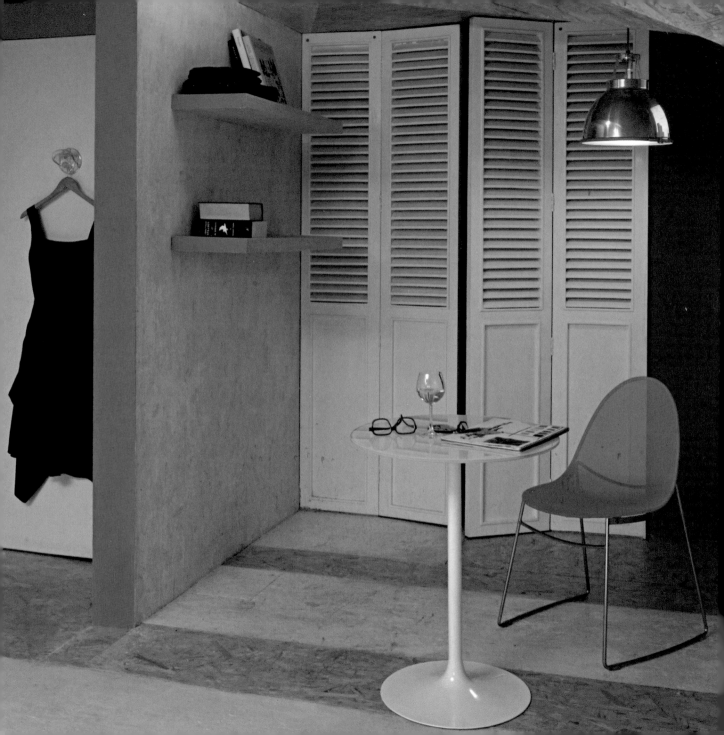

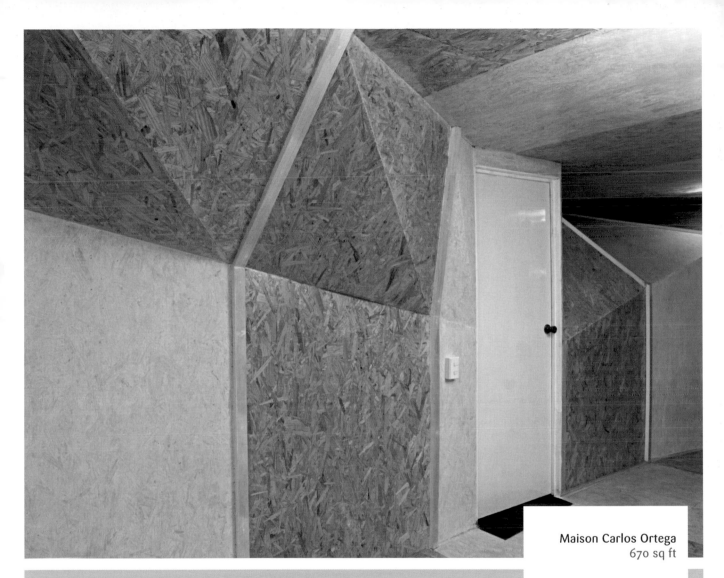

Maison Carlos Ortega
670 sq ft

Architect: ROW Studio
Location: Mexico City, Mexico
Photographer: © Jorge Silva

This conversion of an existing space into an apartment and showroom for fashion designer Carlos Ortega created a clear distinction between public and private areas. The public areas serve both as living room and as showroom for the client's label. The private areas are mainly used for the storage of the designer's own clothes and creations, and as dressing rooms for the designer's clientele.

The two areas are separated by a faceted wall spanning from the kitchen to the bedroom on a diagonal axis. A second wall with the same characteristics crosses the first. It provides ample shelving space.

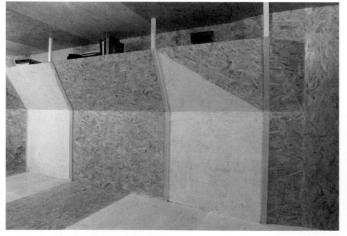

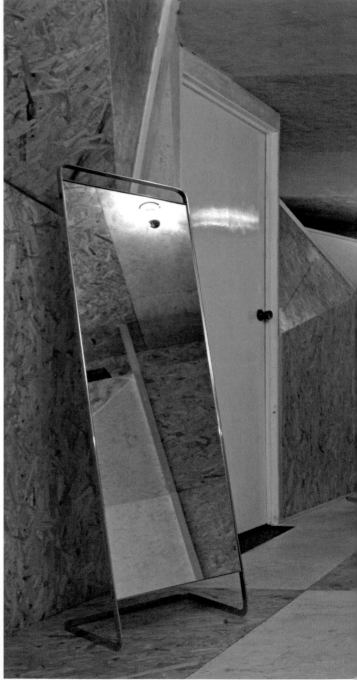

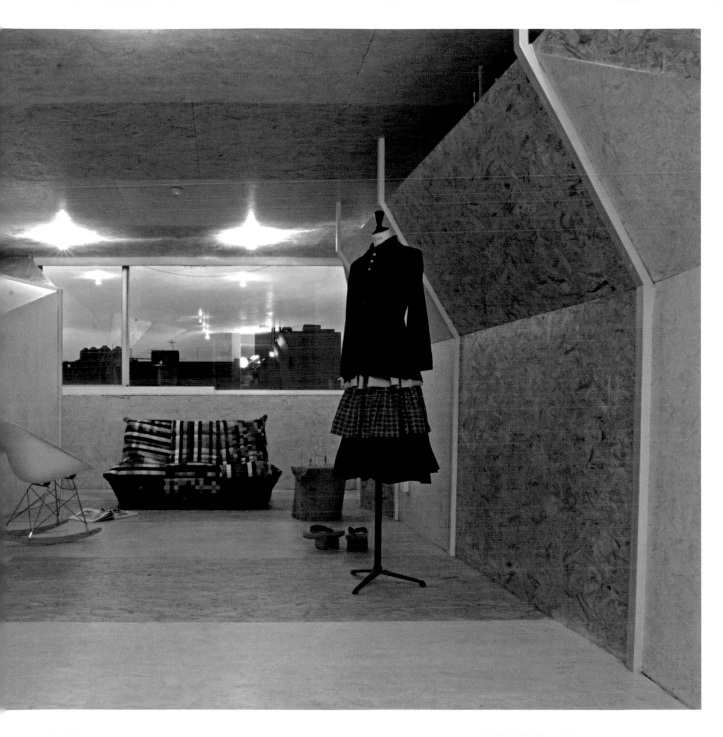

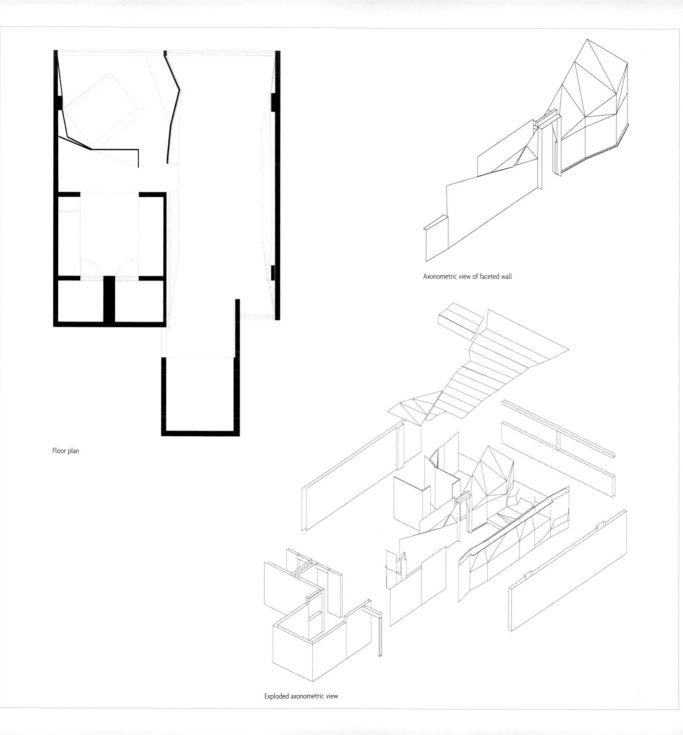

Floor plan

Axonometric view of faceted wall

Exploded axonometric view

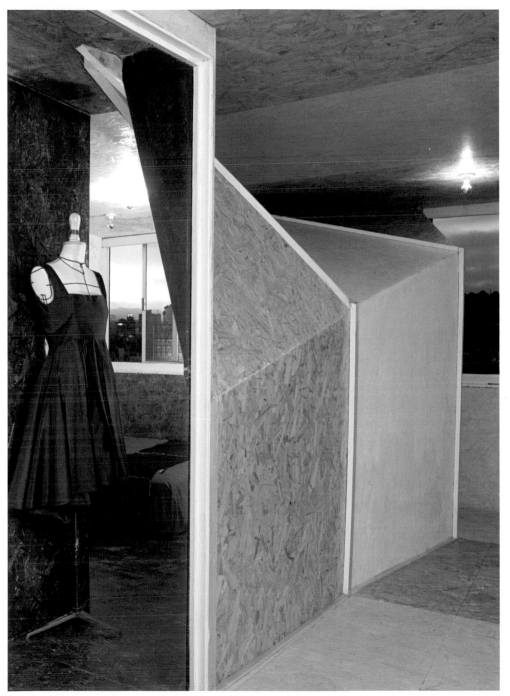

The remodel was done in oriented strand board (OSB) panels, with some details tinted in different colors. These tinted sections follow different color sequences: from yellow to white, yellow to red, and black to white.

080

Create the walk-in closet that best suits your needs, but also make it a space you enjoy going into. Turn it into a personal space that expresses your personality, just like any other room in your home.

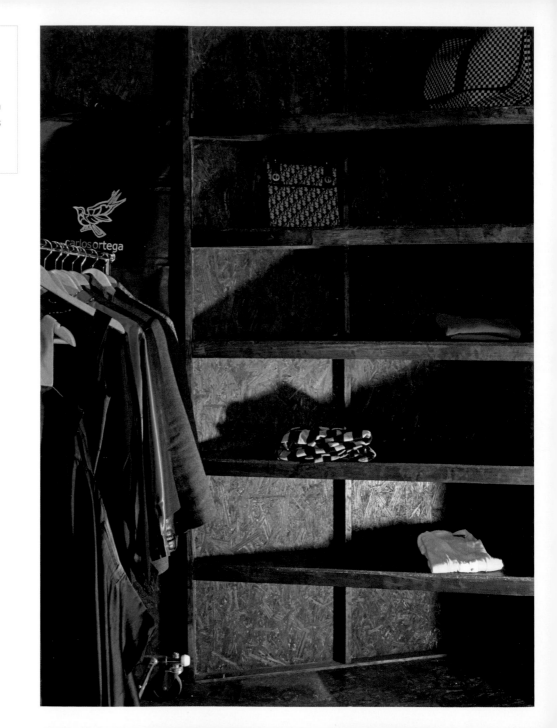

Oriented strand board
makes a very cool and
cheap finish. Applied to
one or more surfaces of a
small space and to furniture,
it adds visual interest.

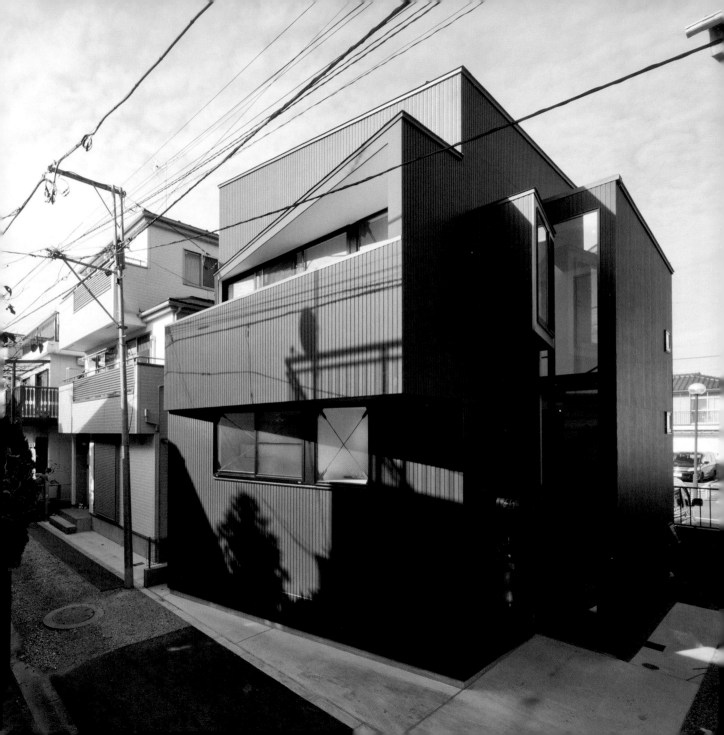

This house, which faces a narrow alley, is a response to the strict Japanese building regulations that limit building density in an attempt to maintain urban character. Most important, the rules ensure that light and air penetrate into a building. Small plots leave little option but to construct vertically within a very small footprint.

House in Shimomaruko
678 sq ft

Architect: **Atelier HAKO Architects**
Location: **Oota, Tokyo, Japan**
Photographer: © **Atelier HAKO Architects, Atelier Flor**

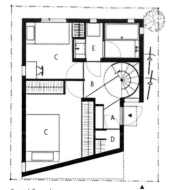

Ground-floor plan

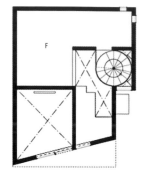

Intermediate-floor plan

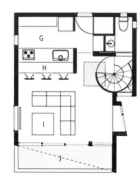

Second-floor plan

A. Entrance
B. Hall
C. Bedroom
D. Storage
E. Bathroom
F. Loft
G. Kitchen
H. Dining area
I. Living area
J. Terrace

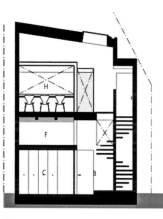

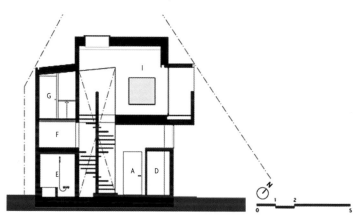

Sections

The split-level design of the house
has the effect of visually enlarging
the rooms. Open spaces around
the staircase intensify this effect
and promote fluid circulation.

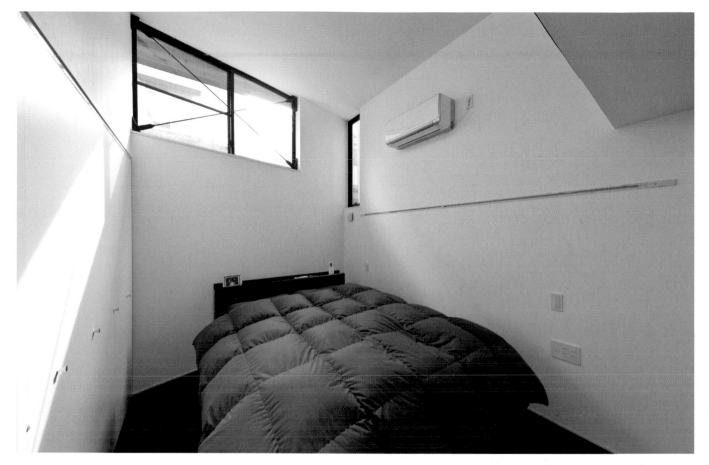

The house evolves upward from the more private rooms to the more public.

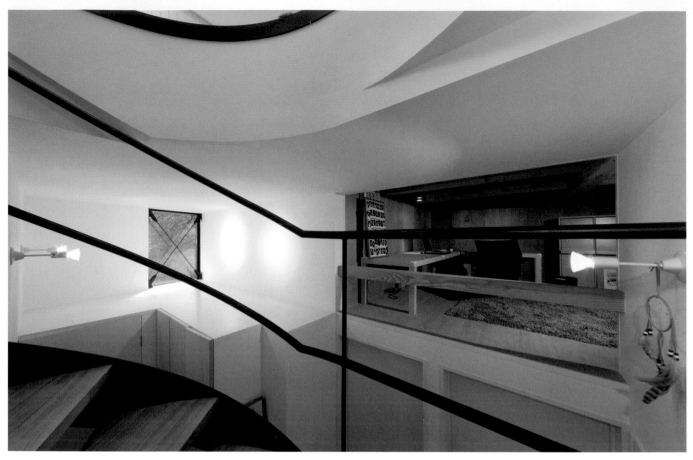

082

Skylights let light into spaces where windows aren't possible. Placed above an open staircase, a skylight provides lots of light that reaches as far down as the staircase goes.

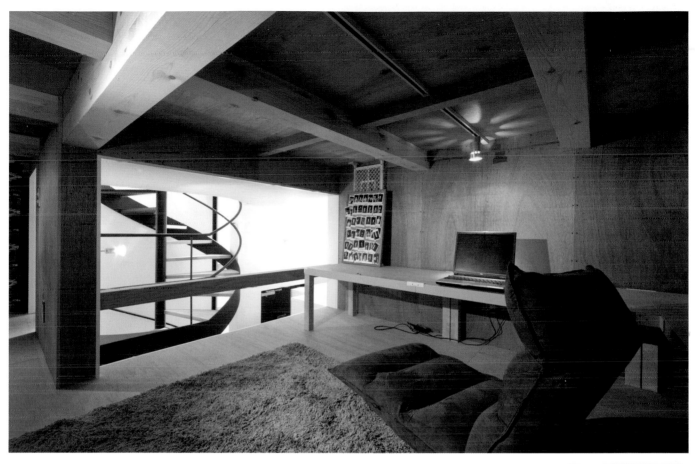

083

Make a room more dynamic and less confined by connecting it with an atrium or an open staircase.

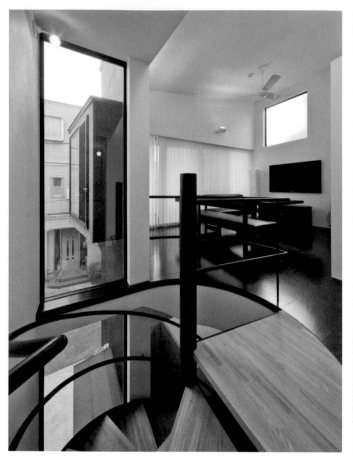

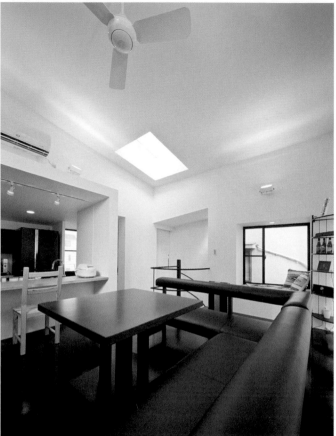

The top floor benefits from abundant light. A southeastern orientation opens the living–dining area to the outdoors.

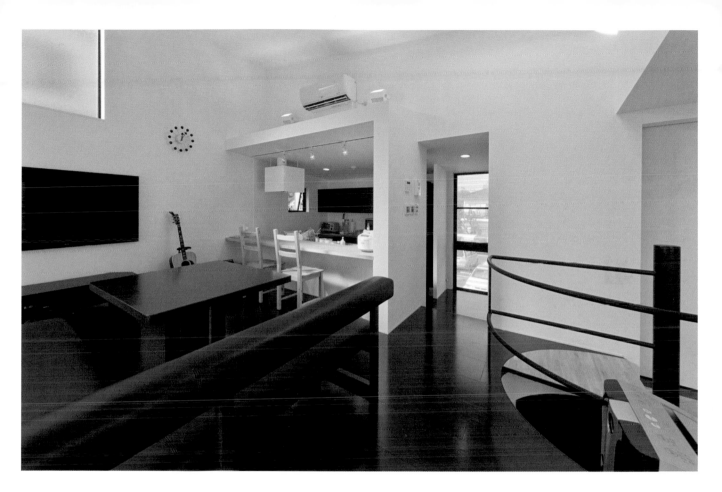

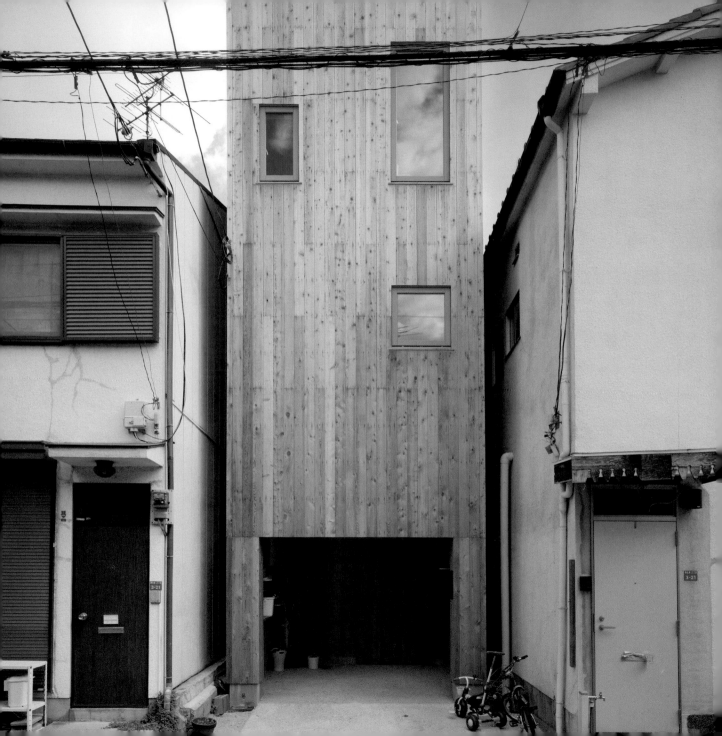

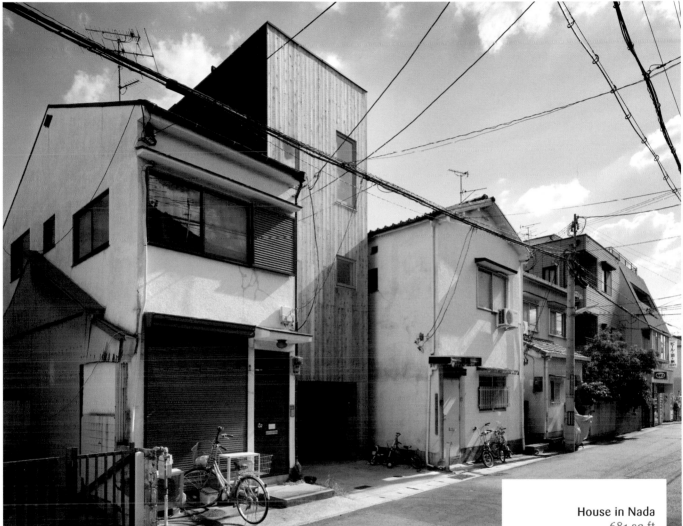

House in Nada
681 sq ft

Architect: Fujiwarramuro
Architects
Location: Kobe, Japan
Photographer: © Yano Toshiyuki

This house is located in the heart of the city of Kobe. The site, flanked by existing houses, is so small that one might walk by without even noticing it. Despite the limitations of the site, the program had to satisfy the needs of a family of four. Fortunately, the building regulations allowed for a tall construction.

084

Consider a floor made of spaced-out wood slats to bring light to a dark space and make it less confined. Light filters through the floor, just like it would through a screen.

North elevation

Section y-y'

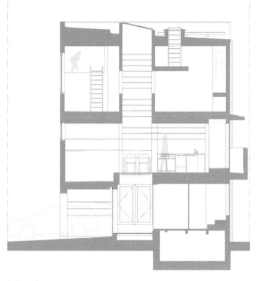

Section x-x'

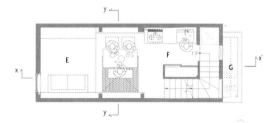

Second-floor plan

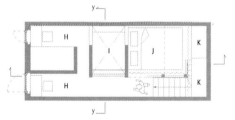

Third-floor plan

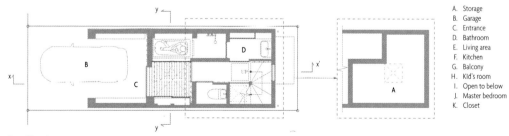

Ground-floor plan

A. Storage
B. Garage
C. Entrance
D. Bathroom
E. Living area
F. Kitchen
G. Balcony
H. Kid's room
I. Open to below
J. Master bedroom
K. Closet

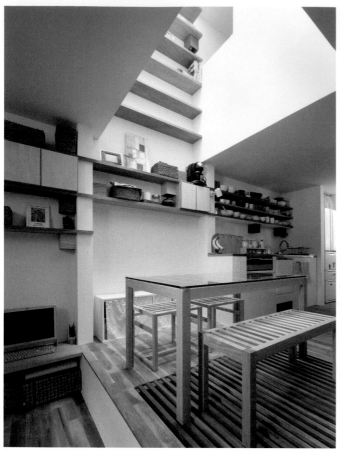

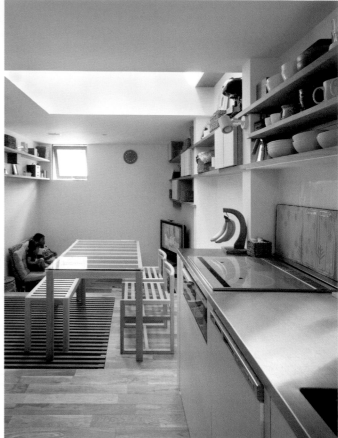

Shelves on the atrium wall from the
ground floor to the third level accentuate
the verticality of the building and create
a greater sense of space.

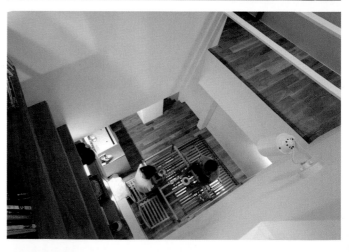

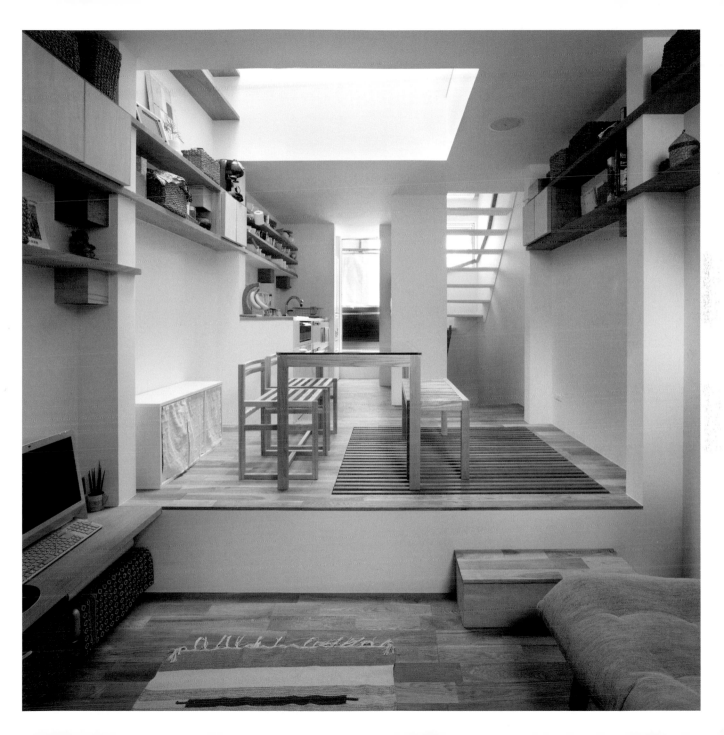

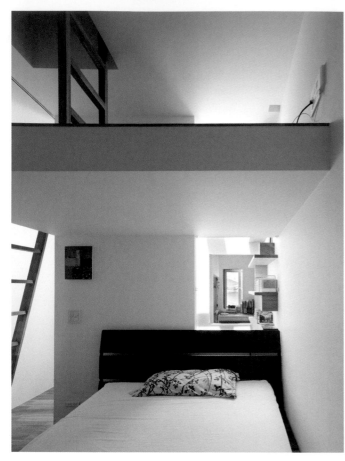
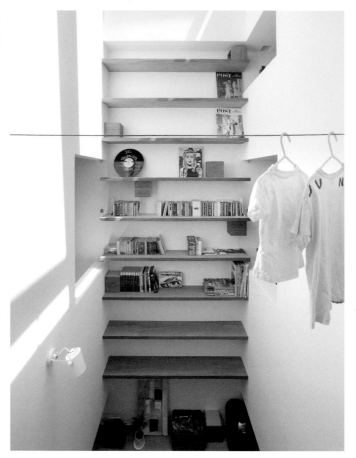

085

High ceilings allow for the
construction of a loft, which
makes up for the shortage
of storage space that usually
comes with a small house.

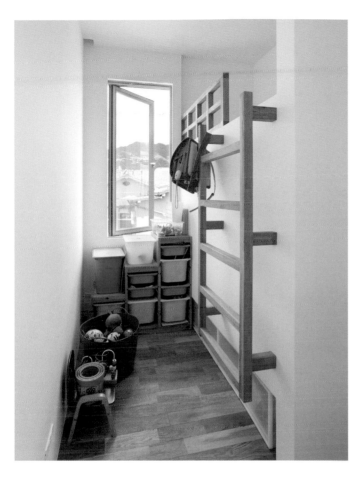

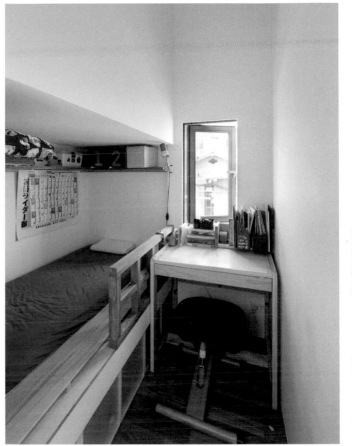

A bunk bed divides the children's spaces: one room has the lower bed, the other has the upper bed.

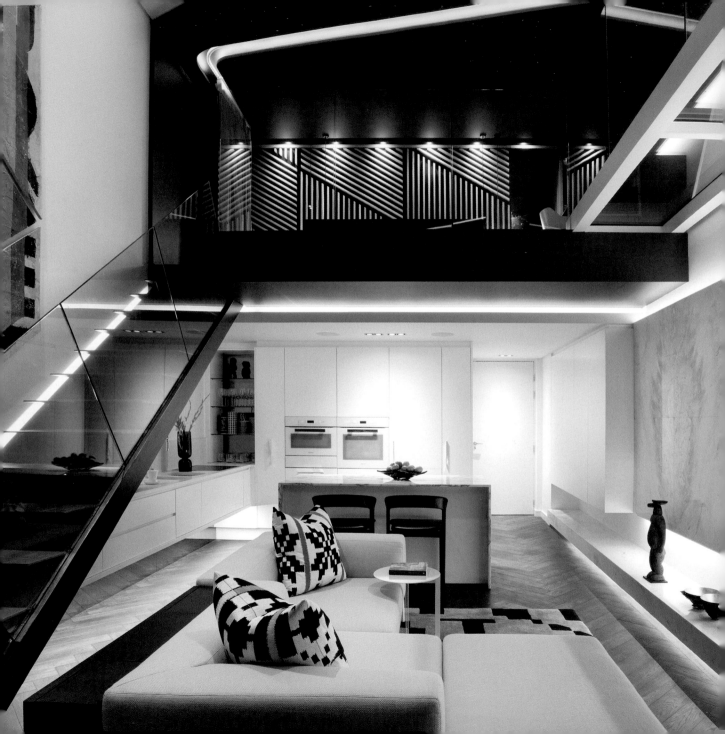

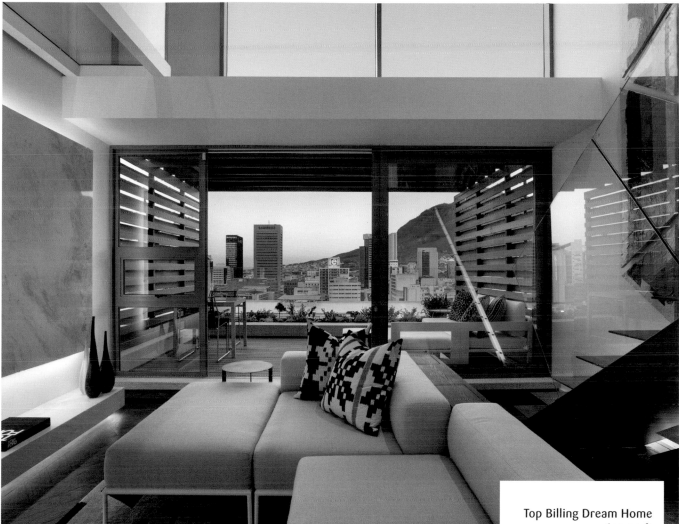

Top Billing Dream Home
699 sq ft

Architect: Antoni Associates
Location: Cape Town,
South Africa
Photographer: © Adam Letch

The spatial constrictions of this existing duplex apartment influenced the design process, which highlights clever functionality. Spaces double up in function wherever possible. Conceptually, the design consists of a light living area with a dark bedroom loft cantilevered overhead.

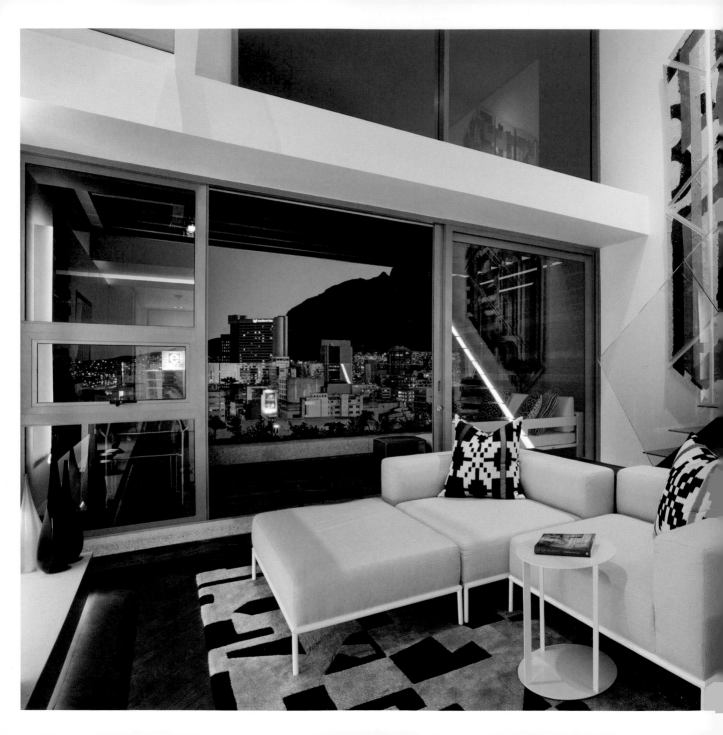

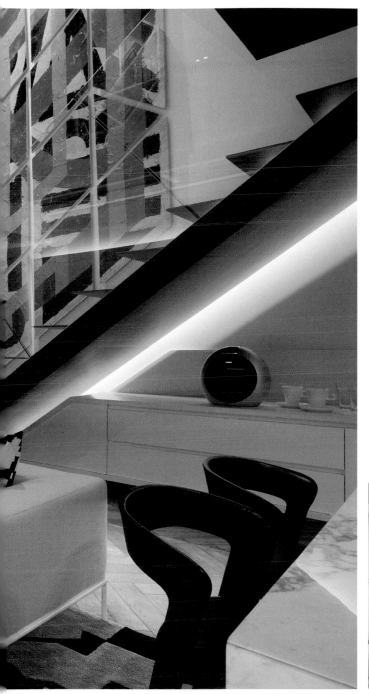

Angular motifs were introduced to break up the boxy appearance of the apartment and add visual interest. Dark wood flooring brings in warmth, while concealed LED lighting adds depth to the space.

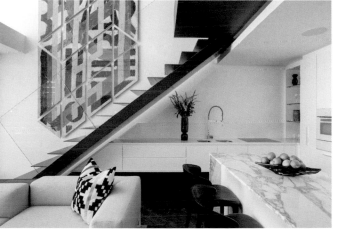

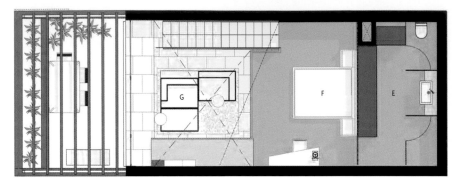

Upper-floor plan

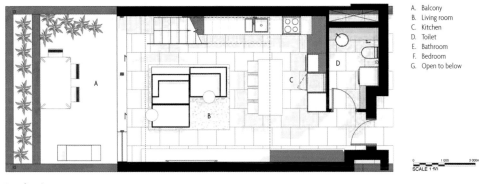

A. Balcony
B. Living room
C. Kitchen
D. Toilet
E. Bathroom
F. Bedroom
G. Open to below

SCALE 1:50

Lower-floor plan

The lower floor features a continuous spatial flow between the kitchen, the living room and the balcony, with uninterrupted views of Cape Town. The kitchen is cleverly tucked under the staircase.

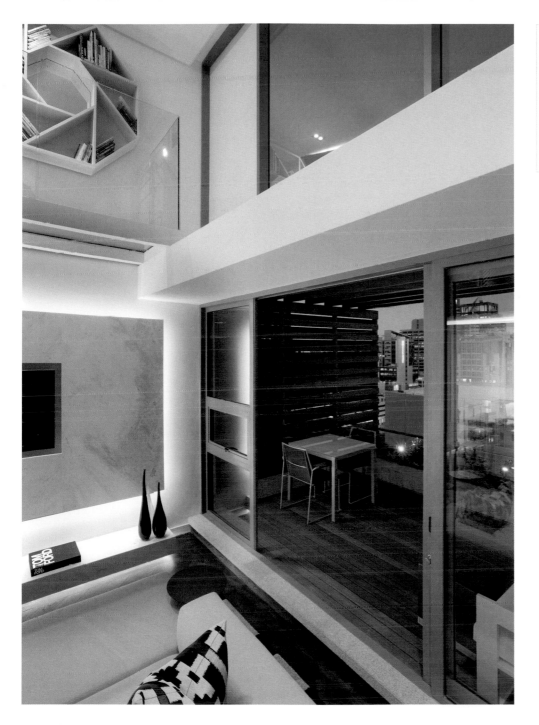

Span a bridge along one tall wall to provide acccss to the uppermost shelves of a floor-to-ceiling wall library. This will expand the floor area of your home and make the most of a double-height space.

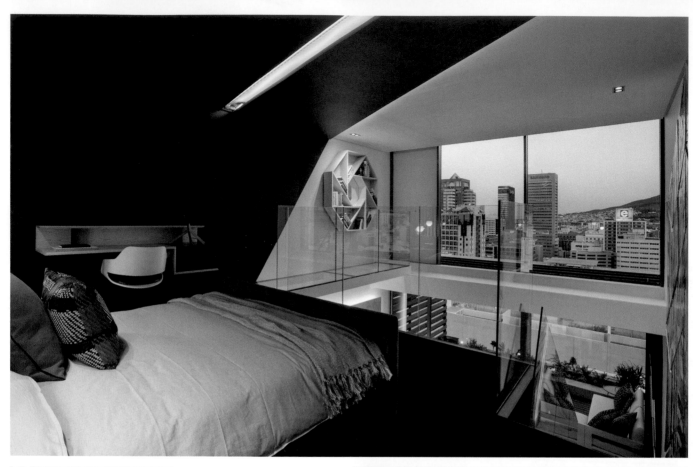

087

Light colors reflect light. This helps make a room feel larger than it actually is. Using dark colors in an adjacent room farther away from a light source emphasizes this effect.

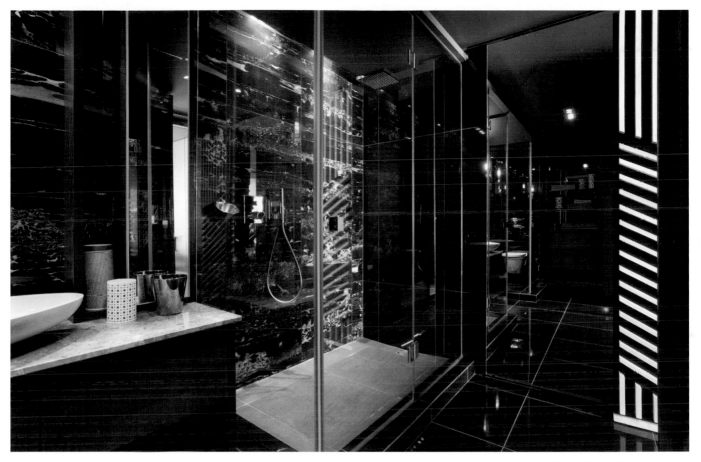

Due to the small size of the apartment, the designers combined the master dressing room and the en-suite bathroom, resulting in a sophisticated sanctuary for bathing and dressing.

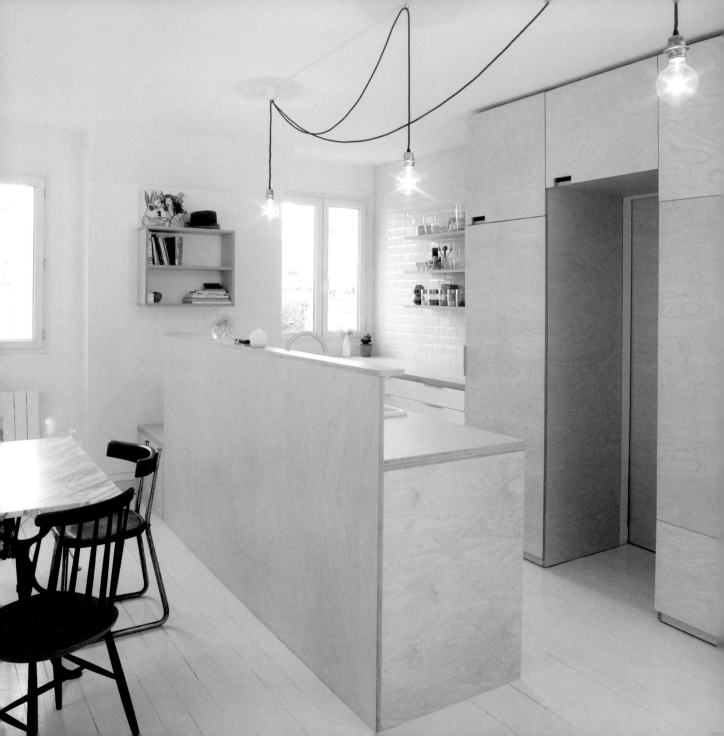

An existing 753-square-foot apartment was renovated to accommodate a family of four. The removal of some of the partition walls created a larger living area, while an open kitchen became the main feature of the space.

Blank
753 sq ft

Architect: Septembre Architecture
Location: Paris, France
Photographer: © David Foessel

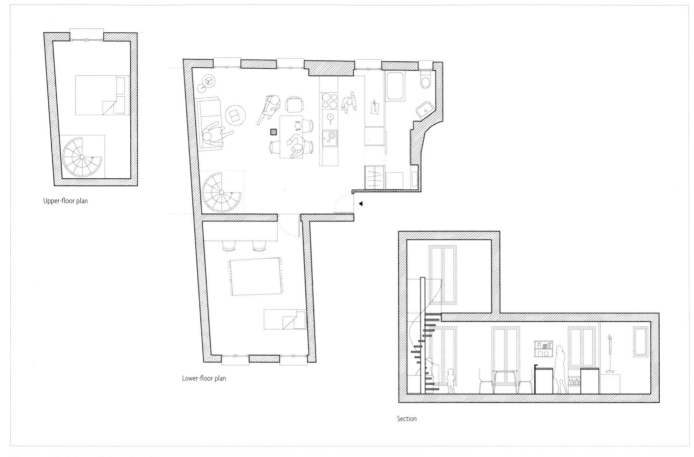

Upper-floor plan

Lower-floor plan

Section

The removal of the walls to make a large
and comfortable living area left behind
an unexpected load-bearing post that
was eventually integrated into the design.

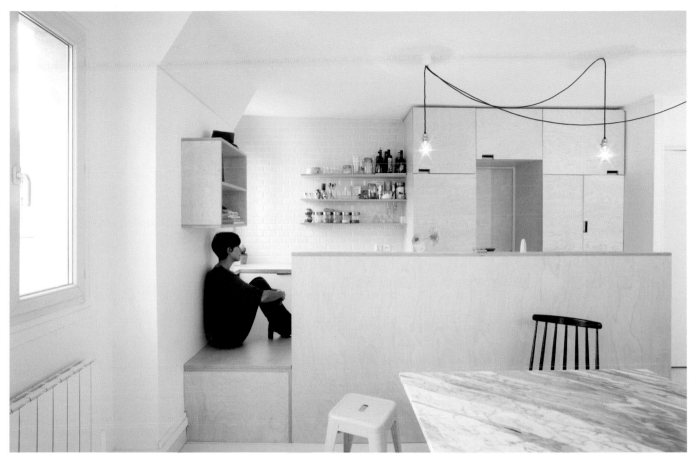

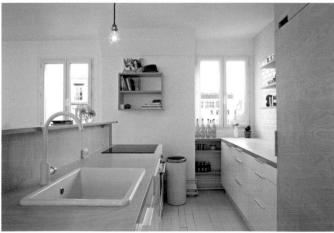

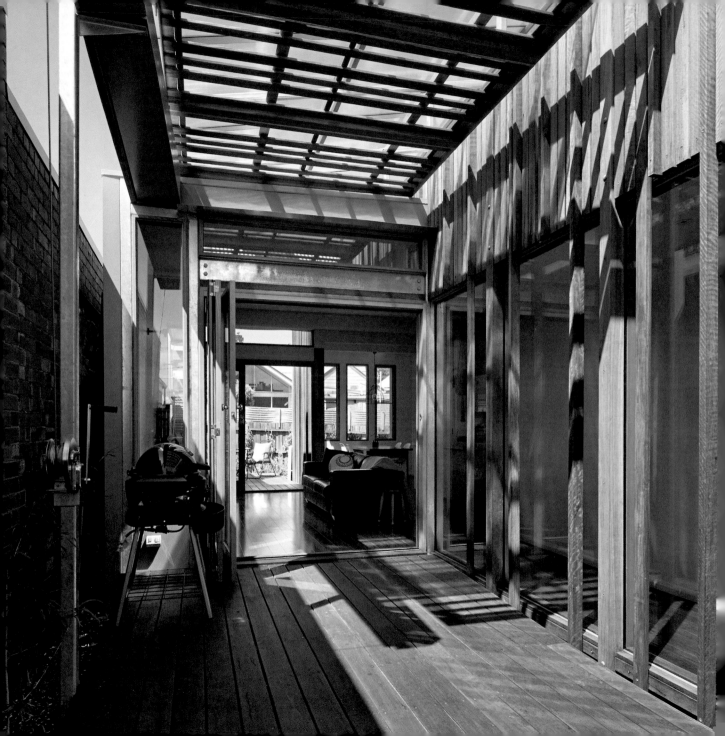

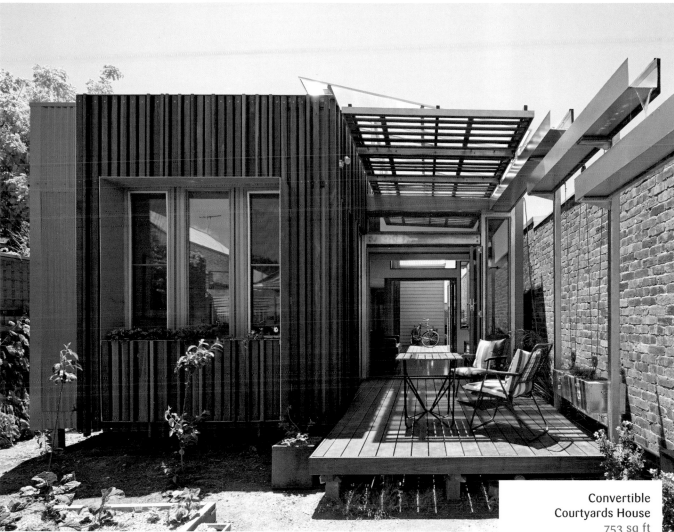

This project added a kitchen, living area, dining area, master bedroom, en-suite bathroom and two decks to this previously overlooked yet charming weatherboard cottage. A central courtyard was created between the weatherboard and modern extension in order to flood the open kitchen and living and dining areas with natural light.

Convertible Courtyards House
753 sq ft

Architect: Christopher Megowan Design

Location: Prahran, Victoria, Australia

Photographer: © Nils Koenning

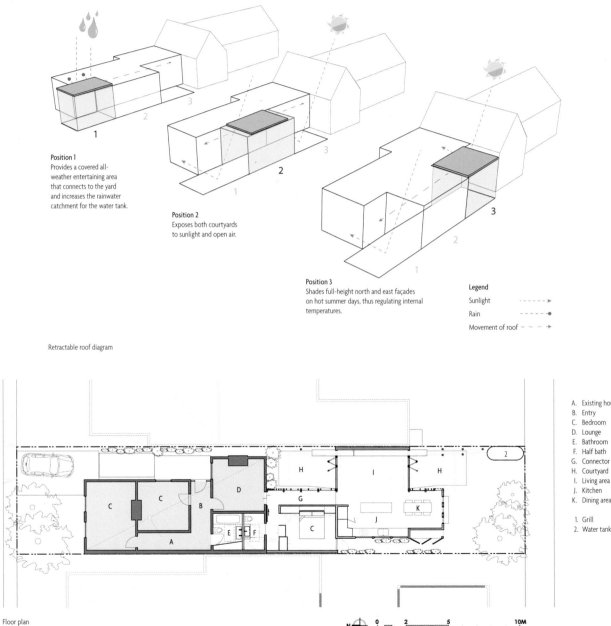

Position 1
Provides a covered all-weather entertaining area that connects to the yard and increases the rainwater catchment for the water tank.

Position 2
Exposes both courtyards to sunlight and open air.

Position 3
Shades full-height north and east façades on hot summer days, thus regulating internal temperatures.

Legend

Sunlight - - - - - →

Rain - - - - - ●

Movement of roof - - - →

Retractable roof diagram

A. Existing house
B. Entry
C. Bedroom
D. Lounge
E. Bathroom
F. Half bath
G. Connector
H. Courtyard
I. Living area
J. Kitchen
K. Dining area

1. Grill
2. Water tank

Floor plan

N 0 2 5 10M

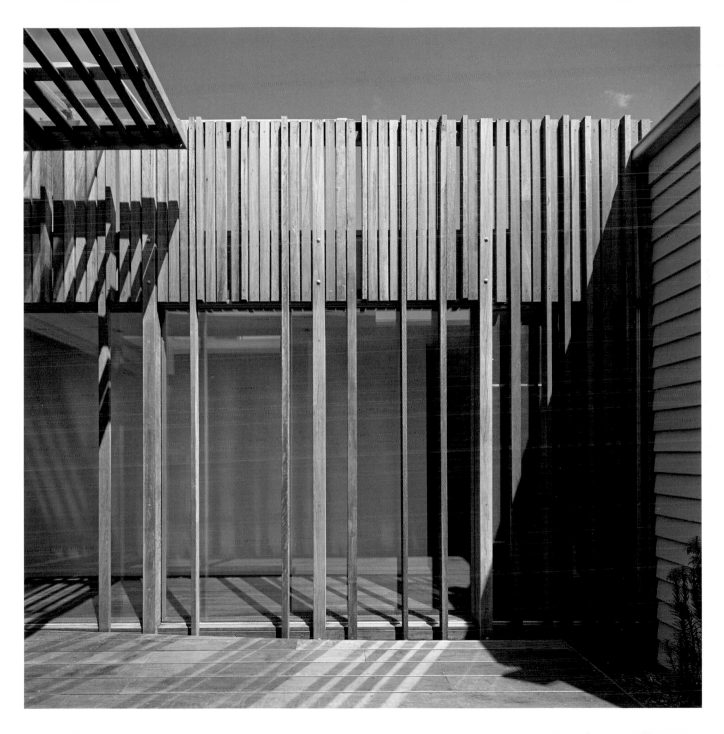

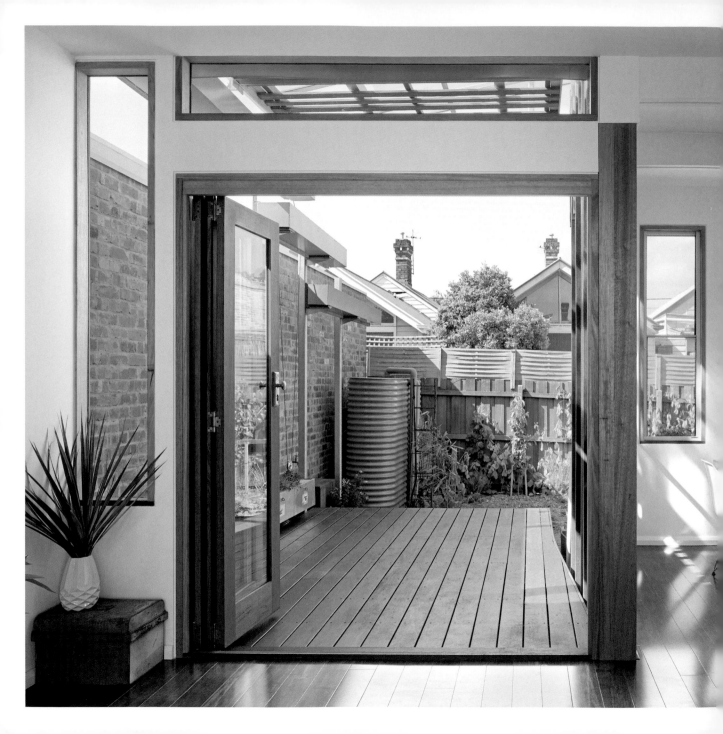

A glazed connector runs along the central courtyard. A second courtyard straddles the south-oriented living room and allows access to the rear vegetable garden.

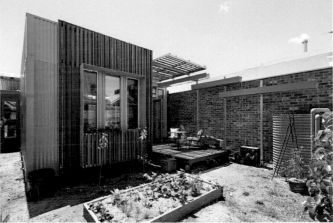

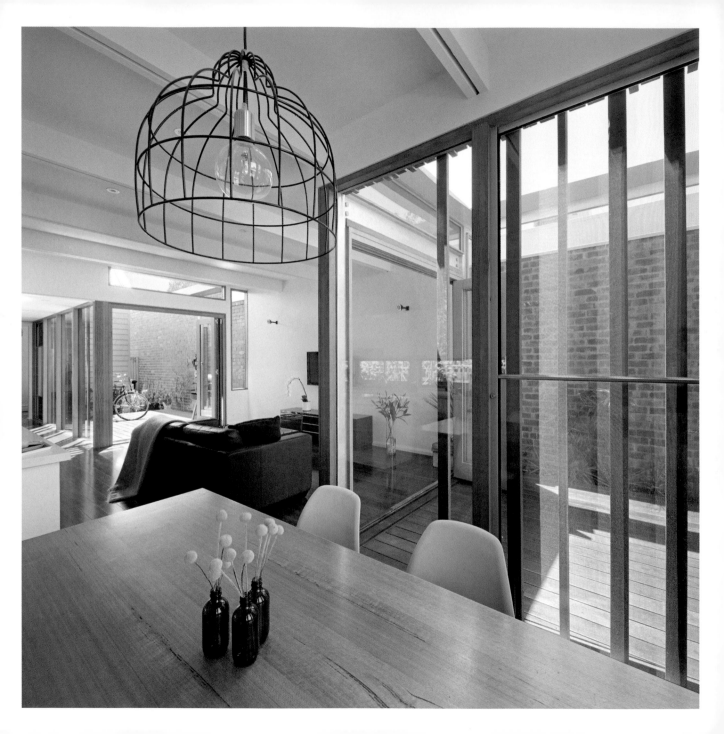

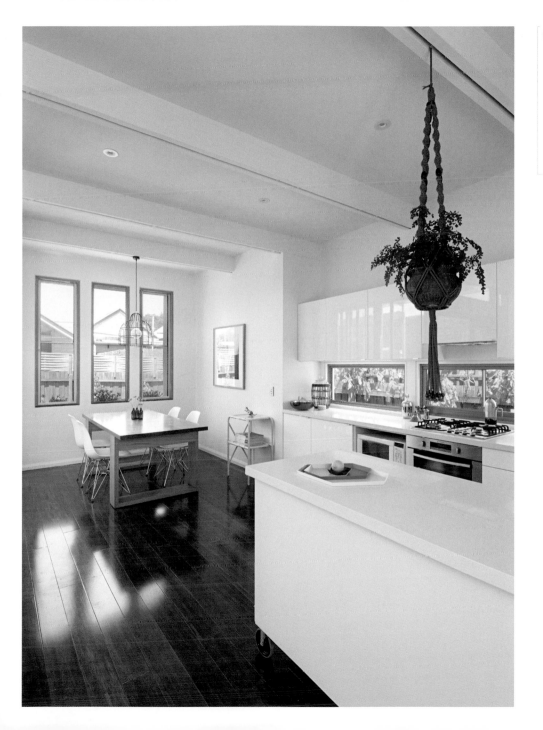

Enjoy unrestricted views
of your garden or terrace
and expand your living space
to the outdoors by means of
sliding or bifolding glass doors.

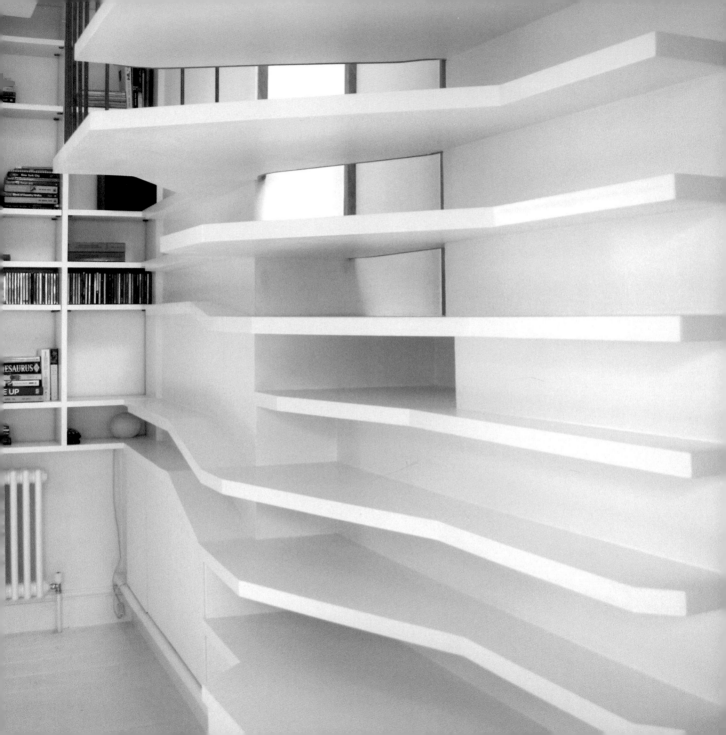

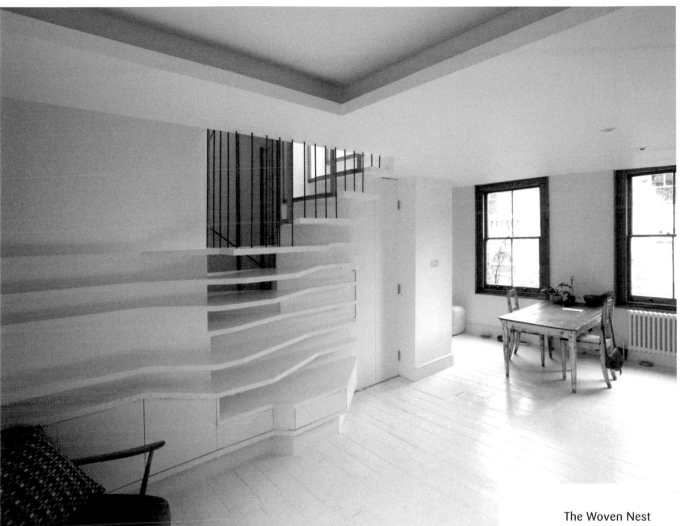

The Woven Nest
764 sq ft

Architect: Atmos Studio

Location: London,
United Kingdom

Photographer: © Atmos Studio,
Christoph Bolten

This home for an actress and musician is carefully slotted between buildings and sight lines. Planning constraints generated a complex series of intertwining spaces enlivened by light and interconnectivity. The project's palette expresses the client's interest in Japanese economy, restraint and invention, providing a sense of surprising spaciousness within tight confines.

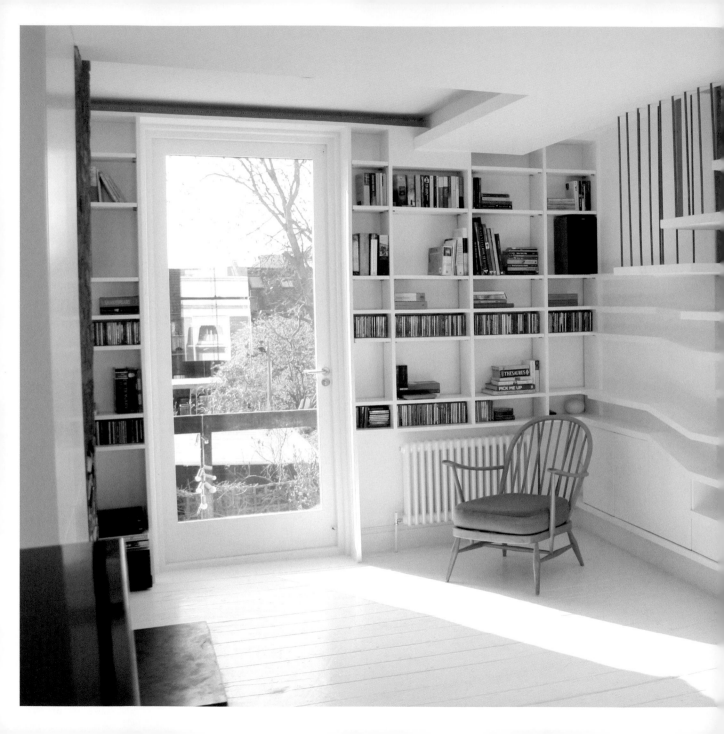

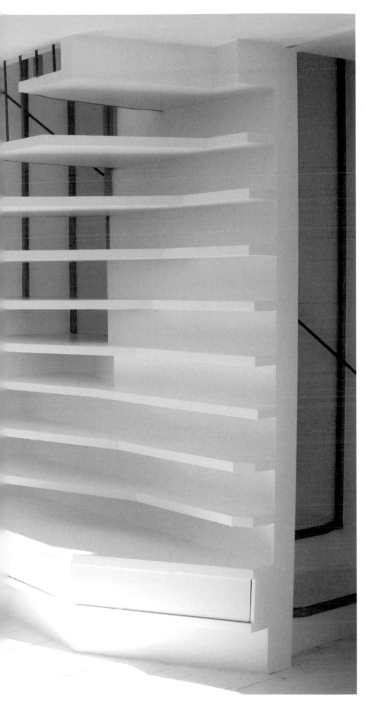

A single curl of complex built-in furniture, bridging inside and outside, both closed and open in its careful compaction and alignment, unifies the house.

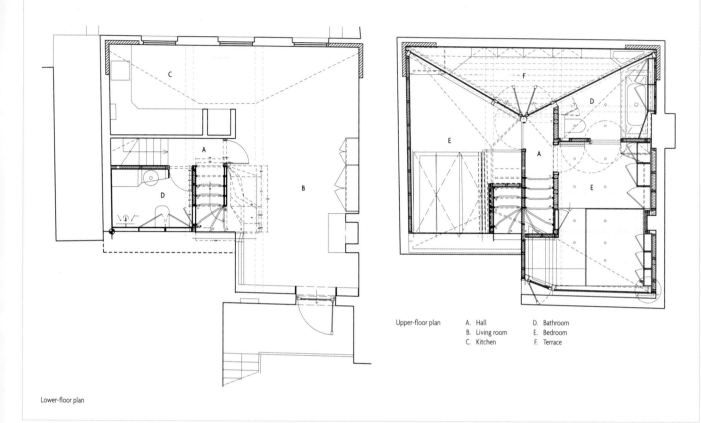

Upper-floor plan

A. Hall
B. Living room
C. Kitchen
D. Bathroom
E. Bedroom
F. Terrace

Lower-floor plan

The recessed angled glass walls with doors open up to a small but convenient terrace. The doors from the hall and bedroom fold together neatly.

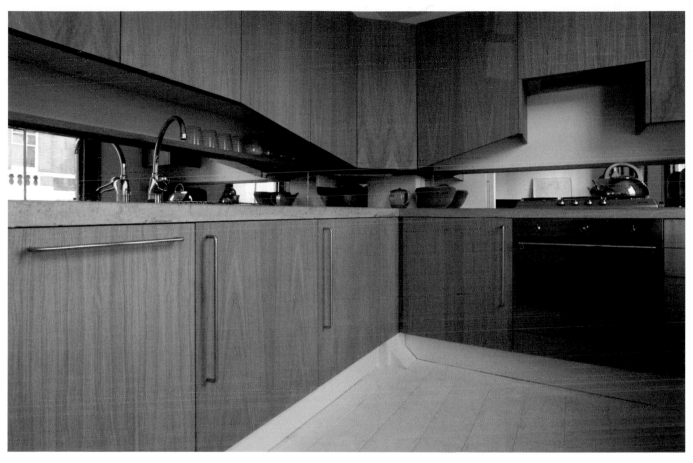

090

Keep your kitchen
counters clutter-free by
adding a shallow shelf
between the countertop
and upper cabinets.

Spaces from adjacent rooms
are borrowed and traded,
with each room offering
a panoply of different views.

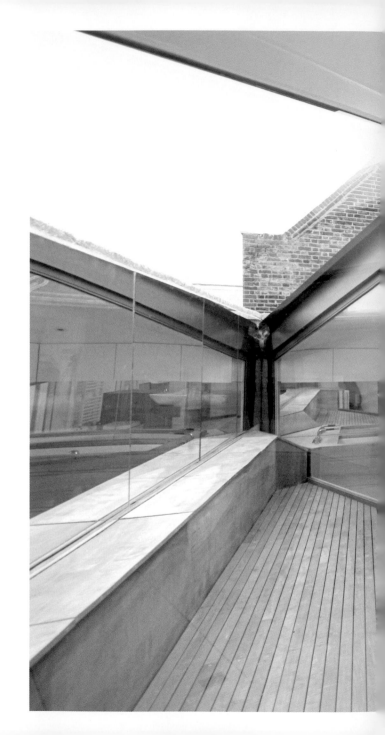

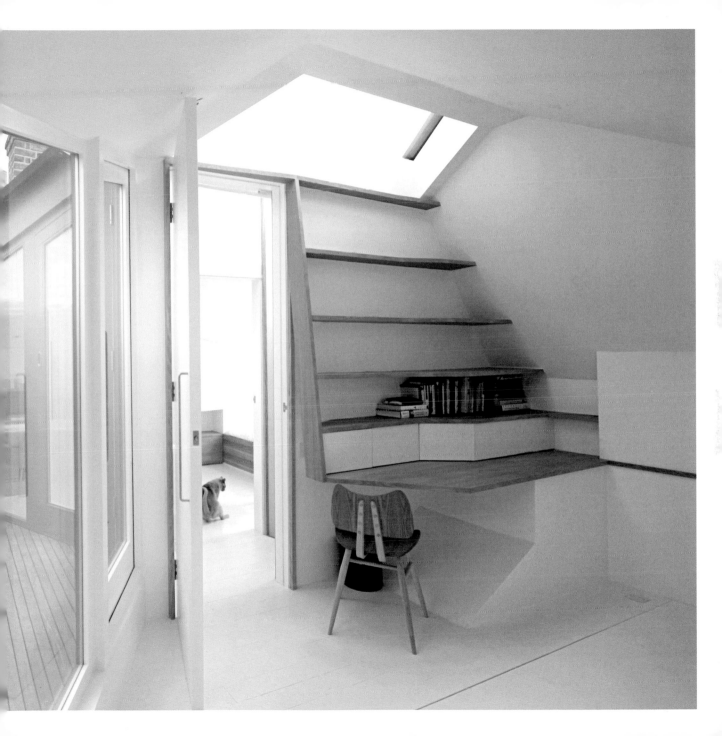

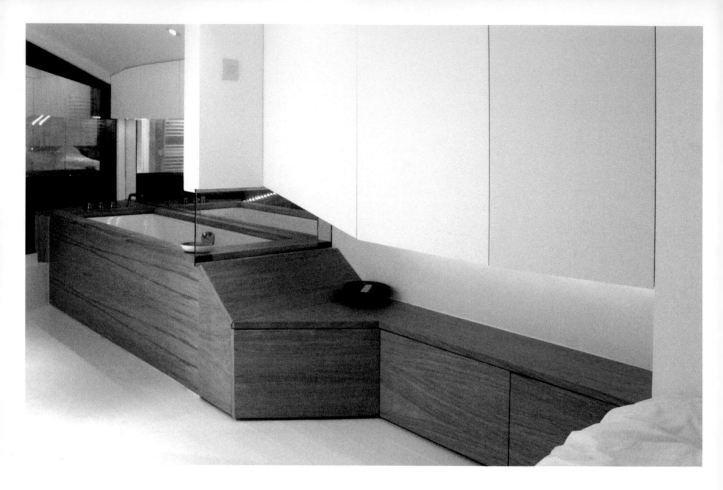

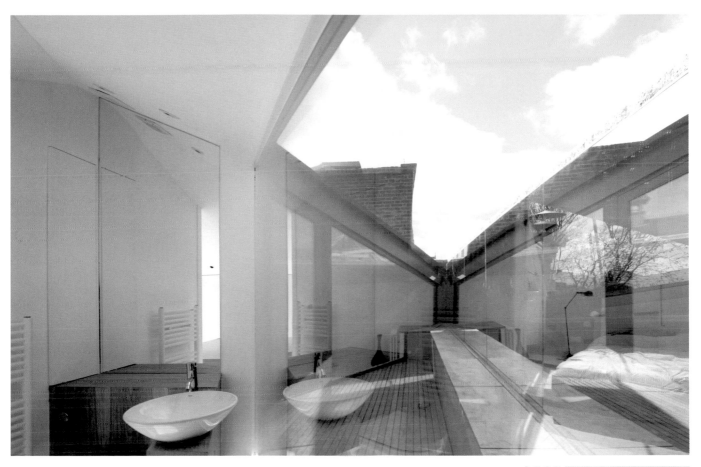

092

Reflection and transparency double and quadruple the views and encourage visual exploration, while the continuity of the built-in furniture provides a sense of elongation.

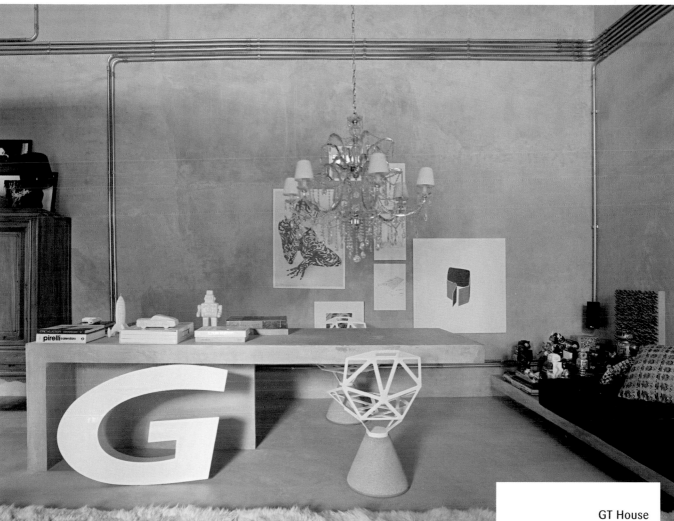

GT House
786 sq ft

Architect: Studio
Guilherme Torres
Location: Londrina, Brazil
Photographer: © Roberto
Wagner

Architect Guilherme Torres wanted his own small studio apartment to look industrial and experimental. The concrete table immediately draws attention: it's large and heavy in a small space. But most important, the permanent quality of this material contrasts with the versatility of the piece of furniture. It is used for working, eating and displaying.

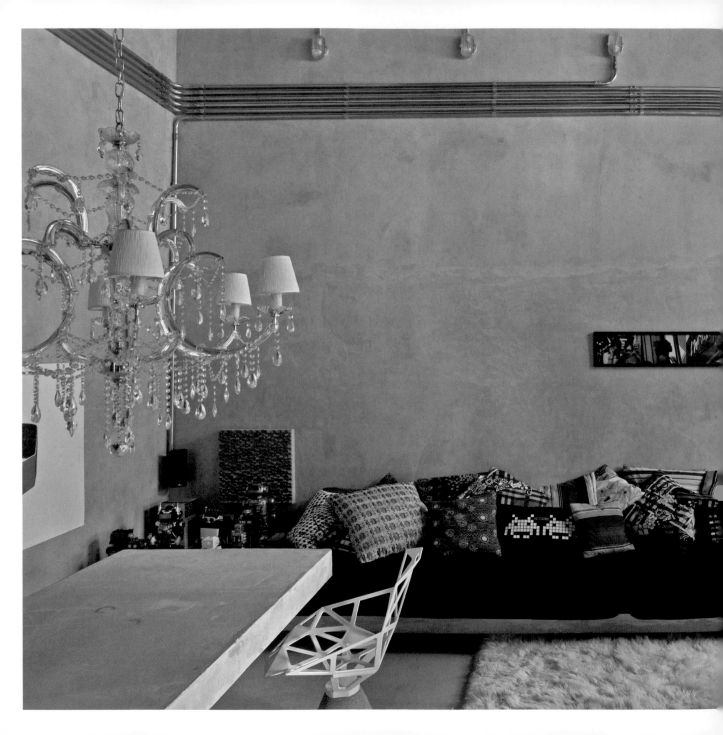

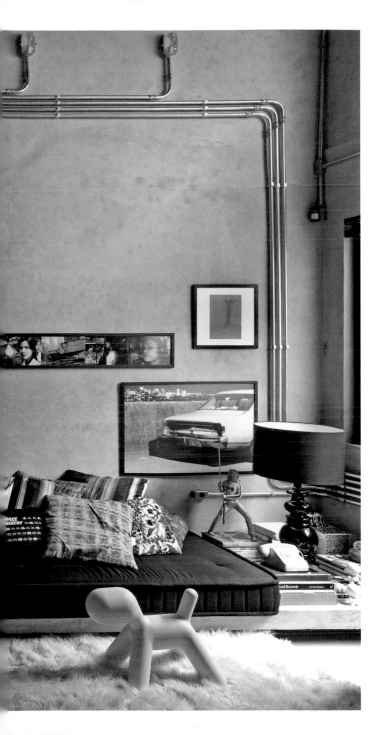

Scale is important when dealing with small spaces. Avoid tall pieces of furniture, as they can make a room feel cramped. Low furniture, on the other hand, can visually expand the space and lift up the ceiling.

A small space doesn't have to be filled with low-profile furniture. Choose a few interesting pieces that will help set the style and organize the space.

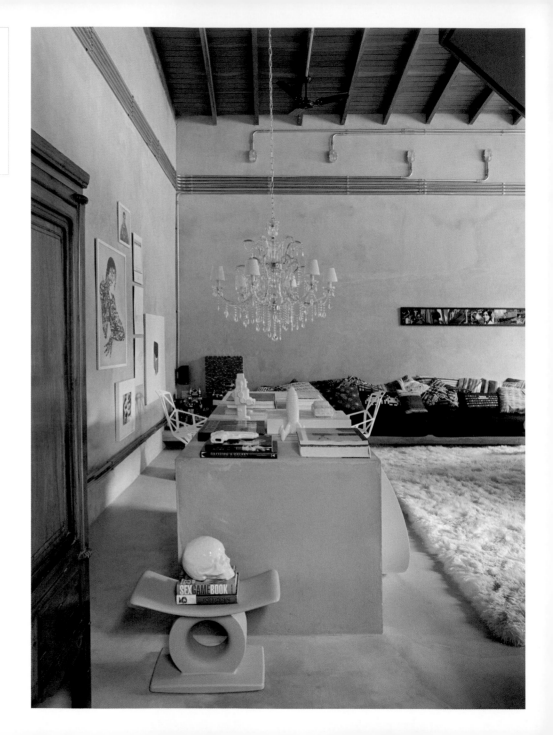

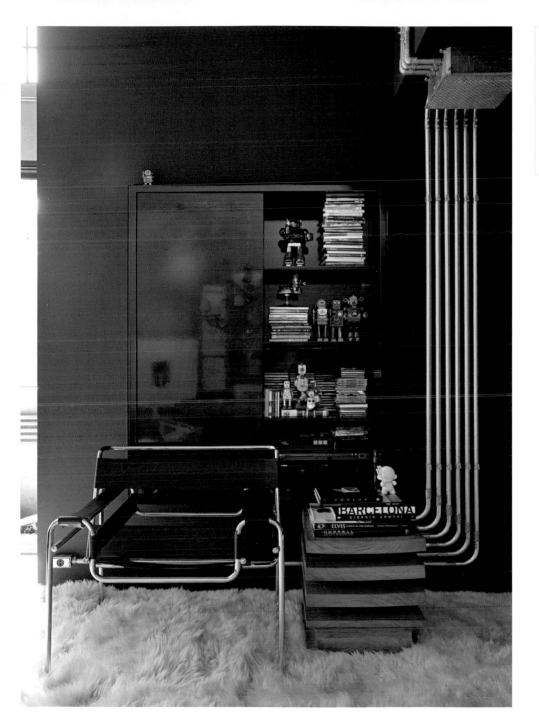

Build your decoration around a limited color palette. You can apply this rule to walls, floor, ceiling, furniture and accessories. You can choose an accent color to create focal points.

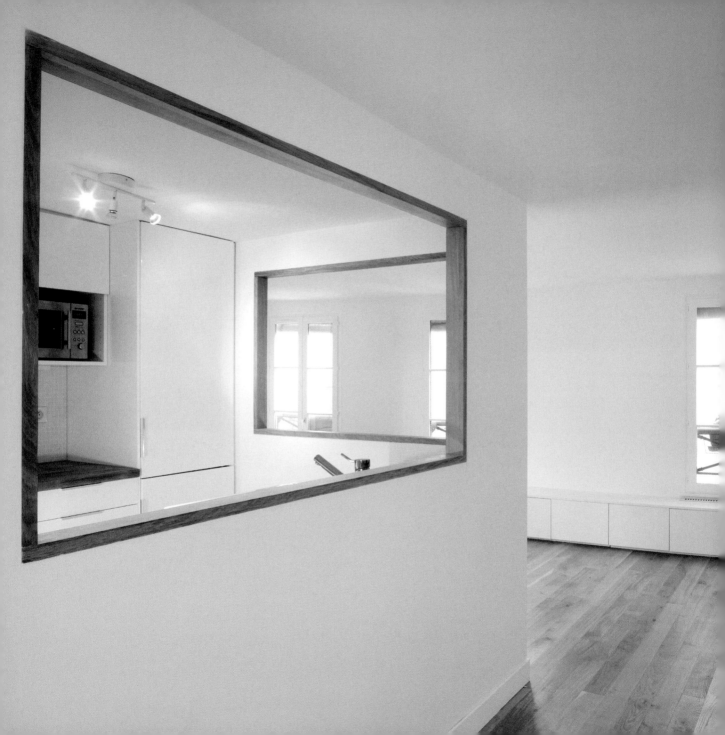

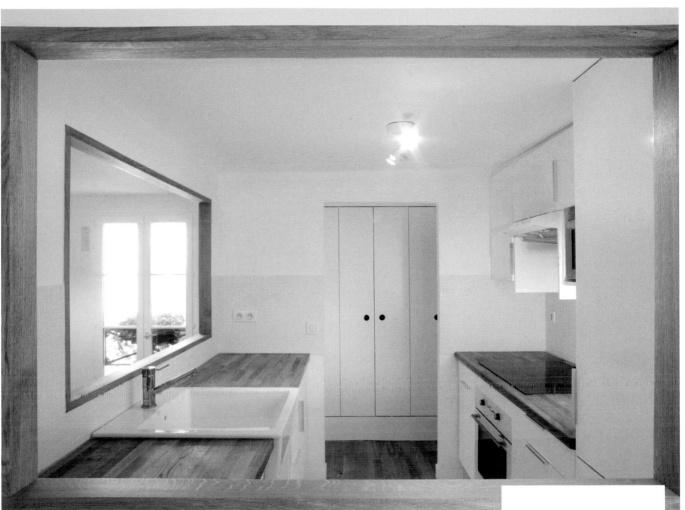

Kiosk
796 sq ft

Architect: Septembre Architecture

Location: Paris, France

Photographer: © David Foessel

The refurbishment of this apartment involved a complete layout reconfiguration to make it less compartmentalized. The result was stunning. Not only did the design make the most of the limited space, but it also added character. Emphasis was put on making the living area as spacious as possible. Taking center stage, the kitchen organizes the different functions of the apartment, creating a sense of entry.

096

Turn your kitchen into a focal point of your living area. Completely open or semi-enclosed, the kitchen can be a place of social interaction where the cook can participate in the conversation.

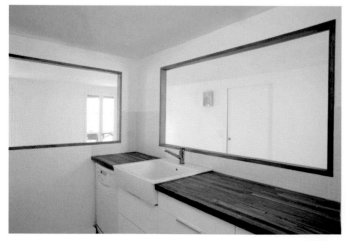

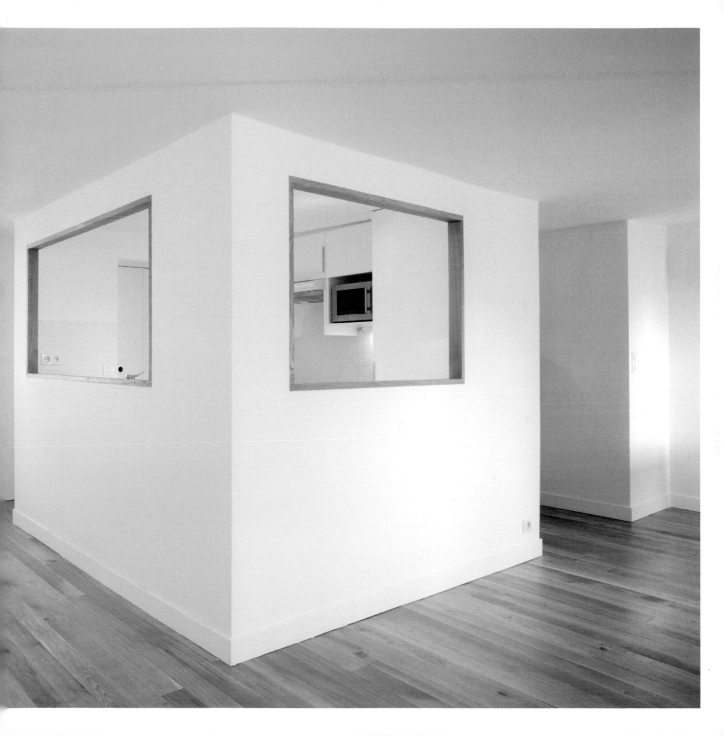

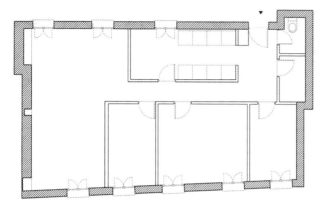

Existing floor plan

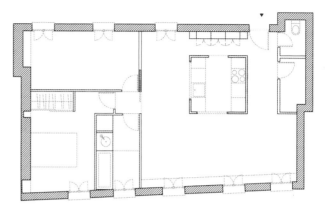

New floor plan

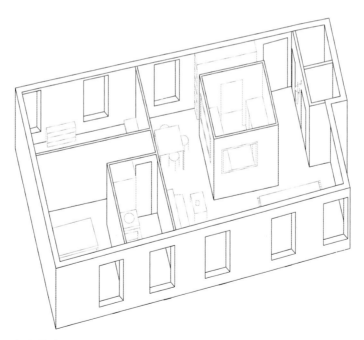

Axonometric view

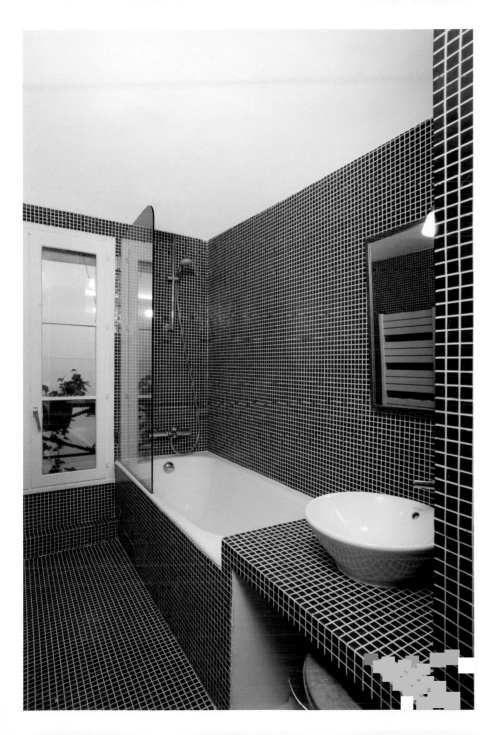

Enhance your bathroom
and add value to your home
by upgrading fixtures and
finishes, adding storage,
and improving lighting.

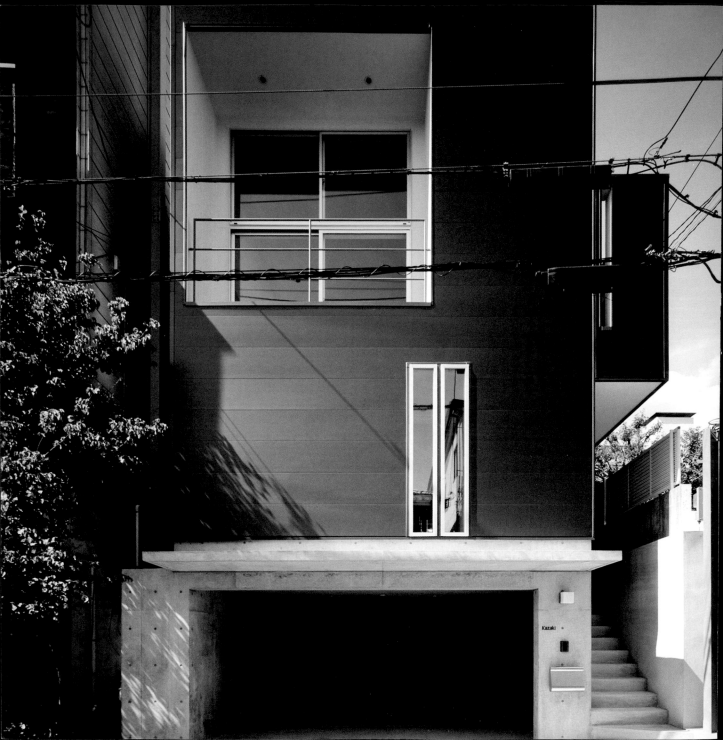

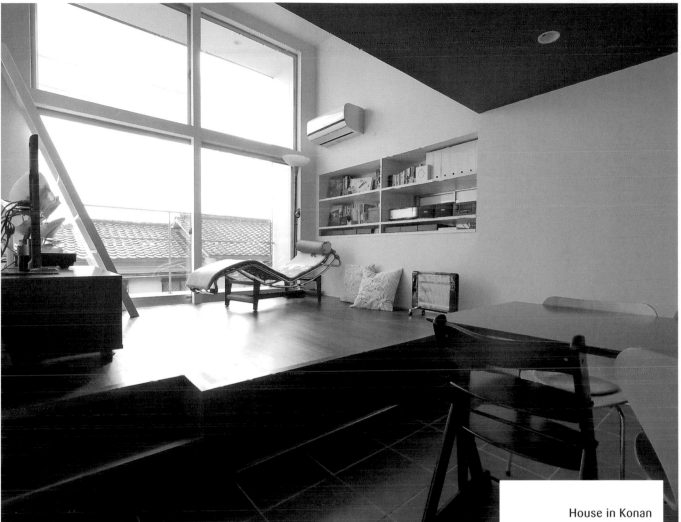

Architect: Coo Planning
Location: Konan, Japan
Photography: Yuko Tada,
Coo Planning

This residence was designed for a couple with children. Despite its small size, the house is smartly laid out on four levels, and manages to fit all the living space the couple needs, including a garage, a deck and a study loft above the kitchen. The simple yet strong design fosters openness by means of a split-level layout that takes advantage of the tall ceiling.

The home's entrance, a tatami room,
a bathroom and a bedroom are on the
floor directly above the garage. The third
floor is the family's communal area, with
an open kitchen and living room.

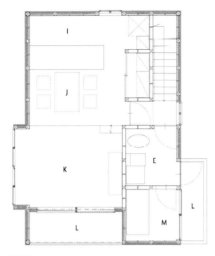

Third-floor plan

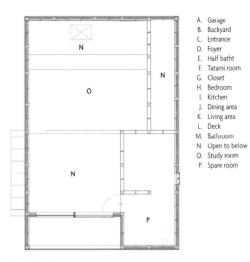

Fourth-floor plan

A. Garage
B. Backyard
C. Entrance
D. Foyer
E. Half batht
F. Tatami room
G. Closet
H. Bedroom
I. Kitchen
J. Dining area
K. Living area
L. Deck
M. Ballroom
N. Open to below
O. Study room
P. Spare room

Ground-floor plan

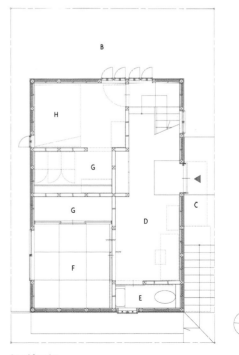

Second-floor plan

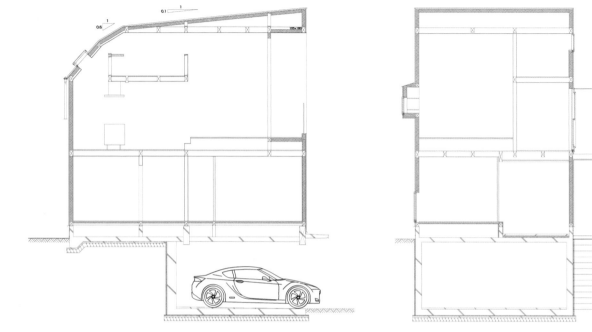

Sections

An open plan is ideal in
rectangular spaces with
windows on either or
both short walls. This
layout helps brighten up
the middle of the space
with even light throughout.

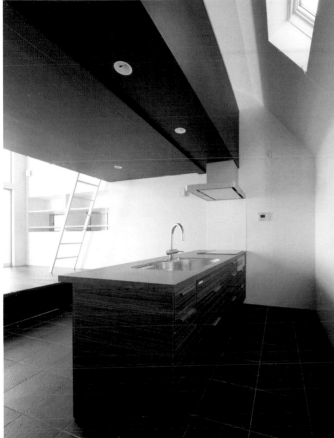

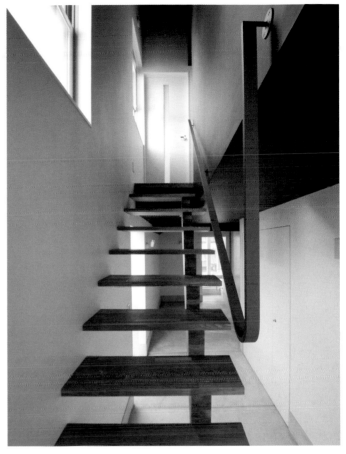

099

Open-riser staircases let the surrounding space breathe through them. This is why they are particularly well suited for small spaces. Their almost weightless appearance creates a smooth transition between levels.

100

The available floor area is a determining factor when you are deciding between a regular staircase and a ladder. What you'll use the upper floor for and how often you'll use it will influence your decision.

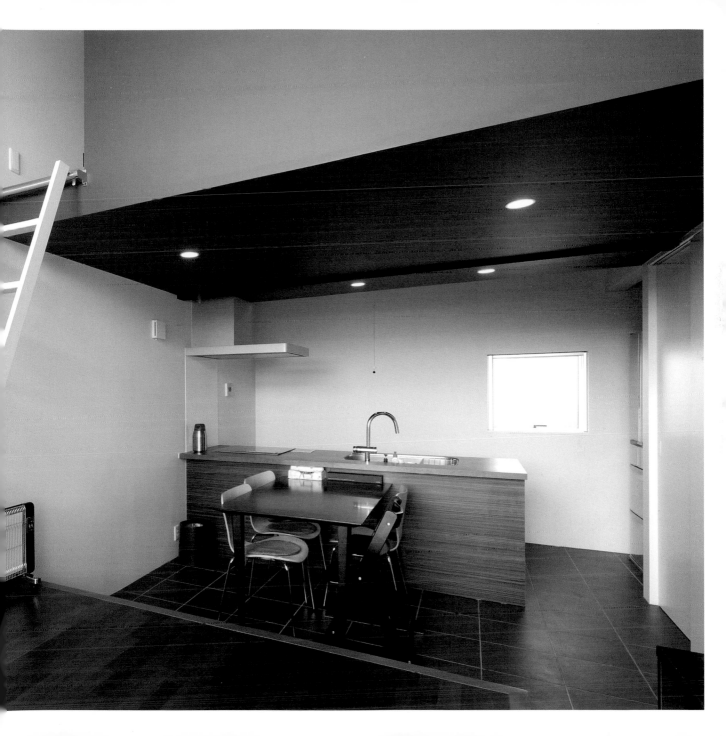

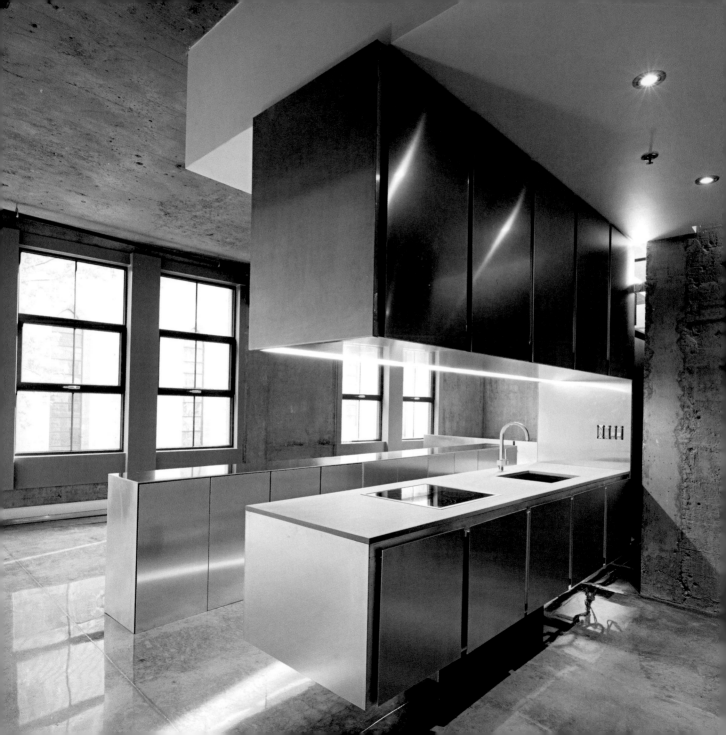

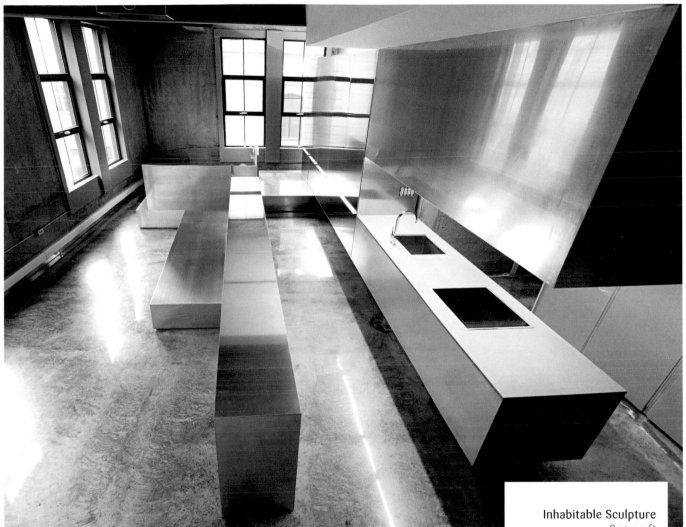

Inhabitable Sculpture
807 sq ft

Architect: Jean-Maxime
Labrecque, Architecte
Location: Montreal, QB, Canada
Photographer: © Frédéric
Bouchard

Two conditions were established by the client at the beginning of this project: "a space that people will find cold" and "living in a gallery." In response to these requirements, the existing space was stripped down to its original industrial concrete walls, floors and ceilings. Then a multifunctional piece of furniture made of raw aluminum, inspired by Donald Judd's work, was installed.

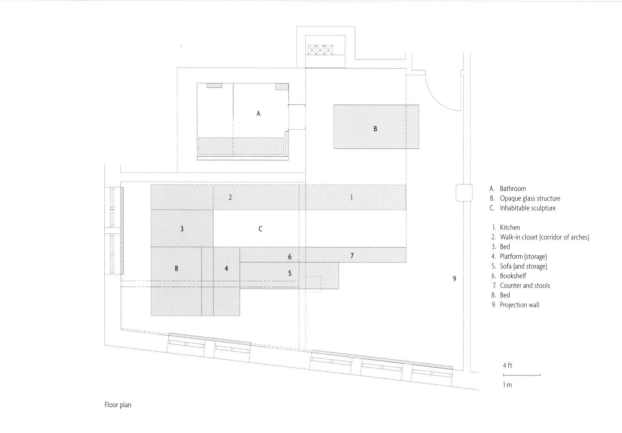

A. Bathroom
B. Opaque glass structure
C. Inhabitable sculpture

1. Kitchen
2. Walk-in closet (corridor of arches)
3. Bed
4. Platform (storage)
5. Sofa (and storage)
6. Bookshelf
7. Counter and stools
8. Bed
9. Projection wall

4 ft

1 m

Floor plan

The aluminum cabinet is composed of modules and fulfills all the dwelling's functions: bed, walk-in closet, bookshelf, sofa, counter, stools, kitchen and storage.

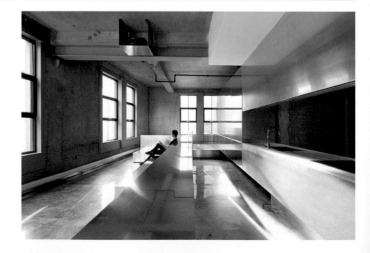

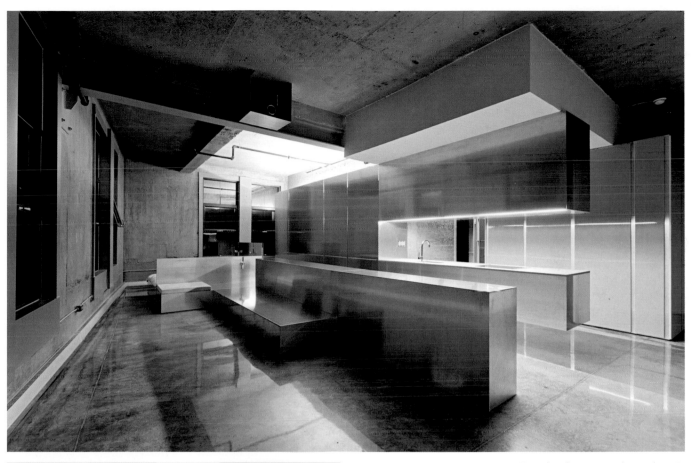

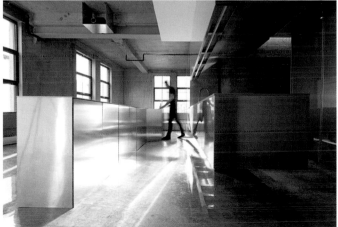

Two other elements complement the main area's aluminum cabinet: an opaque glass structure contains appliances, storage and a water heater, and an old concrete vault houses the bathroom.

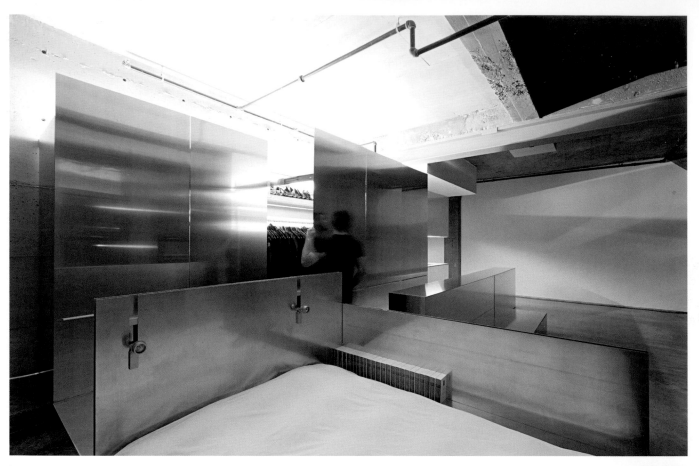

101

Outfit your closet to maximize space, whether it is a reach-in or a walk-in. Every closet needs smart solutions to ensure that everything has a designated spot.

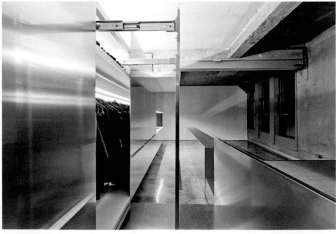

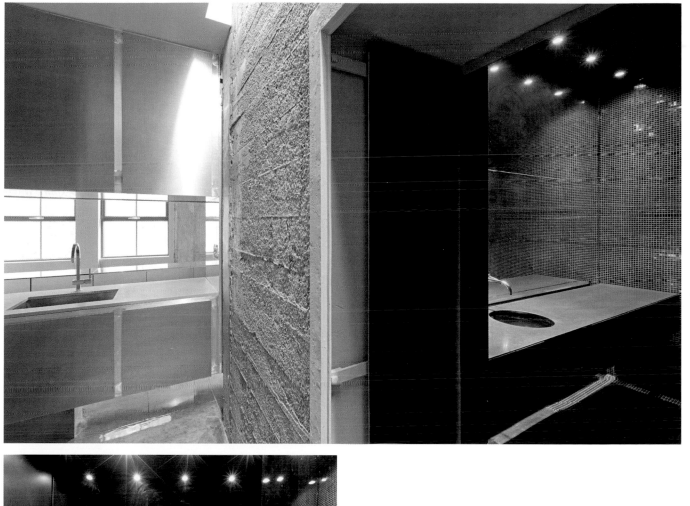

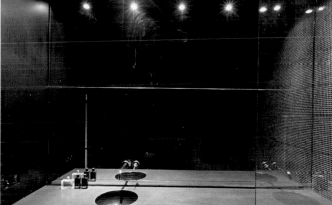

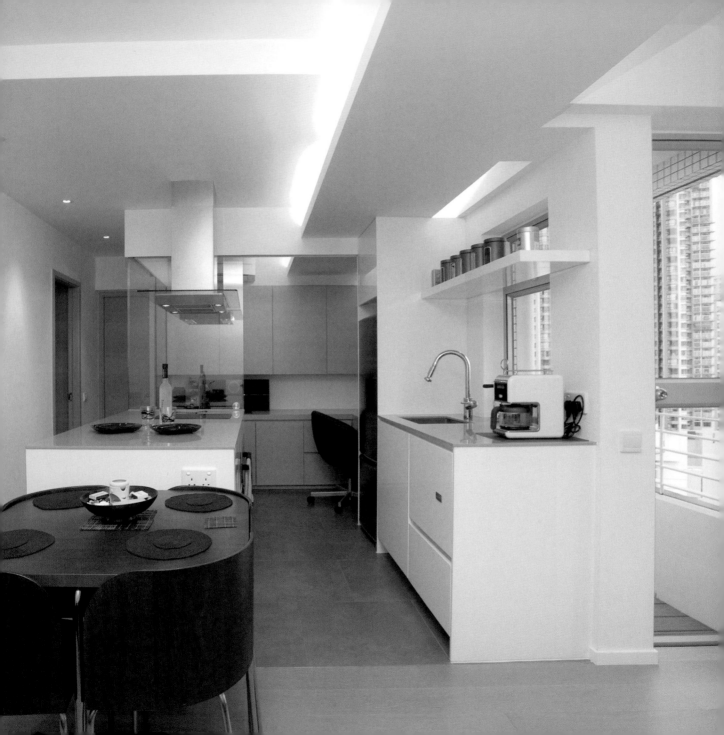

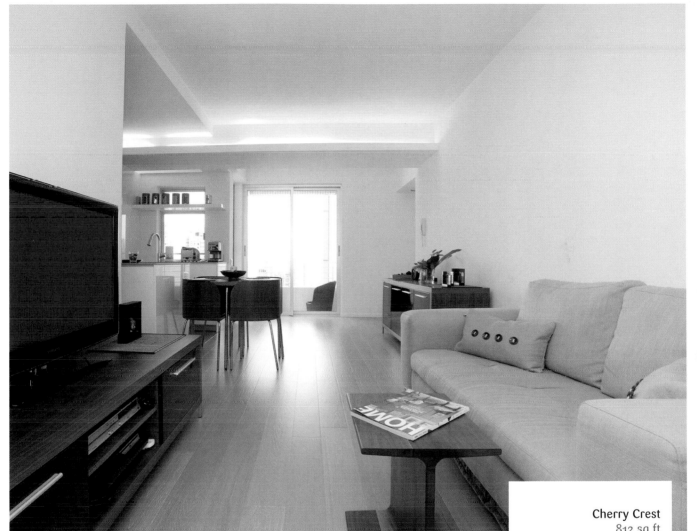

The design of this apartment is aimed toward maximizing the limited space without putting comfort and spaciousness at stake. The uniqueness of this design rests on a careful selection of compact furnishings and equipment. A palette of neutral colors and a good use of natural and artificial lighting were key to achieving the desired atmosphere.

Cherry Crest
812 sq ft

Designer: **Clifton Leung Design Workshop**
Location: **Hong Kong (SAR)**, China
Photographer: © **Red Dog**

Floor plan

The living room and the kitchen
share an open space, which is
further extended by a small balcony
that is only large enough for two
chairs but offers spectacular views.

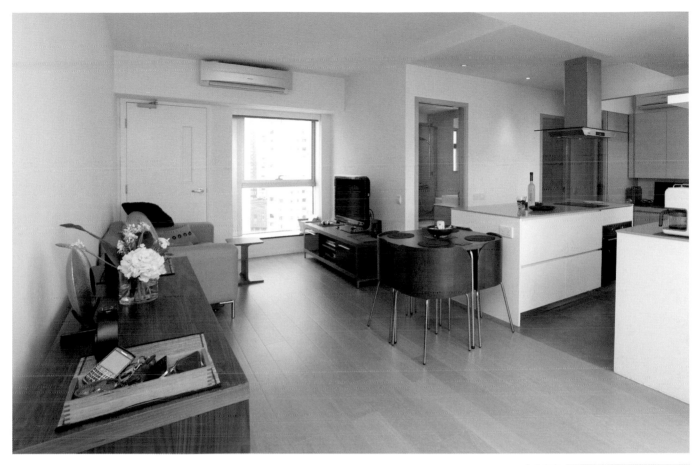

102

Low furniture is best suited
for small rooms with low
ceilings. It's all about scale.
For instance, a large, bulky
armoire generally looks
awkward in a small room.

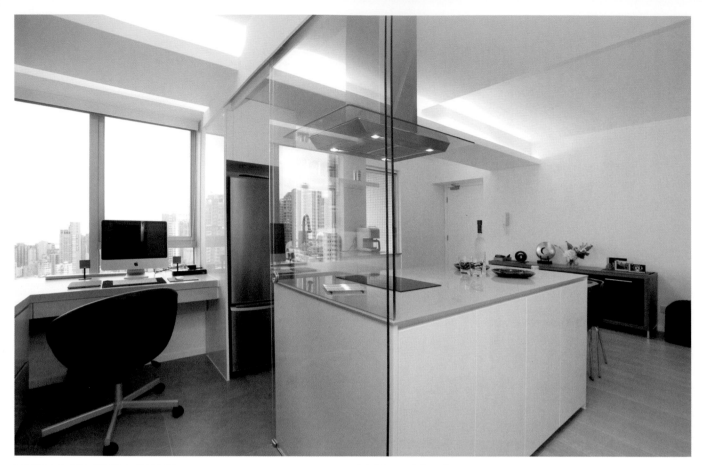

103

To separate two areas that share the same open space without hindering lines or losing airy appeal, use glass partitions or glass sliding doors.

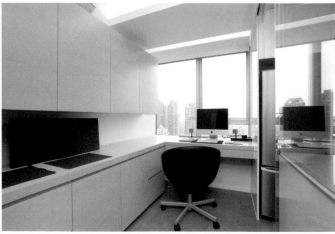

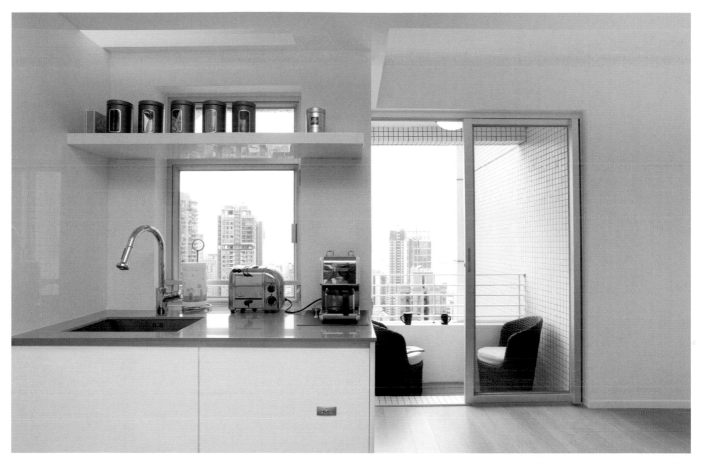

104

Minimize wall partitions as much as possible. Instead, use movable screens, glass dividers or sliding panels to separate different areas. These elements allow for a more flexible space configuration.

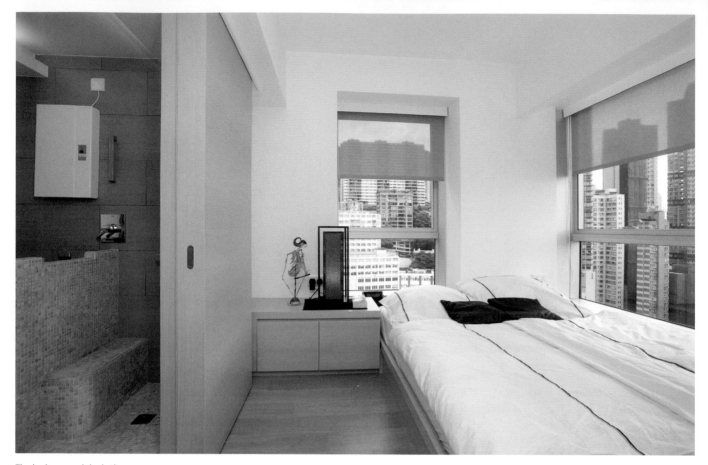

The bedroom and the bathroom are conveniently separated by sliding doors. The use of sliding doors is a space-saving solution throughout the apartment.

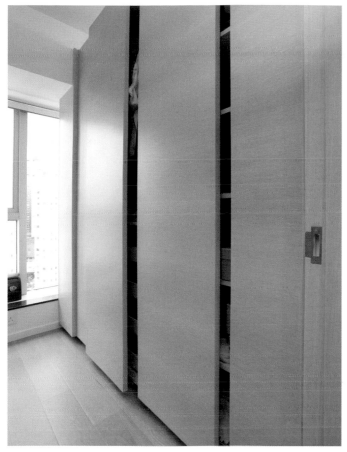
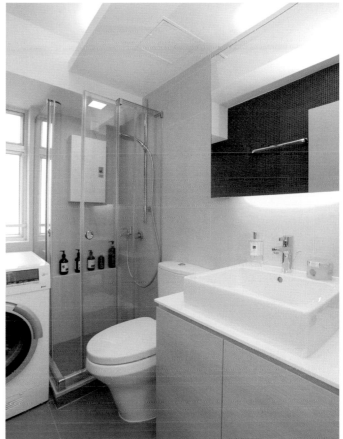

105

Transform a spare room into a dressing room or walk-in closet. This will allow you to clear up your bedroom, make it more spacious and turn it into a retreat for relaxation.

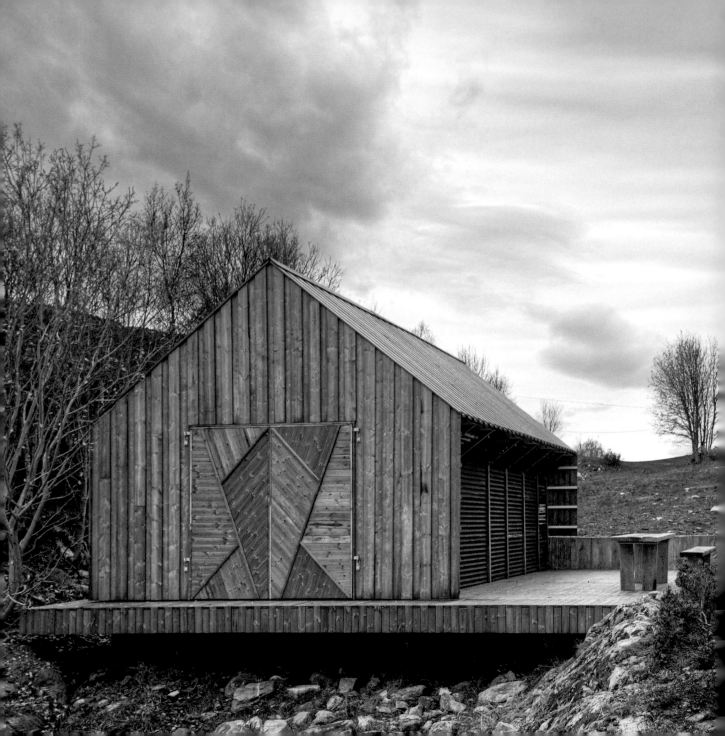

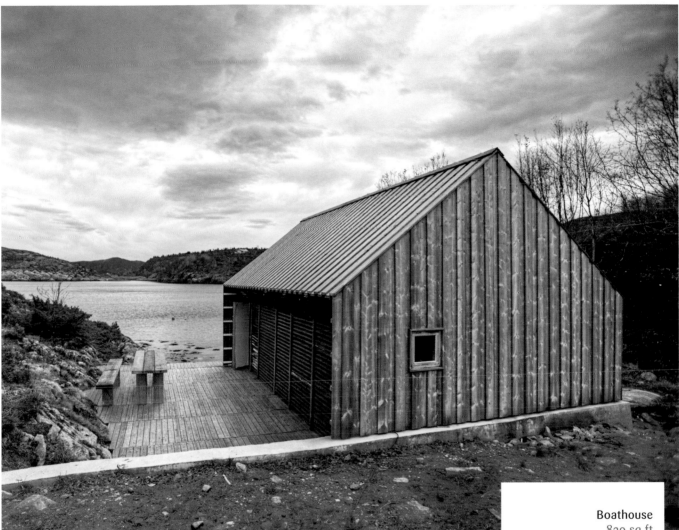

Boathouse
829 sq ft

Architect: TYIN tegnestue Architects

Location: More og Romsdal, Norway

Photographer: © Pasi Aalto

Traditionally, boathouses in Norway's coastal regions were used for storing boats and fishing gear. But today, many of them are being converted into summer homes. This particular boathouse had deteriorated. The owner decided to tear it down and rebuild it. The simplicity of the old structure, the stunning location and the honest use of materials inspired the design.

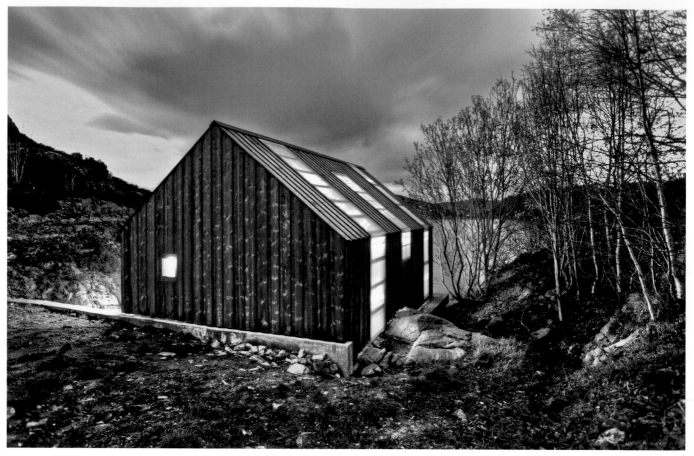

106

Corrugated fiberglass panels are great for exterior siding. They can also be used as inexpensive, decorative interior partitions. The effect produced is similar to that of a shoji screen.

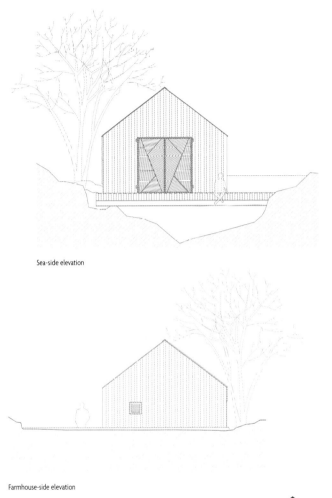

Sea-side elevation

Deck-side elevation

Farmhouse-side elevation

Mountain-side elevation

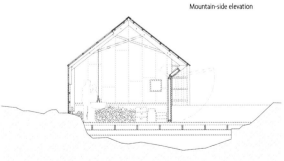

Section

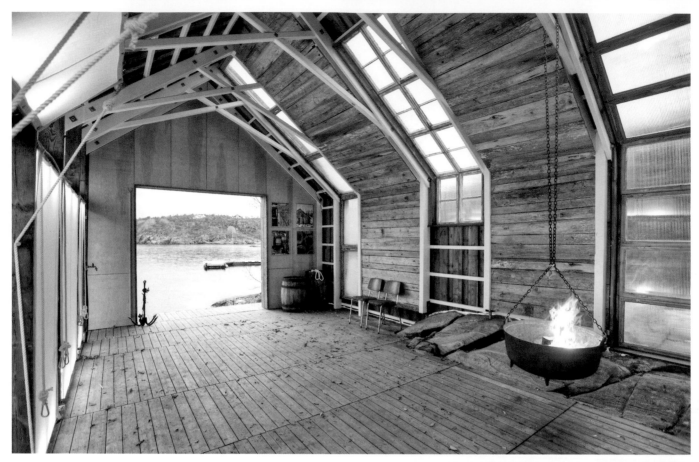

The remoteness of the location made the reuse of materials a key element of the new design. Some of the interior surfaces are clad in reclaimed materials.

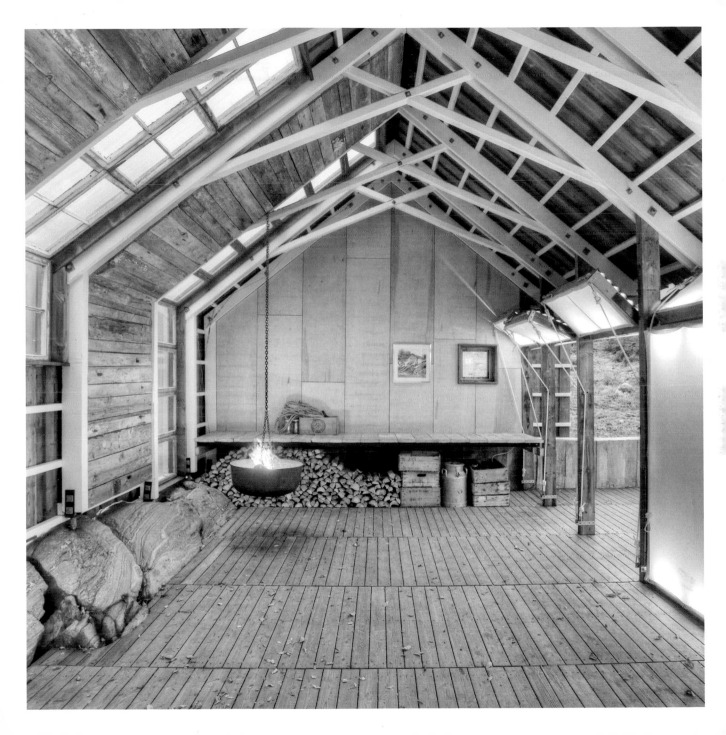

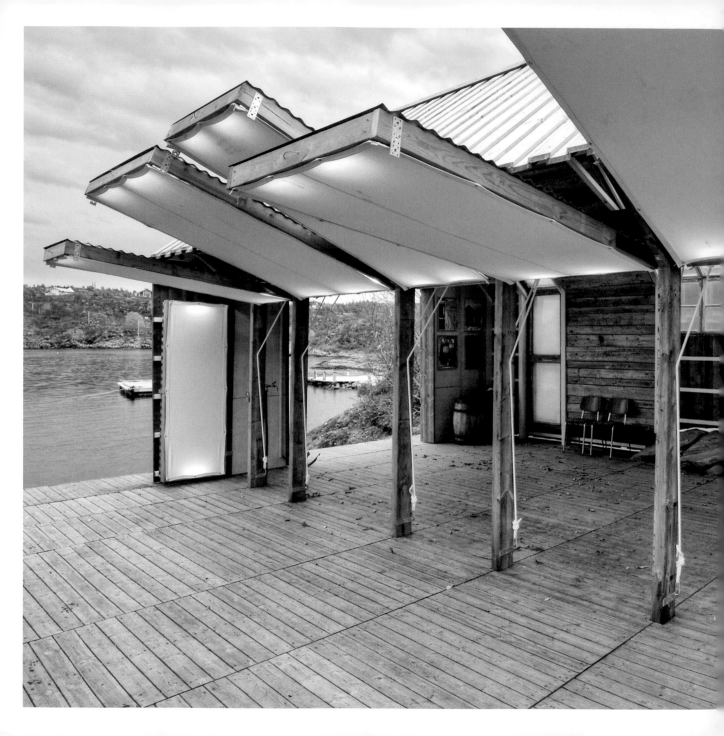

Swing-up doors have a double use: they allow interior activities to easily spill outdoors, and they provide sun protection.

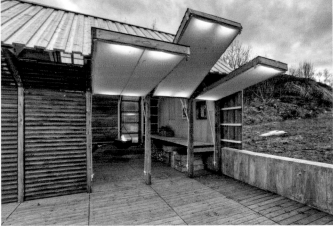

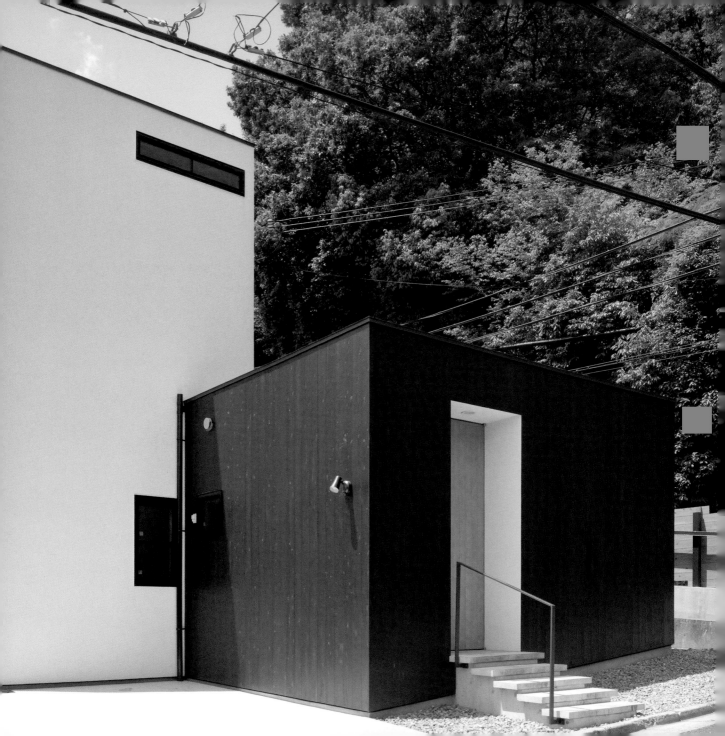

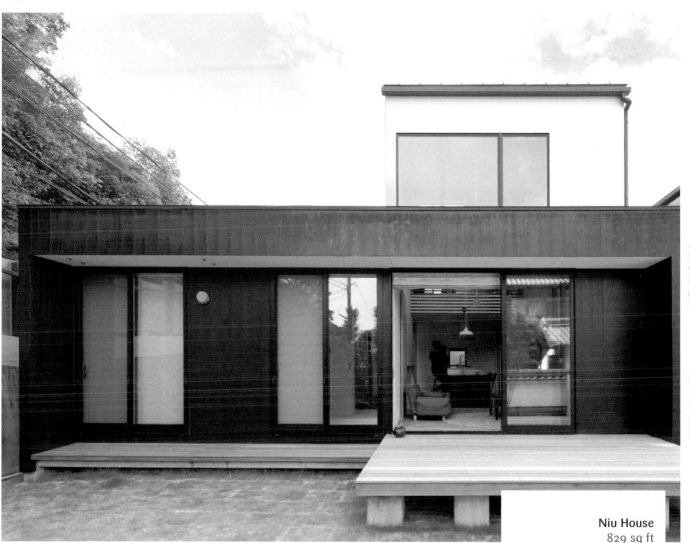

Sandwiched between look-alike prefabricated and traditional Japanese homes, this modern residence was designed for a young couple. Two volumes, one white and the other black, formally differentiate the functions of the house. The two volumes intersect, generating a small courtyard in the center that brings light to the surrounding spaces.

Niu House
829 sq ft

Architect: Yoshihiro Yamamoto
Architects Atelier

Location: Ikoma City,
Nara, Japan

Photographer: © Yohei Sasakura

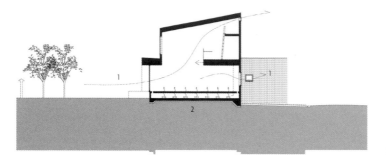

Section

1. Airflow
2. Heating and cooling unit

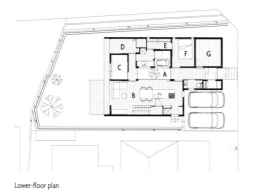

Lower-floor plan

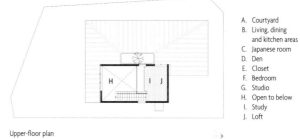

Upper-floor plan

A. Courtyard
B. Living, dining and kitchen areas
C. Japanese room
D. Den
E. Closet
F. Bedroom
G. Studio
H. Open to below
I. Study
J. Loft

108

You can make a small space airy by choosing minimal architectural details. Furniture should be simple, with little ornament. Keep the color palette to a maximum of two shades and an accent color.

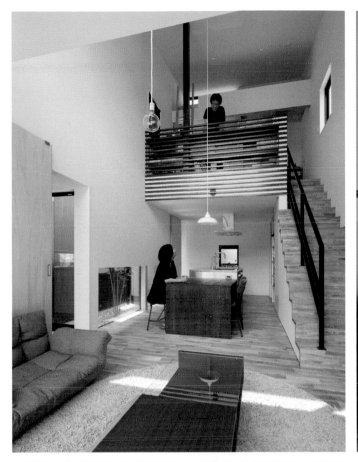

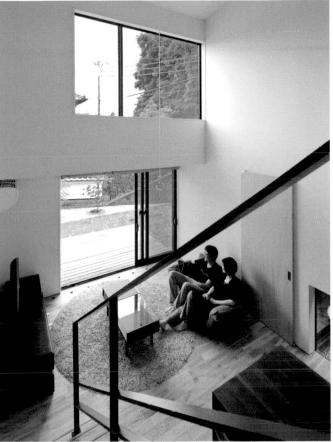

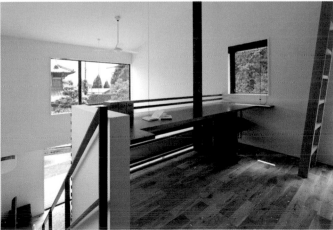

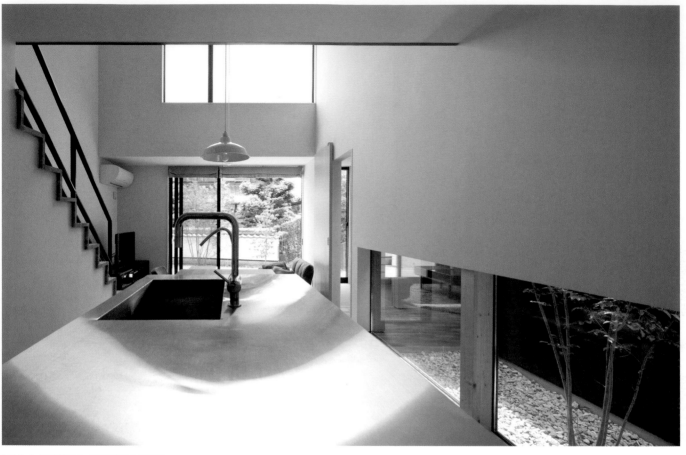

109

The shape and location of windows can dramatically change the perception of a space, more so if the space is small: for instance, a horizontal window visually elongates the space.

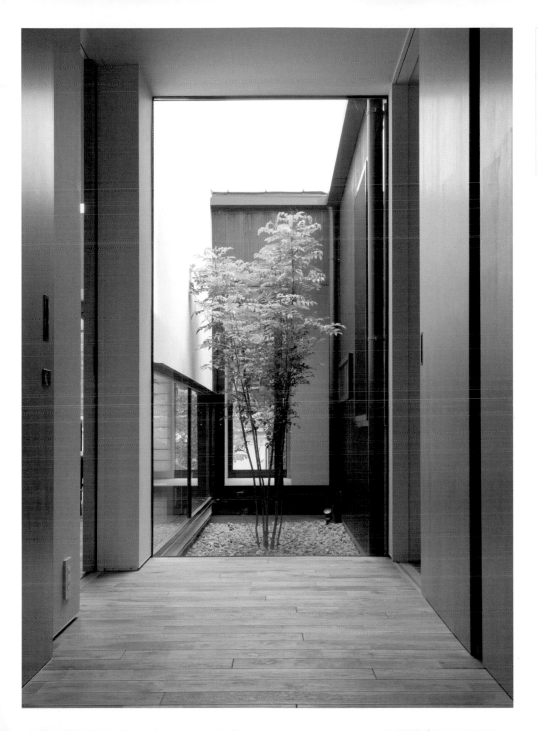

Centrally located, a courtyard can be a feature around which the plan of a house is organized. It also compensates for the limited dimensions of a space.

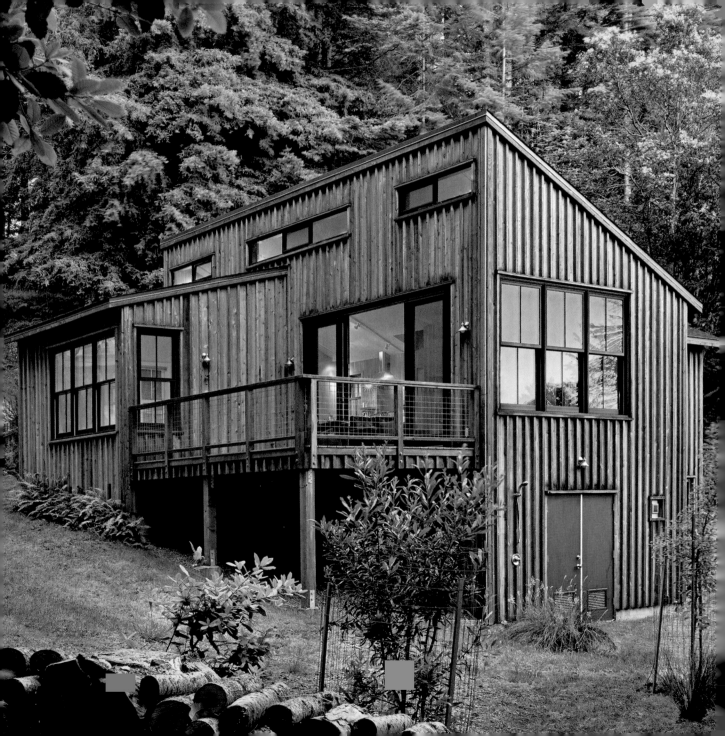

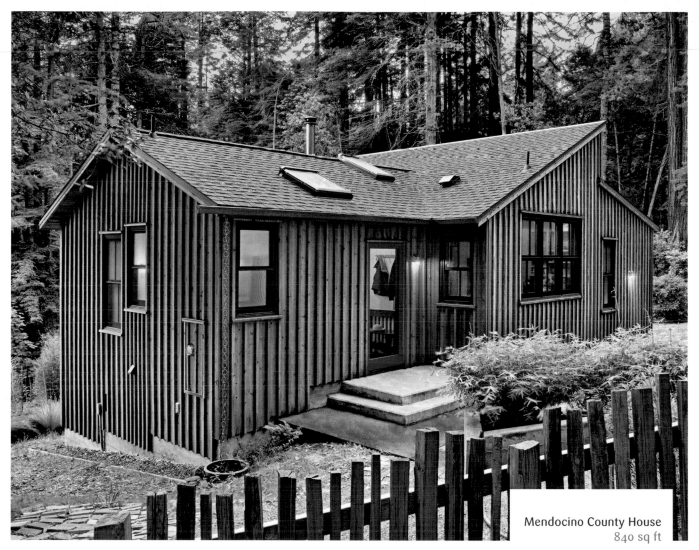

Mendocino County House
840 sq ft

Designed as a weekend getaway, this compact two-bedroom cottage was built on a challenging site that determined its size and orientation. The site is steep, and as the neighboring houses are likely candidates for expansion, the orientation and placement of the openings needed be chosen to ensure permanent privacy and open views.

Architect: Cathy Schwabe Architecture

Location: Gualala, CA, USA

Photographer: © David Wakely Photography

The cottage has an intimate feel with a sense of privacy, which makes it a wonderful retreat for a couple. At the same time, the unexpected feeling of spaciousness makes it comfortable enough for groups.

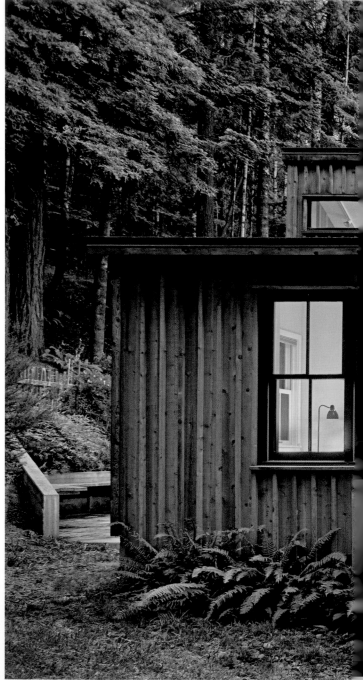

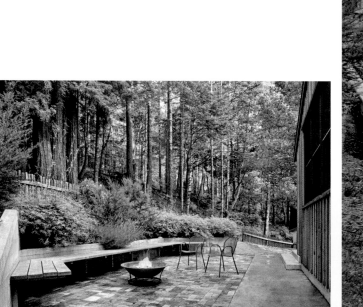

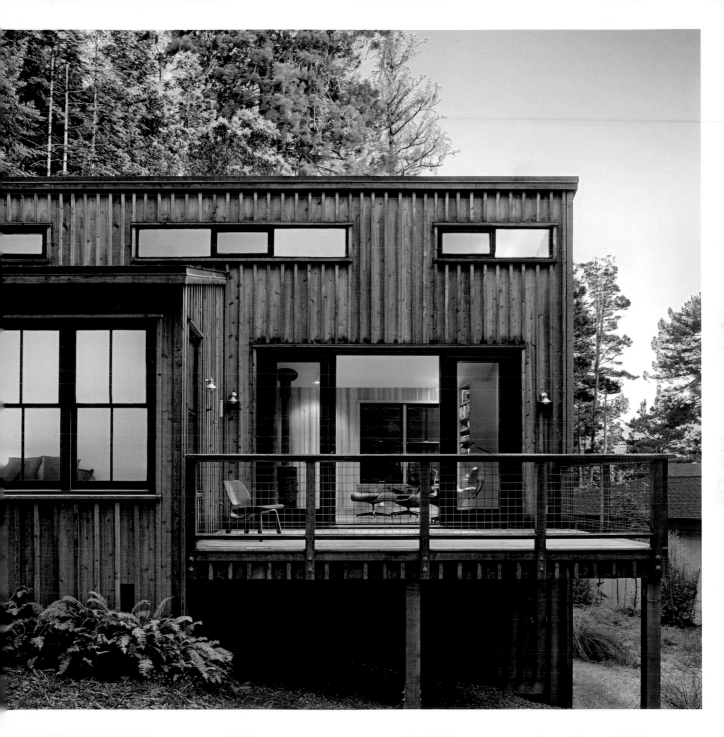

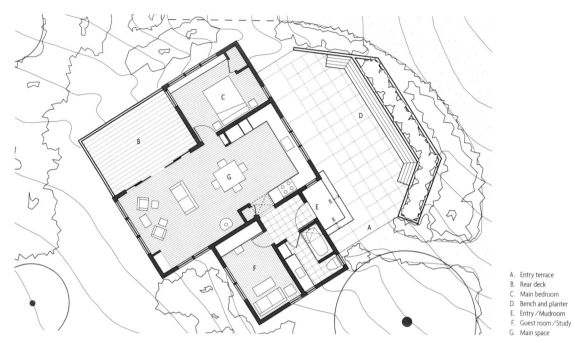

Floor plan

A. Entry terrace
B. Rear deck
C. Main bedroom
D. Bench and planter
E. Entry / Mudroom
F. Guest room / Study
G. Main space

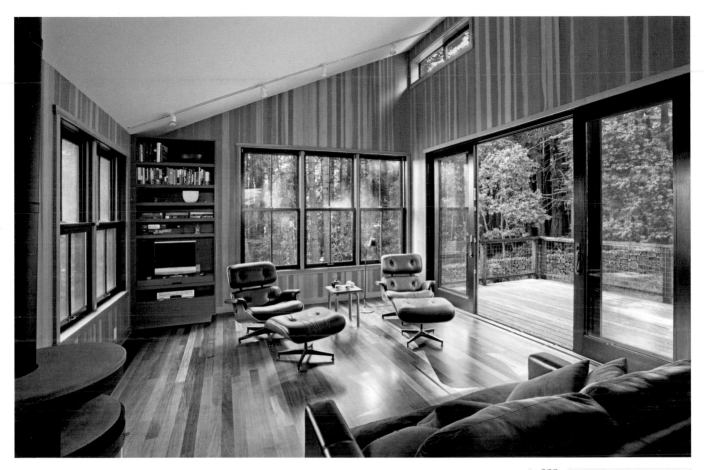

Small spaces should combine functions to the greatest extent possible, and dedicated circulation space should be kept to a minimum.

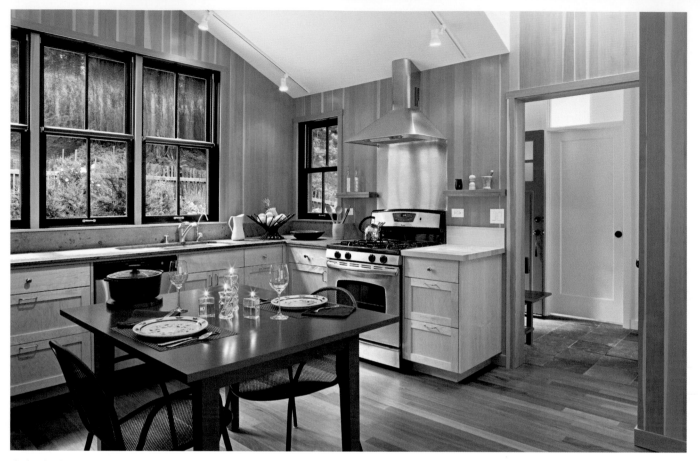

The height of the repeated simple volume of each room, a one-way sloped cathedral ceiling and openings on multiple sides make the rooms seem larger than they are.

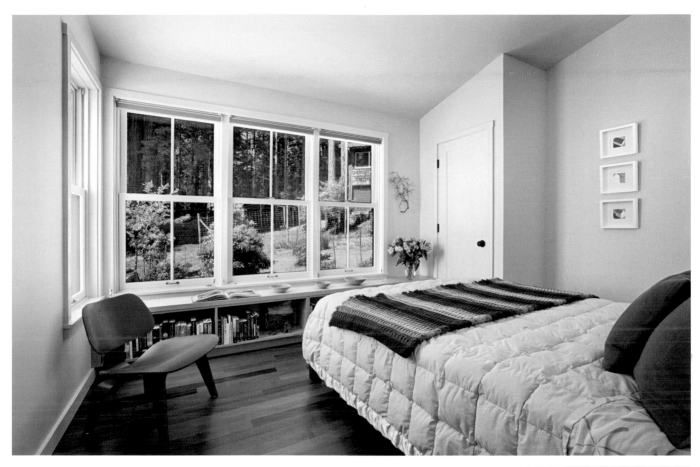

112

Built-in cabinets, used wherever possible, decrease the need for additional furniture and require less floor area.

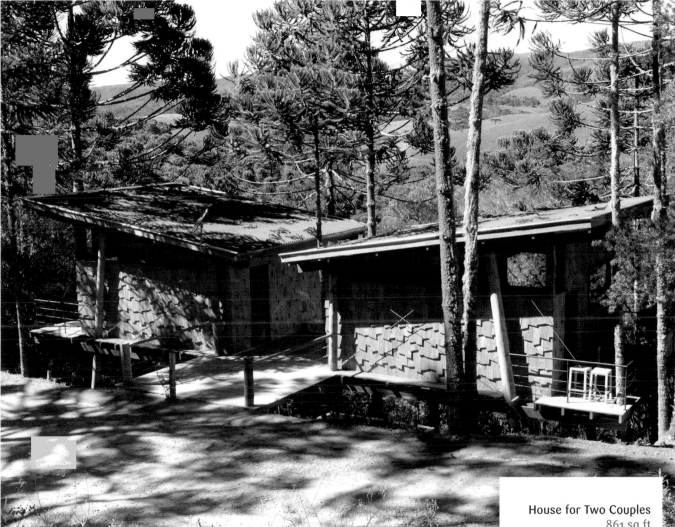

House for Two Couples
861 sq ft

Architect: Cabana Arquitetos

Location: Campos do Jordão,
São Paulo, Brazil

Photographer: © Andre
Eisenlohr

Implanted among trees, the construction is camouflaged by nature's surroundings so as not to be hidden from view. The house design consists of two modules, 270 square feet each, mounted on a deck of 321 square feet. The modules, which are separated by two Chilean pines, are each equipped with a bedroom, a kitchen and a bathroom. The scale of the plan was reduced, allowing the smallest area possible.

Section

Floor plan

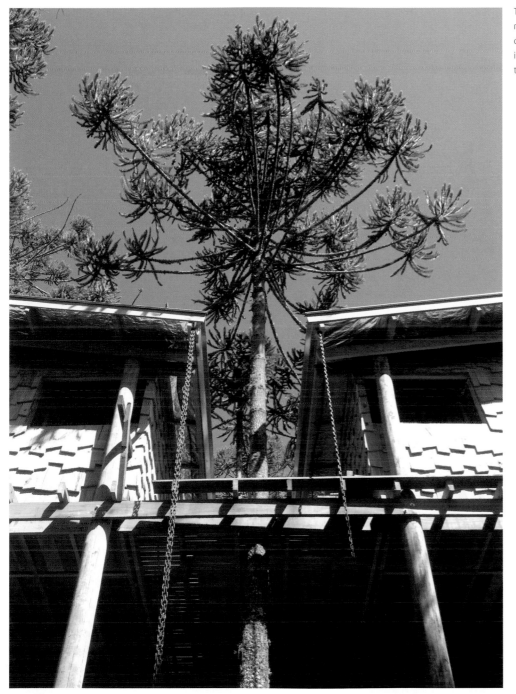

The house has an eye-catching roofline with two shed roofs. The overall design is geometric, but it fits well among the trees, thanks to its construction entirely of wood.

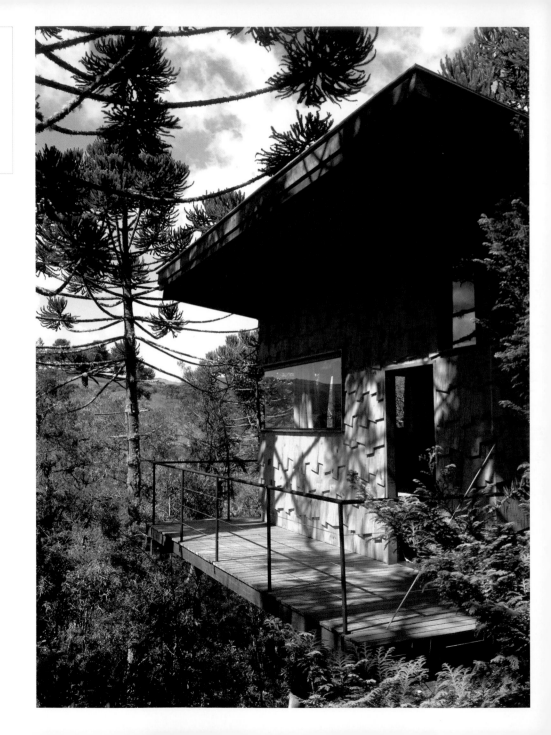

113

Balconies may be just small extensions, but their effect on the interior space is big; they are a valuable asset for tiny spaces.

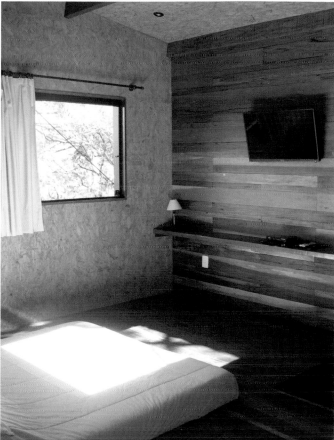

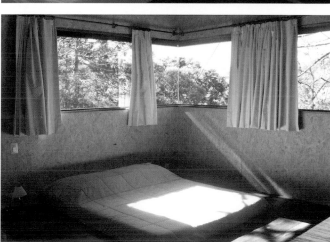

114

You can focus on the materials and colors of a small interior if you keep furnishings and decorations to a minimum. The sparse built-in furniture and rough finishes give this space a monastic atmosphere.

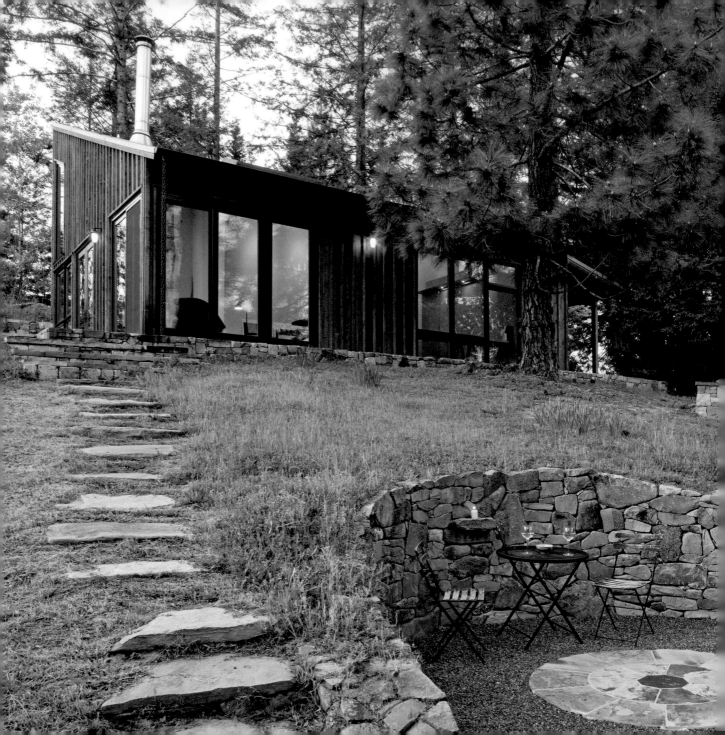

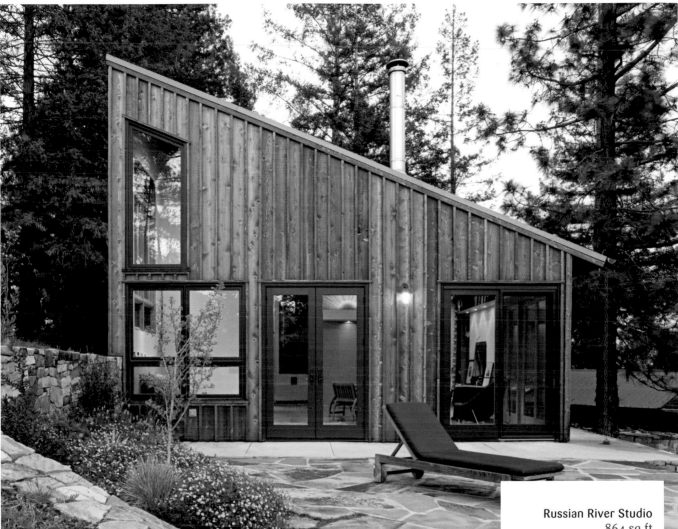

Russian River Studio
864 sq ft

Architect: Cathy Schwabe
Architecture
Location: Forestville, CA, USA
Photographer: © David Wakely
Photography

This studio was built as an addition to an existing log cabin. Its layout is simple: a narrow spine of enclosed spaces under a storage loft and a large, rectangular, light-filled main room. This rectangle expands to include an area with a desk behind sliding panels and a sitting area in another corner that can also be used for sleeping.

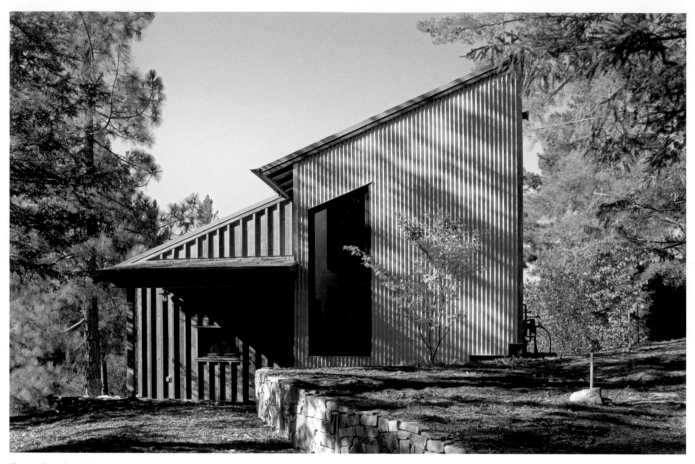

The small studio, which opens onto a setting of terraces and stepped stone walls, acts as both an extension of the main dwelling and a separate building in the landscape.

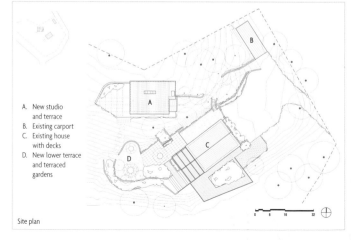

A. New studio
 and terrace
B. Existing carport
C. Existing house
 with decks
D. New lower terrace
 and terraced
 gardens

Site plan

Storage-level plan

Roof plan

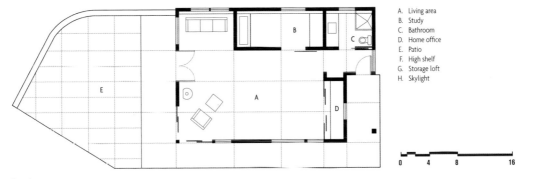

A. Living area
B. Study
C. Bathroom
D. Home office
E. Patio
F. High shelf
G. Storage loft
H. Skylight

0 4 8 16

Floor plan

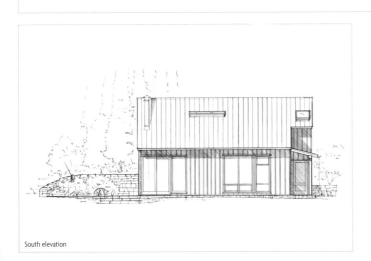

South elevation

115

High ceilings help a space feel airy. Even better, windows at different heights on two or more walls of a room distribute the light evenly, avoiding dark corners.

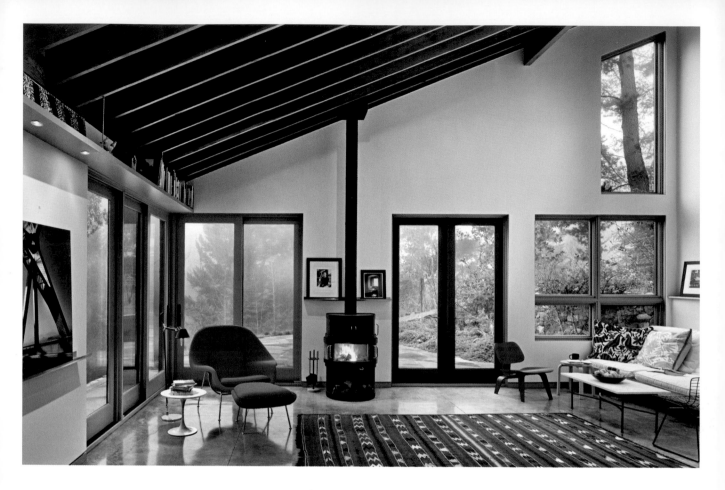

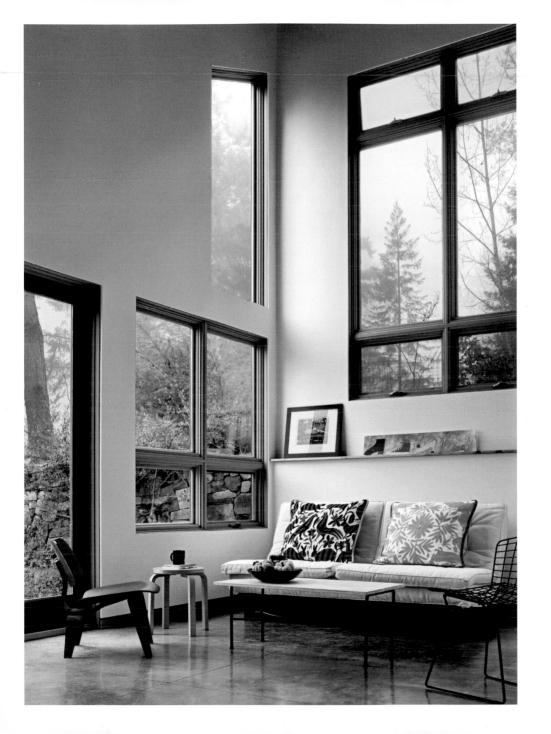

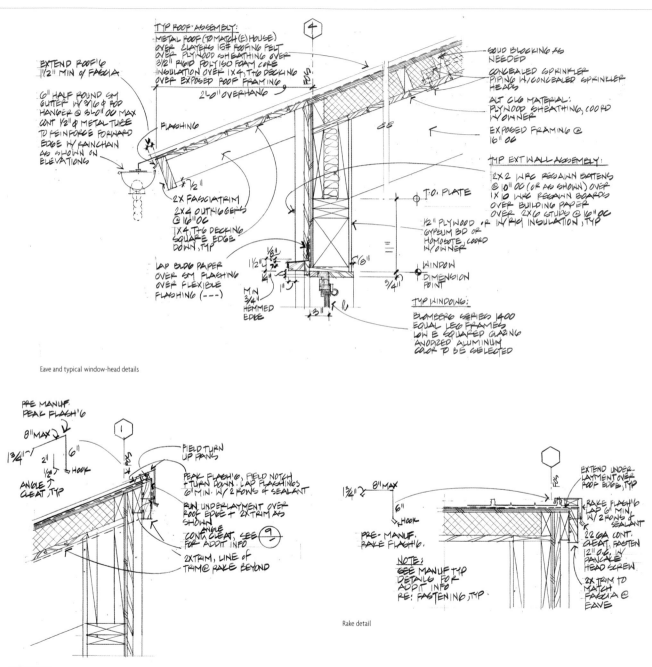

TYP ROOF ASSEMBLY:
METAL ROOF (TO MATCH (E) HOUSE)
OVER 2 LAYERS 15# ROOFING FELT
OVER PLYWOOD SHEATHING OVER
3½" RIGID POLYISO FOAM CORE
INSULATION OVER 1X4, T&G DECKING
OVER EXPOSED ROOF FRAMING

2'-0" OVERHANG

4

FLASHING

EXTEND ROOF'G
1½" MIN @ FASCIA

6" HALF ROUND SM
GUTTER W/ 3/16 ∅ ROD
HANGER @ 3'-0" OC MAX
CONT ½" ∅ METAL TUBE
TO REINFORCE FORWARD
EDGE W/ RAINCHAIN
AS SHOWN ON
ELEVATIONS

SOLID BLOCKING AS
NEEDED

CONCEALED SPRINKLER
PIPING W/ CONCEALED SPRINKLER
HEADS

ALT CLG MATERIAL:
PLYWOOD SHEATHING, COORD
W/OWNER

EXPOSED FRAMING @
16" OC

½"

2X FASCIA TRIM
2X4 OUTRIGGERS
@ 16" OC
1X4, T&G DECKING
SQUARE EDGE
DOWN, TYP

LAP BLDG PAPER
OVER SM FLASHING
OVER FLEXIBLE
FLASHING (---)

⅛"
1½"
¾"
1"

MIN
¾"
HEMMED
EDGE

3"

T.O. PLATE

TYP EXT WALL ASSEMBLY:
2X2 WRC RESAWN BATTENS
@ 10" OC (OR AS SHOWN) OVER
1X10 WRC RESAWN BOARDS
OVER BUILDING PAPER
OVER 2X6 STUDS @ 16" OC
W/ R19 INSULATION, TYP

½" PLYWOOD OR
GYPSUM BD OR
HOMOSOTE, COORD
W/OWNER

6"

WINDOW
DIMENSION
POINT

¾"

TYP WINDOWS:
BLOMBERG SERIES 1400
EQUAL LEG FRAMES
LOW E SQUARED GLAZING
ANODIZED ALUMINUM
COLOR TO BE SELECTED

Eave and typical window-head details

PRE MANUF.
PEAK FLASH'G

8" MAX
1¾"
2"
½"
6"
HOOK

1

ANGLE
CLEAT, TYP

FIELD TURN
UP PANS

PEAK FLASH'G, FIELD NOTCH
+ TURN DOWN. LAP FLASHINGS
6" MIN W/ 2 ROWS OF SEALANT

RUN UNDERLAYMENT OVER
ROOF EDGE + 2X TRIM AS
SHOWN

ANGLE
CONT. CLEAT, SEE 9
FOR ADDIT INFO

2X TRIM, LINE OF
TRIM @ RAKE BEYOND

Roof peak detail

1¾" 2
8" MAX
6"
HOOK

PRE-MANUF.
RAKE FLASH'G.

NOTE:
SEE MANUF TYP
DETAILS FOR
ADDIT INFO
RE: FASTENING, TYP.

EXTEND UNDER-
LAYMENT OVER
ROOF EDGE, TYP

RAKE FLASH'G
LAP 6" MIN
W/ 2 ROWS OF
SEALANT

22 GA CONT.
CLEAT, FASTEN
12" OC. W/
PANCAKE
HEAD SCREW

2X TRIM TO
MATCH
FASCIA @
EAVE

Rake detail

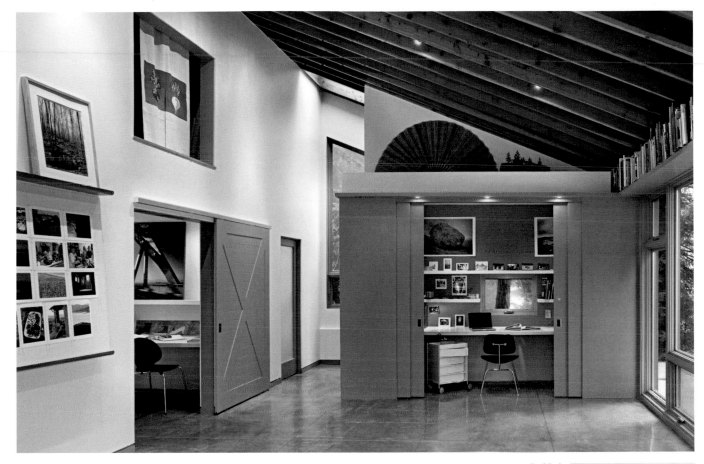

116

Combining a comfortable living area with an efficient home office is a challenge. A wall-mounted desktop and shelves concealed behind sliding doors make a perfect incognito workspace.

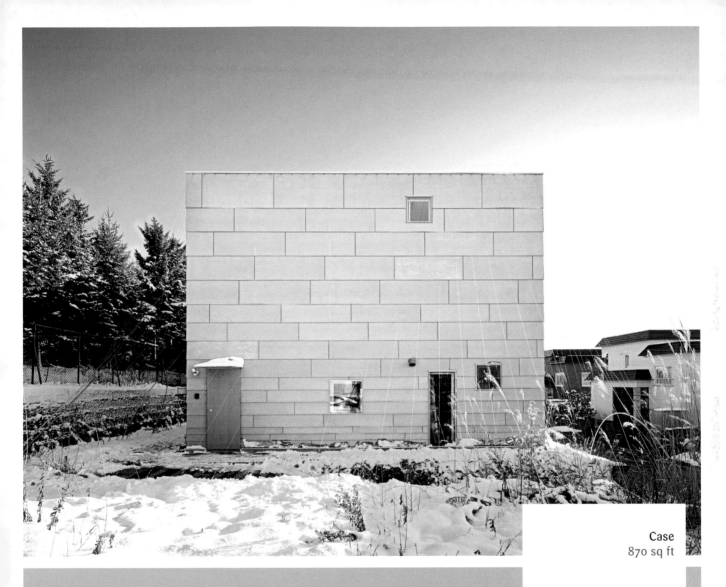

Case
870 sq ft

Architect: **Jun Igarashi Architects**
Location: Sapporo,
Hokkaido, Japan
Photographer: © Daici Ano

This house's footprint was determined by setbacks from the street and adjacent buildings, regulated by city planning laws. But this didn't get in the way of creating a spacious dwelling. Two winding steel staircases connect the various levels, all open under a 23-foot-high ceiling.

117

Connect adjacent spaces visually by means of openings. By doing this, you'll add depth and visual interest to a space. Light is an important design component that enhances this effect.

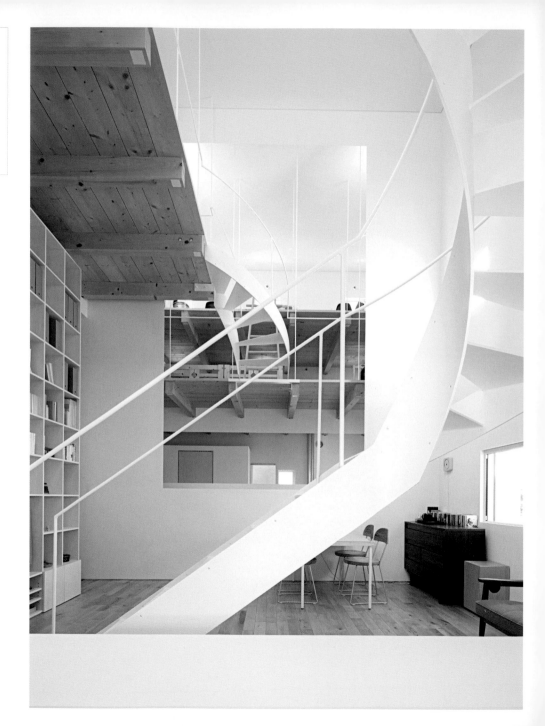

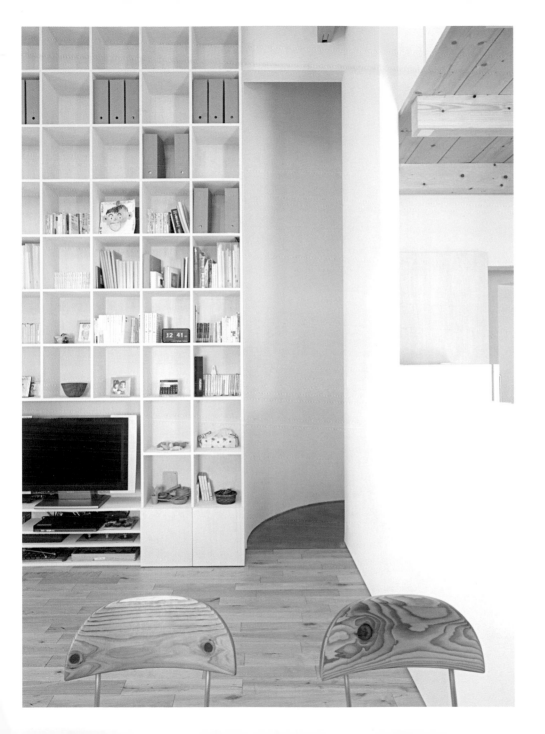

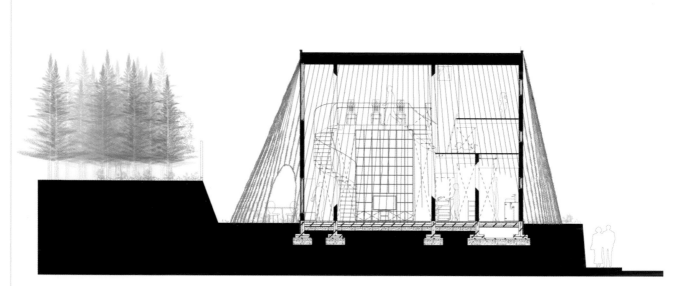

Section

The driving concept of this house's design is connectivity. One level leads effortlessly to the next by means of simple spiral staircases. A story-spanning bookcase enhances the verticality of the space.

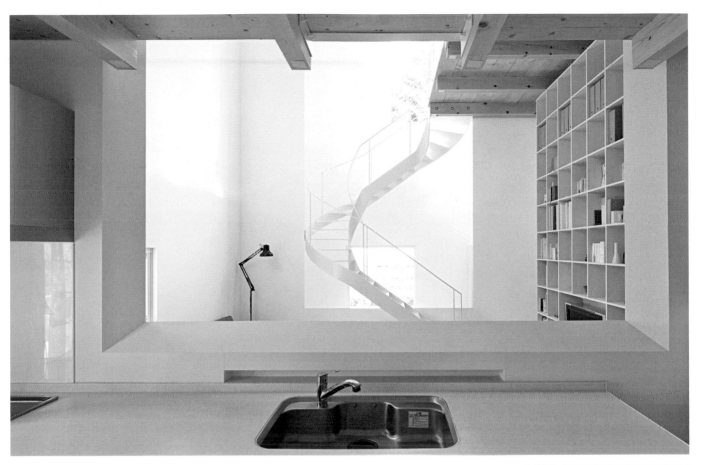

118

The lack of art on the walls and the limited color and material selection direct the attention to the architectural qualities of the house. These design decisions contributed to the creation of an airy atmosphere.

119

Where privacy is necessary, such as in the bathroom on the ground floor, curved walls are an unconventional but creative solution. They express the idea of flexibility and movement.

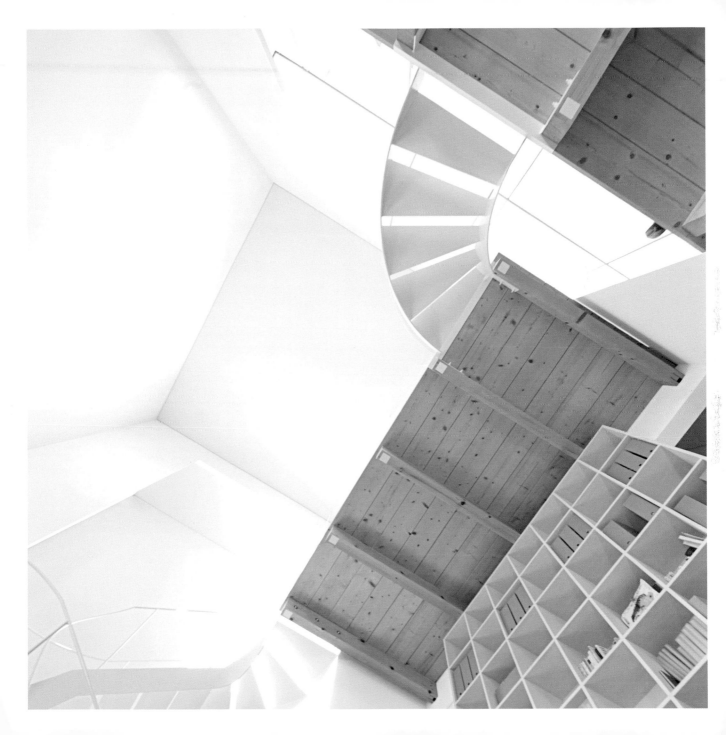

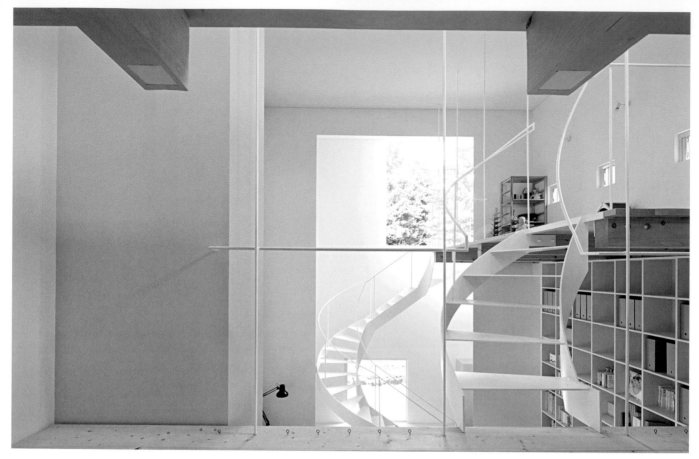

120

Open-riser staircases are perhaps the least obstructive design. Their appearance is generally weightless. This quality makes them an excellent choice for small spaces.

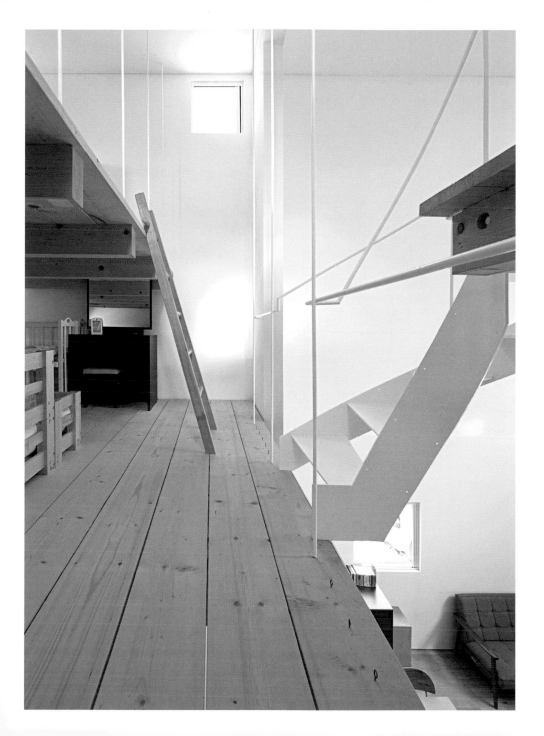

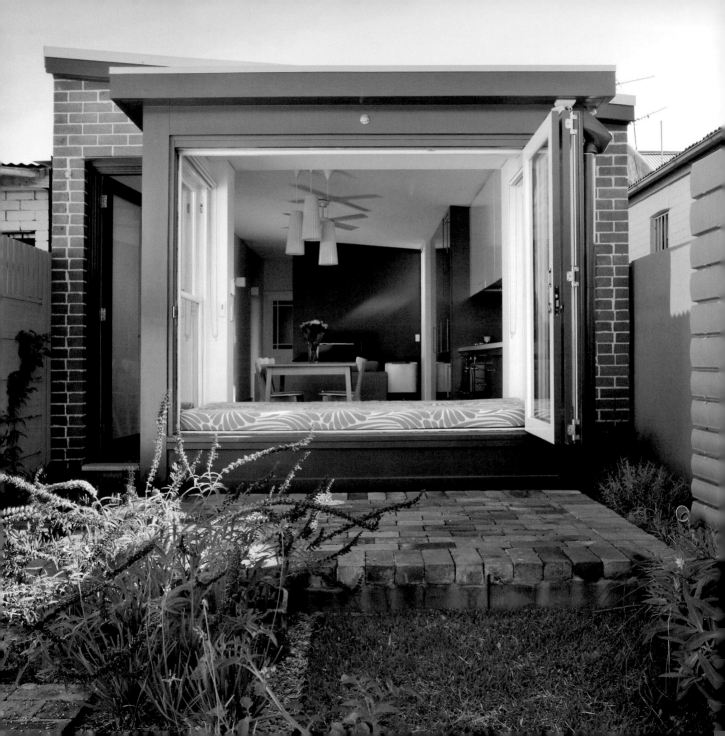

The house is a Victorian semidetached single-level cottage. While the front has beautiful rooms, the back was a series of small and oddly arranged rooms that had no relationship to the backyard. The back half of the cottage was demolished to make room for a more space-efficient layout and to establish a connection with the backyard.

Victorian Workers Cottage Addition
871 sq ft

Architect: Danny Broe Architect

Location: Enmore, West Sydney, Australia

Photographer: © Karina Illovska

The most prominent feature of the new design is the bay window at the back of the cottage. It provides a threshold between the interior space and the backyard. Rather than just an access, it is also an informal place to relax.

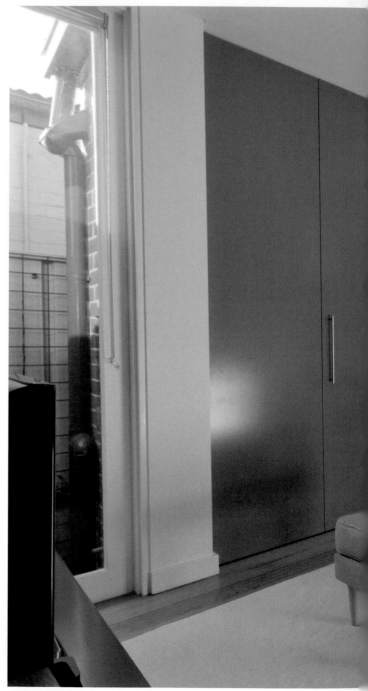

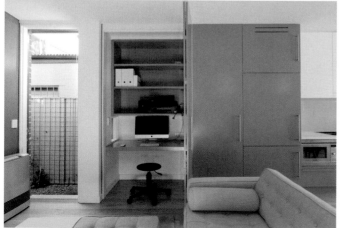

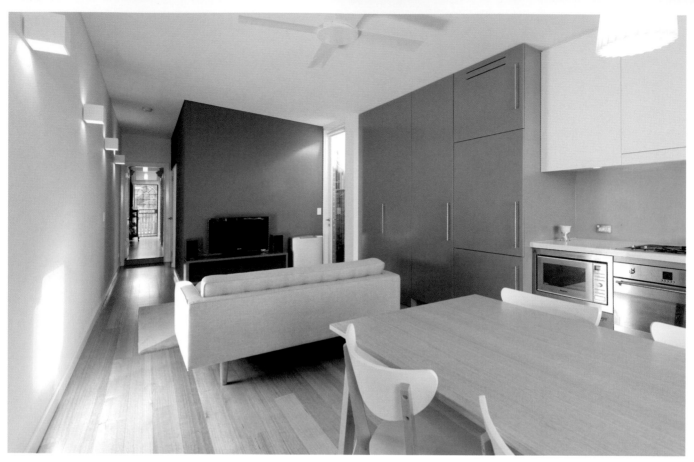

121

Use light colors to make walls recede and vibrant colors to create focal points. Paint large, bulky elements with different colors to reduce their scale and adapt them better to the proportions of a small space.

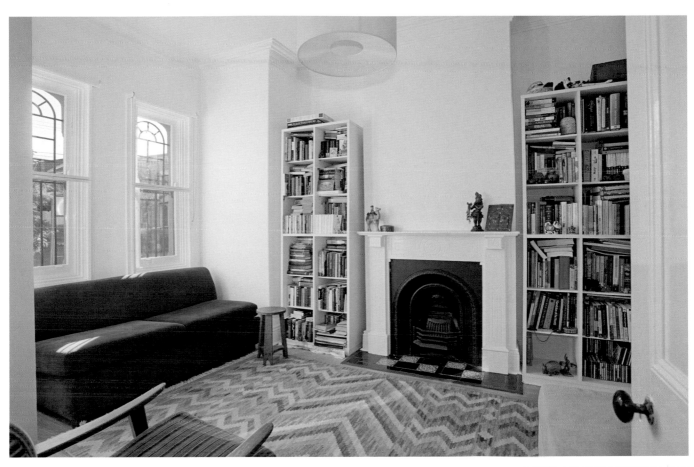

122

Paint floor-to-ceiling surfaces to give the illusion of space and height. You can create a more dynamic result by painting various surfaces to different heights.

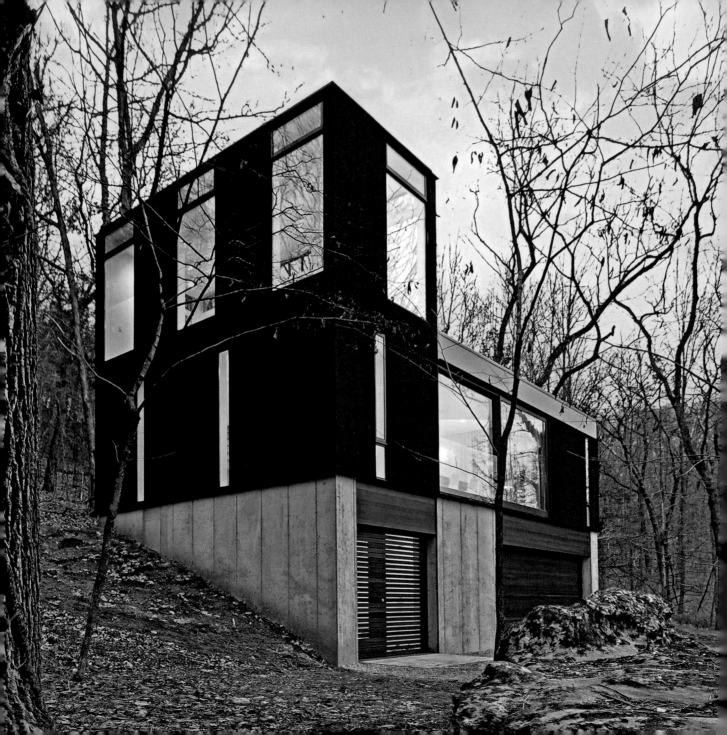

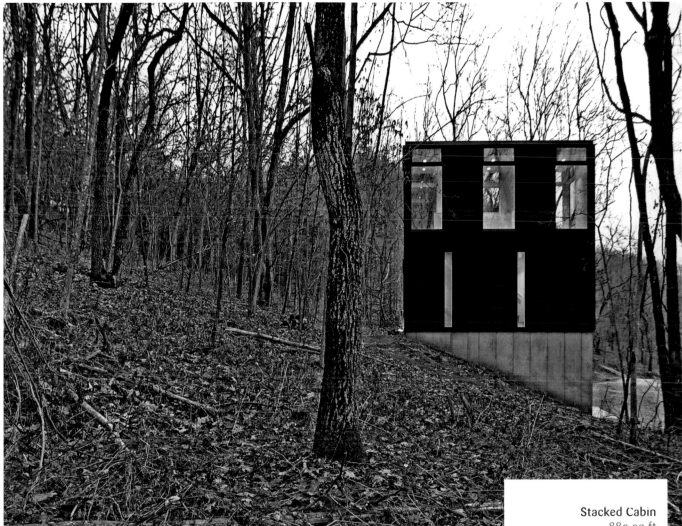

Stacked Cabin
880 sq ft

Architect: **Johnsen Schmaling Architects**

Location: Muscoda, WI, USA

Photographer: © John J. Macaulay

This cabin for a young family sits at the end of an old logging road that hugs the edge of a small clearing. The tight budget required a rigorously simple structure. The configuration of the traditional cabin compound, including an open-plan longhouse with communal living spaces, an outhouse and a freestanding toolshed, was reorganized vertically in order to minimize the building's footprint and take advantage of the sloped site.

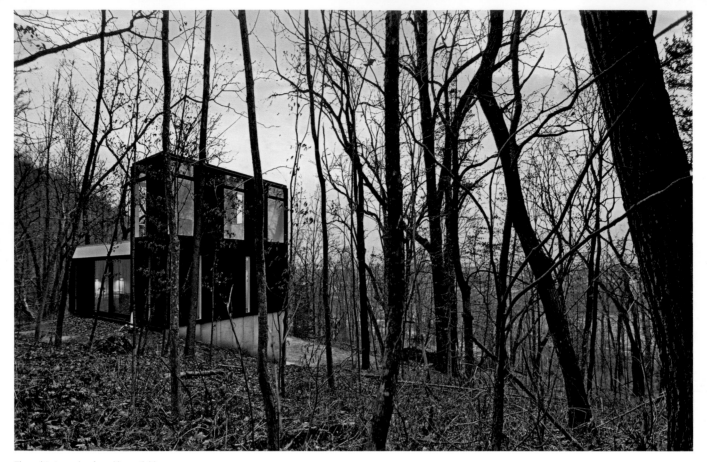

The cabin is made of readily available materials used in the region's farmstead architecture. On the outside are exposed concrete, cedar, anodized metal and cementitious plaster.

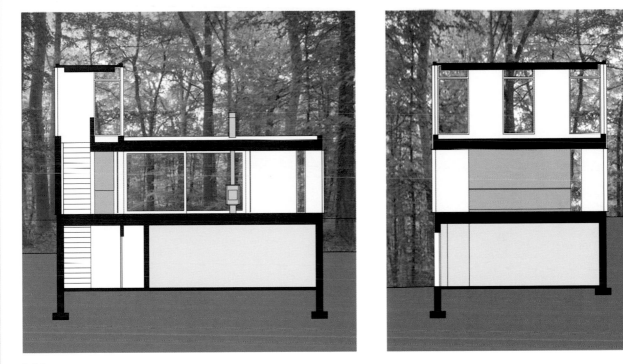

Sections

Volumetric morphology diagram

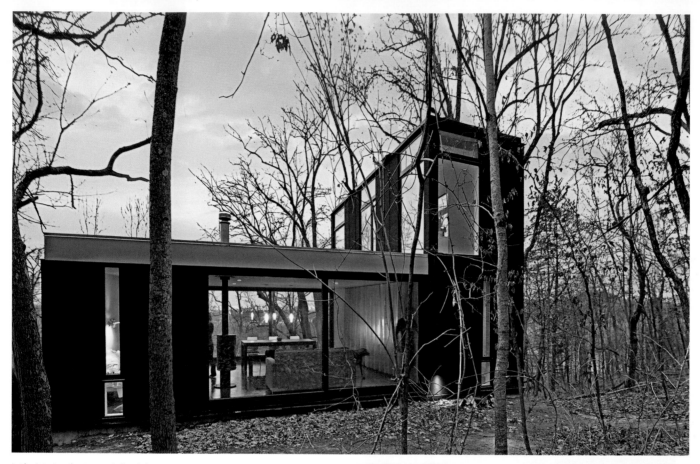

In the interior, the two main levels have tinted polished concrete floors that provide durable surfaces, and built-in cabinets painted white.

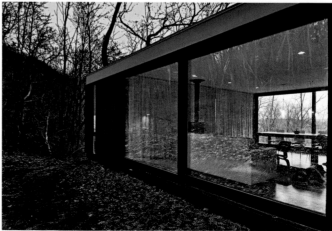

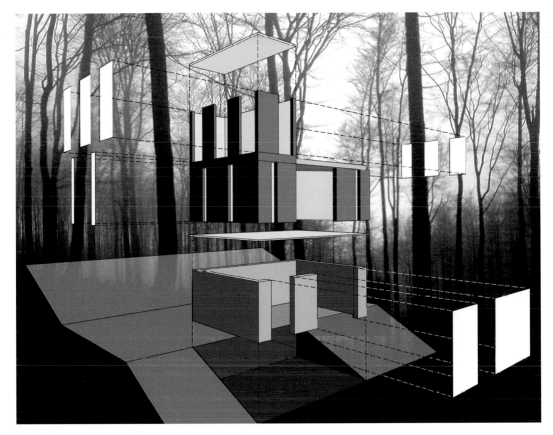

Exploded axonometric view

Lower-floor plan

Intermediate-floor plan

Top-floor plan

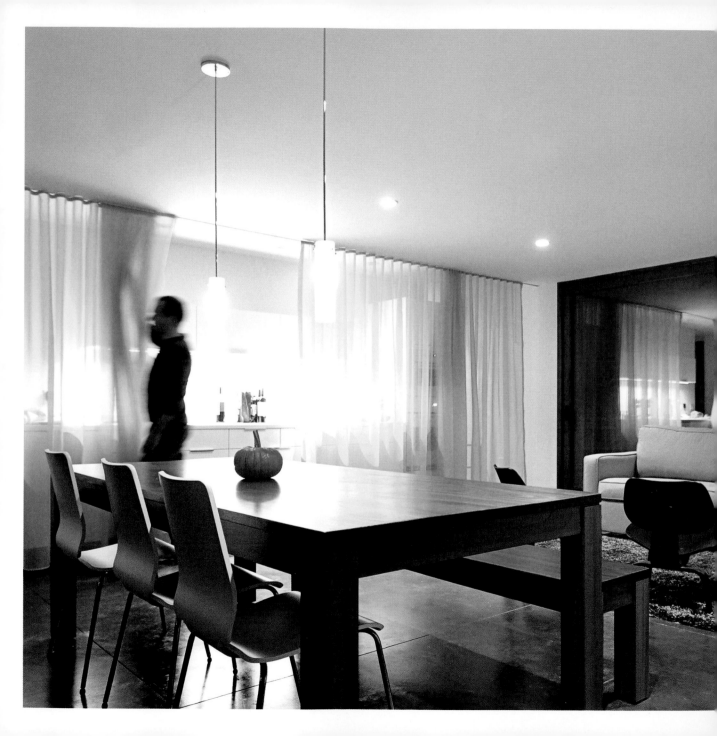

Floor-to-ceiling curtains
are a practical and affordable
solution that provide sleeping
areas with privacy and screen
the kitchen off when it is
not in use.

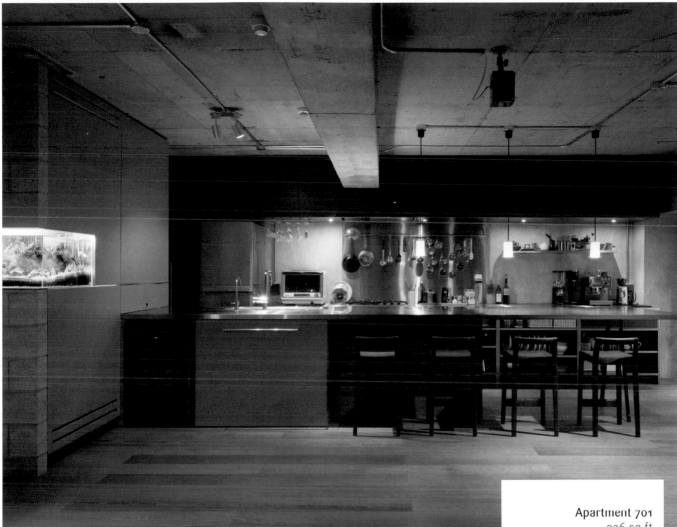

Apartment 701 is a renovation project that focused on the occupant's lifestyle. His interest in entertaining and cooking led Keiji Ashizawa Design to create a home where the kitchen, with adjoining dinner counter, takes center stage. Sitting at the counter, guests can follow the cooking preparations, just like in Japanese Teppanyaki-style dining.

Architect: Keiji Ashizawa Design
Location: Tokyo, Japan
Photographer: © Takumi Ota

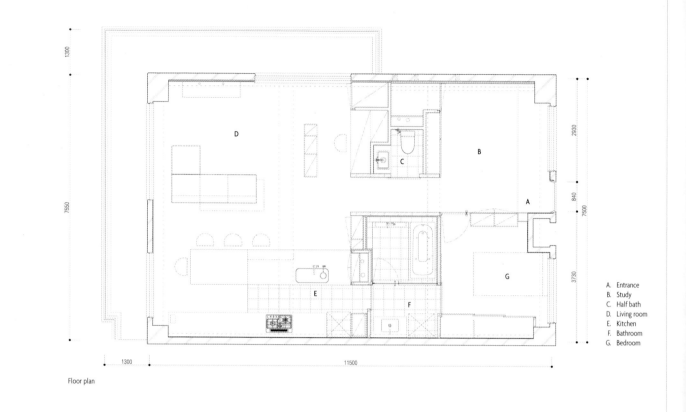

Floor plan

1300

11500

7550

1300

2930

840

7500

3730

A. Entrance
B. Study
C. Half bath
D. Living room
E. Kitchen
F. Bathroom
G. Bedroom

The bedroom is enclosed in a large
container just short of the ceiling's
concrete beams. The container generates
a narrow passage between the social
and the private spaces.

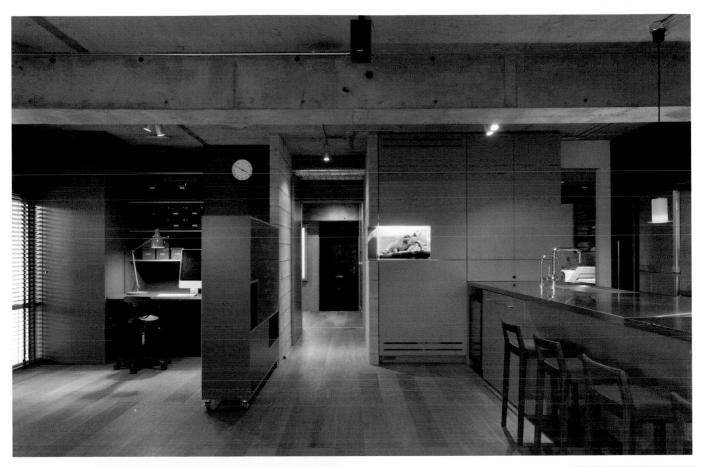

124

Use shelf units and sideboards in lieu of floor-to-ceiling partitions to separate different areas. They improve the openness of the small space and provide much-needed storage space.

125

Open shelves can add character to your kitchen. But there are some drawbacks: there is nowhere to hide your not-so-attractive kitchenware, and it's a constant battle to keep dust and grime off.

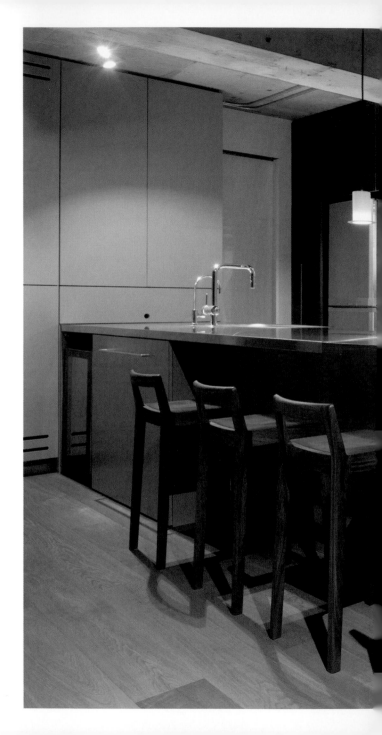

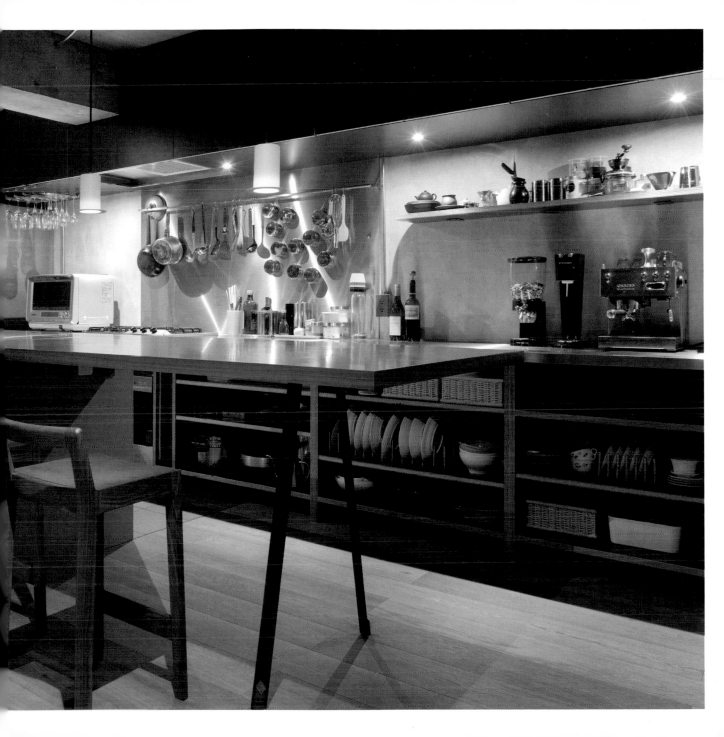

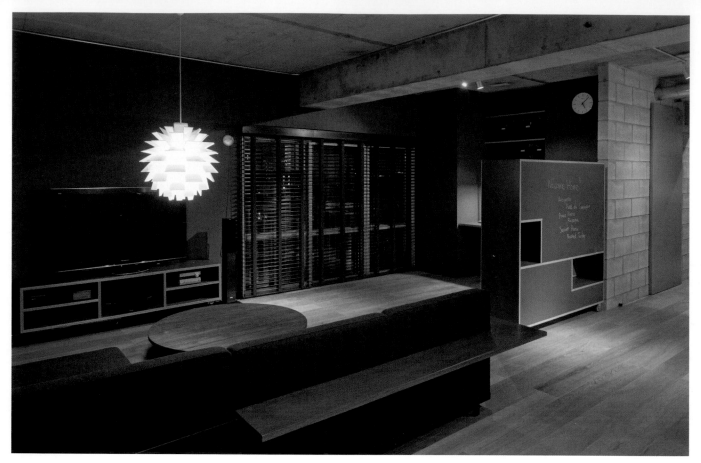

126

High ceilings or abundant natural light are the conditions under which you can enjoy the dramatic effect that black walls produce. Everything else in the space must be chosen to enhance this effect.

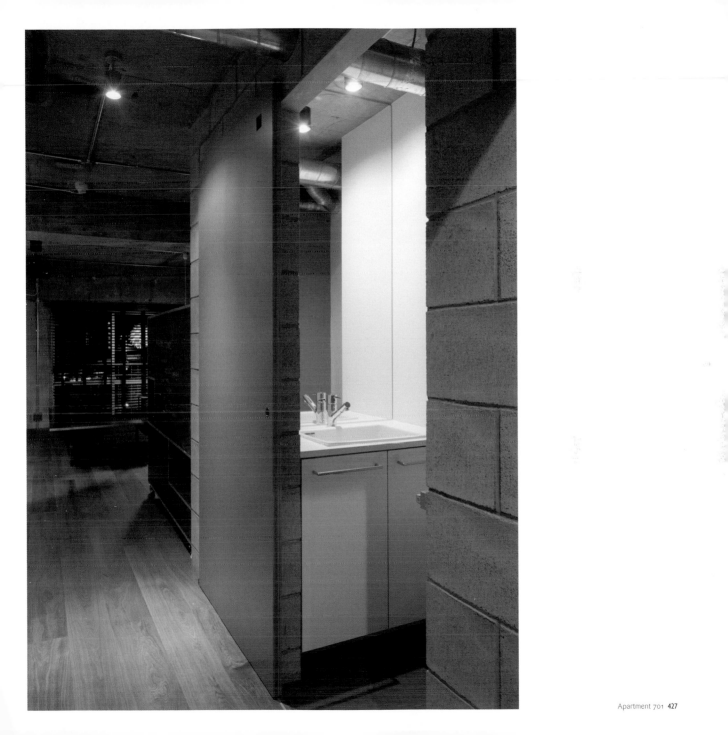

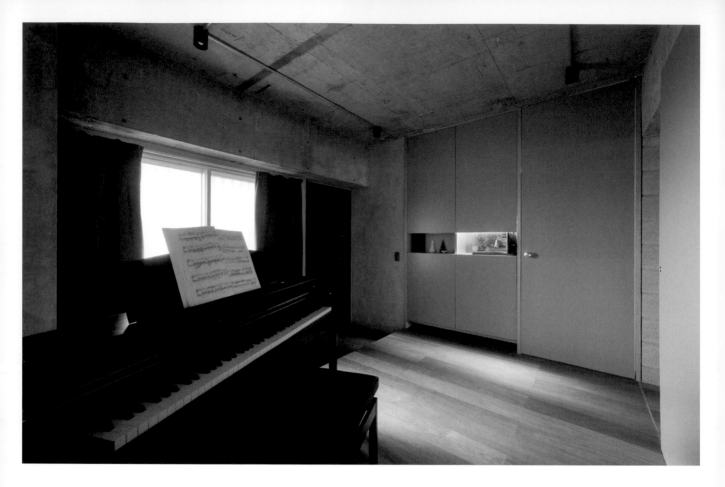

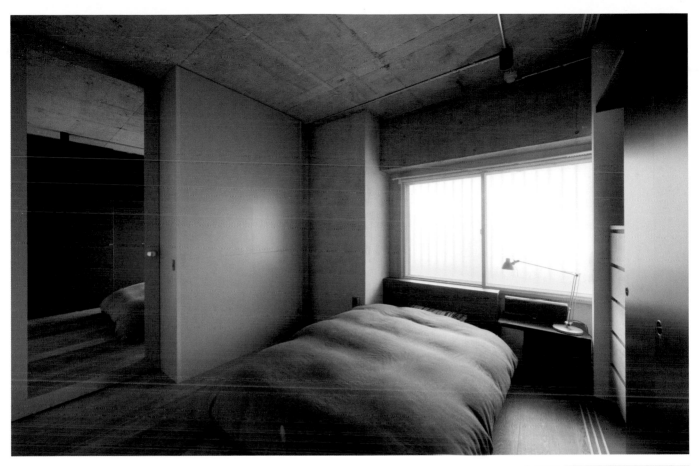

127

In rooms with bare hard surfaces where sound waves bounce between walls, ceiling and floor, bring in area rugs and curtains to mitigate the flutter echo. In the bedroom, throw in lots of pillows.

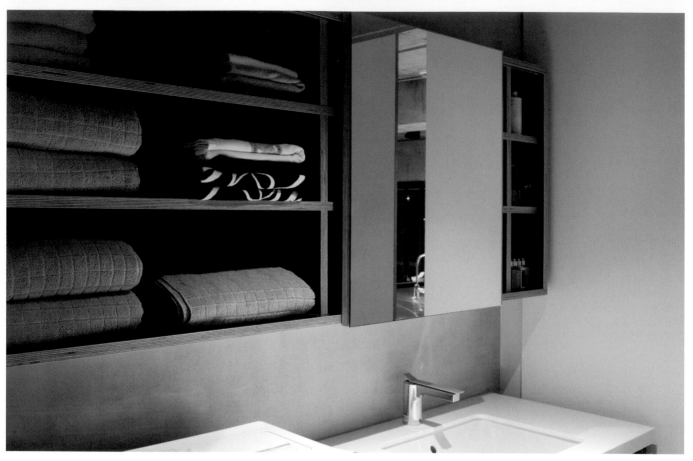

128

Efficient storage solutions are needed in bathrooms where space is often sparse but accessories are plentiful. Upgrade your bathroom with stylish cabinets that provide both open and concealed storage.

The recessed cabinet with a mirrored sliding door combines with the stainless-steel shower fittings and drain to bring a little brightness to this dark but sophisticated small bathroom.

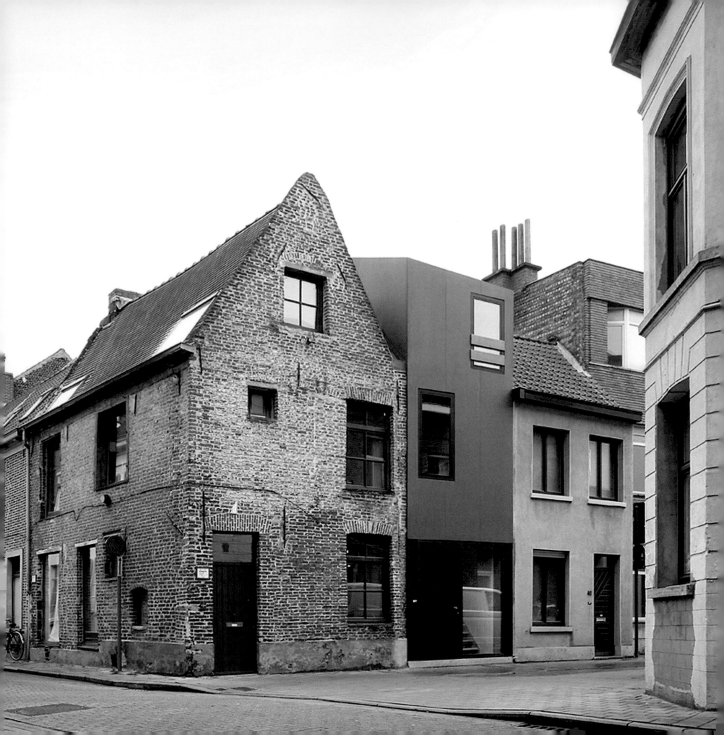

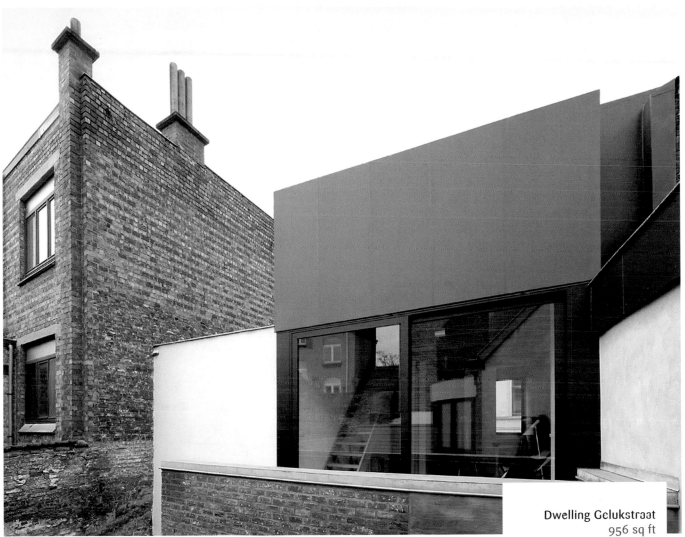

Dwelling Gelukstraat
956 sq ft

Architect: Dierendonckblancke Architecten

Location: Ghent, Belgium

Photographer: © Filip Dujardin

Located on a narrow, irregular site in the center of Ghent, Belgium, this tiny dwelling was built as an extension to an existing house. Despite the restrictions of the site and the small budget, the new building makes quite an impression. Sandwiched between two traditional buildings and painted dark gray, it stands three floors tall and makes the most of every square foot.

Site footprint

Existing conditions

New house
nr 42

Extension of house
nr 38

New house
nr 42

Extension of house
nr 38

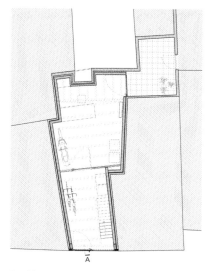

Ground-floor plan

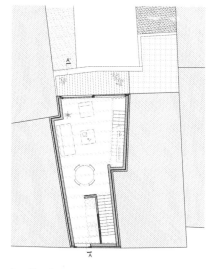

Second-floor plan

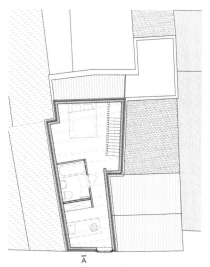

Third-floor plan

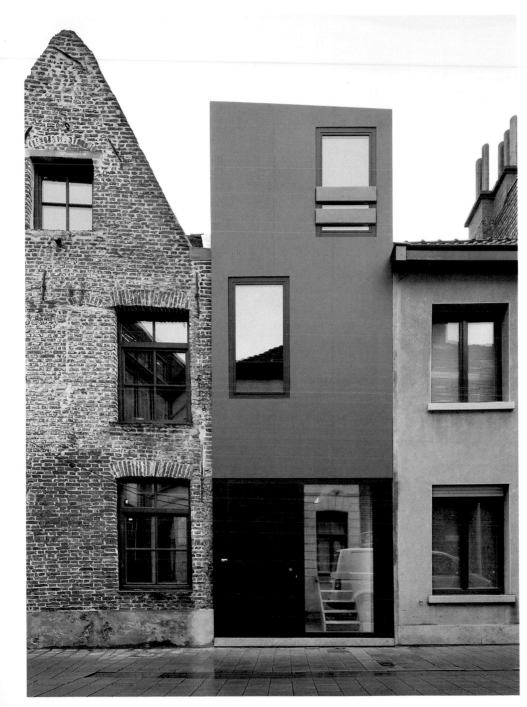

On the ground floor, an atelier is connected to the existing house through a small courtyard. The living area is located on the second floor. A bedroom, a bathroom and an office occupy the upper floor.

A staircase at the entrance leads
to the kitchen on the second floor.
While the kitchen has views of
the street, the living room faces the
courtyard at the back of the house.

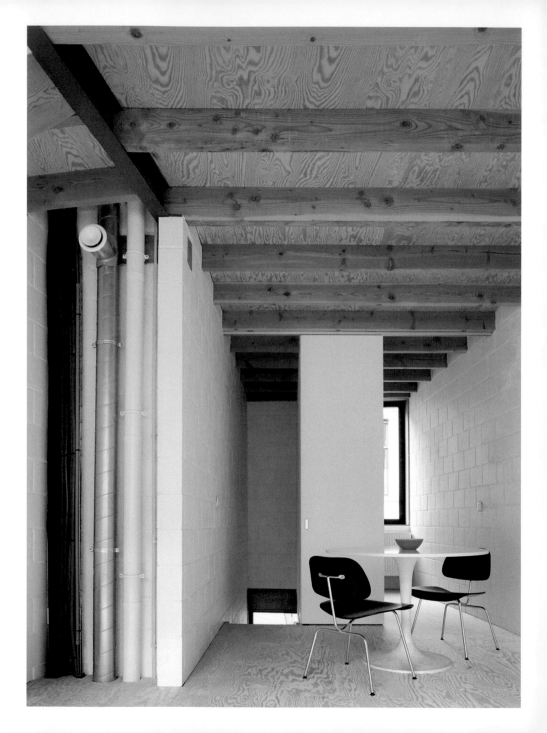

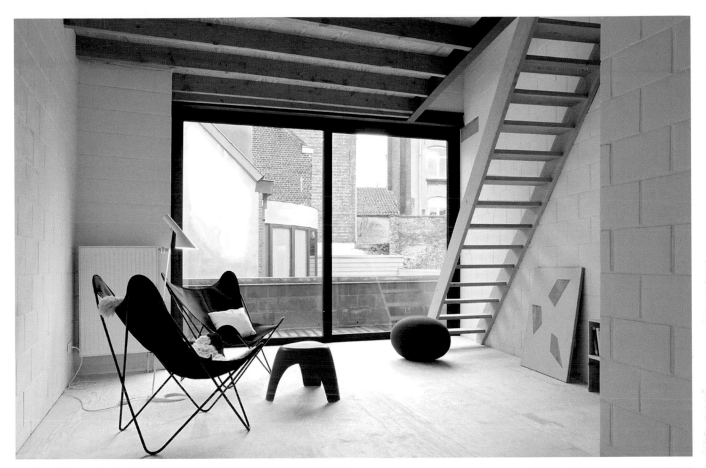

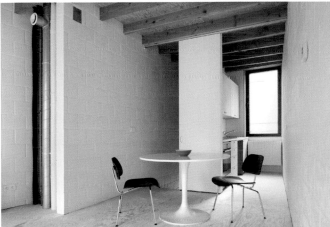

129

Leave the floor joists exposed to make a space look taller and to provide it with a rough industrial look. To strengthen this effect, and to gain a few inches of floor space, use only paint to finish concrete walls.

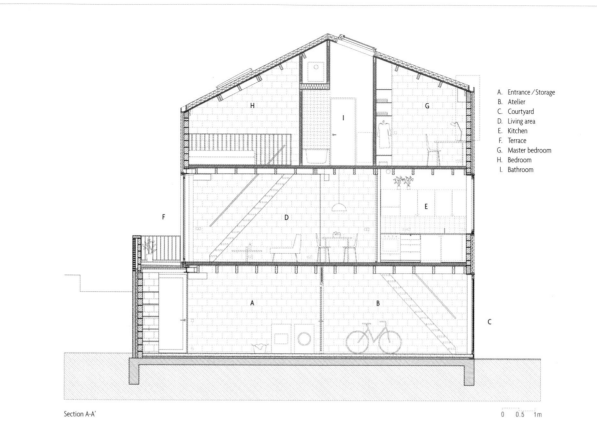

A. Entrance / Storage
B. Atelier
C. Courtyard
D. Living area
E. Kitchen
F. Terrace
G. Master bedroom
H. Bedroom
I. Bathroom

Section A-A'

0 0.5 1m

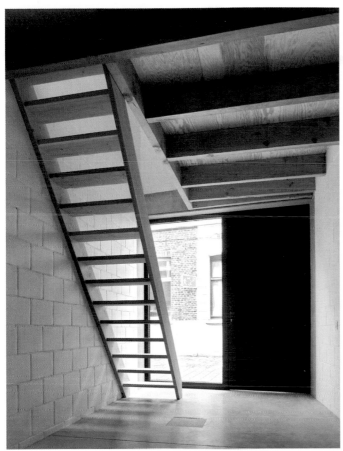

130

Bare walls and exposed floor joists revealing the structural skeleton of a building add dimension to a space, while facilitating a conceptual narrative.

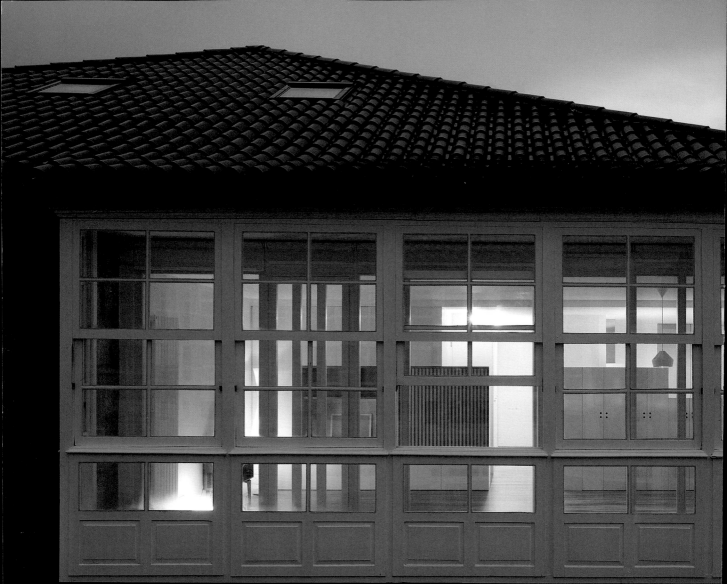

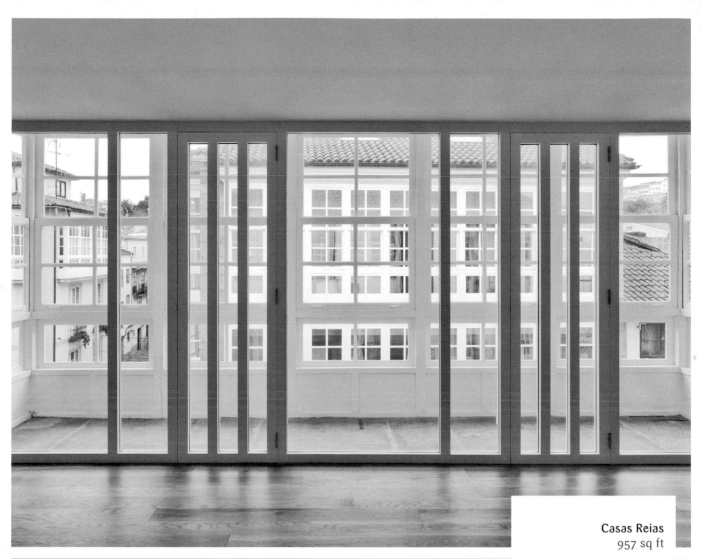

Casas Reias
957 sq ft

Architect: Concheiro de Montard, Architects

Location: Santiago de Compostela, Spain

Photographer: © Luís Díaz Díaz

The existing space was fragmented into small, dark rooms. Turning this apartment into a luminous single-space home was a priority. This was achieved by completely gutting the interior and taking advantage of the only two sources of natural light: a glassed-in bay with views over the historic old town, and three small windows in the thick stone walls.

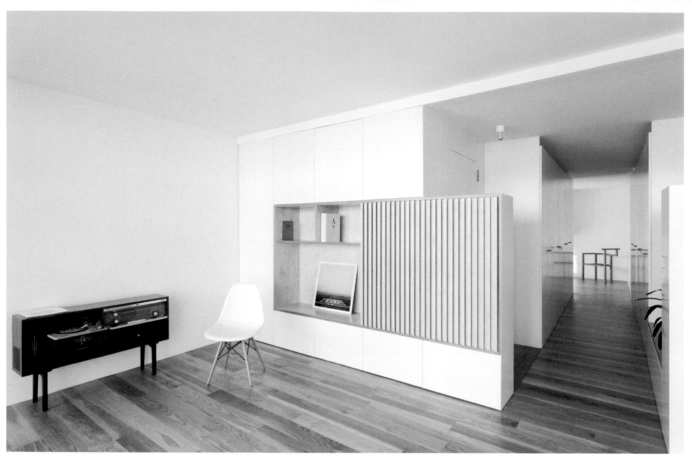

131

Built-in furniture helps clear space, as cumbersome freestanding furniture can be avoided. Built-in furniture can also help connect adjacent rooms. This gives the space depth and visual interest.

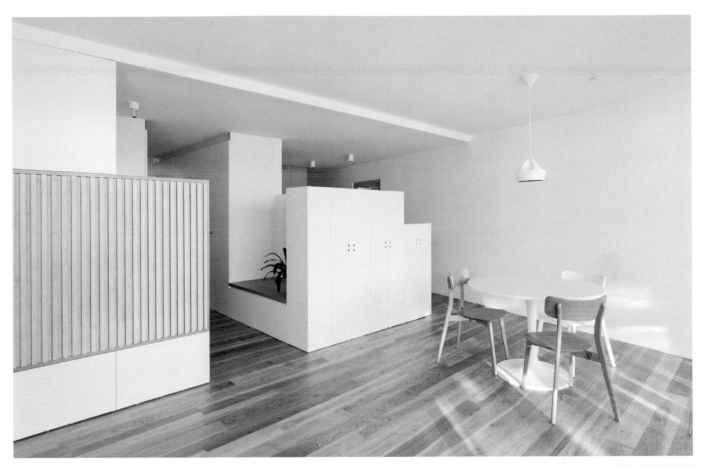

132

Use low wall separations where necessary, avoiding floor-to-ceiling partitions. The space will look less confined. This will also improve lighting, as light will be able to reach deeper into the space.

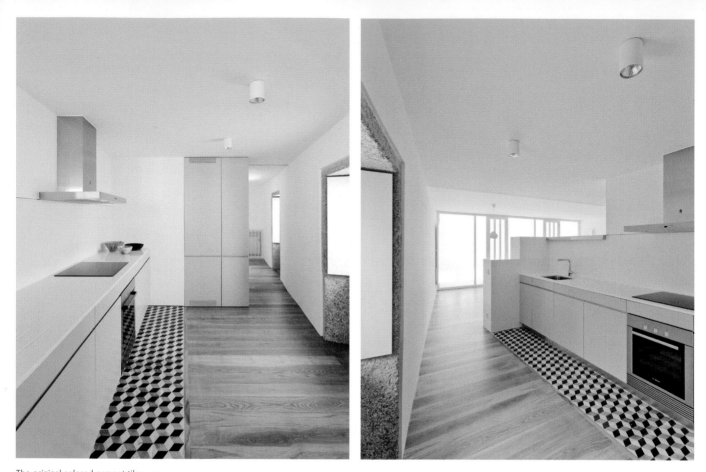

The original colored cement tiles were
rearranged to form a long, narrow strip
along the one-wall kitchen, defining
the area and adding color to the
otherwise monochromatic space.

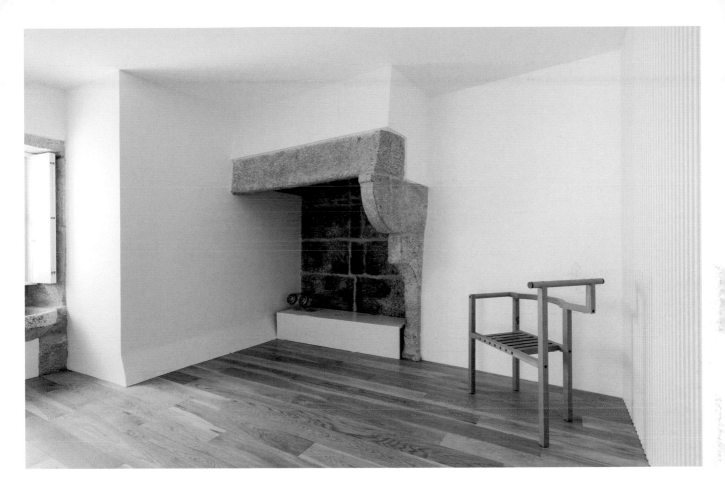

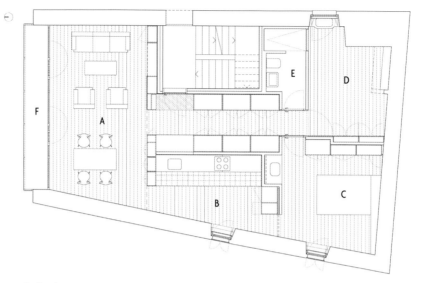

A. Living–dining room
B. Kitchen
C. Bedroom
D. Study
E. Bathroom
F. Gallery

New floor plan

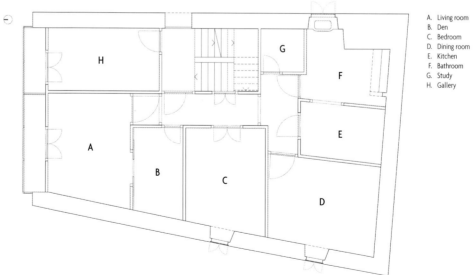

A. Living room
B. Den
C. Bedroom
D. Dining room
E. Kitchen
F. Bathroom
G. Study
H. Gallery

Existing floor plan

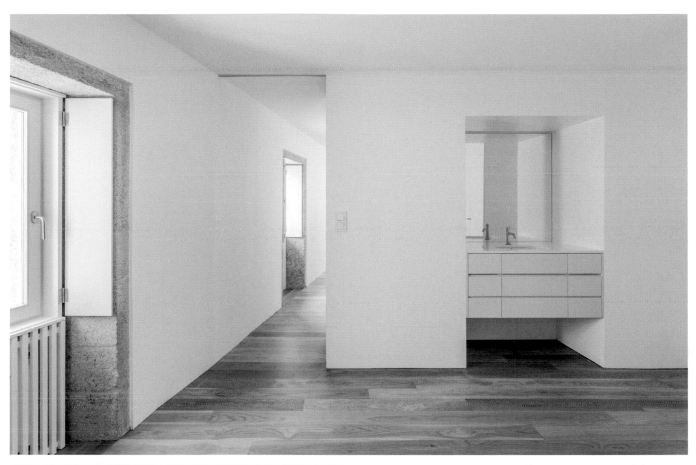

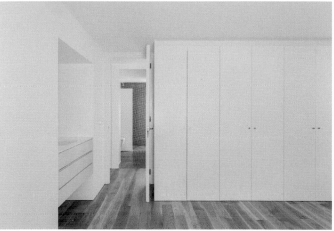

The new space is conceived of as a series of spaces with specific characters, all laid out such that one space leads to the next, with no partition or door blocking the continuity.

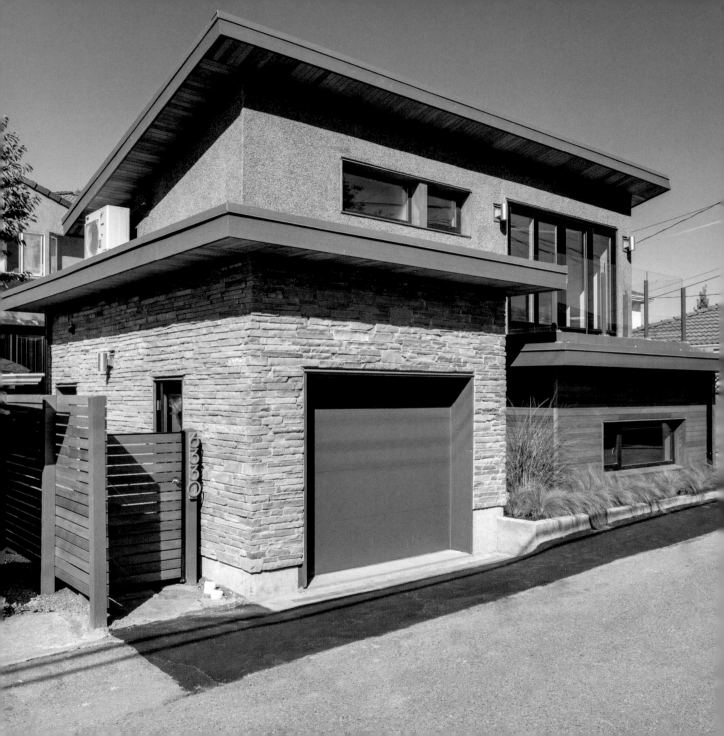

Small homes are often solutions born of limited sites, modest budgets or both. This 970-square-foot house is another example of laneway construction, built as part of an initiative to increase the density of Vancouver's metropolitan area.

Laneway House 2
970 sq ft

Architect: Lanefab
Design/Build
Location: Vancouver,
BC, Canada
Photographer: © Colin Perry

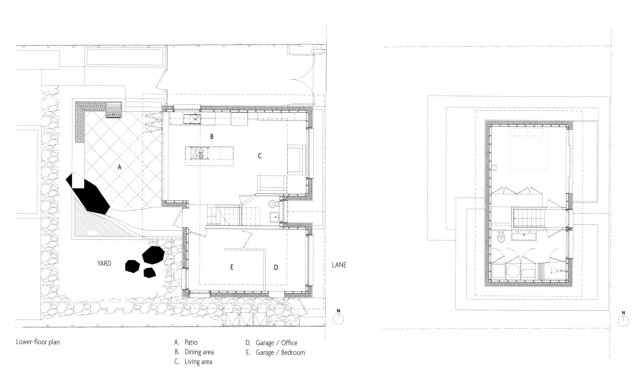

Lower-floor plan

A. Patio
B. Dining area
C. Living area
D. Garage / Office
E. Garage / Bedroom

N

Upper-floor plan

N

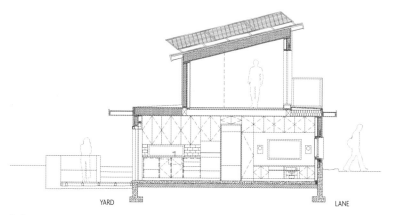

YARD

LANE

Section

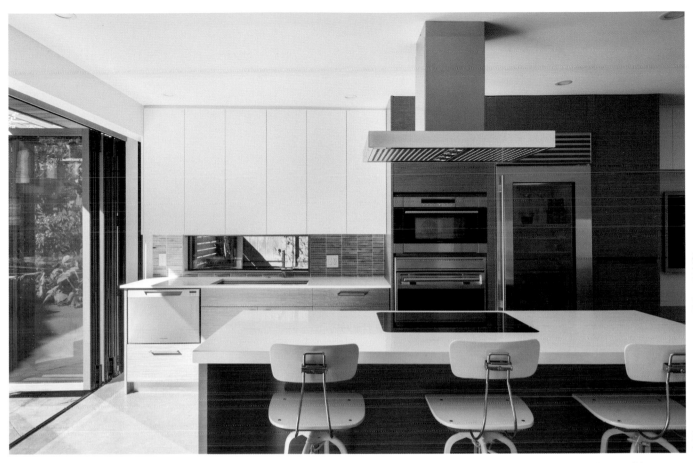

The ground floor of this small laneway house integrates a living room and an open kitchen with the backyard, which is shared with the main house on the same property.

133

Bifold doors allow you to create the largest possible opening. They are a modern alternative to French doors and sliding doors, which allow only a much smaller opening.

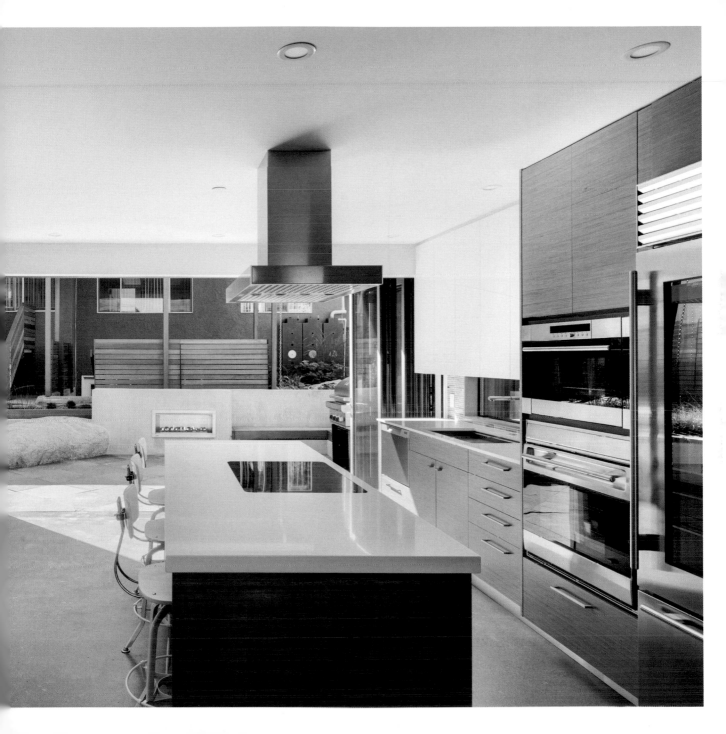

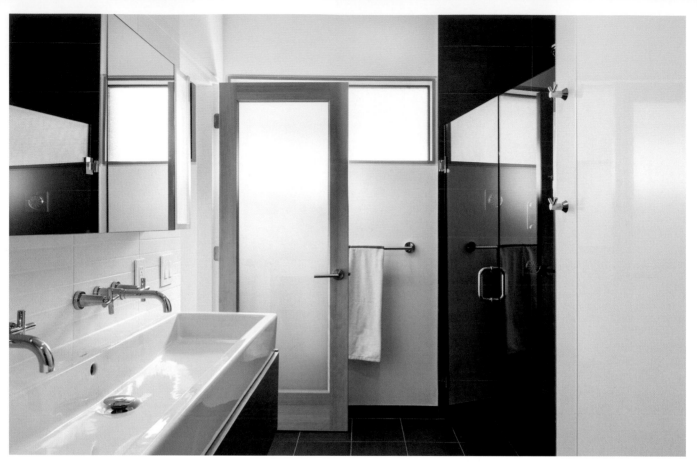

134

An extra-wide sink is perfect for a small bathroom that doesn't have room for a double-sink vanity.

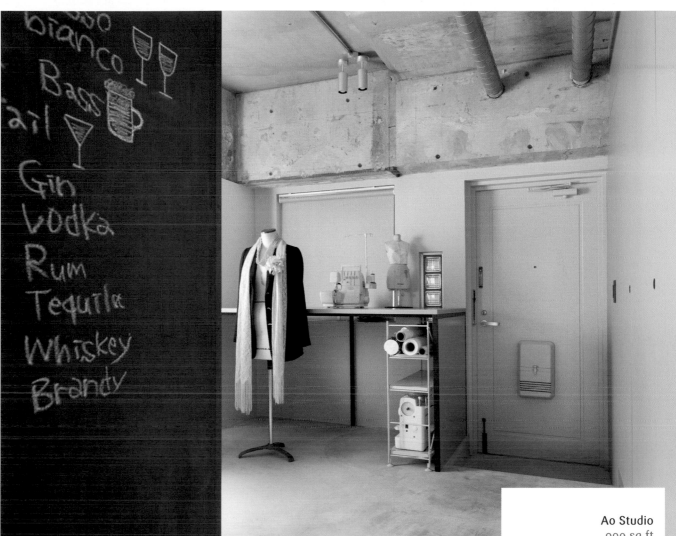

Ao Studio
990 sq ft

Architect: Keiji Ashizawa Design
Location: Saitama, Japan
Photographer: © Takumi Ota

Ao is a renovated apartment for a young working couple. Its layout reflects the lifestyles and personalities of the couple: one a patternmaker, the other a restaurateur, they both work from home and each requires very specific spaces. As part of the program, they requested that the apartment could also be a place to relax and entertain.

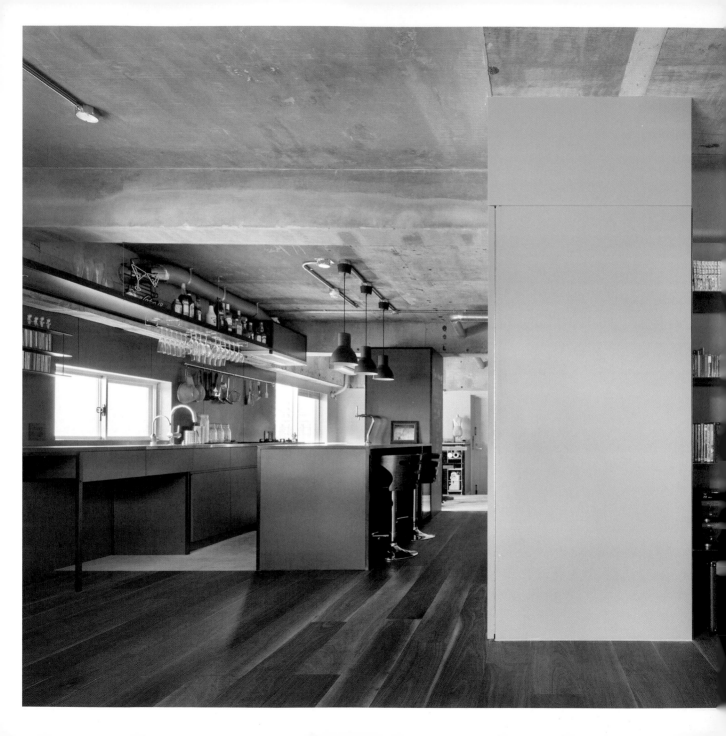

Incorporate built-in furniture
into the design where possible,
to clear the space and enhance
the sense of amplitude.

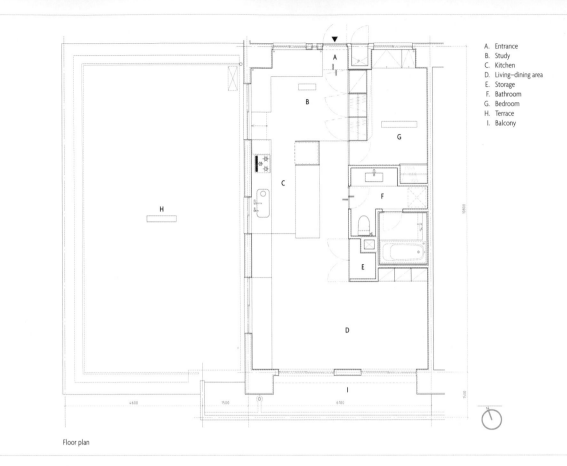

Floor plan

A. Entrance
B. Study
C. Kitchen
D. Living–dining area
E. Storage
F. Bathroom
G. Bedroom
H. Terrace
I. Balcony

All existing partitions were removed
to reveal a light-filled space with
various large openings, one of which
connects to a terrace almost the size
of the apartment.

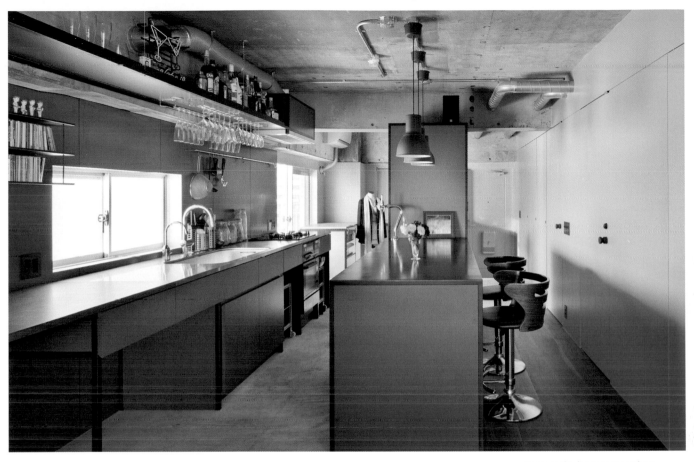

An open-plan living space with an adjacent work studio is at the center of the new arrangement. The bedroom and bathroom are hidden from sight within a bright blue volume.

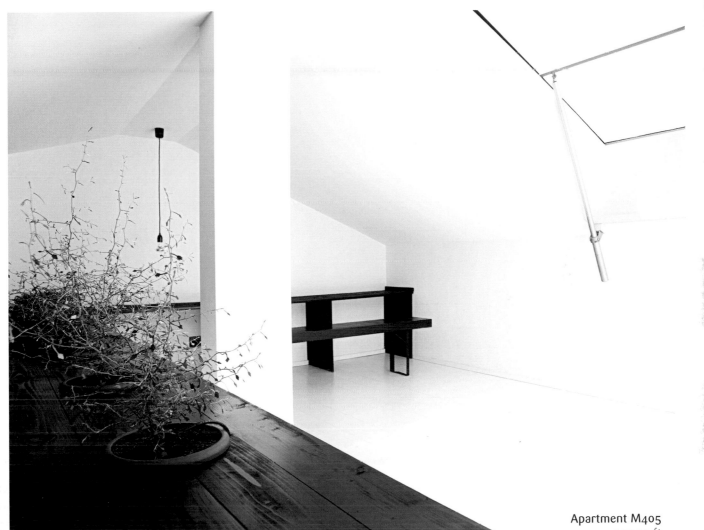

Apartment M405
990 sq ft

Architect: **StudioCE**
Location: **Berlin, Germany**
Photographer: © Ludger Paffrath

The complete makeover of this apartment resulted in a modern, highly creative space. The main challenge was to remodel it on a small budget. This was achieved by inserting a multifunctional wall that integrates shelving for the kitchen and planter boxes. The wall extends above the floor of the loft. At that level, the wall morphs into a desk, becoming a workspace.

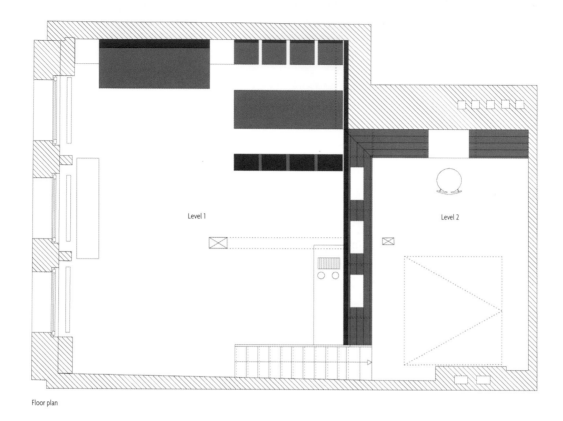

Level 1

Level 2

Floor plan

136

When space is tight, create areas that are multifunctional. Not only are multifunctional furnishings smart, but they can also be structurally interesting components of a limited space.

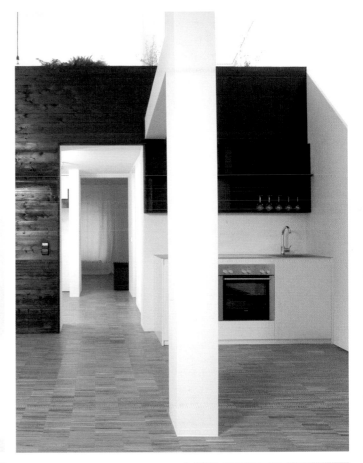

137

Harmonize the disparate elements of an existing space to provide it with unexpected spaciousness.

Wall elevation

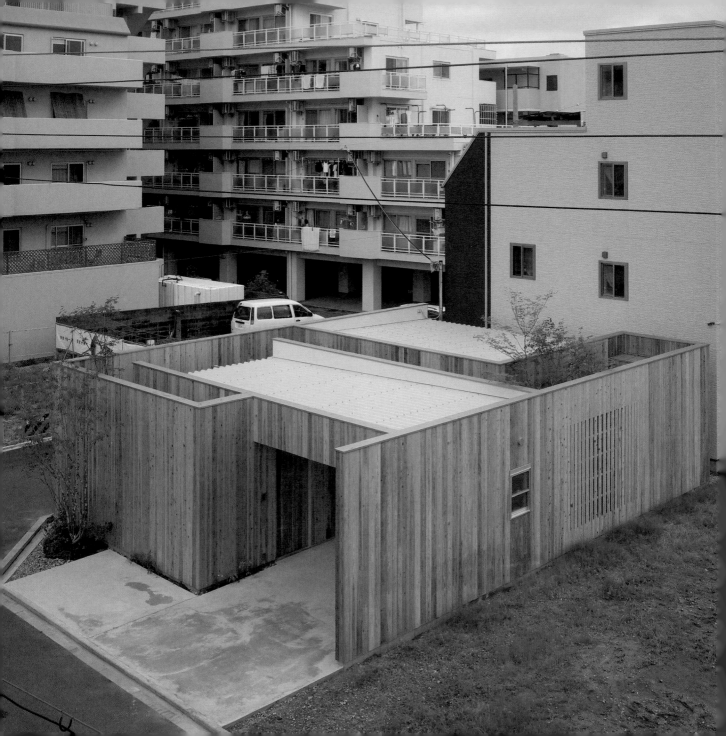

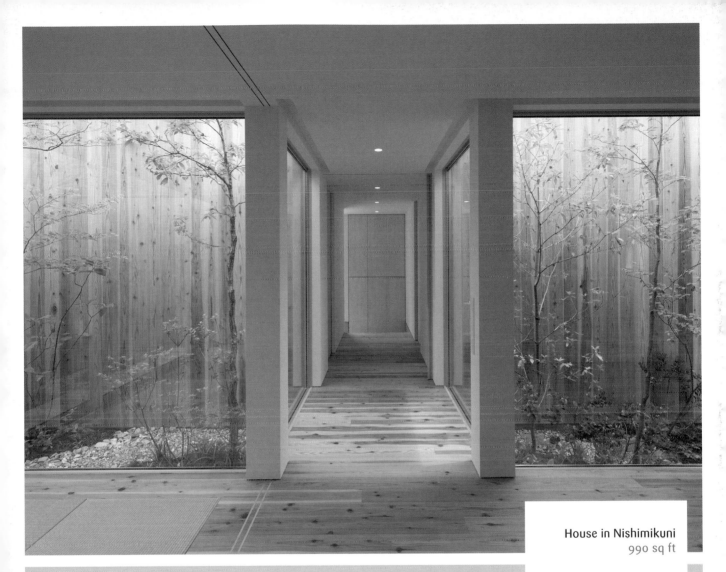

Designed for a retired couple, this house tackles the issue of how to provide privacy in an urban area and still offer a glimpse of the sky. Among the gray high-rises of the Nishimikuni district of Osaka stands a one-story house protected by a wooden fence as tall as the house. The fence keeps the interior of the house out of view from the outside.

Architect: Arbol Design
Location: Osaka City, Japan
Photographer: © Yasunori Shimomura

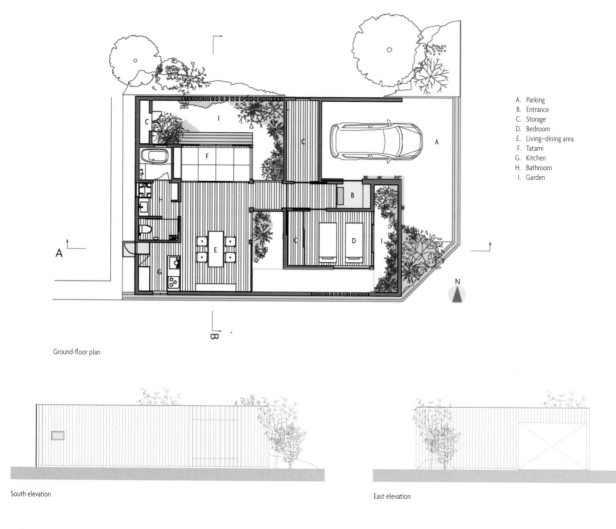

A. Parking
B. Entrance
C. Storage
D. Bedroom
E. Living–dining area
F. Tatami
G. Kitchen
H. Bathroom
I. Garden

Ground-floor plan

South elevation

East elevation

Section A

Section B

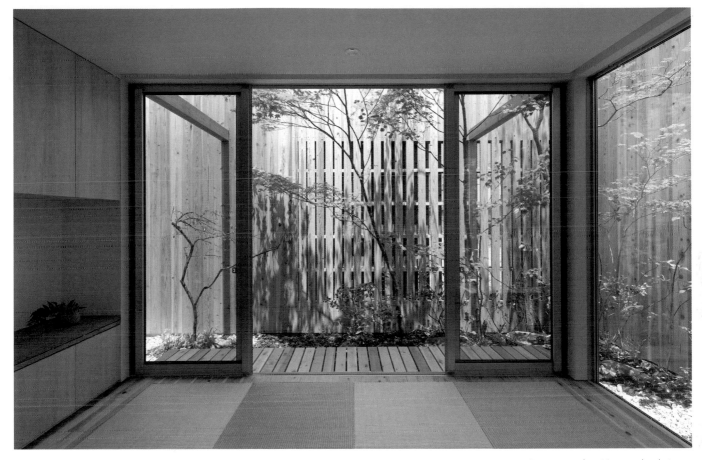

A narrow garden strip meanders between the house and the wooden fence around it. It is an interstitial space that brings a little bit of nature to this small house in a dense urban environment.

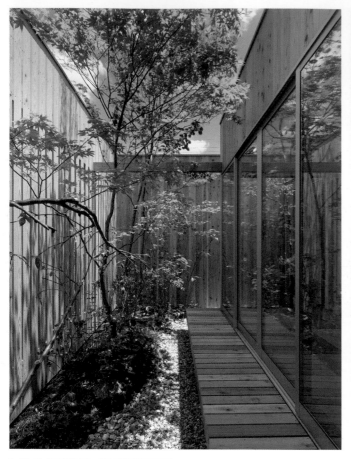
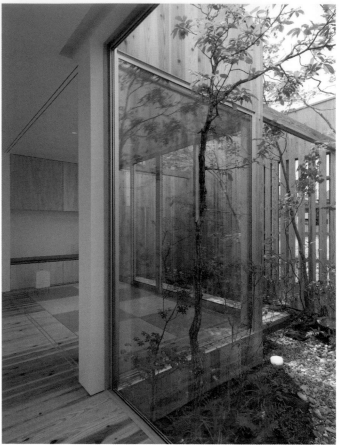

138

Patios and courtyards
can be as much a part of
an integrated house design
as any room: they have the
advantage of being exterior
extensions of a home's interior.

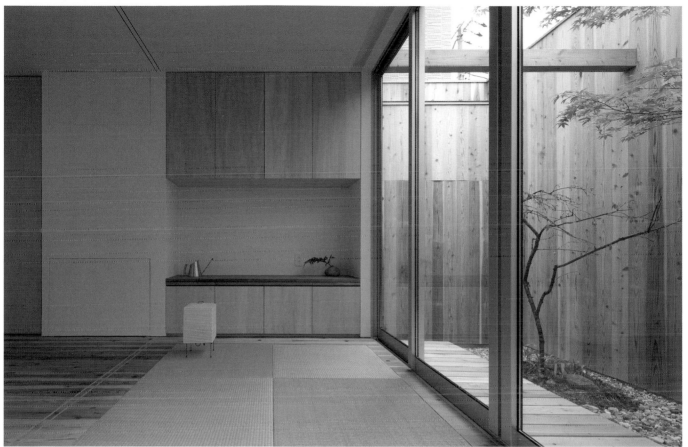

139

You can expand the perception of a space by borrowing materials and finishes from an adjacent area. This is only possible if there is a visual connection between the two spaces.

140

Enhance the architectural
character of your home
by keeping furnishings
and decoration to a minimum.
This will simultaneously
improve circulation.

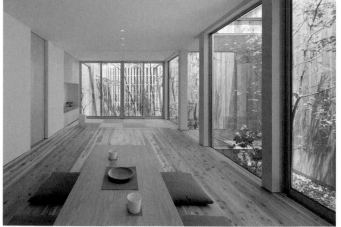

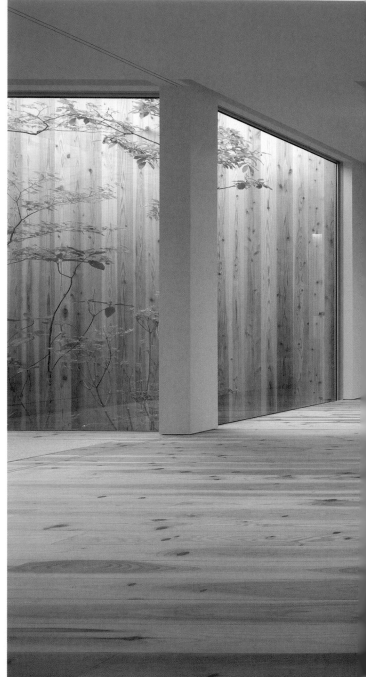

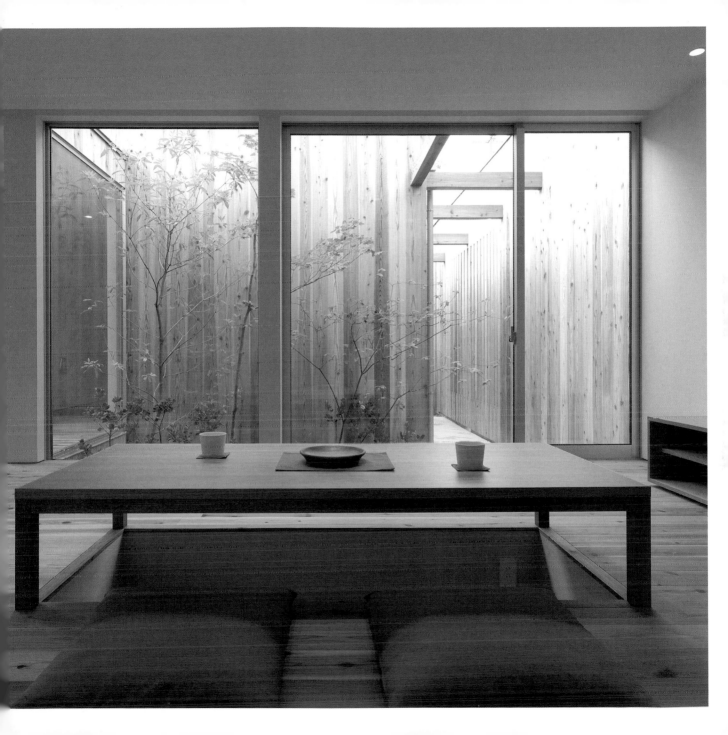

141

Long, narrow corridors can be made more interesting by alternating materials. This design solution creates rhythm and helps lead the eye to a particular place.

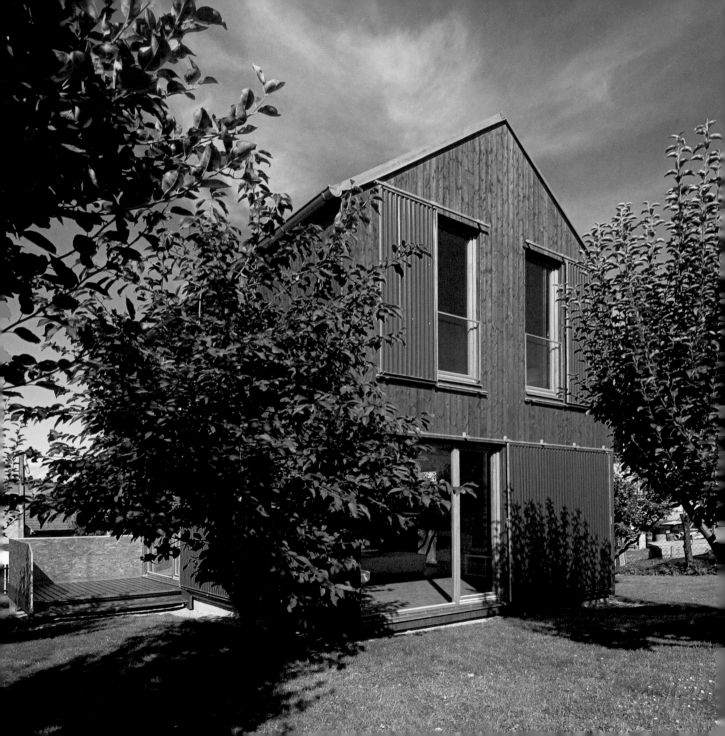

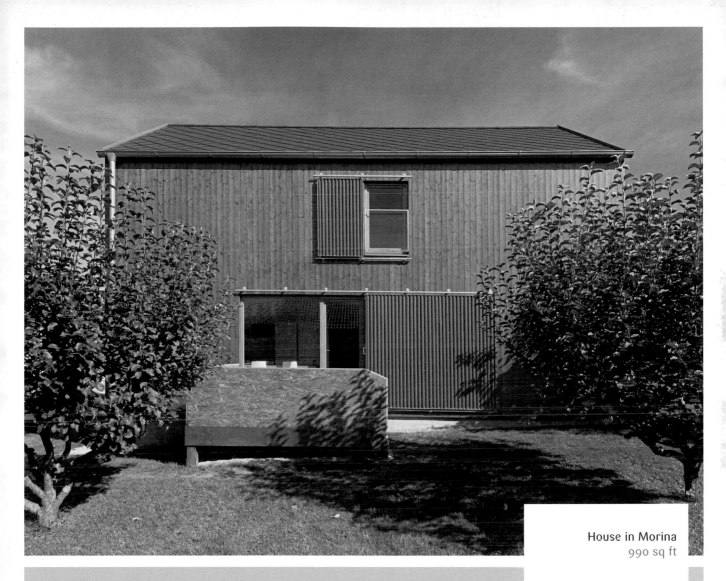

The overall design of this single-story house with an attic was strongly influenced by the traditional architecture of the area. But the sliding translucent shutters give the first indication that this home is anything, but traditional. The interior has an open layout: small, but spacious and inviting.

House in Morina
990 sq ft

Architect: ArchTeam

Location: Morina, Czech Republic

Photographer: © Ester Havlova

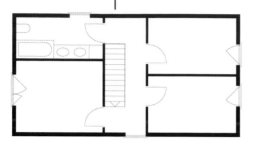

Second-floor plan

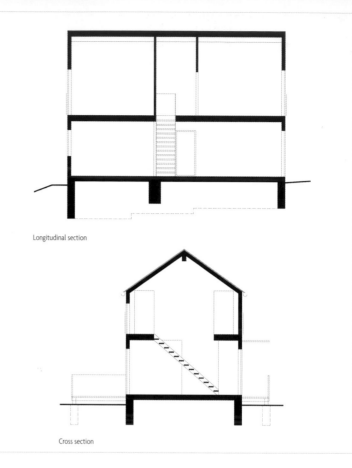

Longitudinal section

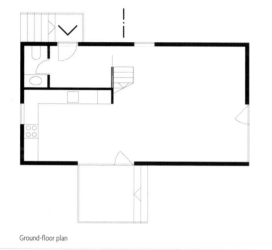

Ground-floor plan

Cross section

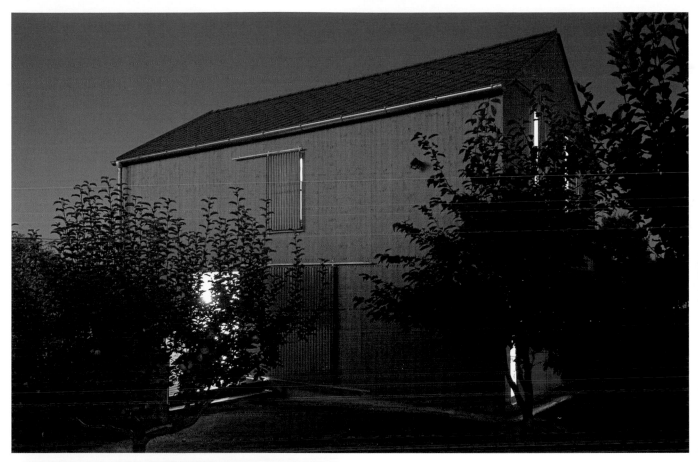

Changes in the position of the shutters and in interior and exterior lighting change the appearance of the façades and the home atmosphere.

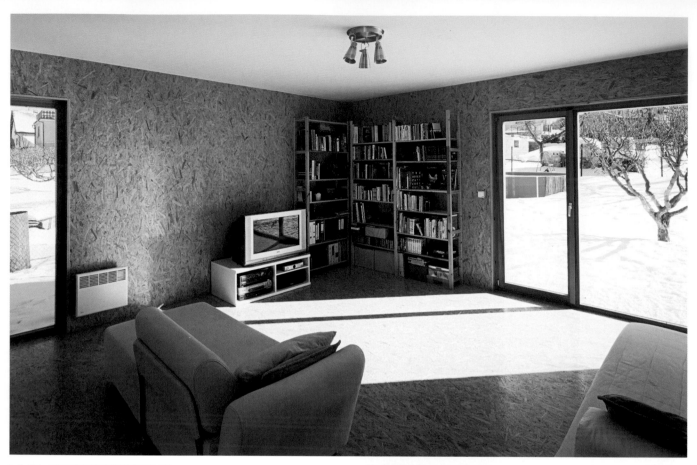

142

If you are thinking of opening up a small, confined space by combining various rooms, consult an architect first. The work should be done properly and in accordance with building codes.

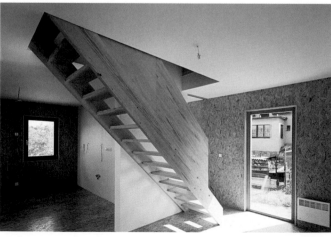

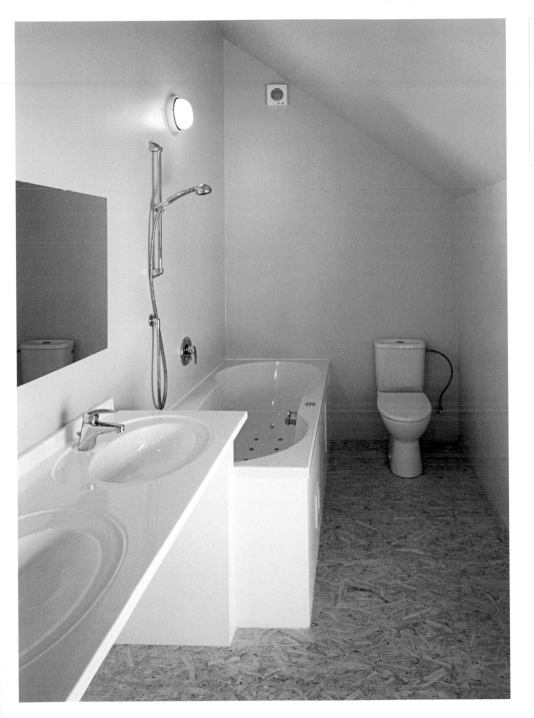

Small but functional, a bathroom can easily be tucked under the sloped ceiling of an attic space, providing the snug feeling often found in cottage-style homes.

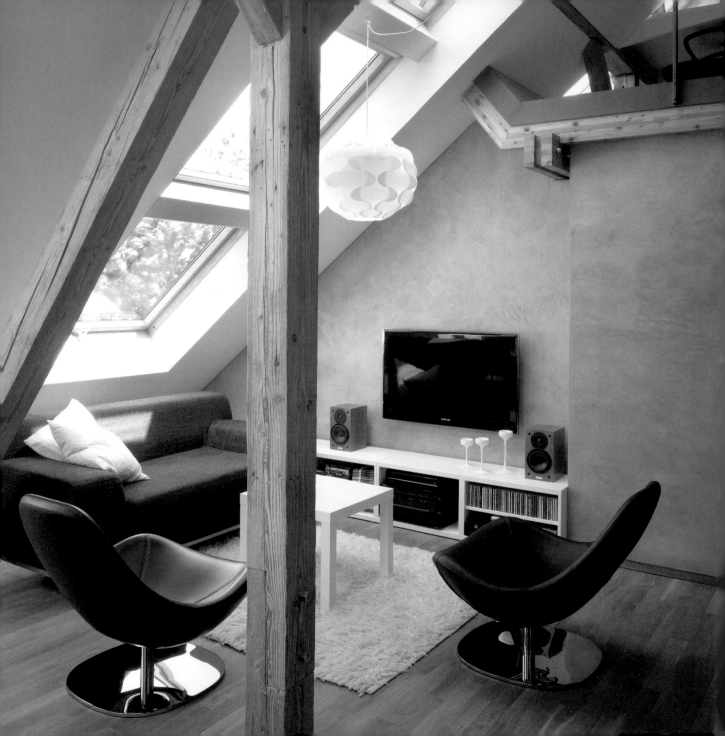

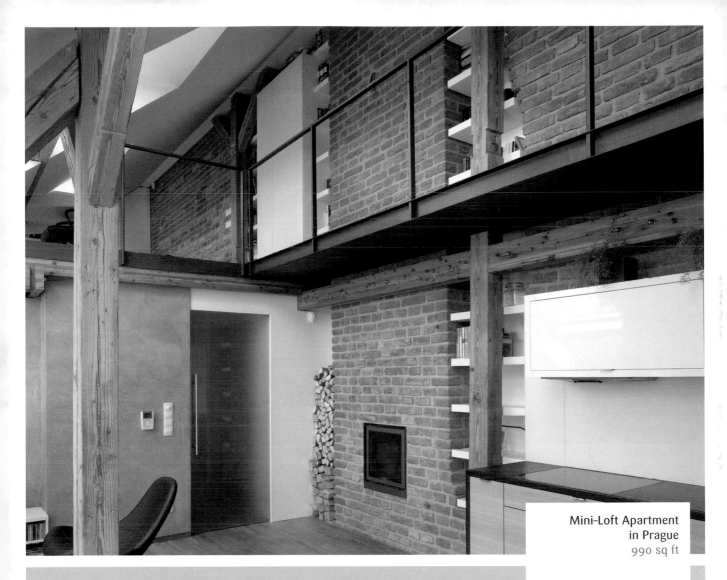

Architect: idhea

Location: Prague,
Czech Republic

Photographer: © Filip Slapal

This loft is in the attic of an apartment building built in the 1930s. It was originally used for drying laundry. The concept of the loft arose from two contradictory requirements: an effort toward the most effective use of limited floor space and the creation of a clear, generous space. The loft was therefore planned on two levels.

Upper-floor plan

Lower-floor plan

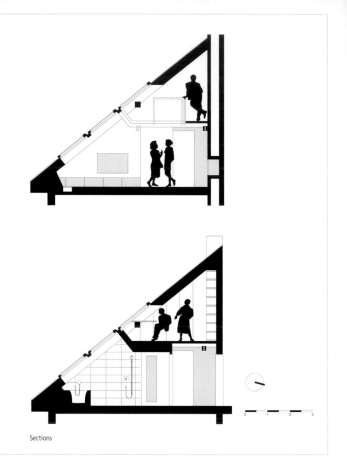

Sections

The loft level is accessed via a staircase
and a steel footbridge, which offers
views of the double space.

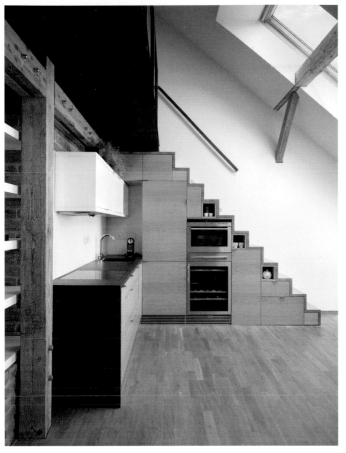
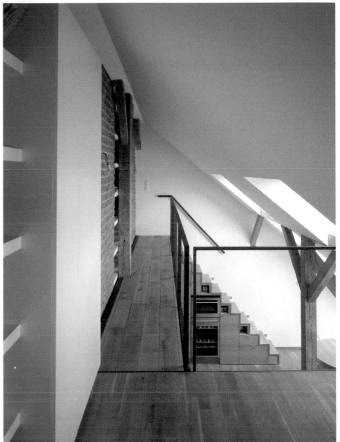

Sloped ceilings often come with design challenges. They can certainly make a room feel awkward, but with good planning and appropriate shelving or furniture, you can turn this obstacle into a positive feature.

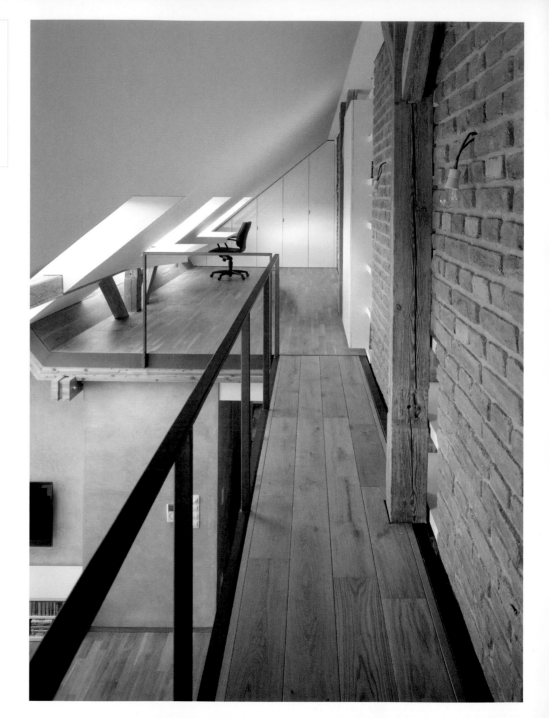

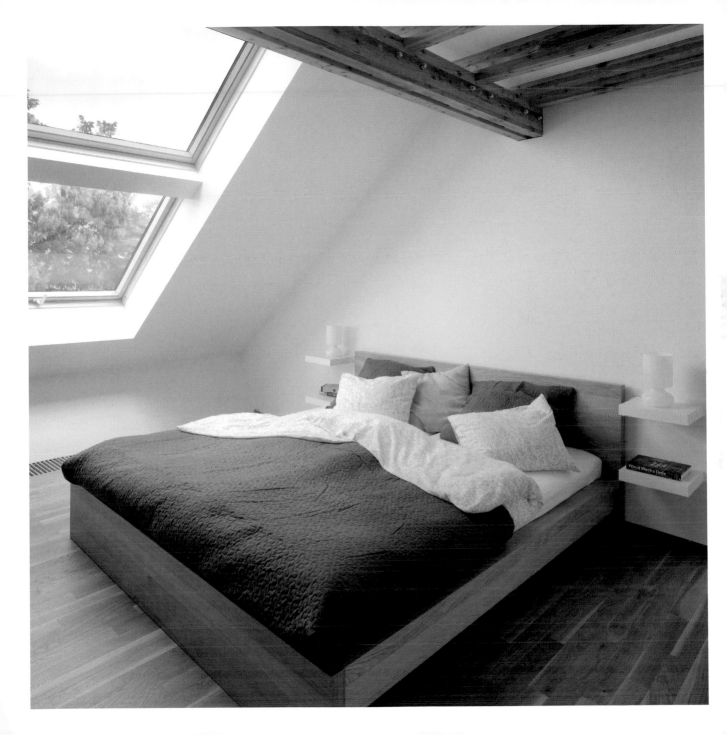

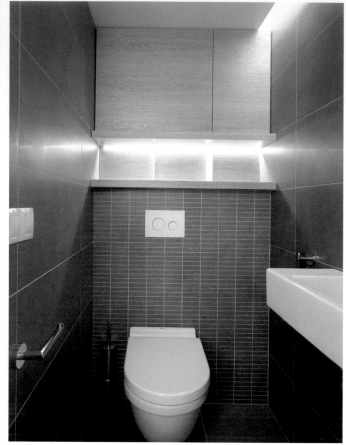

146

A wall-hung water closet
is an ideal solution for small
bathrooms, as it can easily
be integrated into a design.

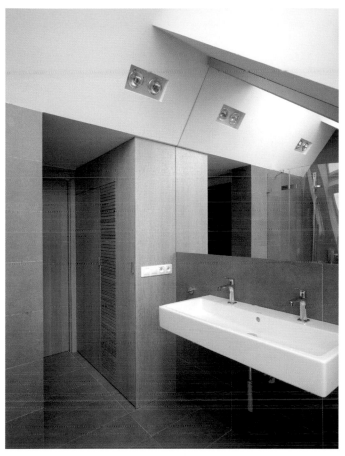

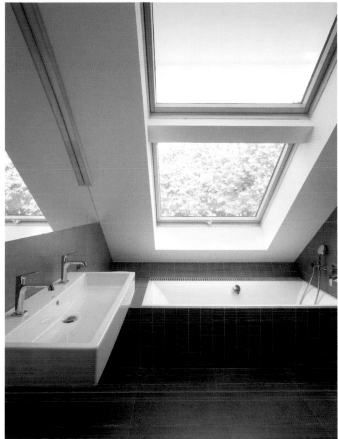

147

This bathroom makes smart use of the low ceiling to position the bathtub. The skylight gives an extra few inches of headroom and offers a glimpse of the exterior without causing privacy issues.

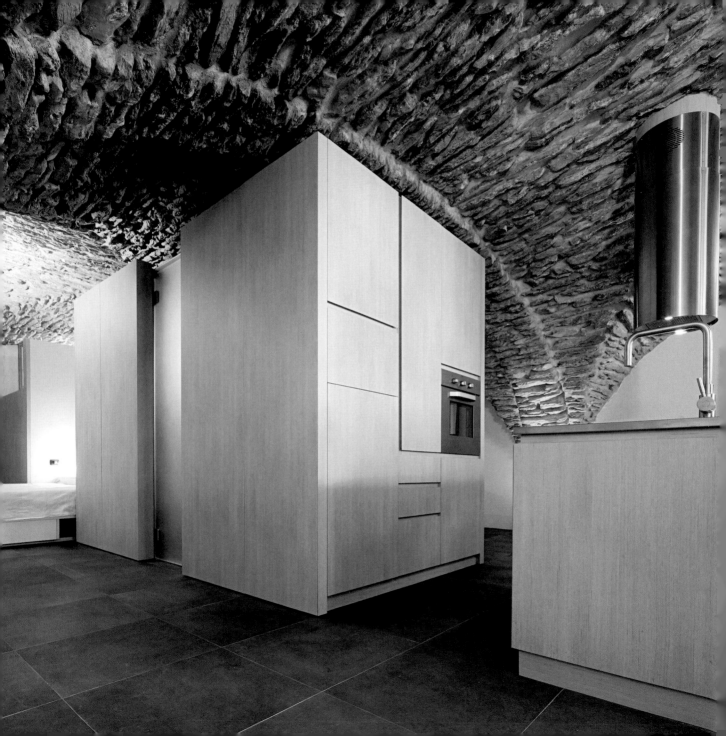

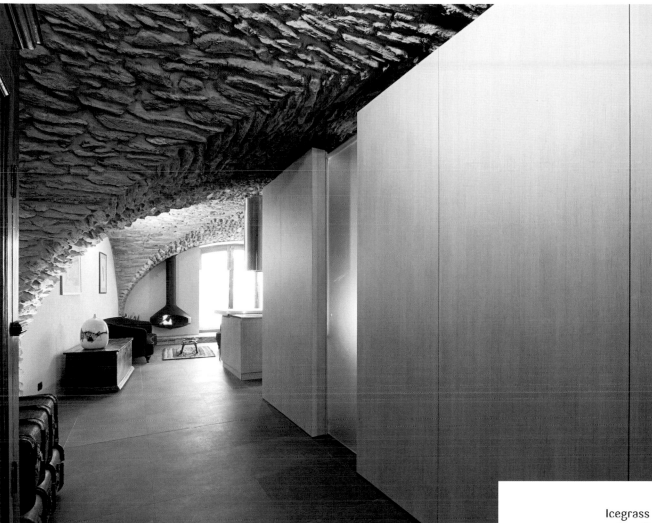

Icegrass
1,076 sq ft

Architect: Studioata
Location: Pragelato, Italy
Photographer: © Beppe Giardino

Icegrass is a remodeled mountain hut. Its design emphasizes the difference between existing and new construction. This is achieved by the insertion of three wood-clad blocks that contrast with the existing stone vaulted structure. These volumes efficiently organize the space, separating different areas and providing privacy wherever it is needed.

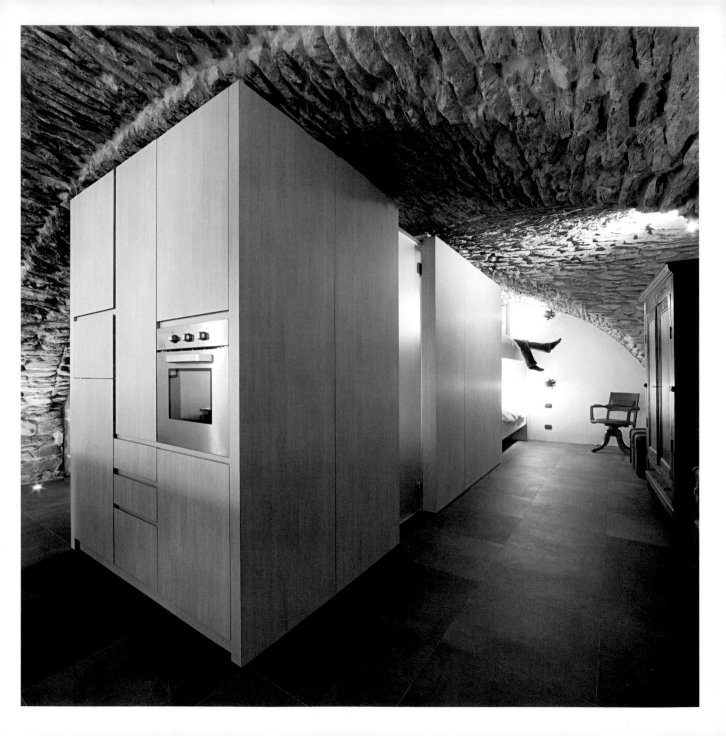

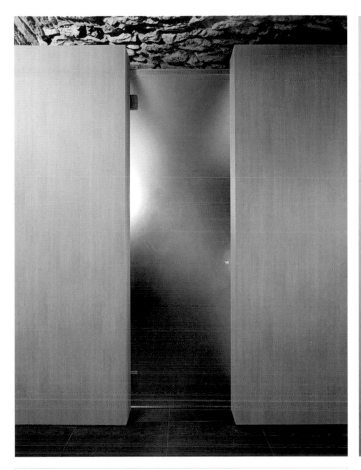

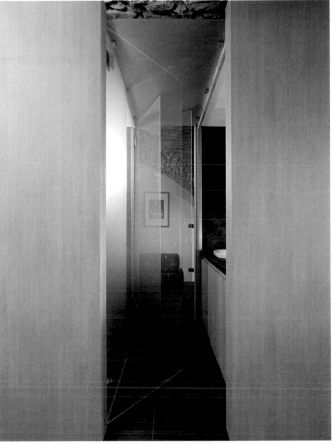

Sketch

148

Frosted glass adds depth to the space, letting light through while providing privacy. It can be used as a fixed panel or a movable partition to separate different areas.

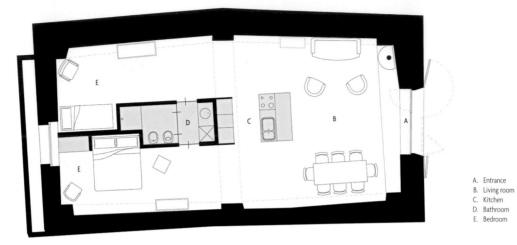

Floor plan

A. Entrance
B. Living room
C. Kitchen
D. Bathroom
E. Bedroom

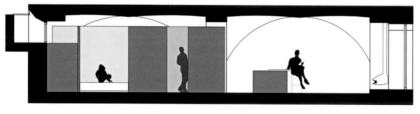

Section

The tall block in the middle can be connected to the other tall block by the frosted glass doors, or it can be freestanding. These variations change the circulation around the space.

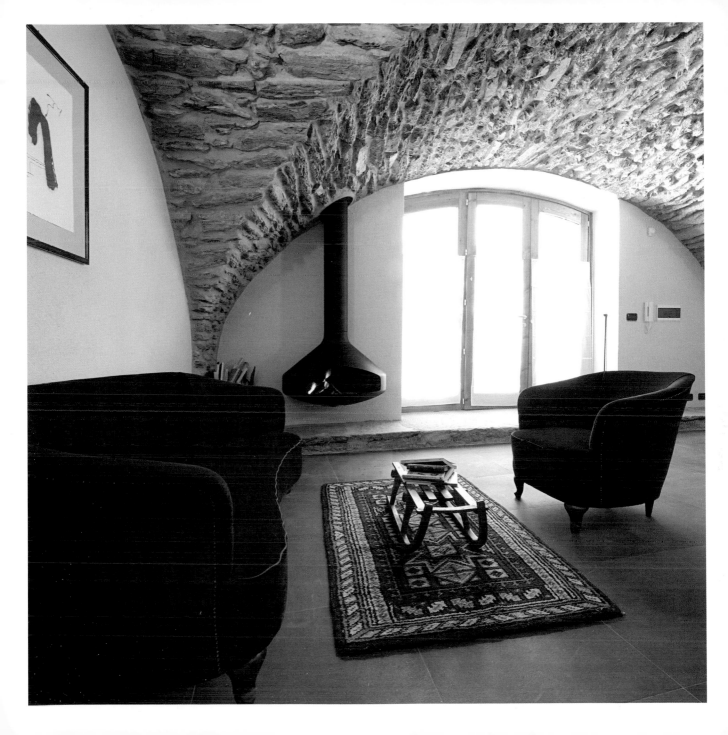

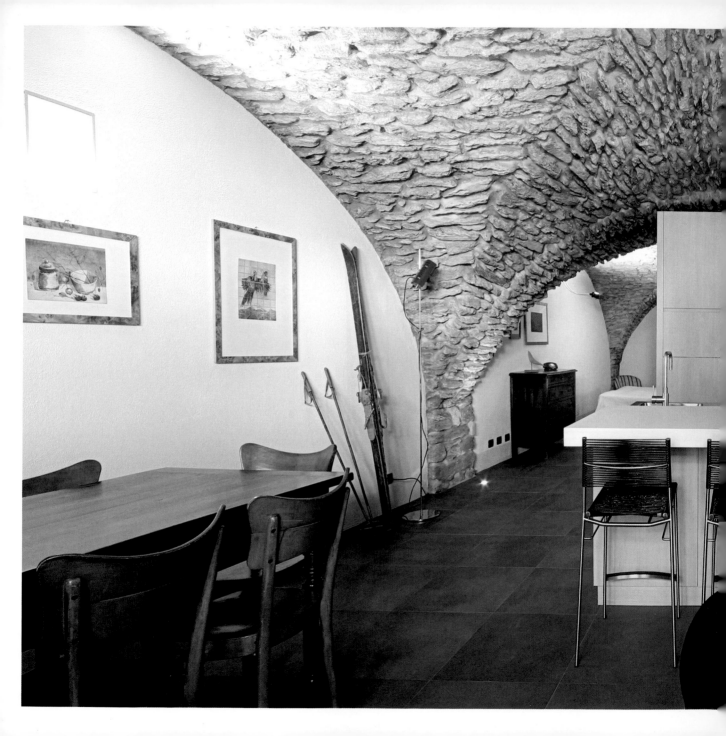

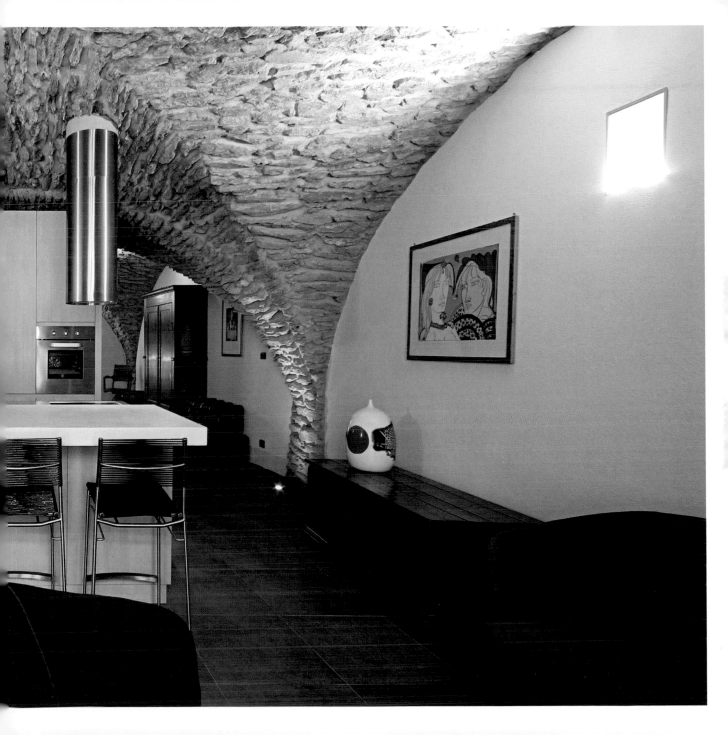

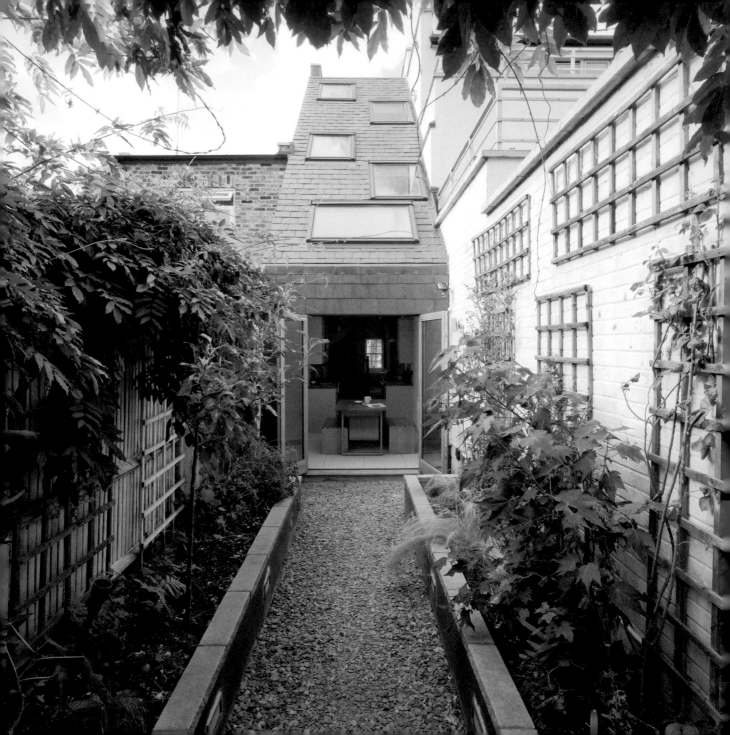

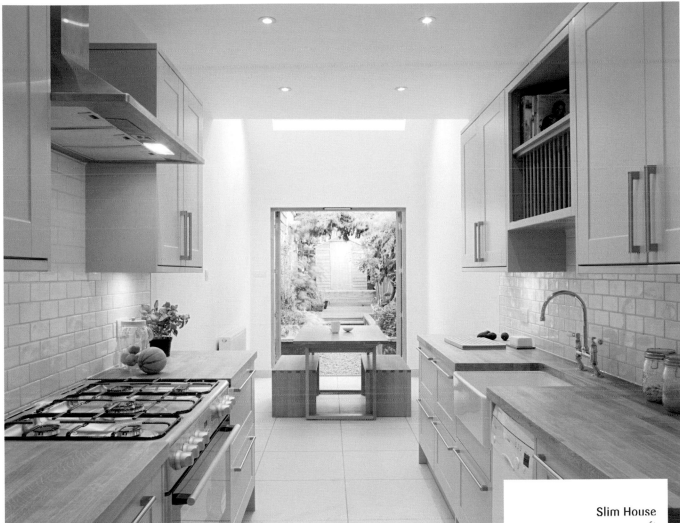

Who would have guessed that this bright London townhouse was once a dark building with limited access to the garden? At just 7 ½ feet, its width was a challenge when it came to remodeling the house. A restricted budget led to a series of original and practical solutions.

Slim House
1,119 sq ft

Architect: Alma-nac
Collaborative Architecture
Location: Clapham, London, UK
Photographer: © Richard Chivers

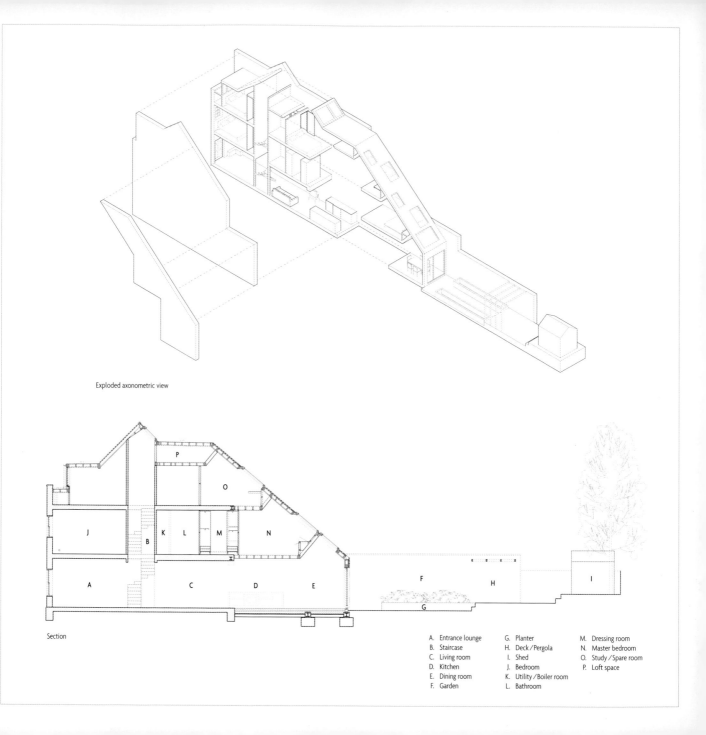

Exploded axonometric view

Section

A. Entrance lounge
B. Staircase
C. Living room
D. Kitchen
E. Dining room
F. Garden
G. Planter
H. Deck / Pergola
I. Shed
J. Bedroom
K. Utility / Boiler room
L. Bathroom
M. Dressing room
N. Master bedroom
O. Study / Spare room
P. Loft space

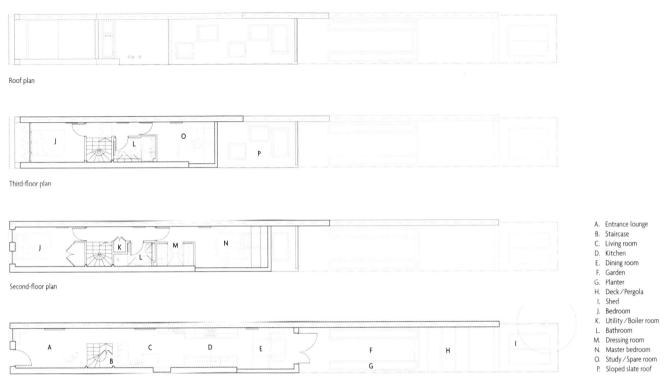

Roof plan

Third-floor plan

Second-floor plan

Ground floor plan

A. Entrance lounge
B. Staircase
C. Living room
D. Kitchen
E. Dining room
F. Garden
G. Planter
H. Deck / Pergola
I. Shed
J. Bedroom
K. Utility / Boiler room
L. Bathroom
M. Dressing room
N. Master bedroom
O. Study / Spare room
P. Sloped slate roof

The neighboring properties had been extended to the full depth of the site. For the townhouse, this option was rejected from the beginning, as it proved problematic in terms of bringing light into the center of the plan.

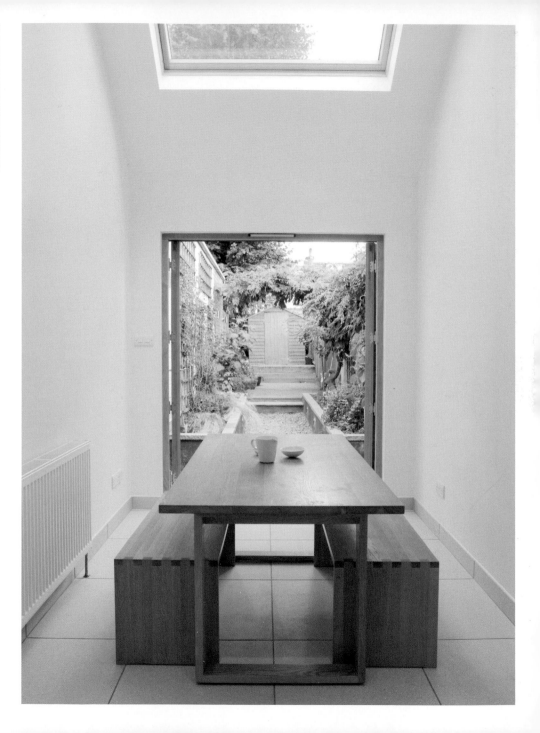

149

A narrow space can be multipurpose, as long as it's tall and airy. It can make a wonderful breakfast nook and a comfortable place for working, with good lighting and, perhaps, pleasant views.

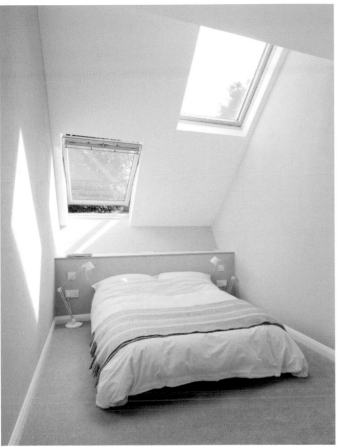

The creation of storage
space is always a requirement
when dealing with small
homes. Storage should not
get in the way of a relaxing,
comfortable atmosphere.

DIRECTORY

3XA
Wroclaw, Poland
www.3xa.pl

4site architecture
Sydney, NSW, Australia;
Melbourne, VIC, Australia
www.4site-architecture.com

Ábaton
Madrid, Spain
http://abaton.es

Aberjung Design Agency
Graz, Austria
www.aberjung.com

Alex Nogueira/ARQUITETO.só
Campo Grande, MS, Brazil
http://alexnarq.wix.com

alma-nac collaborative architecture
London, UK
www.alma-nac.com

Antoni Associates
Cape Town, South Africa
www.aainteriors.co.za

AP 1211 / Alan Chu
São Paulo, Brazil
www.alanchu.com

arbol
Osaka, Japan
http://arbol-design.com

Architekturbüro Jungmann
Lienz, Austria
office@architekt-jungmann.at

ARCHTEAM
Prague, Brno and Náchod,
Czech Republic
http://www.archteam.cz

atelier HAKO architects
Tokyo, Japan
www.hako-arch.com

atmos Studio
London, UK
www.atmosstudio.com

Beriot, bernardini arquitectos
Madrid, Spain; Paris, France
www.beriotbernardini.net

CABANA arquitectos
São Paulo, Brazil
www.cabana.arq.br

Cathy Schwabe Architecture
Oakland, CA, USA
www.cathyschwabearchitecture.com

CHRISTALLINE architect
Jakarta, Indonesia
www.chrystallineartchitect.com

Christopher Megowan Design
St Kilda, VIC, Australia
www.christophermegowandesign.com

Clifton Leung Design Workshop
Hong Kong, SAR, China
www.cliftonleungdesignworkshop.com

Colombo and Serboli Architecture
Barcelona, Spain
http://cargocollective.com

Consexto
Porto, Portugal
www.consexto.com

Coo Planning
Osaka, Japan
www.cooplanning.com

Concheiro de Montard
Santiago de Compostela, Spain
www.prefix-re.com

craft design
London, UK
www.craftdesign.co

Cristina Bordoiu
Arad, Romania
www.facebook.com/bordoiucristina

danny-broe-architects
Surry Hills, NSW, Australia
www.dannybroearchitect.com

Dierendonckblancke Architecten
Ghent, Belgium
http://dierendonckblancke.eu

Eva Cotman
Barcelona, Spain; Pazin, Croatia
http://evacotman.com

FABRE/deMARIEN architectes
Bordeaux, France
www.fabredemarien.com

Falken Reynolds Interiors
Vancouver, BC, Canada
http://falkenreynolds.com

Fild
Kiev, Ukraine
www.thefild.com

Francesco Librizzi Studio
Milan, Italy
www.francescolibrizzi.com

Fujiwarramuro Architects
Osaka, Japan
www.aplan.jp

Gosplan
Genoa, Italy
www.gosplan.it

idhea
Prague, Czech Republic
http://www.idhea.cz

Jean-Maxime Labrecque Architecte
Montreal, QC, Canada
www.inpho.ws

Jerome A. Levin
Roslyn Harbor, NY, USA
http://jeromealevin.com

Johnsen Schmaling Architects
Milwaukee, WI, USA
www.johnsenschmaling.com

Jun Igarashi Architects
Hokkaido and Sapporo, Japan
http://jun-igarashi.com

Keiji Ashizawa Design
Tokyo, Japan
www.keijidesign.com

Lanefab Design/Build
Vancouver, BC, USA
www.lanefab.com

MKCA // Michael K Chen Architecture
New York, NY, USA
http://mkca.com

Minimal USA
New York, NY, USA
www.minimalusa.com

PorterFanna Architecture
New York, NY, USA
www.porterfanna.com

ROW Studio
Mexico City, Mexico
http://rowarch.com

Sandra Meštrovic
Zagreb, Croatia
www.sandra-mestrovic.com

S-AR stación-Arquitectura
Monterrey, Mexico
http://s-ar.mx

Sauquet Arquitectes i Associats
Sabadell, Spain
http://sauquetarquitectes.com

studioata
Turin, Italy
http://studioata.com

Studio Bichara
Rome, Italy

Septembre Architecture
Paris, France
www.septembrearchitecture.com

StudioCE
Berlin, Germany
www.studioce.de

Studio Guilherme Torres
São Paulo, Brazil
www.guilhermetorres.com.br

Tim Wickens Architect
Toronto, ON, Canada
www.twai.ca

Torsten Ottejjö
Uddevalla, Sweden
http://ottesjo.se

TYIN tegnestue Architects
Trondheim, Norway
www.tyinarchitects.com

martin kalleso arkitekter
Havneholmen, Copenhagen, Denmark
http://kallesoearkitekt.dk

Unemori Architects
Tokyo, Japan
www.unemori-archi.com

UUfie
Toronto, ON, Canada

WG3
Graz, Austria
www.wg3.at

Yoshihiro Yamamoto Architects Atelier
Osaka, Japan
http://yoshihiroyamamoto.com

Zébra3/Buy-Sellf
Bègles, France
www.zebra3.org